SCAD

Postmodern Currents
Art and Artists in the
Age of Electronic Media

Studies in the Fine Arts:
The Avant-Garde, No. 64

Stephen C. Foster, Series Editor

Professor of Art History
University of Iowa

Other Titles in This Series

Postmodern Currents
Art and Artists in the
Age of Electronic Media

by
Margot Lovejoy

U·M·I Research Press

Ann Arbor / London

Produced and distributed by
UMI Research Press
an imprint of
University Microfilms Inc.
Ann Arbor, Michigan 48106

Library of Congress Cataloging in Publication Data

Lovejoy, Margot.
 Postmodern currents : art and artists in the age of electronic
media / by Margot Lovejoy.
 p. cm—(Studies in the fine arts. The avant-garde ; no.
64)
 Bibliography: p.
 Includes index.
 ISBN 0-8357-1904-9 (alk. paper)
 1. Mass media and the arts—United States. 2. Postmodernism—
United States. 3. Art and technology—United States. I. Title.
II. Series: Studies in the fine arts. Avant-garde ; no. 64.
NX180.M3L58 1989
700'.1'05—dc19 88-39453
 CIP

British Library CIP data is available.

Mark Kostabi, Untitled Drawing
(Courtesy Ronald Feldman Fine Arts, Inc., N.Y.)

Contents

Figures

Foreword

Because innovation is continuous, it is difficult to establish precise boundaries between historical periods. Which painting or building signals the beginning of the Renaissance? Which work of the imagination or of scientific discovery signals its end? Answers to such questions are bound to seem arbitrary. Surely a historical period is not just the temporal site of certain artifacts and discrete intellectual events. We give names like "medieval" and "Renaissance" and "modern" to stretches of time that appear to be unified by characteristic beliefs and procedures—or, what is more to the point of Margot Lovejoy's *Postmodern Currents: Art and Artists in the Age of Electronic Media*, periods disrupted by characteristic conflicts.

No society can prevent discord in the relations between individuals and institutions. We know from our own experience and historical memory that those relations have often been difficult, even violent, in modern times. Politics attained modernity in the American and French revolutions. The burst of scientific and technological development in the late eighteenth century is called the Industrial Revolution, a phrase that evokes riot and new poverty, as well as abundant goods and new wealth. Nonetheless, we are sometimes tempted to assume that modern conflict differs from earlier varieties only in degree, not in kind. This assumption leads to the comforting reflection that certain other periods may have been even more violent than ours. Perhaps they were. But the relations between selves and institutions during the past two centuries have inflicted on ordinary life a new kind, not simply a new degree, of harshness.

The modern period began when technological change speeded up to the point where succeeding generations could no longer feel certain that they lived in the same world. As Lovejoy's *Postmodern Currents* documents in vivid detail, modern technology disrupts the history of experience; it changes not only the landscape but the way that landscape is seen. It shapes perception and induces a new kind of uneasiness, the distrust we feel toward tools and convenience that we would be reluctant to do without—devices that have, after all, done much to define what we are. But why should the familiar things of our world—automobiles, television sets, com-

puters—be such frequent targets of our distrust? Lovejoy suggests an answer in her discussion of artists' access to high-level computer and video technologies.

Access is difficult when innovations sponsored by large corporate and governmental institutions remain under their control, as they so often do. No television network is likely to offer itself as an artist's medium, so video artists must work at a smaller scale. Yet, no matter how intimate and productive one's interaction with technology, there is always the sense that it remains the instrument of institutional authority that by its nature stands in opposition to the self. And the still increasing rate of technological development makes that opposition particularly effective. Often bureaucracies and marketplaces can maintain an ascendancy over individuals (including their own personnel) simply by sustaining change at a destabilizing pace. During the past two centuries, to be a self is to be under relentless pressure to catch up. This pressure has no precedent in earlier times. Individuals were not prepared for it two centuries ago, nor have we adapted to it yet. Artists try to relieve the pressure of change by extricating technology from institutional agendas—that is, some artists engage in that struggle.

Lovejoy draws a distinction between artists who flee technology and those who try to engage it on terms other than the ones dictated by institutional purposes. The contrast is between art as nostalgia for a premodern, premechanical pastoral and art as a means of grappling with a quick-moving present. From this distinction follows another: between the artists who engaged their art with mechanical and photo-mechanical technology and those who grapple with the electronic technology that has appeared in the last few decades. Among the first group are Marcel Duchamp, the Dadaists and Surrealists, and the Pop artists—most notably Andy Warhol, who, as Lovejoy recalls, went so far in embracing the machine as to wish that he could become one himself. The second group is not so well known. Museums and galleries still do not pay much attention to video and computer artists. *Postmodern Currents* is an indispensable guide to an area of culture that is treated as marginal but has already become more central as the electronic media more powerfully define us and our world. Lovejoy singles out for close examination the artists who carry on with the task that has occupied the most courageous sensibilities since the time of the Industrial Revolution: to experiment with advanced technology not for some definable gain but for the sake of making it a more helpful mediator between individuals and institutions. Shaped by aesthetic motives, technology will be better at shaping us.

CARTER RATCLIFF

Preface

As an artist who has *always* used technology in my work, I've *always* felt cheated by art history. Although by the end of the sixties and early seventies a few books began to treat the relationship between art and technology seriously, it was not until ten years ago, when I read the translation of Walter Benjamin's essay "The Work of Art in the Age of Mechanical Reproduction" that I felt that "aha" response. Benjamin's (1936) statement that technology has not just *influenced* art but has *transformed* it raised as many questions in my mind as it answered. But his arguments were so compelling, so inclusive of larger issues not previously addressed by other historians, that I immediately felt the need to extend his analysis to include the present. It was satisfying to finally have a context for addressing questions that had always bothered me: Why has technology been treated as such a taboo and left out of art history? Why is film not included in art history while architecture is? Why has it taken so long for the influence of technology to be recognized as a significant force in forming cultural experience? Why is so little attention from the art world being directed to the startling new possibilities for art offered by electronic media? What effect will the new electronic media have on the future of art and on the future of art institutions?

I have written this book out of a mixture of puzzlement, fascination, curiosity, and finally, commitment to share what I have learned over the many years it has taken to complete my investigation. It grows out of the concerns artists themselves have about the development of art. Because artists' work is necessarily in the vanguard relative to later interpretation of it by art historians or critics, this book is meant as a frame-of-reference for the future. It is a survey designed to make connections—to penetrate the morass of issues and historical detail, to find pathways which cross over fields to reveal a structure which, like a Mayan monument covered by jungle growth and long hidden by neglect, is suddenly revealed for what it is. The function of this cross-disciplinary book is simply to uncover these connections. In extending Benjamin's theories about how technology

changes the way art is produced, disseminated, and valued, and how new art forms grow from new tools for representation and new conditions for communication, I examined the conditions of our postmodern electronic age to find the roots of the present crisis in art.

Because this book is a survey, a major regret on my part is that I cannot include more of the important art works and artists. I've only been able to touch the tip of the proverbial iceberg. Difficult choices had to be made in order to complete my task without too much digression from the points that needed to be covered. Because each area of electronic media is now so large and has so many practitioners, I had to decide whether to present more historical illustrations or more current work. I tended toward the latter. As in any survey, much of the material has had to be greatly condensed. Although some technological information presented here will inevitably be superseded by new developments even before *Postmodern Currents* appears in print, I believe reporting on the current status of technology will help to create a flavor for the issues under discussion. Changes are occurring at an ever-increasing tempo. It is my hope that the reader will find this book to be an important signal along the path.

Acknowledgments

Apart from the many artists, galleries, and colleagues who helped make this book a reality, I owe a special thanks to the State University of New York at Purchase, which awarded me a semester's paid leave, and later a sabbatical. A Guggenheim Fellowship is also partially responsible for the freedom needed to complete this work.

This book would not have been possible without the support, encouragement, and vital help of several extremely important individuals: my daughter Kristin for her commitment as sounding board and researcher; Ruth Danon for her editorial judgement; Lucinda Furlong for her overall critique; my daughter Meg for her critical analysis; Beryl and Blume Gillman for their skilful help; and my husband Derek, for his invaluable, enduring support. To each, my profound thanks.

Introduction

Our fine arts were developed, their types and uses were estab-
lished, in times very different from the present, by men whose
power of action upon things was insignificant in comparison
with ours. But the amazing growth of our techniques, the
adaptability and precision they have attained, the ideas and
habits they are creating, make it a certainty that profound
changes are impending in the ancient craft of the Beautiful.
In all the arts there is a physical component which can no
longer be considered or treated as it used to be, which cannot
remain unaffected by our modern knowledge and power. . . .
We must expect great innovations to transform the entire tech-
nique of the arts, thereby affecting artistic invention itself and
perhaps even bringing about an amazing change in our very
notion of art.

<div align="right">Paul Valéry</div>

Living at the end of the twentieth century in new conditions produced by the electronic era, artists are profoundly aware that they are relating to a cultural and technological climate which strongly affects the way they see, think, and work.

The purpose of this book is to examine the relatedness between techno-logical development and aesthetic change. It reviews the present crisis in our own electronic era by seeing it as a paradigm parallel to the one created by the Industrial Revolution and the rise of the Mechanical Age. For exam-ple, if we can see that the technology of photography catalyzed the modern-ist ethos in art, we can also see that emergent electronic technologies are creating the new period tentatively named Postmodernism. This new period will be just as distinct and different from its precursors as was Modernism.

Technology Changes Ideas about the Purpose of Art

Although technological progress has always generated major social, political, and economic upheavals which are reflected in cultural change, its direct influence on art—its production and its social purpose—has not always been acknowledged in the analyses of art historians, who tend to disregard its importance . One of the most insightful commentaries on the role technology plays in its relationship to the function of art as a form of social communication was written in 1936 by the German critic/philosopher Walter Benjamin: "The Work of Art in the Age of Mechanical Reproduction." His visionary essay catalogs the way the technology of photography has transformed the entire nature of art—the way it is produced, the way it is seen, its value in social and financial terms, and the way it affects the relationship between the artist and his role in society. For example, up to now, when we look at the history of art, we see almost no mention of photography except to discuss whether it is valid as an art form. According to Benjamin, however, *the primary question* has not been addressed: he claimed that "the very invention of photography had ... transformed the entire nature of art." His essay argued that the development of photography not only affected how works of art are made, seen, and communicated but that the technology of photography produced dynamic new art forms such as photography, photomontage, and film. It provided ways in which art could be studied, reproduced, and communicated to a much broader public than ever before. He explored issues such as how major shifts brought about by widespread integrated changes in technological conditions in society change the collective consciousness; how the social function of art has changed; how new works of art such as film and video, inherently designed for reproducibility, raise fundamental questions about originality and authorship, and about the relationship between the artist and his public.

This book is based on Benjamin's theories. Although the first English translations of his essays were published only in 1968 (*Illuminations,* edited by Hannah Arendt), Benjamin's diverse and thoughtful series of writings on art, culture, myth, and society have already become legendary. He is now regarded by many as the greatest literary critic of this century. Born in Berlin in 1892, Benjamin moved to Paris to escape the Nazi regime. In 1940, he committed suicide while attempting to escape from Occupied France. Ahead of his time, he touched on profound issues which had remained undiscussed; and in so doing, he touched on the basic developments which are at the root of Postmodernism. Benjamin's essays "The Work of Art in the Age of Mechanical Reproduction" and "The Author as Producer" have become bedrock influences for much new thinking and have been reproduced in important collections of postmodern essays such as *Art After Mod-*

ernism and *Video Culture.* Yet there has still been little true acknowledg-
ment or elucidation of his controversial theories in relation to the new visual
electronic technologies (simultaneously emergent in the late fifties), the
computer, video, and the copier, and there has been no description of these
media in terms of their potential for art and their influence on the collective
consciousness.

Deep Change in Technological Standards
Creates Change in the Collective Consciousness

The Industrial Revolution depended on mechanical machines made of rigid
parts which imitated animal or muscle power for industrial production.
Electronic machines, however, use disembodied, invisible electric charges
which imitate the instantaneous processes of the brain and nervous system,
providing the immediacy of simultaneous communication. Electronic ma-
chines such as the computer, the video, and the copier create information
and services (rather than manufactured goods). The instantaneity of the
electronic pulse, its very all-at-onceness, produces unmistakable instant
electronic communication interdependencies. These affect us directly in
our personal lives via the mass media; in our jobs which now demand
computer literacy; in the marketplace internationalized via electronic bank-
ing and investment; in our cultural response through an expanding inven-
tory of technological tools, materials, and practices. Paradoxically, we ex-
perience this electronic all-at-onceness as both a threat and a benefit. On
the one hand, it provides the potential for unprecedented human develop-
ment, communication, and democratic enlightenment. On the other, it is a
frightening, alienating influence—forcing us to confront our relationship to
the pressing issues of who owns and controls powerful technologies, espe-
cially those which can threaten us with global annihilation at the press of a
button.

　By now, we have developed mechanical or electronic extensions of
almost everything we used to do with our bodies alone: a welding tool as
extension of the hand; a camera as extension of the eye; sound systems as
an extension of the ear; the computer as an extension of the brain. These
extensions of our human faculties create profound changes in the relation-
ship among our senses which lead to new perceptions and altered con-
sciousness of the world. Commenting on the impact on his art brought about
by technological and social change in his own generation, Henri Matisse
remarked: "Our senses have a developmental age which is not that of the
immediate environment, but that of the period into which we were born.
We are born with the sensibility of that period, that phase of civilization,
and it counts for more than anything learning can give us."

The history of change in consciousness is tied to the enormous advances in technology from preindustrial times to the electronic present. "The telephone, television, and computer are literal projections of our perceptual and cognitive mechanisms. In effect, the electronics revolution has supplied us with a colossal collective external nervous system that enables us to tune in the world, or even outer space, at a glance. Television, challenges our concepts of space, simultaneity, and individuality—50 million people watching a man walk on the moon, or *Three's Company*. Together."[1] The rapid change now occurring is creating a moment where the kinds of work produced by the new generation of artists makes their work "no longer in the same conversation" with their elders.

When technology extends our senses and consciousness, "the initial shock gradually dissipates as the entire community absorbs the new habit of perception into all of its areas of work and association."[2] For example, when millions of T.V. viewers saw the first man landing on the moon, their romantic moon mythologies were forever shattered. The moon had acquired new aspects of significance. An artist creating a landscape now has a concept of time/space unlike those of previous generations. The concept of landscape has changed to add a diverse set of understandings that may include aerial viewpoints, map references, and cosmic deep space. Even the aspect of time is affected now that we have experienced jet lag (the physicality of losing, for example, twenty-four hours crossing the International Date Line, in a single flight from Tokyo to New York) and have contemplated the two years it would take to reach Mars.

Exploration of space has also established new relations between ideas concerning perspective, the fourth dimension, and non-Euclidean geometries—and therefore our ideas about subject matter and illusion in art. The computer is now being used by artists, for example, to explore and visualize some of these relations.

Changes in technology transform the structure of art itself by promoting the creation of new art forms. Photography, video, and the computer have dramatically changed the possibilities for visual representation, allowing for the dynamic analysis of motion, time, space, and the abstract relations between them. The use of technology in art shifts the emphasis from traditional reliance on hand skills and affords the artist a much more intense engagement with decision making and with the creative process itself. The new electronic-media tools (video, computer, copier) provide a powerful means for extending and transforming the conception and execution of works of art. These new media open dramatic new avenues for exploration in the arts, expanding their parameters, and creating new forms. They foster fresh insight and aesthetic growth. For example, the computer is a universal

tool whose digital alphabet code can be used indiscriminately to address image, text, or sound as information in its database. Because it can be used in *every* field of endeavor, its use is already forging new links not only between the arts themselves but with science as well.

Yet Why Is Technology Seen as a Threat to Art?

The threat recognized by the poet/critic Baudelaire in 1859 when he wrote, "If photography is allowed to stand in for art in some of its functions, it will soon supplant or corrupt it completely,"[3] is heightened today by new electronic technologies which extend not only the eye of the artist but his *conceptual functions* as well. Photographic technologies were stigmatized for direct use in art until relatively recently. Parallel stigmatization and prejudice is apparent in present-day attitudes about the use of new electronic media.

Since the Industrial Revolution, Western cultural attitudes have continued to put "man" in opposition to "machine." Translated into cultural values, this view opens itself easily towards dualisms in the inevitable comparison between technology (as an offshoot of science) and art. "The clichés associated with artmaking—that it is an outpouring of the creative, the uncontrolled the spontaneous, harnessed through form ... counter the conventions of the scientific process which involve formal mastery of a different sort, an attempt to make empirical reality 'knowable' through a tidy program of investigation, experimentation and conclusion ... reason vs. inspiration; logic vs. the irrational; the intellect vs. passion."[4] Cultural opposition to the new photographic devices of the 1850s centered around the issues of humanism versus the mechanistic, the scientific, the objective—which came to represent lack of feeling or of human intervention—a direct contradiction to the romantic posture of the artist with his "god-given" inspiration and creativity. This romantic posture persists despite the completely new terms scientific progress imposes through the technologically mediated conditions of contemporary life.

Paranoia about the direct use of technology in art-making is largely due to an old fear (which began when photography was invented) that machines are a substitute for art—that new authoritative, powerful mechanical devices will replace society's need for the artist, or that indeed the machine will somehow turn every man into an artist. The error in these lines of thought "is the underlying assumption that technology (or the machine) is a force unto itself rather than a set of inventions by humans who are responsible for their use and abuse. Since technology does not function autonomously it is as illogical to say that the computer, for example, threatens the

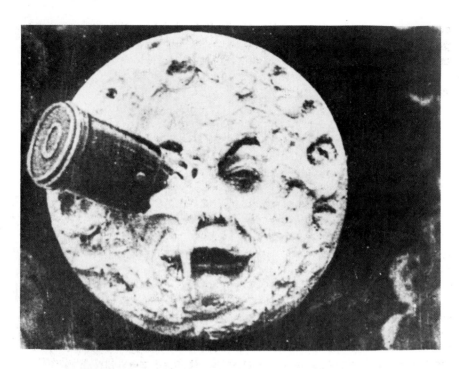

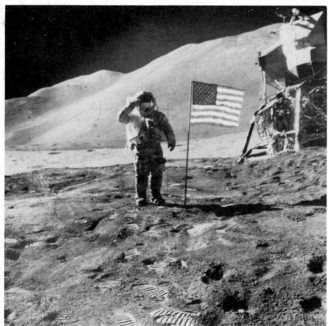

creative processes as it is to embrace the opposite extreme,"[5] for it cannot provide the meaning, interpretation, value or position relative to ethics or aesthetics that is the essential function of the artist.

Artists' Response to Technology

Artists' response to technology ranges from obstinate, aggressive refusal tinged with suspicion, skepticism, and resistance, to outright embrace of "the new" as a positive act of renewal, an open conviction that nostalgia for the past cannot respond to to the needs of the present or provide a map for the future. For example, the Futurists and the Constructivists reveled in the dynamism, the speed, the democratic productivity of the machine age as opposed to the romantic traditionalists of their time. However, the Dadaists and Surrealists presented an ironic critique or caricature of the machine by using it as an icon and as part of a political statement about social and cultural conditions.

Refusal takes several forms. For some artists, it takes the form of a conservative, obstinate refusal of modernity involving loyalty to the traditional practice of art and the patient pleasures of hand gesture and experiment through slow manipulation using time-honored practices. For others, it takes the form of a refusal of the present by turning inward to a private metaphorical world apart from time itself. For yet others, the refusal may be aggressive or derisive—a political refusal or denunciation of technological civilization in which man is seen as a powerless endangered species in a system where technology is owned and manipulated by those in power to control and direct the culture and society as a whole.

Those artists who seek out "the new" and take up the challenge represented by the emergent technologies use them because they can then inter-

Figure 1. *(Top)* George Méliès, *Le Voyage dans la Lune,* 1902
Film still.
(Museum of Modern Art/Film Stills Archive, New York)

Figure 2. National Aeronautics and Space Administration (NASA), *Astronaut David Scott Plants American Flag on the Moon,* July 26, 1971
These two images reflect powerful changes in our awareness. Méliès's 1902 fantasy film about the moon landing evokes "man on the moon" mythologies—green cheese and all the cliches still embedded in our vocabularies about the moon. The 1971 reality of the moon landing, as seen internationally on living-room television screens, created a major generation gap between adults who saw it as proof of the impossible come true, and their young children, who saw it as just an everyday event on T.V. For the children, it was the basis of the expectations of their age. Today's generation witnessed the 1988 scaling of Mt. Everest via a miniaturized T.V. camera so small it could be placed in the headgear of one of the climbers.

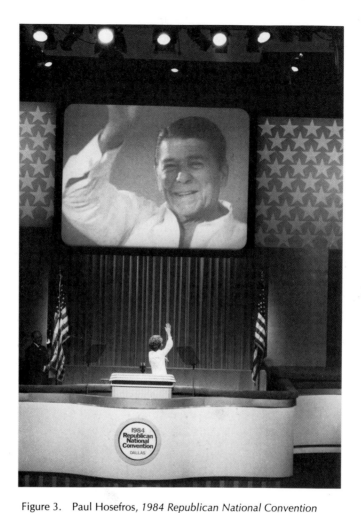

Figure 3. Paul Hosefros, *1984 Republican National Convention*
Photograph, *The New York Times*.
Television played a role in promoting nationalism during
the NASA moon landing by showing astronaut David Scott
planting the American flag on that faraway no-man's land,
as though it were possible to "own" the moon. Television
is also used as a potent political tool, used to inform the
potential voter as well as to confuse and mystify, offering
images rather than substance. Here, Ronald Reagan is
shown on a giant video screen high above the convention-
hall crowd as he is about to arrive in the building, his every
move monitored for all to see, a form of power born out
of curiosity fed by the immediacy of technologically
transmitted images.

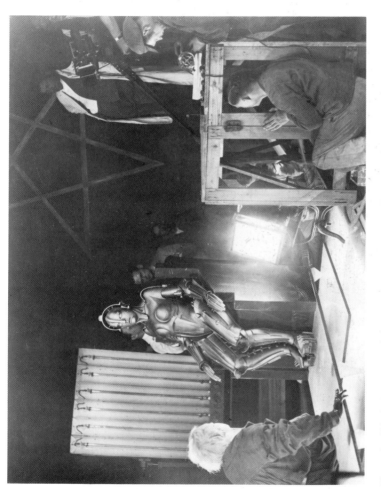

Figure 4. Fritz Lang, *Metropolis*, 1926
Film still.

Lang constructs a terrifying image of a twenty-first century totalitarian society dominated by technology. Here, he is shown on set shooting a scene from *Metropolis*, his last major silent film, where the mad scientist Rotwang reveals "The False Maria" robot he has created—the personification of technology used for evil persuasive purposes.
(Museum of Modern Art/Film Stills Archive, New York)

act more intensely and expressively with the fresh issues and subject matter of contemporary life. Use of new materials and processes allows artists free rein to invent new forms and to gain important insights by using a contemporary technological base. When dedicated to exploring social issues, technology can be a powerful force in creating statements which help both to clarify social and cultural issues and to raise questions which help in the orientation to the dangers and complexity of our era.

Risks of Acceptance

There are real risks in using technology for making art. For instance, there is the danger of dominance by a powerful new technique which can subvert the experimental, playful character of art with its dedication to raising questions and to exploring meaning. Because access to technology is expensive and difficult, artists may have to make important artistic, stylistic, and political concessions in order to obtain funding for their projects through governmental or corporate institutions. If the project is not a popular one, and does not fit the current funding guidelines, it may never be realized due to lack of resources. The technological artwork is then sometimes controlled by forces beyond the power of the artist. Through coercion, then, the artwork might be used as a tool to maintain institutional values rather than as a means of questioning them.

If artists can liberate technology from those who own and manipulate its use for goals of power or profit, technology can be used constructively as an enlightening influence to gain new insight, to seek new meaning, to open higher levels of communication and perception. For example, commercial television commonly portrays as the truth sensationalist news stories and documentaries to a mass audience which is increasingly passive and addicted to it as their major form of access to the outside world. The Wizard of Oz is the ultimate metaphor for the manipulation of consciousness by television. Finally unmasked as a fragile mortal playing God behind a screen of lights and a thunder of noise, the Wizard of Oz characterizes the power of the media to confuse truth and fiction. We often mistake highly edited presentations of an event as factual truth. "Our absorption and belief in media's second-hand information can distract us from home truths that we sorely need to deal with, or—to use the metaphor of Oz once again—[it distracts us] from getting back to [the reality of] Kansas."[6] As artist Ed Paschke has remarked: "I don't think we realize how ingrained in us that way of seeing that format really is. There's life and there's T.V."

Although access to television transmission for artists is an enormously difficult enterprise because of tight control of its technology by powerful commercial interests, the battle to present alternative viewpoints is being

fought, and in some cases, won. Public television and public cable T.V. stations are now regularly transmitting some of the videos independently produced by artists who want to connect with a larger audience. Equal time on T.V. for such independent voices *could* be the end of the tyranny imposed by the commercial system. It *could* be the beginning of a much larger audience and a significantly different role for art. As economist John Kenneth Galbraith commented in the 1960s: "The American business man having accommodated himself to the scientist in the course of accommodating himself to the 20th century, must now come to terms with the artist."

Art as Object or Art as Communication

One of the major issues Benjamin addressed was the economic, political, and cultural impact of the new photomechanical reproduction technologies and their relationship to the reproduction of art. Art reproduction squarely confronts the issue of the social function of art as opposed to its market value. For example, oil painting, which had dominated the European cultural outlook for four centuries, was indissolubly linked with the private property system as an original "cult" object which could be bought and sold. The value of the painting was tied to its material uniqueness as an original art object—its value as a precious object, rather than to its value as a form of social communication. Photomechanical copying of art works undermined the commodity value of art. Art work could be widely disseminated—enlarged, reduced, printed as postcards, or posters, for enjoyment of the public at large. Photomechanical reproduction increased the size of the audience for art and democratized its cultural influence.

However, through reproduction, the art was seen in a different context from the original setting and time period from which it was produced, and thus it acquired a different meaning. For example, artworks which once belonged uniquely to ancient civilizations, royalty, or the church, now appear as color reproductions in an international proliferation of art books and magazines. Reproduction has provided the impetus for widespread study and analysis of art of the past while allowing for a completely new perspective on it. Through inexpensive multiple reproduction, images become transformed as icons of the past, familiar as cultural reference points and internalized as part of popular culture. As such, they acquire new social meaning, value, and use. Take for example, the *Mona Lisa*. Torn from its original ritual "time and place" in a Medici palace, the most famous and valuable painting in the world now resides in a bulletproof, glass-enclosed, climate-controlled setting at the Louvre in Paris. How can the present-day cultural pilgrim see the *Mona Lisa* simply for its aesthetic value without

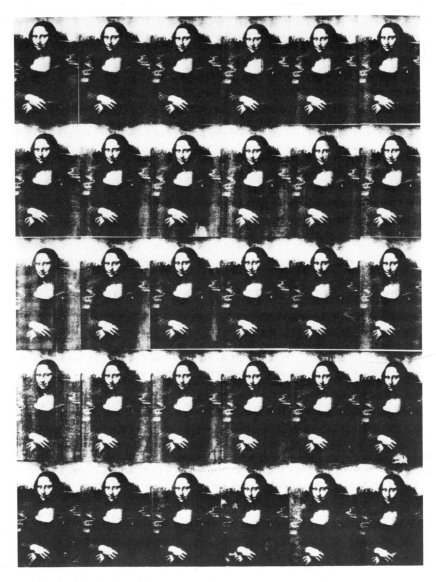

Figure 5. Andy Warhol, *Thirty Are Better than One*, 1963
Silkscreen on canvas, 110 1/4″ × 82 1/4″.
Warhol creates an "original" constructed of thirty copies
of the original. His appropriation of the most famous
cultural icon of all time is a comment on the power of
reproductive media to promote celebrity.
(Photo: Nathan Rabin)

references to its baggage of fame and financial value after having seen it countless times, for example, in contexts as wrenchingly different as a small art book illustration or blown up (as in a recent commercial billboard advertising campaign) and wearing headphones?

The excellence and quality of today's color reproductions raises further questions about market value. Art magazines full of reproductions of the most current work in New York galleries are closely scrutinized by artists in Berlin, Moscow, Tokyo, and São Paulo. These have helped to promote a dominant international network and style, encouraged and supported by the closely woven system of museums, critics, and the art market. An art work which has become famous by the sheer multiplicity of its public reproduction and dissemination gains value, making it a strong collector's item with a higher price. Several questions then arise: Who selects contemporary art work for reproduction and promotion? What is the relationship between critics, museums, galleries, and collectors who regard art as a good investment for capital gain? How does this system affect the struggle of an avantgarde to survive institutionalized selection and promotion of certain kinds of art?

The technology of photography produced a completely new art form, the moving picture, an incomparable means of insight and expression that presents reality and feeling through fracture and microcosm. Cinematic film, which depends on edited, radically reordered sequencing of visual material, brought with it a new form of pictorial literacy concerning the assembly and sequencing of reality. In its analysis of different points of view, it extends our perception and comprehension of the factors which rule our conscious and unconscious impulses. With the close-up, space expands and reveals entirely new structural aspects of a subject. Movement can be artificially slowed or speeded up—opening a new control not possible to the naked eye. The camera can now invade with infinitesimal close-ups hitherto unseen worlds in the spaces inside the human body or those far away in distant galaxies. It can open up and simulate worlds that hitherto have existed only in the imagination.

Film dramatically changed the relationship between the artist and his public. Film is conceived for mass viewing, reproduction, and distribution while painting and sculpture are designed for individual contemplation. Today's new electronic reproduction technology is now in the hands of a broad international public who can easily record transmissions of film and video via their own living room T.V. and VCR. Videocassette tapes are playing a dramatic role in democratizing aesthetic experience by taking it out of the realm of art object as expensive commodity. In this perspective, video—a form now being used by a growing number of artists—cannot be seen as an art object with a price tag designed for an elite audience but

Figure 6. Barbara Kruger, Untitled, 1982
Unique photostat, 71 3/4" × 45 5/8".
Kruger reproduces a (patriarchal) cultural myth to comment
on different levels of value—e.g., the value placed on hype
about "genius" and "originality" in relation to art market
value as opposed to the communication value of the
artwork. Through creating her own work from found,
appropriated images, she confronts the art market method
of assessing the artist as part of the "cult of genius" and the
original as related to the hand of the artist by discarding
both concepts.
(Collection: The Museum of Modern Art, New York)

Figure 7. Paul Hosefros, *Gauguin and His Flatterers*, June 25, 1988
 Photograph, *The New York Times*.
 This Gauguin painting destined for sale to the public has
 its value increased by being shown on the front page of the
 New York Times. Copies of the original newspaper (sold
 for a few cents) show how copies of the original painting
 (sold for a few dollars) are here being compared to the
 original (sold for a few million). The right to reproduce this
 photographic copy (of the copies and the original) was
 purchased for $100 to reproduce an agreed-upon number
 of copies of the original.

rather in its primary function as means of communicating ideas to a broader public. In this sense, photomechanical and electronic reproduction methods have expanded the potential influence of an art work and thus extended the role of the artist in society.

Parallel Paradigms—Photography Is to Modernism as Electronic Media Is to Postmodernism

The invention of photography provided for the fine arts what the printing press gave to the world of knowledge and ideas—a quantum leap into another set of possibilities. Parallel to this is the paradigm offered by new electronic media. Up to then, technological change in the arts had been painstakingly slow; and the emphasis on realism in art had continued in an unbroken line from Renaissance times. However, from its invention in 1839, the possibilities provided by photography for authoritative realism and the invention of radically different new art forms (as in cinema) acted as a catalyst in challenging tradition . In the 1880s, faster film and additional advances in photographic technology allowed for its full impact to be felt in everyday life via photomechanical reproductions in books and newspapers, the use of the Kodak instant camera (1888), and (by 1895) the development of cinematography. Photography helped to profoundly transform social and cultural communications and eventually led to the rise of a modernist aesthetic. "Photography had a double significance since it provided a model for imitation and at the same time, challenged the painter to go further."[7]

The discovery of photography essentially questioned the functions of art. The theology of a "pure" art, which grew once photography (as reproduction, as stills, as photomontage, as cinema) supplanted some of the social-use value of art, contained within its ideology such concepts as the divine genius of the painter and the sanctity of hand skills as the *only* means of making art. These attitudes grew out of a powerful negative reaction to the threat of the machine age, with its useful but alienating inventions, and laid the groundwork for a modernist aesthetic. Instead of embracing photography and its new technologies, mainstream modernist attitudes in art led to the repression of photography as a direct influence. The most progressive painters eventually developed a modernist aesthetic which lay far beyond figuration to a "higher reality" in art which, through a series of progressions, led the artist towards the renunciation of all external influence from the outside world—to a stripped down, "pure," and highly individualized study of formal aesthetic principles. The art works judged best by the art establishment were those which demonstrated advances in the progressive stages of this process. The mainstream art community shared a passionate common

belief in this modernist "single truth" aesthetic. It pervaded the field of music, poetry, literature, dance, and experimental film. However, the avant-garde consistently reacted to this narrow form of activity and used photography and its technologies to create an antiaesthetic commentary.

The new set of possibilities opened through the the invention of electronic technologies (with their astonishing implications for representation, as tools for developing new art forms for the art community of today) has, by now, far surpassed the mechanical age and undermined the narrowness and suppression of forms inherent in the modernist construct. Postmodernism (ultimately an unsatisfactory term for such a completely new era) now opens the door to include a vast new territory of issues and unresolved questions such as those of authorship, subjectivity, and uniqueness posed by Walter Benjamin's analysis of photography's impact. Photographic influence has now been greatly expanded by electronic media. Images have now become a principal conduit of information, culture, and society in the Western world. Postmodernism is a new condition, essentially a much broader territory where the suppression of social and cultural influence is no longer possible. The parallels and commonalities between these two paradigms form much of the subject matter of the succeeding chapters of this volume.

This book is a survey. Although Walter Benjamin's essays are provocative and challenging they are also polemical, and they have not been set into the context of a historical overview. In Part One, "Sources," historical moments in Modernism are selected because they illustrate specifically the paradigm in the relationship (first developed by Benjamin) between photography and the rise of Modernism. Similarly I illustrate how the rise of electronic media parallels the birth of Postmodernism. In Part One I present specific examples from art history, which provides the basis for our understanding of Part Two, "Systems." This section opens out to include a broader view of each of the three most important electronic media and the artists who have pioneered their use. It reviews the history of their nearly simultaneous development and raises questions about the future of cultural production and its relationship to the public. The dramatic new terms scientific progress imposes radically shift all our assumptions about art and life.

Although the ensuing discussion in Part One cannot claim to fully elucidate the relationship between art, technology, and cultural manifestations, it is meant to serve as an overview. Insight is offered about how motivations for aesthetic change arose and how technological transformation has propelled it. It isolates those issues, movements, and representational modes which most clearly serve as a foundation for reaching an assessment of the new electronic media, their effect on the next generation of artists, and the cultural issues they will be reflecting and confront-

ing. Just as an image's well-chosen explicit detail can illuminate important elements of a larger picture, this discussion is meant to bring into focus cultural issues which have at their base essential underlying social, political, and economic factors which can only be briefly touched on but which must be kept uppermost in the mind of the reader. These ideas and their implications for the future are brought together again in chapter 7, following the more detailed discussion of electronic media earlier in Part Two.

Part One

Sources

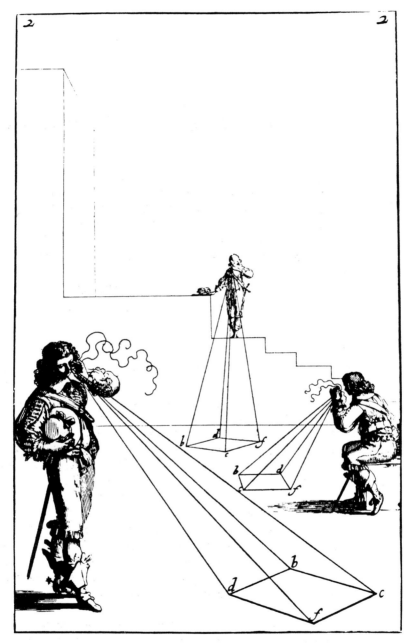

Figure 8. Abraham Bosse (1602–76), Perspective Drawing
Sighting dimensional illusion using the mathematical
structure of perspective.

1

Technics and Art: Illusion and Invention

One of the foremost tasks of art has always been the creation of a demand which could be fully satisfied only later. The history of every art form shows critical epochs in which a certain art form aspires to effects which could be fully obtained only with a changed technical standard, that is to say, in a new art form.

Walter Benjamin

Seeing Is Changing

The eye of any age is the mind of that age. Today we see things very differently than ever before. This is a result of dramatic changes brought about by the increasingly technology-dominated conditions of our lives and by the radically new means of representation available to us for organizing human sense perception. Devices that modify the way we see and think are bound to affect the style, content, and philosophy of art works. For example, conventions of Renaissance perspective (a major advance for its time in the formulation of illusionistic space) dictate a single viewpoint as the center of the visible world. Images are constructed so that the convergence of mathematically structured vanishing points address the central vantage point of the single spectator as being the ideal in the creation of illusion. But the invention of the camera represents a completely different outlook. The images it captures depend on where the camera eye is pointed—and when. The momentary reality of photographs is inseparable from the concept of time passing and the experience of visual reality in a particular place.

The notion of multiple viewpoints melded together are a phenomenon of cinematography. Here the camera moves, rises, falls, distances objects, moves in close to them—coordinating all angles of view in a complex

juxtaposition of images moving in time. Film and video represent a deepening of perception, for they permit analysis of different points of view and extend comprehension beyond our immediate understanding by revealing entirely new structures of a subject than is available to the naked eye. As a result of the prevalence of film and television in daily life, our awareness of the multiple grammars of the moving image deeply influence the way we see and think.

However, another major shift in the history of representation is now taking place. Due to the convergence of the computer with video (and thus film), images can now be composed of information models of objects and space. When information about a particular scene is encoded in the computer (for example, as standard measurements, sonar mapping, or via a video scan where the behaviour of light in a space is digitized as numerical information) it becomes a digital code or alphabet and can thus be combined with text or music which is addressable in the same code (although each of these retain their own characteristics). The digital code can contain all the mapped information about a space—the top, side, bottom of a chair, its proximity to a wall, the size and placement of a book resting on it, and its location in a room. The room is no longer an image but an informational pattern. Parts of the image and their point of view can then be selected from the data base for viewing on a monitor or can be reproduced as a video tape with music and text, a photographic slide for enlargement, or as a copier print. Ultimately, by the turn of the century, computer-processed electronic images will replace conventional camera images.

A further aspect of this shift lies in the realm of interaction with the spectator. For instance, since all the coded data is addressable on a video disk as numbers, a complete many-sided story (encoded with branched-out versions of each aspect of it) can be interactively "read" by the spectator. The viewer makes choices as to how the story will progress from among the many details, descriptions, and episodes of its telling that are offered as numbered options. In this sense, the conception of the piece is designed to take place centrally within the spectator's domain, similar yet very different from that of the ideal center of a Renaissance perspective.

The computer, then, is essentially a container for all media. It makes possible the building of images from the inside out instead of from the outside in, where we use a map or diagram of the space to conjure up the image itself and its final resolution or point of view. The idea of formulating images out of a system of logic (using mathematical codes rather than photographically captured light waves) is intrinsically the same as that of Oriental and Islamic art. In these ancient traditions, representation of an object is not always depicted as it appears to the eye. Rather, it is a diagrammatic or schematic image of a concept. For example, in a mandala, each

shape and detail depicted has assigned cultural and philosophic meanings in a prescribed code of belief or logic. The audience of that period knew what each detail meant as they "read" the image to plumb its meaning according to well-understood assumptions of that time.

The Influence of Tools

In a recent essay, electronic-media pioneer Sonia Sheridan commented on the influence of tools—manual, mechanical, photographic, or electronic—on artists' perceptions. Tool types are implicitly related to questions of time and space and have a bearing on the nature and structure of artistic production and conceptualization. Each type of tool offers its own possibilities, its own strengths and weaknesses. Each is characteristic of a particular epoch, and its marks are a reflection of that time period. Although the coherence of the artist's conceptualization process is the most important aspect of art-making, the influence of tools and of technological conditions transform the production and dissemination of art.

For example, a meticulously detailed oil painting may require months of manual labor and planning and, in its final form, represent the focusing of both a mental and physical act. It is a unique production, a single cultural object imbued with the mark of the hand. By contrast, a photolithograph can be produced as a multiple image in a different time ratio using manual, mechanical, and photographic tools. These means of production will reflect characteristics of the mechanical era both as aspects of a photographic mechanism and the gear of a press. "With mechanical aids, elements of time and space can be manipulated with new speed ... application of energy by mechanical means alters our physical environment. ... The arm with the gear is the symbol of the mechanical era which removed tedious labor."[1] The multiple print form makes the art work more available to a wider public.

Electronic tools have a "hidden point of view, far more complex than that which is built into a brush, a printing press or a camera."[2] Silently and instantaneously, they store, collect, transmit, and multiply visual and digital information according to the programmed instructions situated within their electronic system boxes, removing much of the tedium of routine manual and mental functions. "Think it—Have it."[3]

The electronic peripheral devices of computers (keyboard, digital drawing pad—manual; printer, plotter—mechanical; copier, film recorder, or video—electronic/photographic) combine and subsume all levels of art production tool types. The artworks produced by these systems inherently reflect the characteristic marks of their electronic production origins and are disseminated as multiples (photographic prints, copier prints) or transmitted

Figure 9. Warda Geismar, Untitled, 1988
Drawing and collage.
Visual recording systems include: photographic
continuous tone grain; photocopier grain texture; halftone
dots; computer pixels; printer matrix dots; laser printer dot
patterns.

Figure 10. Warda Geismar, Untitled, 1988
Drawing and collage.
Tools have expanded to include, besides traditional ones,
the new time, movement, and deep space ones combined
with sound.

as video. "The invasion of the very fabric of the art object by technology and what one may loosely call the technological imagination can best be grasped in artistic practices such as collage, assemblage, montage, and photomontage; it finds its ultimate fulfillment in photography and film (video), art forms which can not only be reproduced, but are in fact designed for mechanical (and electronic) reproducibility."[4]

How the influence of electronic tools with their greatly expanded capacities for representation, image processing, and distribution have affected artists and their work remains to be analyzed in depth, "for one system flows into another before we have absorbed the first."[5] We stand only at the beginning of a dramatic new era of technological invention and change, with its consequent social, cultural, political, and ecological upheavals. Whenever common use of new technological tools deeply penetrates the fabric of cultural life, the issue of "what is art" arises out of the new social and historical processes which have been set in motion.

The enormous shift now taking place in the possibilities for representation brings us to a point of historical necessity. Today it is more important than ever to acknowledge the link between aesthetic traditions of the past and how they were influenced by the underlying role played by technology. Changes in technology affect not only the means of representation open to artists, but the social, economic, political, and cultural climate in which their art is produced. Attitudes about seeing and representation change constantly as a result of new conditions for seeing and understanding. Development of artists' awareness and potential is part of an organic process of change which radiates outwards, concentrically based on the historic steps of aesthetic and technological growth which are always in tandem with the social and cultural change taking place at its center. As Bill Viola, well-known video artist, commented recently, "We are moving into the past as well as into the future. It's an organic progression, like the way a tree grows—a tree doesn't grow from bottom to top, becoming taller. It radiates out from the center, expanding concentrically. Slice a cross section and you see concentric circles."

Art and Science Converge in the Renaissance

There have been times when the goals of art and science converged. We can refer to modern movements such as Constructivism, Futurism, Suprematism, and to important groups such as the Bauhaus, and Experiments in Art and Technology. However, the Renaissance period offers the purest example of this relationship, for the incomparable development of Renaissance art rested to a large extent on the integration of several new sciences and the impetus for new studies based on scientific data. Renaissance artists

made use of anatomy and perspective, mathematics, meteorology and chromatology to reach their goals of heightened beauty and naturalism. Their enlightened work signaled a crucial breaking point which severed it not only from the traditions of the Middle Ages, but also from the cultural patterns of the East. In restructuring the image through the mathematical principles of vanishing point perspective discovered by the Florentine architect Brunelleschi in 1420, artists gained insight into organizing visual information to create the illusion of space on a two-dimensional surface. The picture plane became a "window" through which could be seen the illusion, the imitation of reality.

Another important mathematical consideration influencing artists in capturing the desired harmony and order to be found in the proportions of nature was their use of the golden rectangle. Derived from the Golden Section, a strategy used in the design of the Parthenon, it was confirmed by the Fibonacci series of numbers in the sixteenth century. This harmonious mathematical proportioning of space continues to be a strong influence in contemporary art, architecture, and the design of everyday objects. In some sense, these mathematical underpinnings in art can be seen as direct antecedents to the mathematcial algorithms of the computer.

The goals of science and art seem united also in the work of the greatest visionary figure of the Renaissance, Leonardo da Vinci (1452–1519), often called the patron saint of art-and-technology. Leonardo was convinced that painting was a demonstration of universal knowledge. The depth and precision of his theoretical analysis of nature (botanical observations, notes on the turbulence of water and clouds), the drawings of his inventions (submarines, flying machines, engineering schemas), and his drawings of perspective and human anatomy are still stunning to us today. His notebooks are proof of the versatility and universality of his thinking as he attempted to fathom the riddles of human personality and the mysteries of natural phenomena. His universal approach seems all the more dazzling as reflected against today's excessive fragmentation of knowledge.

Until the late Renaissance, little or no distinction[6] was made between art and science, art and artisan, scientist and technician. Once the printing press was discovered (ca. 1436), technical information could be widely distributed. Such a body of specialized knowledge grew that a breach developed between disciplines, including a barrier between the fine arts and the applied arts. As the fine arts became more and more removed from precise, broad mastery of technical knowledge, the role of the artist shifted to a more philosophical plane with a different social function. The focus of art centered on the search for visual accuracy and harmony and the solution of issues related to composition and pictorial structure as much as it did on allegory and metaphor.

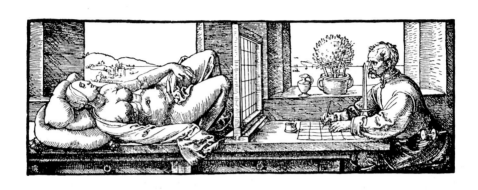

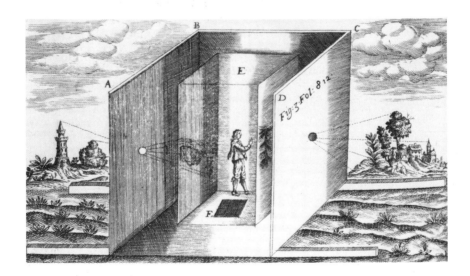

The Need for Visual Accuracy Led to
Use of the Camera Obscura or Artificial Eye

Artists were constantly searching for mechanical aids to help them reach their goals. In their search to mirror nature for their important church commissions, they invented practical tools to perfect and improve techniques for observing and representing objective reality. For example, Dürer's fifteenth-century set of woodcuts illustrate contemporary mechanical drawing devices for converting a view of 3-D objects into 2-D drawings in perspective. These include sighting devices for foreshortening; an eyepiece and framed grid on transparent glass for portrait sketching; and stringed movable grids for mounting on drawing tables. These reflect the practical technological interests of artists which lay behind their intense search to perfect and improve techniques for representation in order to meet their specific needs as primary image-providers for their times.

It is not surprising then that the natural phenomenon of the camera obscura was taken up as a means which could help them significantly in transcribing what they saw. Many different styles of "cameras" were designed to address the popular needs of artists. This harnessing by artists of the natural phenomenon of the camera obscura and its use as an imaging tool predated photography by nearly 300 years.

Although many of the painters who used the "machine for seeing" or "artificial eye" despaired over the distortions[7] caused by lenses which foreshortened their views and vied with their notions of true perspective, it enjoyed widespread continuous use throughout the seventeenth, eighteenth, and nineteenth centuries as a convenient tool for artists. The camera

Figure 11. *(Top)* Albrecht Dürer, Untitled, 1538
 Woodcut.
 Artists have always designed their own tools for creating the two-dimensional illusion on paper or canvas of what they see, such as this early grid with a sighting eyepiece.

Figure 12. Early Camera Obscura, from A. Kircher, *Ars Magna Lucis et Umbrae,* 1645
 The camera obscura was recorded by Aristotle (382–22 B.C.) and was well known to Arabs in medieval times. Leonardo described it in his *Codex Atlanticus:* "When the images of illuminated objects pass through a small round hole into a very dark room, if you receive them on a piece of white paper placed vertically in the room at some distance from the aperture, you will see on the paper all those objects in their natural shapes and colors. They will be reduced in size and upside down, owing to the intersection of the rays at the aperture. If these images come from a place which is illuminated by the sun, they will seem as if painted on the paper." *(Collection: Boston Athenaeum)*

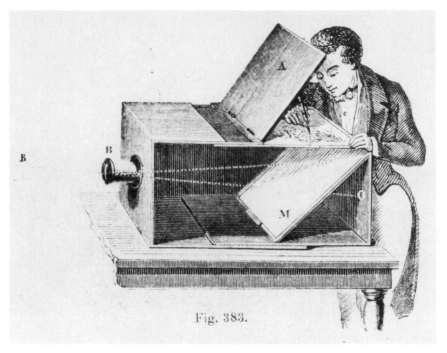

Fig. 383.

Figure 13. Camera Obscura, circa Seventeenth Century
By 1685, a portable camera obscura (in appearance,
much like the first cameras) had been invented by Johann
Zahn, a German monk. Described as a machine for
drawing, this version concentrated and focused the light
rays gathered by the lens onto a mirror which then
reflected the image upwards where transparent paper was
fixed in place for tracing the image. Count Francesco
Algarotti confirms the use of the camera obscura as a tool
in his 1764 essay on painting: "The best modern painters
amongst the Italians have availed themselves greatly of
this contrivance; nor is it possible they should have
otherwise represented things so much to life. Everyone
knows of what service it has been to Spanoletto of
Bologna, some of whose pictures have a grand and most
wonderful effect." Canaletto, Guardi, Bellotto, Crespi,
Zucarelli, and Canale used it as an aid in preparing their
drawings and paintings.
*(International Museum of Photography, George Eastman
House)*

CHAMBRE CLAIRE

selon Amici.

Perfectionnée par Vincent Chevalier,
Quai de l'Horloge 69, au Microscope Achromatique.

Figure 14. Camera Lucida, circa Eighteenth Century
The camera lucida consisted of a lens arrangement that
enabled the artist to view subject and drawing paper in
the same "frame," and thus the image that seemed
projected on the paper could be simply outlined.
(*International Museum of Photography, George Eastman
House*)

obscura relieved some of the drudgery of visual reportage and demonstrated both the strong need for the development of a system to record their images (such as photography), but demonstrates also the willingness of the artistic community to accept the use of mechanical imaging devices in the creation of their work.

By the 1830s, the only missing link for permanently fixing the camera's images on paper was the light-sensitive chemistry of photography. Although scientists and inventors such as Schultze and Wedgwood made contributions to the study of photosensitivity, it was an artist/printer, Joseph Nicéphore Niépce, who made the first real breakthrough in the link-up between the optical principles of the camera obscura with light-sensitive chemistry. In 1826 he successfully made an eight-hour exposure on a sensitized pewter plate in a camera—capturing the world's first faint photograph of a scene from his window. However, the follow-up invention of the silvery daguerrotype in 1839 received far more attention.

However, it was the British artist/inventor Henry Fox Talbot who succeeded in producing (1840) the first truly viable photographic process—the negative/positive system. His method is still in use today because from a single negative, an unlimited number of photographic prints can be produced, leaving the negative intact. Talbot called his discovery "photogenic drawing" and later published a book entitled *The Pencil of Nature*.

Because the camera was so related to its use over hundreds of years as a convenient imaging tool for artists the invention of the fixed images of the photograpic process seemed at first an astonishing boon to the art community of the time. Yet, in its fullest sense as a means of reproduction and duplication as well as a revolutionary means of representation and reportage, it created a transformative crisis in the art world which became fully evident only a century later.

Invention of Photography: Reaction and Counter-Reaction

The invention of photography produced intense international excitement in artistic and scientific circles and general recognition of its rich potential for society as a whole. In the arts, there were widely differing views. At first, there was initial acceptance.[8] Delacroix wrote an essay on art instruction (1850) in which he advised the study of the photograph.[9] Courbet and Ingres joined the host of artists who now began to commission photographs as references for their large formal paintings.

Yet in conservative circles, there was swift negative reaction. When the invention of the daguerreotype was announced in 1839, the critic Paul Delaroche declared, "From today, painting is dead." With the prime emphasis in art based on figuration and naturalism as it had been since Renais-

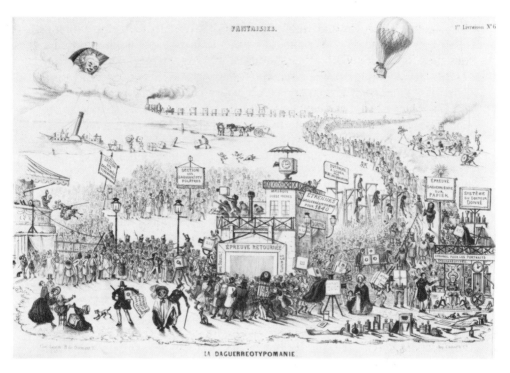

Figure 15. Théodore Maurisset, *La Daguerreotypomanie,* 1839
Lithograph, published in *La Caricature.*
This first caricature of photography lampoons the social,
economic, and cutlural upheaval brought about by the
invention of photography. There are cameras
everywhere—on wheelbarrows, railway cars, steamboats,
packed on heads, shoulders, backs, underarm, set on
tripods, roofs, even hanging from a balloon. Cheering
sections are marked off for daguerreotype Lovers and
Haters.
*(International Museum of Photography, George Eastman
House)*

sance times, the invention of photography collided head on with the vision and attitudes of artists and intellectuals who were at odds with the realities of the Industrial Revolution.

Photomechanical reproduction of artists' line drawings (and later, photographs) through the use of photo-engraving, photo-gravure, and photo-lithography revolutionized the commercial printing trades. Reproductive photography made a powerful contribution to the development of communication, due not only to the proliferation of newspapers and popular illustrated magazines, but also because it allowed for the study of art itself. Photographic reproductions of the art of the past could now be reprinted much more effectively than through the use of drawings or engravings. Artists could now contemplate and study the works of their international contemporaries at close range, in the comfort of their studios. The work of art had been liberated by the processes of photography from its ritual "cult" seclusion (for example, in tombs, temples, or churches) to reside now without benefit of its "aura" of place on the pages of art books and magazines or on the pages of newspapers mixed with texts or advertisements. Ancient or modern art from anywhere could now be reproduced as posters, postcards, or as reproductions for framing. The printed image increased the range of communications incomparably.

In 1849, more than 100,000 daguerreotype portraits were taken in Paris alone. Portraiture is perhaps the last aspect of the photographic image which still has "cult" value in the sense that remembrance of recorded family history is invested with a cult value. However, those painters who relied on portraiture as a livelihood were now threatened by the low-cost, eminently superior photographic method for capturing moments in time. They were affected by the same technological unemployment which affected scores of illustrators and graphic artists. A mood of panic developed. Faced with the inevitability of change, nineteenth-century art workers began to embrace the medium of photography for their everyday livelihood, much like the reaction of many contemporary designers and graphic artists who are finding it necessary to acquire computer skills to avoid technological unemployment.

In England, social theorist/critic John Ruskin and poet/craftsman William Morris reacted strongly to forms and values of the Industrial Age and were able to articulate widespread negative feeling about the new social conditions. They proclaimed that artist and machine were essentially incompatible and that fragmentation of the work process robs the worker of pride and purpose in what he produces—in short, that "production by machinery is evil." They emphasized hand skills as a positive value over tools of industrial production—a prejudice which has persisted into modern times.

Photomechanical reproduction raised questions about the "unique-ness" of copies as works of art. Strong prejudice was attached towards works executed by the "hand of the artist" (proof of manual skill). These were deemed doubly precious in an age dominated by the machine. Accep-tance of these attitudes in the art world represents a break in the openness of artists towards use of mechanical drawing devices and hardened artists' negative opinions about the overt use of photography in their work, al-though many continued to use photographs as a reference or to use them to project images onto their canvases as a way of initiating a new painting. Walter Benjamin has termed this strong prejudice for traditional materials and hand skills "a fetishistic, fundamentally anti-technological notion of art." His comments offer a perspective on parallel attitudes concerning electronic media today.

In denying a change in collective consciousness called for by the new crisis conditions brought about by industrial technological advance, most artists were able at first to avoid facing the fundamental issues forced upon them by the radical intervention of photography. These issues had to do with creating a new social function for their work, a new subject matter, a new way of seeing and experimenting with new art forms and of dealing with the question of the copy as opposed to the value of the original. Instead of facing these issues, they developed a doctrine, of *l'art pour l'art,* that is, a theology-based idea of "pure" art, which canonized it as a spiritual entity which lay beyond categorization. The absolute emphasis was now on the exhibition value of the work. This was coupled with myths of divine genius and creativity and the sanctity of the "hand of the artist" as the only viable source for artmaking. This sense of "pure" art was an attempt to extend the magical, ritualized meaning, the "aura" of a work which up to then related to its original value as a social production.

Once a work of art could be reproduced or was designed to be repro-duced through photographic intervention, a crisis of authenticity arose. Walter Benjamin writes in his "Work of Art in the Age of Mechanical Reproduction":

> With the different methods of technical reproduction of a work of art, its fitness for exhibition increased to such an extent that the quantitative shift between its two poles turned into a qualitative transformation of its nature. This is comparable to the situation of the work of art in prehistoric times when by the absolute emphasis on its cult value, it was, first and foremost, an instrument of magic. Only later did it come to be recognized as a work of art. In the same way today, by the absolute emphasis on its exhibition value the work of art becomes a creation with entirely new functions, among which the one we are conscious of, the artistic function, later may be recognized as incidental. This much is certain: today photography and the film are the most serviceable exemplifica-tions of their new function.

Scientific Discoveries and Camera Vision
Influence Development of a New Aesthetic

The new photographic technologies spawned scientific research into many areas of interest to artists such as color theory and the nature of light and vision, research which is paralleled today by developments in computer imaging where a vast amount has now been discovered about the specifics of perception, optical functions, color theory, and artificial intelligence—the functions of how we see and how we think. Manet was the first to defy the 500-year-old conventions of pictorial space dictated by single vanishing point perspective that had been in control of the picture plane since its discovery during the Renaissance. His new vision, influenced by photography, was at odds with the prevailing concepts of realism at the time. The goal of the naturalists and the realists was also to define actuality or realism, but their vision was seen through the prism of classical conventions. For example, the goal of the naturalists, based on the ideas of the painter Théodore Rousseau, principal figure of the Barbizon school (ca. 1830–70), was to recreate reality so as to establish a direct, metaphysically satisfying relationship with nature as a force concealing a purposeful order—a profound pantheism. Every bump on every tree bore testimony to the full scope of divine presence. On the other hand, Courbet's realist manifesto (1861) was a commitment to concentrate only on scenes from contemporary life, "To prove that everyday life contains as much nobility and poetry as any subject from history or myth." It was a powerful reaction at the time to the frivolous eclecticism of the New Empire's Academy represented by Bouguereau, Gérôme, Meissonier, Cabanel, and Winterhalter. However, Courbet's realist pictures were self-conscious allegories of everyday life full of classical overtones.

Manet rejected the conventions of foreground, middle ground, and background and the modeling of space in diminishing tones to create the illusion of distant space. Instead, he interjected the immediate vision suggested by the momentary time frame of photography to create paintings which would "capture the immediacy of instant vision." In doing so, he rejected the entire tradition of academic art's pictorial translation, with its dividing lines and modeling between picture planes, and substituted a flattened space where shapes disappear into each other and level out, much like the high contrast effects so characteristic of the photograph.

Manet's rejection of classical tradition and his effort to create a new kind of visual presence is synthesized in the work of Monet, who thought of the object "not in terms of the form he knew the object to have, but in terms of the image which the light from the object reflected into the retina of the eye."[10]

Eadweard Muybridge's stop-motion photographs captured in rapid movement through time which, up to then, had not been avai detailed analysis and study by artists. Internationally distributed by 1887, his richly illustrated book became a fundamental source of information in the art community. His multiple exposure photographic investigations of human and animal locomotion revealed clearly all the errors made up to then by painters and sculptors in their representations, for example, of the running stances of horses in battle scenes (e.g., Géricault, Delacroix, Velásquez). Degas's racing scenes painted after 1880 depict their natural gait made evident by the time-stopped photograph.

The momentary effect, the instantaneous and unexpected angle of view intrinsic to camera vision also strongly affected artists' outlook. Degas's work reflects a fresh change of view as he incorporated the apparently "artless" compositional accidents of the serial camera "snapshot" as part of his style. For although the photograph had been criticized for its lack of style, literalness, and nonselective qualities, it had produced a fresh way of seeing which Degas transformed into a new kind of pictorial logic.

Influenced and stimulated by the work of Muybridge and others who were experimenting with the serial effects of motion and photography, Joseph Marey in 1882 invented a "photographic gun" which could capture linear trajectories of moving objects in a single image which he called chronophotography. Artificially lighted oscillations of movement were photographed against a dark ground by means of activating intermittently the shutter of the "gun" during a long exposure. The chronophotographs served as inspiration for the Cubists and Futurists, who were directly influenced by the broken, serialized abstract linear patterns of movement.

These influences led to a new way of conceiving pictures, explained Maurice Denis in the 1880s: "A picture before being a horse, a nude or an anecdote is essentially a flat surface covered with colors assembled in a certain order." A radically different aesthetic was developing—one which would eventually lead toward abstraction and away from figuration and external influence.

Photographic Technologies Spawn Dramatic New Art Forms

By the 1880s "art" photography featuring still-life and draped models had become commonplace. These works reveal clearly that a relationship had developed between painting and photography. A number of painters abandoned their trade and took up the new medium, bringing to it not only their knowledge of composition and sensitivity to tonal qualities, but also their sense of style and interest in experimentation. Others made use of photo-

Figure 16. Eadweard Muybridge, *Woman Kicking*, 1887
Collotype, plate 367 from *Animal Locomotion*.
Muybridge's books of stop-motion photographs of human and animal locomotion expanded the possibilities of
perception by capturing time and movement frame-by-frame. Generations of artists have used these works, which are
still current today.
(Collection: The Museum of Modern Art, New York)

graphic projections on their canvases as a way of initiating work on a painting.

Photographers soon opened themselves to criticism through gallery exhibitions of their own works in 1855 and 1859. However, criticism focused on whether photographs could contain "the soul and expression to be found in true art." The poet/critic Baudelaire regarded the presumptions of the new art form as corrupting: "It must return to its real task which is to be the servant of the sciences and of the arts but the very humble servant, like printing and shorthand, which have neither created nor supplanted literature."

Since existing French copyright laws applied only to the arts, photography had first legally to be declared as an art form before it could come under their protection. In a test case in 1862, arguments cleverly turned around the questions: Is the painter any less a painter when he reproduces exactly? Does not the photographer first compose in his mind before transmitting his perceptions via the camera? The court decision granted full copyright protection to photography as an art form (although engravers were not equally served by this law). These questions about photography as a viable art form obscured the primary question. Photography had transformed the entire nature of art.

The profusion of photomechanically produced imagery available at the turn of the century gave rise also to a striking new art form. The Dadaists exploited publication techniques to develop an extraordinary new kind of found image—collaged images culled directly from printed newspaper and magazine materials. The Dadaists chose authentic fragments from everyday life because they believed these could speak more loudly than any painting. For them, photomontage was essentially a way of outraging the public and destroying the aura or market value of their work by revealing it as appropriated reproductions. For the first time, artists were using collaged photo-imagery and photomechanical techniques as part of conscious artistic style. In photomontage, awkward joints and seams where the image sections were collaged together in the original could be hidden when the image was printed photomechanically, thus imbuing the reproduced collage image with a logic of its own. Its powerful possibilities were brought into focus by artists such as Raoul Hausmann, John Heartfield, and George Grosz as a tool for expressing forcefully and directly a point of view about the chaos of their era.

Independent of the Dadaists, the Russian Constructivists Rodchenko and El Lissitsky used photomontage methods to produce large posters and powerful graphic works because they could be reproduced and distributed at the same speed as a daily newspaper. The Surrealist Max Ernst developed his own poetic approach to photocollage in his small volume *Une Semaine*

Figure 17. Raoul Hausmann, *Tatlin at Home*, 1920
Collage of pasted photo-engravings, gouache, pen and
ink, 41 cm. × 28 cm.
Hausmann was one of the first to use the new form of
collaging photographic images and illustrations from
many sources—including magazines, letters, and
newspapers. After World War I, Berlin Dadaists like
Hausmann, who had always taken a critical, ironic stance
toward the machine, now began to dream of a future in
which supermachines would be placed in the hands of
those who would build a new and better society rather
than in the hands of the old warmongers. To Hausmann,
the Russian Constructivist artist Tatlin was the living
incarnation of these aspirations.
*(Courtesy Moderna Museet, The National Swedish Art
Museums)*

Figure 18. John Heartfield, *Hurrah, Die Butter Ist Alle! (Hurrah, the
Butter Is Gone!)*, 1935
Photomontage, produced for the magazine *A-I-Z*
(December 19, 1935).
Heartfield chose photomontage as an art form that was
powerfully evocative, with expanded possibilities for the
communciation of his ideas. The text recounts Hermann
Goering's Hamburg speech: "Iron has always made a
country strong; butter and lard have at most made the
people fat."

de bonté. By reassembling and recontextualizing appropriated elements of Victorian engravings and changing the relationships between their parts, he created disturbing, sometimes nightmarish effects.

The photographic experiments of Marey and Muybridge to capture movement foreshadowed the invention of cinematography by the Lumière brothers in 1895. The movie camera created an entirely new dimension for photography. Through slow motion, rapid panning, gliding close-ups, zooming to distant views, space, time, illusion and reality were fused in a new way. The flow of moving images permits an analysis from different points of view. New structural formations of subject and image are possible. Cinema appeals to our conscious impulses as well as our unconscious in the dramatic ways it can represent and record our environment. In film, montage became part of the essential element of the grammar of the moving image. Through editing, juxtaposition could easily bring about interruptions, isolations, extensions, enlargements, and reductions to new meanings. "By close-ups of the things around us, by focusing on hidden details of familiar objects, by exploring commonplace milieus under the ingenious guidance of the camera, the film on the one hand extends our comprehension of the necessities which rule our lives, and on the other hand, it manages to assure us of an immense and unexpected field of action."[11]

The experience of seeing a film is very different from seeing a painting before which the spectator, as a single individual, can stand in contemplation of the work, concentrating his attention for as long as desired. With film, the individual usually becomes part of a collective audience whose attention is controlled by the moving image which cannot be arrested. The audience is in effect controlled by the constant sequenced changes of images moving in time, images which are designed to affect his emotions and dominate his thinking process. Film, moving from a silent phase and later to one of sound, led to an intense experience of art with greater collective participation. Some critics chose to call it merely a "pastime," a "diversion for the uneducated," a "spectacle which requires no concentration and presupposes no intelligence." However, from the beginning, film touched the core of an immense public need for creating new myths and legends which help in the adjustment to new times. The great silent filmmakers Eisenstein, Griffiths, Gance, and Chaplin brought the form to a high level. Its arrival marks the beginning of a shift from verbal communication to a greater reliance on image flow as a more significant medium of communications (as in contemporary television).

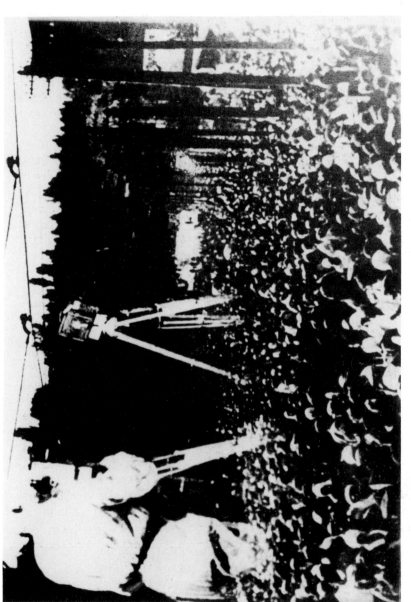

Figure 19. Dziga Vertov, *Man with a Movie Camera*, 1929
Film still.

Vertov's passion for the movie camera's potential to create a fresh perception of the world by freeing time and space—"coordinating all points of the universe"—is captured in this montage of the cameraman towering over crowded streets.

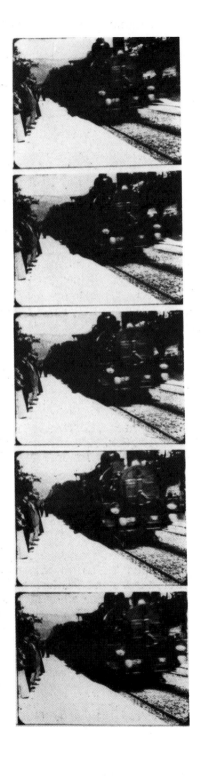

Rise of a Modernist Aesthetic by the End of the Century

When Western culture began to take on the greater complexity of modern times, old ideas about the subject matter for art were challenged. This forced a shift of focus away from pictorial realism to a new point of departure, a viable position from which to begin constructing a fresh modernist aesthetic. The comfortable objective realism of the naturalists, realists, and the Impressionists became irrelevant in the face of a new technological and intellectual climate that challenged all previous assumptions. The structure of all fields of study including psychology, science, and literature began to expand under the impact of new scholarship, of new discoveries, and new relationships brought about to a great extent by an expanded intellectual milieu.

Photography, by taking on the function of pictorial reporter, gave freer rein to expressiveness in art. Picasso commented on this shift of focus to his friend the photographer, Brassai: "Photography has arrived at a point where it is capable of liberating painting from all literature, from the anecdote, and even from the subject. In any case, a certain aspect of the subject now belongs in the domain of photography. So, shouldn't painters profit from their newly acquired liberty . . . to do other things?"[12]

The goal of the Postimpressionists, Fauves, Cubists, Symbolists, and Expressionists was to create images consonant with the integrated relationship between "what one sees and what one feels about what one sees." All experience, dreams, fantasies, poetry, music, and emotion itself became viable subject matter. They began to see that individual realities are only interpretations of the mind. Art, then, is true illusion, not objective reality—a process governed by the act of choice.

Figure 20. Lumière Brothers, Frames from *Un Train Arrive en Gare,* 1896
George Méliès captured the flavor of incredulity at the newness of perception provided by cinematography in this account of the very first public presentation of the Lumière Brothers' demonstration of the new Cinematograph in December, 1895: "I just had time to say to my neighbor: 'They've put us to all this bother for nothing but a magic-lantern show. I've been doing those for years.' Scarcely were the words out of my mouth, when a horse dragging a truck began to walk toward us, followed by other wagons, then by pedestrians—in a word, the whole life of the street. At this spectacle we remained open-mouthed, stupefied, and surprised beyond words. Then came in succession *The Wall,* crumbling in a cloud of dust, *The Arrival of a Train, Baby Eating His Soup,* trees bending in the wind, then *Closing Time at the Lumière Factory,* finally the famous *Sprinkler Sprinkled.* At the end of the performance, delirium broke out, and everyone asked himself how it was possible to obtain such an effect."

Underlying the new drive to movement and abstraction lay the fundamental contribution to perception which photography provided: camera vision as part of the vocabulary of the eye. It provided the impetus toward abstraction; alternation from positive to negative planes and forms; microcosmic and cosmic views of the universe; and gave substance to arbitrary thought in the context of time/space through the moving image. A vast new arena of visual and intellectual communication was brought into play by photography, photomechanical reproduction, and the rise of cinematography.

Despite the important aesthetic development of photomontage and cinema in the 1920s and 1930s within radical avant-garde circles, the direct issues raised by photography were deflected—for the conservative art establishment saw photographs and photomechanical reproduction as a challenge to the "uniqueness" of art objects destined to be sold in the art market. Under the new theology of a "pure" high art, questions about the social value of art remained unanswered. The transformation of society by new forms of photographic communication created further confusion.

The immediate cooptation of photomontage techniques by the commercial world to sell goods rather than ideas, further tainted the use of photographic technologies in the service of the "fine arts." The very intrusion of photography into every aspect of life had the effect of prejudicing its direct use as imagery in art, except as an antiaesthetic statement by the alternative avant-garde movements. Primarily, it acted as a powerful catalyst influencing every aspect of the cultural climate. "The artist could no longer hold the mirror up to nature. He had been freed of that subservience and it was both his curse and his blessing."[13]

2

The Machine Age and Modernism

Photography had overturned the judgement seat of art—a fact which the discourse of modernism found it necessary to repress.

Walter Benjamin

The Machine Age Created an Avant-Garde

The new awareness raised by photography created a divisive schism in the art world, one which persisted until the end of Modernism. "The decades between 1910 and 1930 were characterized by a flood of new movements, groups, and schools, most taking a firm stand on the key issue of the new century: whether art should ignore, oppose, or exploit the technology implicit in rising industrialism."[1] A deep gulf evolved between those artists who still embraced conventional traditional practices and forms (though their outlook was altered) and those who developed an avant-garde antiaesthetic. The former, the Cubists, Fauves, and Postimpressionists, essentially rejected the machine by moving into the new territory of abstraction with its formal concerns. However, the Constructivists and Futurists gave themselves up radically to the spirit of the new age, glorifying the machine as a tool and the machine aesthetic as part of style. Another wing of the avant-garde, the Dadaists, were ready to question the very structure of art itself and its relationship to the art world and society as a whole. They used the machine as an icon to comment on social-political realities. Both wings of the avant-garde used photographic technologies as tools in their work. For example, the Constructivists used photomechanical reproduction methods to quickly print political posters whereas the Dadaists used "readymade" photomontage as a way of attacking the values of the commercial gallery system. "Constructivists and Dada stand as the positive and negative sides

of a total and utopian critique in terms of order and chance, of art within *social* modernity."[2]

Credit for the transition to modernism in Western art is usually given to the Cubists. Following the lead of Picasso and Braque they deliberately jettisoned the single viewpoint of perspectival space and the conventional representation of nature.[3] The Cubist point of departure toward dynamic abstraction was the fractured, broken-up, serialized images suggested by Marey, Muybridge, and cinematography. They aimed instead at a synthetic abstract organization of the picture plane, taking into account the totality of many viewpoints related to a subject. In a single image, they included the front, back, top, and sides of a subject, thus creating an abstracted, formalist, intellectual analysis of a subject. Their interests in formal issues such as space, structure, rhythm, and composition were built in part on developments in photography, but were also a reaction to the possibilities for representation opened by photography and a repression of it. Developing and refining a formalist abstract language and vocabulary was the major concern of Modernism until the Pop movement of the early sixties.

The Russian Constructivists welcomed the machine age positively—believing that the future of society lay in the liberating, beneficial forces of science, technology, and industry. They sought to fuse art and life through a radical approach to mass culture, performance, and production. In proclaiming that "art must align itself with the magnificent radiance of the future," the Italian Futurists also welcomed the machine age. The machine provided Boccioni, Balla, and Severini with the heady iconography for their art. They broke up the static surface forms of cars, trains, and figures seeking "lines of force"—repeating shapes over and over to create swirling, spiraling movement suggestive of unrestrained energy.[4]

In a political break with tradition, the Dadaists confronted conventional art practices with antiart tactics. From avant-garde outposts in Zurich, Berlin, Paris, and New York, Dada periodicals insulted the bourgeoisie, the police, and the art establishment. They designed their ironic, irrational, contrived assemblages of machine parts and photo-collage works to be the center of scandal. They used the formal atmosphere of public galleries to raise fundamental questions about the "purity" of art; its commodity value as compared to its social value; and the uniqueness of hand-made objects in relation to the value of machine-made copies.

Art Going Out into Technology: Fusing Art and Life

Beginning in 1917, the Constructivists began using a combination of technology and art in the hope of building a new social order in postrevolutionary Russia. Their art was based not only on their political ideals, but on

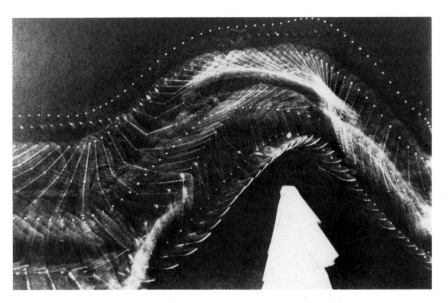

Figure 21. Etienne-Jules Marey, *Chronophotographe Géométrique,*
1884
Chronophotograph.
This multiple exposure in a single frame of a figure
jumping over an obstacle was produced with the aid of
the photographic gun that Marey invented in 1882. The
gun permitted 12 exposures per second. A scientist/
inventor, Marey devoted himself to the study of
movement in all its forms. His fascination led him to
invent a series of tools for observing and recording
movement too fast for the eye to perceive. His multiple
exposures created a means for visualizing concretely the
abstract fluid aspects of motion that had such an impact
on the imagery of the Cubists and Futurists.

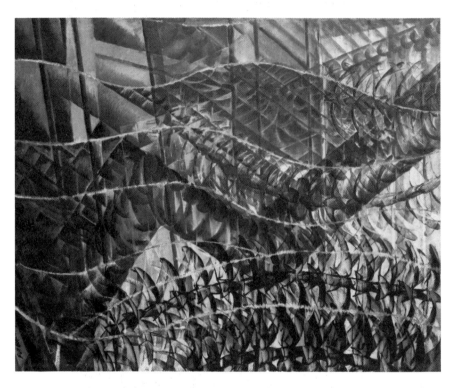

Figure 22. Giacomo Balla, *Swifts: Paths of Movement + Dynamic Sequences,* 1913
Oil on canvas, 34″ × 47″.
Balla's dynamic Futurist painting shows the direct influence of Marey's experimental motion chronophotographs which made the flowing aspects of sequenced movement visible for the first time.
(Collection: Museum of Modern Art, New York)

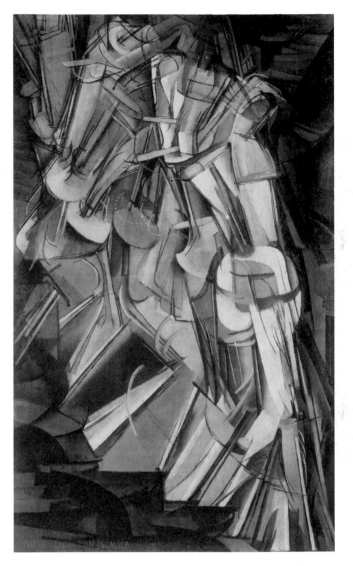

Figure 23. Marcel Duchamp, *Nude Descending a Staircase, No. 2,*
1912
Oil on canvas, 58″ × 35″.
Duchamp admitted that the influence of Marey's multiple
exposures led to this radically different painting which
created such a controversy at the famous New York
Armory show in 1912.
*(Louise and Walter Arensberg Collection, Philadelphia
Museum of Art)*

respect for new technologies, materials, techniques, and the logical structure which arises from these. Tatlin called it: "Art going out into technology." Rodchenko called for a public art and declared the new era : "A time for art to flow into the organization of life." By 1920 visual artists began to involve themselves in an art designed for the public's everyday living—textiles and clothing design, books, furniture, and interiors. At the same time they also designed and distributed political posters, created public monuments, and involved themselves in agit-prop street theater. They designed a train which carried an agit-prop exhibition cross-country and produced work in the form of "spoken newspapers" and "telegraphed posters" which were intended to inform a largely illiterate public. The poet Mayakovsky summed up the prevailing spirit of artistic involvement in creating mass public cultural awareness when he declared: "Let us make the streets our brushes, the squares our palette." Prominent amongst the Constructivists at that time were Tatlin, Rodchenko, Lissitsky, Gabo, Pevsner, Malevitch, and the film director Vertov.

Their enthusiasm for an experimental fusion of the arts expressive of the Russian revolution led to explorations of the connections between theater, architecture, film, and poetry. Lissitsky and Malevitch (like the Cubists and Futurists) were deeply interested in theater costumes and lighting, and designed public spectacles and performance works which were the precursors of today's multimedia works. By the 1920s the momentum of change had brought "just about every possible technique and style of painting, theater, circus and film into play. As such the limits of performance were endless; nowhere was there an attempt to classify or restrict the different disciplines. Constructivist artists committed to production art worked continuously on developing their notions of art in real space, announcing the death of painting."[5]

The Constructivists maintained a separation between their public art with its social use value and their private work in which they continued their prerevolutionary explorations of abstraction. The formal aesthetic inquiries in their paintings and sculptures first developed through their involvement with the Suprematist movement. By the 1920s Rodchenko, Lissitsky, Malevitch, and Popova, in their private works, took the lead in radicalizing abstraction by moving to an extremely reductivist analysis of their painting aesthetic. Malevitch's white square and Rodchenko's black painting were far in advance of their time. (Neoconstructivists of the 1960s were to repeat these experiments in aesthetics.) Rodchenko's 1921 *Last Painting* comprised three canvases, each painted with one of the primary colors (red, yellow, and blue). These critical studies brought many artists of the time to the crucial point of decision at which painting as a private special activity was rejected in favor of art as a "speculative activity to social develop-

ment''—where creativity and daily work were merged. Artists such as Naum Gabo, Nicholas Pevsner, and El Lissitsky did not share this level of social commitment and eventually migrated to Germany, feeling threatened by accusations that art was connected to metaphysics and mysticism. By 1925, when Stalin came to power, major changes brought rapid closure to this period of intense experimentation in the arts.

The Bauhaus: A Machine Aesthetic Tied to Craftsmanship

Constructivist ideas for a fusion of the arts found fertile ground at the Bauhaus school (founded in 1919) where one of the most remarkable faculties in history was assembled: Vasily Kandinsky, Paul Klee, Johannes Itten, Oskar Schlemmer, Marcel Breuer, Herbert Bayer, Josef Albers, and László Moholy-Nagy. The school's founder, Walter Gropius, was convinced of the need to create unity between architect, artist, and craftsman by training artists, engineers, designers, architects, and theater people to believe in a synthesis of the arts. Gropius insisted on a program revolutionary for its times designed to liberate the students from past influences and prejudices. His idea of learning by doing, of developing an aesthetic based on sound craftsmanship, helped to create a unity between the fine arts and the crafts. Modern machine manufacture was embraced as a means capable of producing for the public beautiful commodities to provide an experience of quality in everyday life. The Bauhaus spread its ideas through publication of documents by its faculty and became the center for the propagation and development of new international experimentation in the arts.

Moholy-Nagy, one of the most influential and innovative faculty members of the Bauhaus, schooled his students not only in the use of photography and photomontage, but focused their attention on optical experiments, and the time/motion aspects of film and light as means for making art. In his books *The New Vision* and *Vision and Motion* he developed new theories of perception and vision as they apply to the technological world. For example, Moholy-Nagy engaged in studies for projected light and motorized movement for his new type of kinetic sculpture series of ''time/space modulators'' which explored optical illusion.

He embraced photography as the foundation for a ''new vision'' as a new way of reshaping individual consciousness and thereby as a way of seeing society from a different perspective. His ''new vision'' reflected his commitment to social change. For him, the camera was a tool for educating the eye, to extend and supplement natural vision and traditional perceptual habits. With his students, he used examples of his explorations into the play of light and shadow, unusual perspectives, multiple exposures, photograms, and photomontages to create a new ''optical culture'' born of a changed

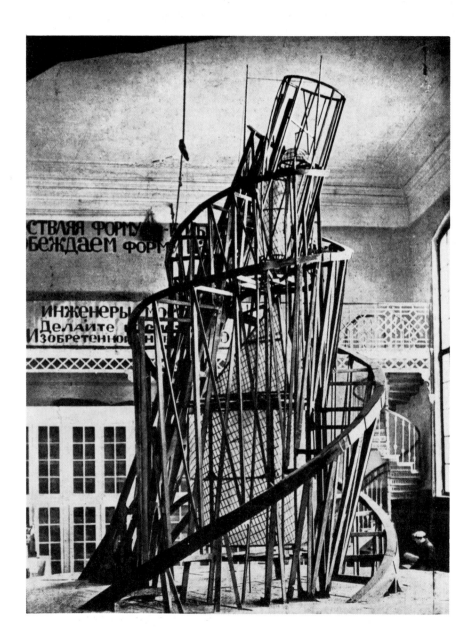

visual awareness. He saw photography as a medium that suggested experiment in art, that posed specific formal questions which (if explored freshly) could lead to new understanding. He saw its relationship conceptually to space, drawing, and text which led to a unique approach to graphic art.

Moholy-Nagy was a tireless technical innovator[6] as well as a painter, thinker, and writer. His powerful influence extended far beyond the Bauhaus when he founded the Chicago School of Design in 1939 after fleeing from Germany. Moholy-Nagy saw light as essential to the production of art and the expression of form. In his kinetic sculpture series of Light Space Modulators, his aim was to produce a work which lay between the movement of film and the light and dark of photograms while concerning himself primarily with optical illusion, light, shadow, space, and movement.

In direct contradiction to prevailing prejudices of the European art establishment of the twenties, where emphasis was still on traditional materials and hand skills for art-making, Moholy-Nagy used industrial plastics to make sculpture. To demonstrate that other possibilities existed in art-making apart from hand skills, Moholy-Nagy ordered the fabrication of a work of art by telephone.

Along with Stieglitz, Moholy-Nagy is credited with raising photography to the level of an art form in its own right. The pioneering influence of Stieglitz is inestimable. Besides his interests in photography and the publication of the important journal *Camera Work*, Stieglitz (1864–1946) operated the 291 Gallery in New York, which became an important meeting place for both American and European artists. By 1905, through the activities of his gallery, Stieglitz was able to introduce to an American audience most of the major French avant-garde painters of the time: Matisse, Picasso, Cézanne, and Braque. Stieglitz made a contribution to the birth of a modern

Figure 24. Vladimir Tatlin, *Monument for the Third International,* 1920
Reconstruction of finished model, 15'5" H.

Tatlin was one of the first to proclaim a new way of using materials, that material—wood, iron, glass, and concrete—itself is the message, and that the expressive importance of material lay in their substance, not their form. His point of view was that form should follow function. His work embodied a long-desired integration of sculpture and architecture. Although *Monument* was never realized, it was originally designed to be 300' higher than the Eiffel Tower. Its spiral framework was to enclose four glass-walled rotating chambers (turning at different speeds) to house different functions. The lowest level, which was to revolve once a year, would be used for conferences. The next level, a slanting pyramid, would rotate once a month and be used for executive activities. The third level, with a hemisphere on top, would contain an information center, and rotate once a day. He left spaces for gears and machinery and girded his tower with functional stairways.

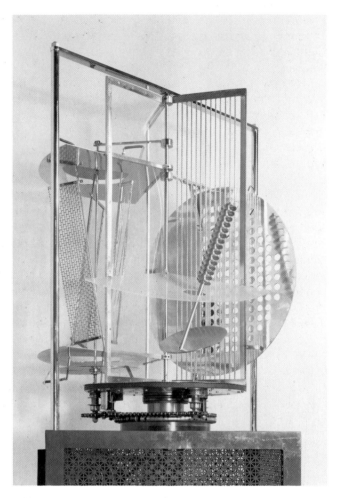

Figure 25. László Moholy-Nagy, *Light Space Modulator,* 1923–30
Kinetic steel sculpture, 151.1 H × 69.9 Base × 69.9 cm. C.
Moholy-Nagy's "Light Prop," an electrically driven,
mechanically complex machine crafted over a period of
several years at the Bauhaus, is a monument to the
Bauhaus Constructivist enthusiasm for the machine
aesthetic. The powerful play of light and shadow patterns
captured an extraordinary dimension of space-time,
achieved through superimpositions, mirroring, and
prismlike effects of moving light. Moholy-Nagy predicted
that light would be an entirely new medium.
*(Courtesy The Busch Reisinger Museum, Harvard
University Art Museums)*

spirit by championing also the antiart ideas of Duchamp, Picabia, and Man Ray as well as the work of American experimentalists. Stieglitz's important work laid the groundwork for the later "official" art world acceptance of photography as an art form in the 1960s.

However, film was the new art form most expressive of the fusing of art and life in the new technological age, one which naturally led to a fusion of all the arts—theater, music, poetry, and literature. Of all the arts, the moving image made the greatest impact on public consciousness. In 1923, the constructivist filmmaker Vertov identified with the movie camera: "I am an eye. I, the machine, show you a world the way only I can see it. I free myself for today and forever from human immobility. I am in constant movement. . . . Freed from the boundaries of time and space, I coordinate any and all points of the universe, wherever I want them to be. My way leads towards the creation of a fresh perception of the world. Thus I explain in a new way the world unknown to you."

In film, the spectator's thoughts are captured and forcibly propelled through a timed, edited, sequenced version of reality. Unnatural juxtapositions of a variety of moving images create a radically new synthesis of them. Film's form and process were avant-garde because of their technical and physical shock value. Film, like Dada, played an important role in undermining nineteenth-century cultural assumptions and institutions. A few painters and sculptors such as Léger, Dali, and Balla made short experimental films over the years.

Vertov's sense of the "kino-eye" and Eisenstein's theories of montage especially influenced "independents," those filmmakers who existed outside of the growing international commercial film industry. By the forties, these "independent" film makers were producing poetic and nonnarrative work. From then on, the underground cinema movement grew rapidly. By the fifties, it had created its own traditions, film cooperatives, distribution system, and film journals, and had attracted many painters, sculptors, and photographers. This growth of interest on the part of artists led to their interest in the sixties in the new moving-image medium of video as a way of expressing their social and perceptual interests.

Duchamp Raises Fundamental Questions about the Function of Art in the Machine Age

Although Marcel Duchamp (1887–1968) began as a Cubist and was claimed by both the Dadaists and the Surrealists, he developed concepts which were beyond the confines of any movement and created a philosophic domain of his own which questioned "every assumption ever made about the function of art."[7] He felt that the machine had formed modern

consciousness. More in keeping with the spirit of the machine age than with painting, Duchamp experimented with new manufactured materials and with the iconography of the machine itself. He introduced and experimented with almost every concept or technique of major importance to avant-garde artists for the next fifty years. His controversial *Nude Descending a Staircase* (which was influenced by Marey's photography) was exhibited in the 1913 Armory Show in New York. Its *succès de scandale* made him an immediate celebrity.

In 1915, he began a large work constructed of metal and glass, a project which occupied him for the next eight years. Often referred to as his masterpiece, *The Bride Stripped Bare by Her Bachelors, Even* (also known as the *Large Glass*) playfully suggests the idea of a "love machine." The transparent *Large Glass*[8] (richly overlaid with puns and references to science, philosophy, and the art of the past) bears within it a totally new approach both with respect to the thinking process in art and with respect to the materials and the making. His use of machine parts with references to popular culture overlaid with their allusions to Freudian thought were the basis of aesthetic ideas and attitudes which continue to be a profound influence.

In 1913, Duchamp exhibited a standard manufactured object, a bicycle wheel mounted on a stool, as a "readymade"—an object elevated in the iconoclastic Dadaist tradition to the realm of art. Duchamp's readymade asked questions about what a work of art could be. Is it an object made by an artists' own hand? Is it defined by certain laws of composition? By denying the very possibility of defining art, by appropriating an ordinary copy—a machine-made object—and placing it in the context of a gallery, Duchamp also created the opportunity for its altered significance: a new thought about the object aimed to "reduce the aesthetic consideration to the choice of the mind, not to the ability or cleverness of the hand."[9] Later, he chose other manufactured objects—a bottle rack, a urinal, a coat rack—as readymades.

As he said years later: "I came to feel an artist might use anything—a dot, a line, the most conventional or unconventional symbol—to say what he wanted to say. This proposition can be demonstrated by choosing—it is the act of choice that is decisive."[10] Duchamp was widening the question posed originally by photography about the uniqueness of a work and the necessity of hand skills. He shifted the possibilities for art-making to place the most important emphasis on the conceptual process, thus introducing the possibility of using the techniques of industrial manufacture as another aspect of choice. This concept directly influenced the Pop artists of the sixties. For them, Duchamp became a cult figure whose ideas helped to coalesce groups of artists, in both England and the United States, who simultaneously began adopting his ideas in the late fifties.

The New Kinetics Use Light and Movement and Machine Parts

Curiosity about natural phenomena, scientific and mathematical puzzles, and their relationship to aesthetic problems led many visual artists to experiment with machine parts and materials, to probe new phenomenological mysteries for their aesthetic potential. These perceptual experiments in both real and illusory movement and time were of special interest to sculptors such as the Constructivist Naum Gabo, who produced, in 1920, the first motorized kinetic sculpture called *Standing Wave*. Moholy-Nagy also worked with motorized movement and light in his *Light Prop,* begun in 1922. Kinetic sculpture relies on the physical use of light and movement and makes use of simple motor-driven devices, motorized light boxes, and various static fluorescent and incandescent light sources.

While working on the *Large Glass* and the readymades, Duchamp had experimented with ideas about the fourth dimension and with movement of various kinds. By 1920, he had built a machine which he called *Rotary Glass Plate,* consisting of narrow, motorized panels revolving around each other. When seen from the front, the moving blades appear as one undulating spiral creating the illusion that a three-dimensional object is two-dimensional, an ironic denial of reality. A few years later, he again played with optical illusion in his *Rotary Demisphere Machine,* which made spinning convex surfaces seemingly become concave. "Underlying Duchamp's optical machines is the concept of a gliding system of dimensions and realities."[11] He also invented a kind of playful measurement system in which he substituted chance as an alternative to the rational approach of science.

These beginnings of a kinetic sculpture movement led to work by Alexander Calder, and a host of other artists, particularly in the post–World War II years, and eventually to the Zero and Grav movements in Europe and the American Art and Technology movement which expanded the concepts of kinetic art into the realm of collaboration between artists and engineers and the use of new technologies.

End of an Era—Who Owns and Controls the Machines?

If the twenties were a period of hope for change, through advances in technology and machine culture, the Depression of the 1930s brought fear and despair, a mood which dominated the art of the Surrealists. For them, the machine represented an intrusion, a menace. Their program was a retreat "to the inner depths of man's mind," and for that there was no need of machines. Confidence in rational technological progress gave way to disillusionment because of rising unemployment, rampant commercialism,

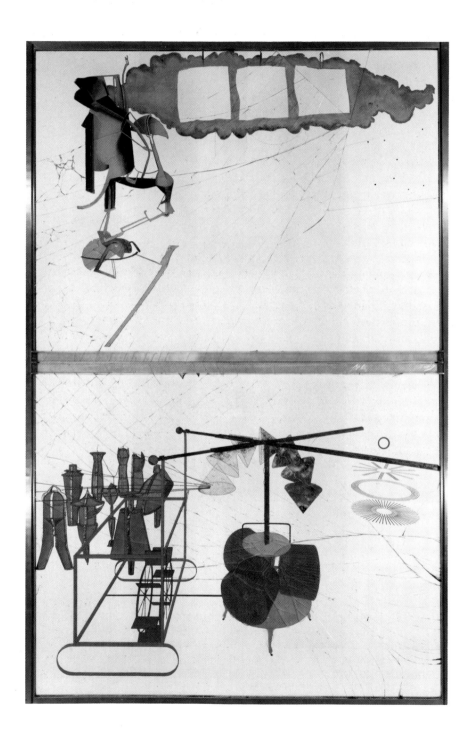

and the rise of fascism—all of which raised deep political questions about the market economy and about the ownership and control of machines. Characterizing this period are Huxley's *Brave New World* and Chaplin's film *Modern Times,* both of which imply that machines create abundance but leave want—materially and spiritually—when they are utilized only for the benefit of property interests. Following the atomic bomb blast and destruction of Hiroshima, fear and horror further sapped faith in technology and confidence in rational behavior.

Many European artists (among them Duchamp and the Surrealist Max Ernst) had stayed on in New York after the war. However, in an important sense, the radical impetus and political commitment of the European avant-garde Modernist movements had been shattered and its impetus translated into an exploration of the formal aesthetic problems posed by Modernism. It was as though the avant-garde belief in the power of art to either transform society or to challenge it was defused and replaced by a utopian American belief in progress through technological development. Art ceased to be a social activity guided by objective and conventional criteria and became an activity of individual self-expression. Untouched by the war that devastated Europe, the American economy's postwar boom conditions produced a group of wealthy American collectors eager to invest in art. The pendulum of the art world began to shift from Paris to New York.

Up to now, Modernism has been discussed both in its critical sense as a new period in art and also as a way of identifying a new epoch of social history which evolved out of modernization. However, a further version of Modernism arises out of the formalist account associated with the critic Clement Greenberg's theory that the work of art should be rendered "pure" by being confined to the effects specific to its own medium; i.e., to the aesthetics of the object itself; to the identification of art with the tradition of painting and sculpture and thus to the aesthetic of the object. It is this version of Modernism to which we refer in the ensuing discussion.

From the early 1950s, the Modernist ethos now oriented itself fully

Figure 26. Marcel Duchamp, *The Large Glass* or *The Bride Stripped Bare by Her Bachelors, Even,* Original: 1915–23, Replica: 1961
Oil, lead, foil, and varnish, 109 1/4″ × 69 1/8″.
The intricate machinelike work presents an ironic attitude towards machines and human beings. Duchamp is said to have been influenced by Raymond Roussel's play in which the functions and forms of machines are related to the sex drive. *The Large Glass* was made of unconventional materials and contains many innovative elements. Because it is on glass, its relation to the viewer and the space it inhabits is dynamic and constantly changing.
(Louise and Walter Arensberg Collection, Philadelphia Museum of Art)

Figure 27. Charlie Chaplin, *Modern Times*, 1936
Film still.
Although *Modern Times* is a powerful manifestation of the pessimism of the 1930s
toward technology and the way that life was being standardized and channeled,
Chaplin demonstrates engagingly how to outwit machines as a way of drawing
attention to the deep problems presented by technology.
(*Museum of Modern Art/Film Stills Archive, New York*)

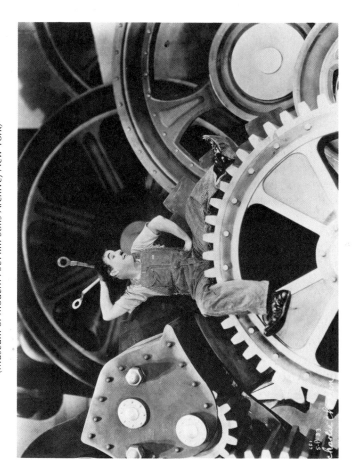

towards solving formal problems of form, color, and texture. A group of American artists—Jackson Pollock, Willem de Kooning, Philip Guston, Arshile Gorky, Robert Motherwell, Adolph Gottlieb, Mark Rothko, and others who loosely came to be known as the Abstract Expressionists—produced work that was heroic, apolitical, and introverted, based on inner sensation and experience, with an emphasis on the medium of painting itself. They made use of traditional materials and painterly gesture. Their work was aesthetic expression as an exalted virtue, as a vehicle for metaphor and symbol. It was the Modernist abstract ethic at its most "pure." By its closure, in the early seventies, Modernism had developed another wing of abstraction—the more mathematically oriented work of the Neoconstructivists (influenced by the earlier process of Malevitch and Rodchenko) which provided an impetus toward the computer as a tool for a number of artists teaching at universities where they had access to computers located in science labs.

Younger artists felt oppressed by the official mainstream acceptance of the heroic stance of Abstract Expressionism which oriented itself so completely towards solving problems of form, color, and texture—a stance that had been so much in tune with American individualism and idealism. To them it seemed dated, mannered, and bankrupt. It was in direct opposition to the more open radical approach to the arts which had been developing at Black Mountain College since 1933.[12] There, the spirit of debate and openness to innovate led the the founding of a different American avant-garde. Poetry, music, film, and theater were lively adjuncts to the painting and sculpture program. Josef Albers, Merce Cunningham, Buckminster Fuller, Willem de Kooning, Clement Greenberg, David Tudor, and countless other major influential figures were all associated with the program at Black Mountain. The musician John Cage (influenced by Eastern aesthetics as well as by Surrealism, the work of Duchamp and Abstract Expressionism) performed theater events which combined his ideas about chance in music with aspects of painting and sculpture. Cage was an especially important influence, for he also taught at New York's New School for Social Research. His inspired classes there attracted a broad spectrum of artists from diverse disciplines. They began experimenting with his theories about the direct interrelatedness between art and everyday life. Out of their experiences, they developed fresh paradigms for dance, theater, music, sculpture, and painting which also gave rise to movements such as the Judson Theater movement, Fluxus, "Happenings" events, Performance, and the Pop art movement.

The Pop Movement—Transition to the Electronic Era and Postmodernism

In the seven-year period 1957–64, the arts in America went through a dramatic upheaval as the formal strategies of Abstract Expressionism and of the Modernist edifice as a whole began to crumble. These ideas gradually began to seem irrelevant in the light of popular consumer culture and in the context of a complex economy which was becoming based more and more on mass electronic communications. A younger group of artists began to demonstrate the direct connections between art and society; they declared their independence from Modernism and Formalism. They began unprecedented use of images appropriated from the mass media. They used everyday pulp images to reflect the cultural style of the consumer society that spawned them. The work of these Pop movement artists marks the transition into the Postmodern period.

The Pop aesthetic was antiart in the Duchampian sense, anti-American in its ironic commentary on the cultural effects of rampant commercialism, and yet profoundly American in its appropriation of the same technology developed and designed for propagating consumer culture. Pop artists borrowed specific photographic images from magazines and billboards, T.V., and newspapers and created a new context for them by adding photographs or drawn elements of their own. Some artists, such as Andy Warhol, actually earned their living as commercial artists. James Rosenquist, for example, painted huge billboards above Times Square and spoke about his experiences painting images of gigantic fields of spaghetti. It was natural for Pop artists like Rosenquist to begin the direct use of photographic imagery in their paintings and prints using photomechanical processing for printed effects as part of both style and of the total rhythm of their creative process.

In England the Pop movement arose at about the same time. There Richard Hamilton and Eduardo Paolozzi were its leading exponents. In the United States, some of the best known artists include Andy Warhol, James Rosenquist, Roy Lichtenstein, Tom Wesselman, Robert Rauschenberg, Jasper Johns, Jim Dine, and Claes Oldenburg. Members of both groups, deeply influenced by the theories and example of Duchamp (who had become a cult figure for them), met each other at the Duchamp retrospective held in California at the Pasadena Museum in 1963.

The very familiarity and commercial popularization of photographic images (which at the end of the nineteenth century prejudiced artists against the direct use of photography in their work) now attracted the most progressive painters and sculptors. In opposition to the formal abstract tendencies of Modernism, figuration—a more public stance in art—began to return, a shift which has become fully established in the Postmodern period. Pop artists renewed questions also about the potential of industrial manufactur-

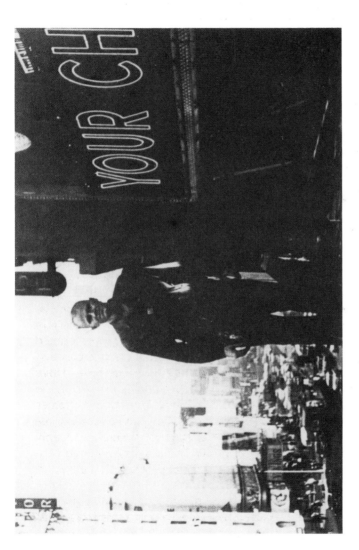

Figure 28. *James Rosenquist Working in Times Square,* 1958
Photograph.
Taking on the occupation of a billboard sign painter for a time, Rosenquist painted images
so large that he remarked, "I could hardly tell what they looked like except for their textures
but I had to be accurate and make them look like the things they were supposed to be."
Swaying on planks 22 stories above the street, Rosenquist mixed paints and created super-
colossal figures. He had to walk three blocks away to be able to scale the size relationships
in the images he was painting. This experience had a profound effect on his work.
(Courtesy Leo Castelli Gallery, New York)

Figure 29. James Rosenquist, *I Love You with My Ford,* 1961
Oil on canvas, 210 cm. × 237.5 cm.
Rosenquist juxtaposes realistically painted mass products such as cars in out-of-scale relationships to other pictorial elements to make us see more clearly, while at the same time proposing a deeper mystery. His work is typical of how Pop artists made use of consumer society images to produce iconic statements.
(Moderna Museet, The National Swedish Art Museums)

ing techniques not only as part of a work's execution, but as part of its total aesthetic—its look, its style, its meaning. The fusion of technical process with aesthetic concern became a fundamental and characteristic aspect of Pop art. Although the subject matter of their work was popular culture, Pop artists distanced the subject from its social relations without assigning a political spin to it—a strategy which served to reify it, and place it within the realm of high art emblems as part of style, thus blocking the social commentary on the means of reproduction as discussed by Walter Benjamin.

By 1962, Andy Warhol began to screenprint high contrast photo-images onto his canvases. More than any of the other Pop artists, Warhol fused the concept and style of industrial production. That photographic images and screen printing were despised, commercially tainted media considered inappropriate for art-making only increased their allure for the avant-garde. They were in fact ideal for translating the style and scale of the serial sequenced images that Warhol devised. Photo-imagery and photomechanical reproduction methods became a vitally important aspect of his aesthetic. Explaining how Warhol produced his "printed" paintings, John Coplans wrote: "Since a major part of the decisions in the silkscreen process are made outside of the printing itself (even the screens for color can be mechanically prepared in advance) making the painting is then a question of screening the image or varying the color. These decisions can be communicated to an assistant. . . . What obviously interests Warhol is the decisions, not the act of making."[13]

Like the Dadaists, Warhol wanted to create scandal, to shock, to raise questions. Like Duchamp, he became an infamous celebrity figure lionized by part of the art world for his extreme ideas. He also became the ironic subject of media attention. For the mass public, Warhol's life style and art created a new phenomena—the artist as famous star. Warhol himself said, "In the future, everyone will be famous for fifteen minutes."

Warhol began making experimental films in his studio and created a new vérité style where there was no editing of the final product. He simply placed the camera in a corner of the room and let it run, an attitude later taken up by video artists. Later, his films became sensationalistic, tackling issues which focused on sex, psychology, and power, based on the personal life styles of his cult following.

Collaborative Workshops and Research into Artists' Materials Lead to a New Range of Work

Pop artists also used collaboration in special ways; beginning in the late fifties, new collaborative printmaking workshops began to spring up around

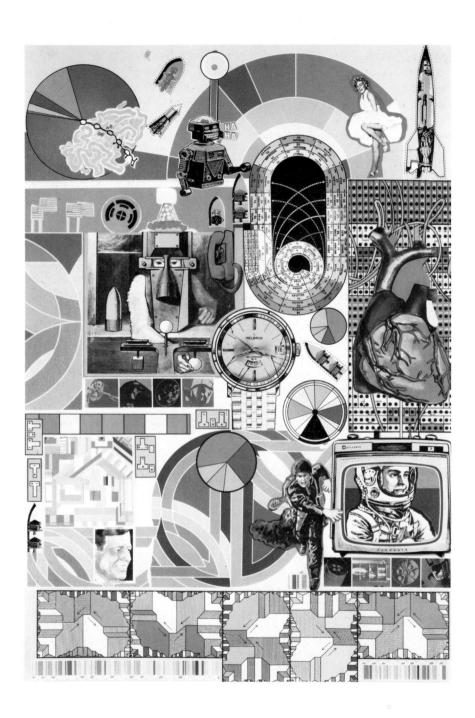

the United States. The earliest of these—Tamarind, Universal Limited Art Editions, and Gemini G.E.L.—invited rising avant-garde Pop artists Rauschenberg, Johns, Dine, Oldenburg, Lichtenstein, Rosenquist, and others to experiment, applying the full range of known commercial technology to their art works. Available to them were light-sensitive resists for metals, large positive aluminum lithographic plates (for use with the precise registration of offset presses), new synthetic meshes and special inks for silk screen, photomechanical production aids such as a range of large format high-contrast film types, contact screens, and process cameras, plastic molding techniques—a veritable feast of technical and industrial processes that up to then had not been explored in the fine arts. An unparalleled spirit of investigation and invention pervaded the workshops, spurring research into new materials and methods. This system of collaborative studios offering technical innovation in-the-service-of-the-arts provided the springboard for a new kind of work which called on unorthodox use of processes and materials. It spurred experimentation—particularly in kinetic sculpture and the large minimalist works, which emphasized industrial fabrication as part of its meaning and style. Attitudes gained from these experiences with the use of photography, industrial photomechanical reproduction methods, and of the use of industrial technology in making fine art prints had spin-offs in painting and sculpture. These experiences demonstrated that art practices in the fine arts could be radically broadened in countless ways to include an extremely diverse range of effects and materials for art-making which resonate with contemporary life.

A new range of work—the huge hard-edge and "Op" works of the sixties, poured paintings, molded canvas surfaces, the pristine, smooth-surfaced Minimalist, and the huge formal Superrealist works of the early seventies—were made possible through the development of new artists' materials such as acrylic paints, mediums, and pigments (synthetic color); adhesives and tapes; plastics (such as styrofoam casting materials); airbrushes; and projecting equipment.[14]

Figure 30. Eduardo Paolozzi, *Artificial Sun,* 1965
Silkscreen print, plate 1 from *As Is When: Interpretations of Ludwig Wittgenstein,* 28" × 22".
When Paolozzi presented his collection of found materials from Pop culture magazines, newspapers, and advertisement posters to a group of artists at the Institute for Contemporary Art in London, he influenced a whole group of British artists to begin thinking about their work in a different cultural context. In this series of silkscreen prints based on Wittgenstein's writings, Paolozzi used photo-silkscreen to create completely new relationships between the disparate elements. *(Donated by Dr. and Mrs. Paul Todd Makler, Philadelphia Museum of Art)*

Figure 31. Richard Hamilton, *Kent State*, 1970
Silkscreen print, 26 7/16″ × 34 3/8″.
When Richard Hamilton photographed his T.V. monitor
during an international news broadcast of the shooting
of Kent State University students demonstrating against
the U.S. invasion of Cambodia, he captured a historic
moment. His translation of the scene into a screen print
still bears the blurry striated quality of an early overseas
transmission. He intended the print as a commemoration
of a moment in time not to be forgotten.
(Collection: Museum of Modern Art, New York)

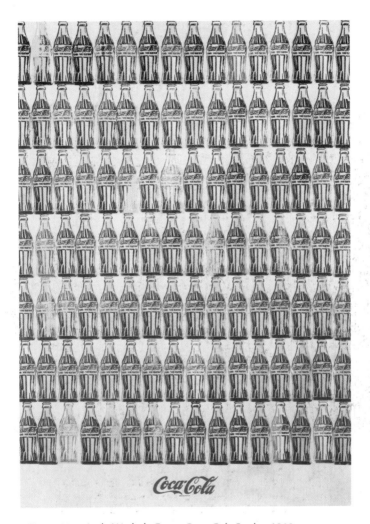

Figure 32. Andy Warhol, *Green Coca-Cola Bottles*, 1962
Silkscreen on canvas, 82 1/4" W × 57" D.
Warhol chose for his work advertising promotion images
that were designed to tap into the consumer's inner
system of desire. Fascinated by consumer culture, its
economics, and its profound effect on the psyche, Warhol
came closest in his "Factory" studio to producing
machinelike effects in these sequences of bottles that
suggest mass-production patterns.
*(Collection: Whitney Museum of American Art, New
York; Photo: Geoffrey Clements)*

Figure 33. Andy Warhol, *Electric Chair,* 1965
Silkscreen on canvas, 22″ × 28″.
Warhol's choice of the electric chair as an emblem of
contemporary America has a chilling effect. The artist's
photographic rendering of the official execution machine
as an icon prompts reflection on the judicial system.
*(Courtesy Leo Castelli Gallery, New York; Photo: Rudolph
Burckhardt)*

The Photorealists use of photographic imagery demonstrated the growing influence of photography. Photorealism incorporated the "distanced cool" of photographs as part of style. What began as the use of found images and materials borrowed from mass culture by the Pop movement as part of their paintings, sculptures, and prints gave rise to art world acceptance of industrial processes, materials, and methods for art-making.

By 1964, two clearly opposing directions in art had become evident. On the one hand, Pop reflected the avant-garde. It emphasized an assemblage approach to art-making in tandem with openness to cultural influence. On the other hand, Minimalism and Conceptualism represented a furtherance of formalist ideals of Modernism—the continuing renunciation of external influence and imagery.

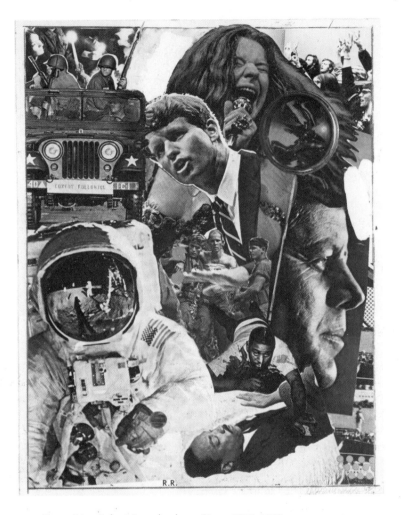

Figure 34. Robert Rauschenberg, *Signs, 1970,* 1970
Silkscreen print, 43" × 34".
Rauschenberg stated that this print was "conceived" to
remind us of the love, terror, and violence of the previous
ten years. Danger lies in forgetting. His photographic
juxtaposition of Martin Luther King's death, the moon
landing, the Kennedy brothers, Janis Joplin (later to die
of a drug overdose), soldiers, and protesters against the
Vietnam War was a restatement of the old issue of
photomontage.
*(Courtesy Castelli Graphics, New York; Photo: Pollitzer,
Strong, & Meyer)*

3

The Electronic Era and Postmodernism

We are in the midst of a vast process in which (literary) forms are being melted down, a process in which many of the contrasts in terms of which we have been accustomed to think may lose their relevance. . . .

Walter Benjamin

Transitions: New Era, New Consciousness

The electronic immediacy of television provided a strong impetus for rapid social transformation in the booming sixties, when everything seemed possible. Signs of technological progress were everywhere. John F. Kennedy campaigned on television. "Tremendous new adventurous energies were loose in the culture: the pill; the joint; the civil rights movement; escalating anti-war protest; black power; radical feminism."[1] In retrospect, those exhilarating turbulent years of social, technological, and cultural evolution paralleled the urgent desire for change which had, at the turn of the century, produced Modernism.

By 1958, 42 million American homes were fed by broadcasts from 52 stations.[2] As a result of the wild barrage of images which flowed through its T.V. sets from all over the world, the public participated collectively, in the comfort and privacy of their living rooms, in a new cultural condition. Apart from the commercial junk, they saw documentary reportage of the moon landing, Kennedy's assassination, the far-away Vietnam War, Martin Luther King's funeral, and the civil rights marches. These compelling images were mixed in with an odd assortment of cultural manifestations ranging from soap operas, game shows, religious sermons, science programs, cooking lessons, gym classes, and reruns of old movies.

The effect of television is different from that of a newspaper because the sequenced flow of images demands the same attention as film. How-

ever, it has the same effect as a newspaper in that in the same day, on different stations, the choice among news, opera, game quizzes, and dog food ads were strung together in a wrenching combination. Programs were generally in half-hour or one-hour segments of time carefully crafted to rivet the attention of the viewer to meet the demands of the commercial system. This chaotic condition where information and theatrical effects were mixed with the totally banal, where art, culture, politics, science, etc., were all brought together outside of their usual contexts and connections, began to create a vast meltdown of forms within the public consciousness. Television became the arena of a confusion, a melting pot of forms, concepts, and banalities which acted as the crucible for a Postmodern consciousness.

Simultaneously, every office, library, and banking establishment in the country began to feel the instant electronic pulse of copy machines. Soon everyone was copying everything from their tax forms, college degrees, newspaper clippings, and drawings, to parts of the body. There was an unparalleled escalation of image and information flow which, like television, deeply affected the lives of everyone, in every walk of life. It took longer for the computer's influence to diffuse the collective consciousness. But by the seventies, its impact was evident in every major area of the economy—especially banking and publishing. Consumer service and cottage industries of all kinds sprouted up as its direct result.

Summing Up: The Machine as Seen at the End of the Mechanical Age

In his catalog for the unusual 1968 Museum of Modern Art exhibition, The Machine as Seen at the End of the Mechanical Age, the curator, Pontus Hultén, documented and surveyed the machine as a major influence in art from the Industrial Revolution to contemporary times. The exhibition was composed of artworks which either commented on technology, used the machine itself as iconography, made use of machines as vital working parts, or showed the machine aesthetic as part of style. He seemed to be summing up an entire epoch and pointing to the new electronic era ahead. He meant the exhibition to be a cultural response, to herald what he saw as the transitional moment from the machine age culture of a manufacturing society based on machines as the "muscle" of industry to an electronic information society culture based on instant communication services. In his catalog essay, Hultén expressed an optimistic view of man and his relationship to technology but pointed also to the importance of watchfulness towards those in power who might be tempted to use technology to manipulate or destroy society. Referring to nuclear technology, he called for an effort of human will to avoid becoming "the victims of what we ourselves produce." Finally he paraphrased what Tristan Tzara said about Dada: "No one can

escape from the machine. Only the machine can enable you to escape from destiny."

Also included in the exhibition were recent electronic works by Nam June Paik, Robert Breer, and others, which incorporated video, computer, sound, and light. The new electronic tools were still in their infancy but their potential was evident, particularly to those artists interested in large multimedia works and interactive projects.

That same year, Cybernetic Serendipity, a large-scale exhibition of "post-machine" art curated by Jasia Reichard, opened at the Institute of Contemporary Art in London and later traveled to Washington. It included computer printouts of musical analysis, computer-designed choreography, and computer-generated texts and poems.

Other exhibitions with art and technology as a theme were in preparation. Software at the Jewish Museum opened in 1970; Explorations at the Smithsonian Institute, Washington, opened in the same year, curated by Gyorgy Kepes, director of MIT's important new Center for Advanced Visual Studies, which was founded in 1968.

These exhibitions were a tribute to the new spirit of openness towards use of industrial techniques in art-making which had an especially dramatic impact on the art of the sixties and seventies, for its new forms had as much to do with process as with idea.

By the time of the 1961 International Exhibition of Art and Motion at the Stedelijk Museum in Amsterdam (also curated by Pontus Hultén) and the 1964 Documenta exhibition in Kassel, Germany, interest in kinetics (which *Time* magazine later termed the "Kinetic Kraze") had grown in Europe toward an escalation of technical means. The Zero and Grav groups (Neodadaist and Neoconstructivist kinetic sculptors) began serious work using the industrial machine technologies. In the United States, sculptors especially began to harness the new electronic tools which were rapidly being developed: electronic communication systems and information technologies; computers and lasers with their scanning possibilities, along with innovation in television and video; light- and audio-sensor controlled environments; programmable strobe and projected light environments with sophisticated consoles.

By 1965, advances in televison technology had spawned the new electronic medium of video. Its relatively light, portable equipment drew widespread interest in the arts[3] because of its transmission-receiving aspects and its low-cost immediate feedback implications in comparison with film. The first video artists conceived their works as sculptural installations and performance. The medium was ideal as the starting point for informal studio closed-circuit experiments with concepts of time and motion—as a continuation of the formalist tradition of kinetic sculpture.

Figure 35. Jean Dupuy (Left), Jean Tinguely (Center), and Alexander
 Calder (Right) with *Heart Beats Dust* at The Machine as
 Seen at the End of the Mechanical Age Exhibition,
 Museum of Modern Art, New York, 1969
 E.A.T. (Experiments in Art and Technology) arranged a
 competition for collaborations between engineers and
 artists. *Heart Beats Dust* was the winning entry. The jurors
 issued this statement: "In each of the winning entries a
 spectrum of technology was used with great impact on
 the art forms. Evident is the realization that neither the
 artist nor the engineer alone could have achieved the
 results. Interaction must have preceded innovation. . . .
 The unexpected and extraordinary, which one
 experiences on viewing these pieces, result from
 inventiveness and imagination, stimulated not by the
 brute force of technical complexity but by probing into
 the workings of natural laws."
 (Photo: Harry Shunk)

Figure 36. Jean Dupuy, Artist, and Ralph Martel, Engineer, *Heart
 Beats Dust,* 1968
 Dust, plywood, glass, light, electronic machine.
 The essential material of this sculpture is dust enclosed
 in a glass-faced cube and made visible by a high intensity
 infrared-light beam. Alexander Calder activates the dust
 by placing the scope to his heart, triggering acoustic
 vibrations by the rhythm of his heart beats. The work
 manifests a form of collaboration with nature where
 natural forces within and outside the human body are
 brought into play.
 (Photo: Harry Shunk)

Figure 37. Mark Tansey, *Secret of the Sphinx,* 1984
Oil on canvas, 60″ × 65″.
Tansey's paintings amass a wealth of information and
combine with imaginative inventiveness to create
mysterious commentaries on history and meaning in
contemporary life. Making obvious use of photographic
style, Tansey subverts it to make his stories seem more
real and to raise questions about technology, history, and
contemporary life.
*(Private Collection, Courtesy Curt Marcus Gallery, New
York)*

Experiments in Art and Technology:
Collaborations in Two Kinds of Thinking, Art and Science

In the United States, artists felt the need to seek collaborations with engineers and scientists to help in producing innovative work using new technologies. Convinced there was a need for an information clearinghouse to make technical information and advice available and a service for arranging individual artist-engineer collaborations, the artist Robert Rauschenberg and scientist Billy Klüver formed a new organization called "Experiments in Art and Technology" (E.A.T.), which published its first bulletin in January 1967. Because of its governmental and corporate contacts, E.A.T. was in an ideal position to act as a liaison between artists,[4] engineers, and corporations and to provide a meeting place where seminars, lectures, and demonstrations could be presented.

Bell Laboratory physicist Billy Klüver's friendship with members of the progressive Swedish avant-garde, such as poet and painter Oyvind Fählstrom and Moderna Museet Director Pontus Hultén, had brought him into contact with both European artists (as an advisor for Hultén's 1961 Stedelijk Museum kinetic exhibition) and with the New York art world. "Klüver saw many parallels between contemporary art and science, both of which were concerned basically with the investigation of life . . . (he had) a vision of American technological genius humanized and made wiser by the imaginative perception of artists. . . . Klüver seemed to speak two languages, contemporary art and contemporary science."[5]

In 1965, when an invitation came to American artists from a Swedish experimental music society to contribute to a festival of art and techhnology, Klüver became the logical liaison between artists and engineers. Although the project fell through, it helped to establish a relationship between a group of choreographers associated with the Judson Memorial Church, and musicians John Cage and David Tudor, multimedia artist Robert Whitman, and Oyvind Fählstrom. They began to combine technology with performance events known as "Happenings." The excitement and energy of the emergent avant-garde were characterized in the efforts of Rauschenberg and Klüver, who in 1966 brought together 30 Bell Laboratory engineers to work with visual artists, dancers, and musicians. They raised funds for an ambitious project called *Nine Evenings: Theater and Engineering* by contacting individual corporations, foundations, art dealers, and collectors. However, from the start, the artist-engineer collaboration system encountered difficulties, for the engineers were not used to working against theatrical deadlines and frustrated artists were unable to rehearse properly without finalized technical support.

Aesthetically and technically, *Nine Evenings* was less than anticipated,

but it proved that collaborations betwen artists and engineers were possible. In many ways, its most important function lay in defining the nature and basis of the problems (not the solutions) inherent in artist-engineer collaborations. Both artists and engineers had to learn new ways of thinking where the practical and the creative could interact. The experience they gained illustrated clearly not only the high financial costs of such ventures but also the enormous amount of time needed in planning and coordination as well as the enormous complexity and difficulty of integrating such diverse kinds of specialized thinking.

For example, the most ambitious (and fateful) project undertaken by E.A.T. came in 1967, the design and construction of an art and technology pavilion for the Pepsi-Cola Company at Expo '70 in Osaka, Japan. Following months of discussion and consultation, a construction and maintenance budget was decided upon and a preliminary concept for a mirror-surfaced domed interior was approved. Sculptures inside and outside, some using laser light and motion, would create a setting for the interactive and performance pieces to be presented inside the dome. The accent was on experimental programming which would involve the public and alter the functional relations between art and the public in a popular setting. Fog jets would shroud the exterior of the pavilion in a perpetual cloud of mist. No one could have predicted the enormous effort and difficulty of realizing such a project which overshot its budget so alarmingly that in the end, Pepsi's tolerance was exhausted and E.A.T. was asked to leave even though work on the pavilion had been completed successfully and (miraculously) on time. The pullout represented a serious setback for E.A.T. in its role as corporate mediator. Many of its 6,000 members began to grumble that they were being bypassed and merely used as statistical fodder for E.A.T.'s grant proposals. Questions began to be raised about the cultural value of such expensive experimentation.

Artists and Industry

The most costly and ambitious exhibition of collaborations between artists and engineers was Art and Technology, an exhibition curated by Maurice Tuchman, which opened at the Los Angeles County Museum in 1971. Five years in preparation, the show featured the work of 22 artists who had been paired to work with specific corporations under an elaborate contract system which covered costs of technical assistance, production, and maintenance of the work for the three-month duration of the exhibition. The contracts represent probably the most consciously thorough practical attempt of all the art and technology exhibitions to ensure there would be no pullouts or inadequate provisions for technical assistance in case of malfunc-

tions. There were three categories of artists using new technologies: first, those whose work was primarily concerned with the direct use of machines to explore the aesthetics of light and kinetic movement. These included Robert Whitman, Rockne Krebs, Newton Harrison, and Boyd Mefferd. The second category was comprised of well-known New York artists whose experimental work made use of fabrication technology (i.e., using the machine as a tool to produce their work), such as Claes Oldenburg, Roy Lichtenstein, Richard Serra, Tony Smith, Andy Warhol, and Robert Rauschenberg. The final group—James Lee, Ron Kitaj, and Oyvind Fählstrom—provided poetic and humorous relief in their serendipitous works by using the machine as an icon.

Although the tumultuous five-year period (1966–71) from the exhibition's original inception to its final presentation was marked by unforgettable sociopolitical malaise, none of the artists in the exhibition used technology to comment on the technological violence of the Vietnam War,

Overleaf and following page:

Figure 38. (Top) Pepsi-Cola Pavilion, Osaka, 1970
 Environment designed by E.A.T.
 The pavilion was designed as an interactive environment inside and out to be
 responsive to sound and light through strategically located systems, most of them
 triggered by the behavior and movement of the spectators. The outside of the
 dome was enveloped in a fog produced by mist jets.
 (Photo: Harry Shunk)

Figure 39. *Variations V,* 1965
 Choreography: Merce Cunningham; Music: John Cage; Film: Stan Van Der Beek.
 Foreground, left to right, John Cage, David Tudor, Gordon Mumma; *rear, left to
 right,* Carolyn Brown, Merce Cunningham, Barbara Dilley.
 Intermedia experimentation in the arts produced works like this one, which
 combined dance movement, film projectors, and music in an important and new
 (for the time) audiovisual performance genre. These works were often without a
 recorded score, similar to impromptu jazz performances. Such performances are
 quite unlike today's counterparts, which, by contrast, are highly planned-out and
 polished works presented to large arts-festival audiences.
 (Photo: Hervé Gloaguen)

Figure 40. Remy Charlip, *Homage to Loie Fuller,* March 8, 1970
 Performance inside the E.A.T. Osaka Pavilion.
 The spherical mirror at the top of the dome, the largest
 one made at the time, reflected not only the viewers, but
 intensified the color and movement of the many
 performances that took place inside. The mylar walls
 created illusionistic reflected effects that produced a
 sense of participation and interactivity.
 (Photo: Harry Shunk)

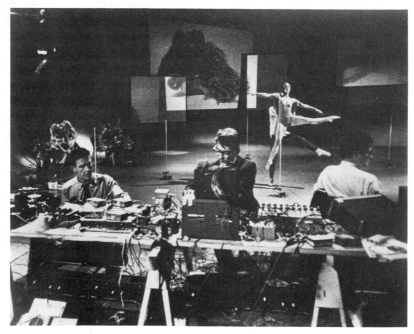

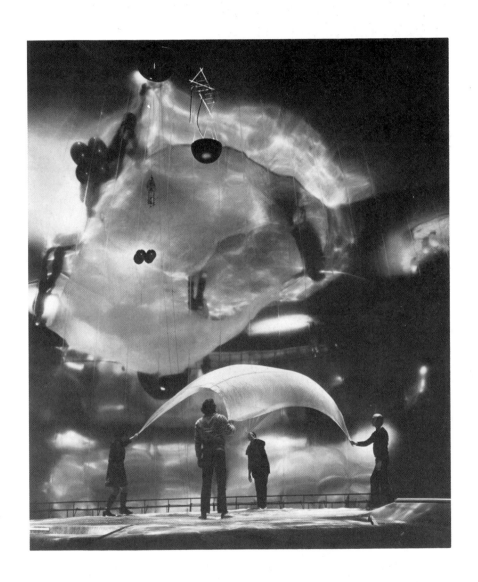

which millions of Americans were watching on television. The war engaged a profound problem in the American ethos, for it challenged the belief in the American dream—man and machine creating a new democratic utopia through technological efficiency and progress. The sixties' mood of hope and optimism was replaced in the early seventies by rage and frustration in a sea of events that seemed out of control. There began to be a growing awareness of the fatal environmental effects of some technologies. That technology could be poeticized and humanized by art suddenly seemed irrelevant when its use had been unleashed for such destructive ends.

The critics attacked—insinuating that the exhibition represented a nefarious marriage between advanced technology, the museums, and big business. They coined new terms—"corporate art" and the "culture of economics."[6] A serious economic depression followed the ten-year war. It signaled a significant cutback in government and corporate support for the arts, a serious threat to costly technological collaborations. A crisis was also brewing in the art world.

In a symbiotic relationship, major critics and museum curators formulate the epistemological judgments which lie at the base of the institutional consecration of "high art." It seemed that a consensus between them emerged in the early seventies for a major change in attitudes towards the validation of art works which relied directly on technological means, except for the new electronic medium of video.

Crisis of Modernism

Museums were skeptical about including in their collections huge works which needed constant mechanical maintenance. Kynaston McShine, Museum of Modern Art curator, wrote in his 1970 essay to the Information exhibition: "The whole nature of collecting is perhaps becoming obsolete, and what is the traditional museum going to do about a work at the bottom of the Sargasso Sea, or in the Kalahari desert, or in the Antarctic, or at the bottom of a volcano? How is the museum going to deal with the introduction of new technology as an everyday part of its curatorial concerns?"

It began to be clear that the new aesthetic constructs and the old institutions were no longer working in tandem with economic, technological, political, and cultural realities, a situation which rapidly took on the proportions of a major new transition in art. Aside from referring to art with a technological basis, to environmental projects and to intermedia works, McShine was also addressing the crisis now occurring in the "official" (i.e., mainstream) Modernist movement which had continued to evolve (albeit with Pop art in opposition).

Tendencies in formal Modernism had largely been absorbed by the

Figure 41. Roy Lichtenstein, *Hopeless,* 1963
Oil on canvas, 44″ × 44″.
The Dada spirit for recycled images (inserted into the
discourse of the sixties by Duchamp) influenced painters
like Lichtenstein, who began to use mass-media images
as subject matter. However, he maintained that his use
of comic strips was for their "look," for purely formal
reasons—not for the same kind of ironic reaction to social
conditions that had earlier motivated the Dadaists and
Surrealists.
(Courtesy Leo Castelli Gallery, New York)

Figure 42. Audrey Flack, *Marilyn*, 1977
Oil over acrylic on canvas, 96″ × 96″.
Flack's photo-realist treatment of Marilyn Monroe as a
cultural icon, as a universal symbol, is quite different from
Lichtenstein's Pop approach. Her keen interest in sources
of human strength, and in feminist issues of her own time,
combined to produce a work that makes use of
photography overtly, for its time references as well as its
explicit detail. Unlike other photo-realists who used the
distanced cool of the photograph as part of a new style,
Flack used it rather to comment on the vulnerability of
her subject.
*(University of Arizona Museum of Art, Edward J.
Gallagher, Jr., Memorial Fund)*

Figure 43. David Salle, *Pastel 1986*, 1986
Diptych: acrylic and oil on canvas, 84" × 162".
By comparison to Flack and Lichtenstein, the use of photography in David Salle's Postmodern assemblages of imagery from popular culture is quite different. He brings together the highly subjective and the questionable as references, revealing a highly sophisticated mind at work. He presents images (chosen from a variety of media) as ghosts of what we already know but juxtaposed in a context designed to trap the mind into a questioning, equivocating stance as to their total meaning. His images force thoughts about content to flicker on and off as a form of friction among groups of associations. Emotion is filtered through layers of ambiguity/familiarity.
(Courtesy Mary Boone Gallery)

mid-seventies. It had led to Conceptualism and the total negation of the art object. Because Conceptualism was too difficult to have much of a public following, it became easy prey for its detractors. Modernist premises emphasized values of traditional aesthetic discourse and representation: authorship and originality; the criterion of talent and skills; progress in artistic style; the uniqueness of the created object; the traditional standards of critical evaluation. From the Abstract Expressionist movement of the fifties, the formalist aesthetic as defined by Greenberg evolved in what seemed a continuing, logical manifestation of intellectual and historically inevitable Modernist progressions—color field painting, process art, and (by 1966) drastically reductive minimal art, with its offshoots into conceptual works, earth works and body works. Existing side by side with the Pop movement, minimal and conceptual art was its almost complete antithesis. While the Pop artists and Photorealists opened their work to let in the real world using found urban junk and mass culture images as iconography, the Minimalists shut it out. They continued to produce works in line with the twentieth-century formal Modernist tradition of reduction and renunciation of external influence with emphasis on the medium being the message. The Minimalists thought of their work as part of a logical sequence of constructed aesthetic progress. They ruthlessly eliminated anything that might divert attention from the essential flatness of the picture plane—figuration, emotional or atmospheric effects, illusionistic concerns—a total "negation of impulses." Apart from its manifestation in paintings (for example those of Robert Ryman, Milton Resnick, and Robert Mangold), Minimalism carried over into the sculptural works of Donald Judd, Richard Serra, Carl Andre, Dan Flavin, and Robert Morris. In its "privileging of the object" as art, it was "official" mainstream work touted by the gallery system and museums. These "pure" emanations had a theatricality to them which conveyed a feeling of seemingly timeless absorption.

Conceptualism, the last of the truly international art movements, was in opposition to Minimalism in the sense that it ran counter to the Greenbergian version of Modernism as being posited *only* in painting and sculpture (an identification which led naturally to the value of the object). The Conceptualists opposed the commodity state of the object and promoted the idea that art as idea could become common property. Because of its reliance on language and text, conceptual works could be disseminated beyond the gallery context, and took on many forms—for example in public projects which were then recorded in magazines or books. Too extreme for the public to follow, too removed from the material object to be viewable or saleable in traditional contexts, too scandalous also, in that it arose in opposition to the Greenberg formulation of Modernism, it suffered when

those theories lost credence. It became a turning point in exemplifying the contradictions of Postmodernism. However, the strategies of Conceptualism and its discourse laid the foundations for the deconstruction period which followed where new lines of inquiry and engagement have opened out. Conceptualist influence has carried over and is a very important aspect of new work by both American and European artists still influenced by it.

What resulted has been named the "Crisis of Modernism." "The shift from art that could only refer to itself, to art that could refer to everything, took place almost overnight."[7] The radically new social, technological, and historical conditions of the sixties and early seventies led to a diverse diffusion of ideas and artistic activities which gradually eroded the purist "high art" vision and moral authority of the modernist period (with its bans on any external references or allusions to interwoven or sequenced events or to human cause and effect), forcing a reconsideration of previous notions about creative endeavor and originality. Modernist resistance to the acceptance of technology as an integral aspect of art-making and cultural development as a whole began to erode under the prevalence and, by now, deep-rooted influence of the new electronic imaging technologies. Not only had these media invaded and changed the very fabric of public life by the mid-seventies, but they also began to play an integral part in altering perceptions and attitudes about the structure of art and its production and dissemination. The wider dispersal and dissemination of artistic practices could no longer be contained within a modernist framework; and a fresh outlook on issues long denied under old cultural constructs led to the new condition of Postmodernism.

Deconstruction

The process of retreating from Modernist models for art seems to entail reexamination and de-construction of all that had been previously assumed. "De-constructing" Modernism means not rejecting it outright, but rather seeing it from a different perspective and understanding it in terms of its opposing forces. For example, the Structuralists and Poststructuralists played a leading role in this process by analyzing cultural practice as a system of codes, symbols, and signs and investigated how meaning is created. The art movements which oppose mainstream tendencies (such as Pop or Conceptualism) and call for radical solutions in art can be seen as resistance to forms which have become "officially" accepted or mainstream. (High-priced art work is always made attractive as culturally valuable by the art market system.) As soon as the opposing form becomes accepted, a further resistance takes its place tangentially and creates the basis for future devel-

opments. The confusion apparent in the art of the eighties arises over over-lapping (with influences from one setting up resonances in the other) and the span of time the changes inevitably take to supersede one another.

Ironically, the status of photography as an art form is a good example of these tendencies. By the early seventies, art world acceptance of photography was validated by its use in Pop movement works. Although a broad range of photographers such as Stieglitz, Steichen, Moholy-Nagy, Ansel Adams, Minor White, Harry Callaghan, and André Kertesz, had asserted photography as a fine-art medium, it had not yet received the validation and attention by the museum and gallery system that it deserved. Photography entered the mainstream through "the back door" by first being silkscreened onto Warhol's canvases, and it made further inroads into artistic practice through its use in the distanced cool of Photorealist paintings. Its technical "look" and character had for sometime appealed to a wide range of artists. This mainstream effect created the impetus for widespread exhibitions of nineteenth-century photographic history, the rise of new photo galleries, and the growth of photographic criticism, and eventually created a market potential for contemporary photographs. Thus, photography as an art medium like any other has now been substantially validated.

Yet "art photography" as a privileged construct which has been canonized through museum collections, print connoisseurship, gallery marketing, and critical/historical scholarship, has now been fetishized as a commodity "object" (made by the hand of the artist, despite the fact that photography is a form of duplication where any number of copies may be taken from the original negative, even without the special hand of the artist), by the very system from which it sought acceptance. Today's photography market touts the "uniqueness" of images as monoprints, a denial of the form's inherent structural properties (i.e., the ability to make "unlimited" copies). The formal, self-referential Modernist aesthetic of "art" photography—with its own purist claims of an acknowledged particular presence or "aura"—has essentially separated it from the more expanded Postmodern view of photography as expressed by Walter Benjamin. "Art photography" as a form has become irrelevant as seen against the social function and influence of photography as the form of mass communication and ideology which dominates the politics and culture of everyday life in public systems of communication such as advertising, television, cinema, fashion, posters, and magazines. For example, Barbara Kruger's Postmodern use of appropriated images and text introduce a different sort of representational aesthetic and sophisticated cultural meaning than a photograph by Sherrie Levine, another artist who has embraced photography because it allows her to comment on important Postmodern issues. Levine questions the "authenticity" and "originality" of a famous artwork by simply re-photographing it and signing her own

name to it, as she has done in replicating works of other artists such as Rodchenko and Walker Evans.

Levine's use of other artists' work to question "the copy" and "the original" recalls the issues raised by Duchamp when he exhibited in a gallery his readymades—objects not only made by machines, but produced industrially as multiples of an object. Duchamp had pointed out that the meaning and value of art is a constructed product of the mind and that changing the context of an object could create a new meaning for it and enable it to be seen differently through a different perspective. This act of appropriation has important shock value because it dramatically brings into focus major issues which normally lie below the surface, issues which need to be questioned. Under Postmodern conditions, Duchamp's ideas about appropriation, the copy and the original, and the value of the object (brought further into focus by Walter Benjamin) have gained fresh impetus.

Photography's Influence Expanded by Electronic Media

Industrialized societies rely more and more on "image flow"—the consumption of photographic images as a principal conduit of information, culture, and ideology. The influence of photographic imagery seeps more and more into daily life through the popularity of magazines, television, and commercial entertainment films. Now the prevalence of VCRs in millions of homes has created "family entertainment centers."

Photography's potential has been expanded by Postmodernism. "Virtually every critical and theoretical issue with which postmodernist art may be said to engage, in one sense or another, can be located within photography. Issues having to do with authorship, subjectivity, and uniqueness are built into the very nature of the photographic process itself. Issues devolving on the simulacrum (authenticity versus artificiality), the stereotype, and the social and sexual positioning of the viewing subject are central to the production and functioning of advertising and other mass-media forms of photography. Postmodernist photographic activity may deal with any or all of these elements and it is worth noting, too that even work constructed by the hand . . . is frequently predicated on the photographic image."[8] (For examples, see the works of Troy Brauntuch, Eric Fischl, David Salle, Mark Tansey, Jack Goldstein, and Robert Longo.)

In line with Postmodern refusal or violation of the formal purist aesthetic of Modernism, the photographically represented world (with all its media, genres, and materials) is being drawn into the fundamental arena of mainstream expression. The use of photography is part of the Postmodern aesthetic through appropriation or quotation of preexisting images, texts, forms, and styles. Important influences from "Pop," which have continued

to be felt as underground "opposing" influences and as a resistance to the mainstream formalism of Modernism (the form most promoted by the major critics, museums, and the art market), are predicated on its use and function as an agent of mass communication and as part of cultural meaning and context.

Out of step with the logical sequence of abstract, formal Modernist development in the early sixties, Pop artists' appropriation of found images and materials for their work and their use of mass culture iconography and technologies had begun to illuminate the unavoidable connections between art and society and the possibilities for creating a shift towards a Postmodern aesthetic linked more to popular culture than to the existing canons of high art. Although the movement did not last beyond the sixties, it opened the way towards figuration in art through the use of photography; commented on cultural conditions, including the new electronic society; and validated the *direct* use of technology both as tool and as influence in the making of art.

Crosscurrents of Postmodernism

What we are experiencing in the eighties can be described in the terms of opposing "Postmodernist" tendencies. On the one hand, there is extreme conservative outright rejection of Modernist abstraction as a "cultural mistake." This takes the form of a return to early figurative aspects of Modernism such as Expressionism, or to resurrection and plundering of even earlier art influences and styles and even to a nostalgic restatement of Minimalism and Conceptualism with a wry Postmodern twist. On the other hand, a radical opposition seeks to critique the history of art and the origins of Modernism: to question rather than exploit existing cultural codes; to explore the social, political, economic, and technological structures which lie at the base of the art of the past and of culture and society as a whole—a continuation of the strategies and discourse of the late Conceptualists.

Manifestly, the more commercially acceptable, mainstream works which fill the galleries and museums in the eighties are conservative and represent a return to tradition—conventional but expressive figuration and a revalidation of painterliness (satisfying a certain public hunger after emptiness) and to subject matter long denied, such as narration, Neoexpressionism, myth, and decorative pattern. Working below the surface, but still discernable, is the progressive cross-current resistance (with its roots in Pop art, performance art, and photography). Its focus is on a critique of representation with special emphasis on the media's public systems of communication such as commercial advertising using photography, electronic media, performance mixed media, and bookworks. There is a move towards the

Figure 44. Robert Longo, *Now Everybody*, 1982–83
Mixed media, 96" × 192" canvas, 79" × 28" × 45" sculpture.
Longo's images are on the cutting edge of his time. He fuses images charged with
contemporary pressures, producing powerful icons. He has said such images
"exist somewhere between movies and monuments." In *Now Everybody*, his use
of photography is explicit, yet the image creates an overwhelming sense of falling
and destruction that pulls the viewer into it. Influenced by the media and
contemporary music, Longo wants his work to be accessible to the average person.
(*Courtesy Metro Pictures; Photo: Pelka/Noble*)

Figure 45. General Idea, *Reconstructing Futures*, 1977
 Room installation.
 General Idea is a Neodada Canadian collaborative group which publishes a regular counterculture
 magazine. Their room installation with its iron screen, sculpturelike leather furniture, and large aerial-
 view photomurals represents a new fusion of materials, forms, and concepts which characterize the
 Postmodern.
 (National Gallery of Canada; Photo: Koury Wingate Gallery, New York)

melding of all the arts—music, theater, dance, film and video, literature, and poetry—into a new synthesis offering potential for far-reaching exploration and development.

The new art is not so much a rejection of old forms as it is creating fresh relationships and different contextual readings. The resulting amalgam is a diverse open pluralism, a reexamination and free quotation of the style and cultural forms of the past as a way of seeking to understand the process of cultural growth that has taken place historically in the process of moving forward into the future. *New York Times* critic Michael Brenson recently provided a commentary on Postmodernism: "Art now jumped back into the world with both feet. . . . It [can] be conceptual, photographic, figurative, or expressive. It [can] mirror and engage the mass media, particularly the visual media like television and film. It [can] have mythical, personal, and social subject matter. . . . It (has) something to say about the giddy excitement and awful conflicts of late twentieth-century life." Whether it is conservative or progressive, the need for aesthetic experience is felt more deeply than ever before by a larger number of people as they strive to situate themselves in the complexity of the electronic age.

The return to an involvement in popular culture where a new, more direct relationship is being forged between the artist and the commercial worlds of television, entertainment, fashion, and industry is creating a schism between "high," or elite, art destined to be seen mostly in art world establishments and "low," or popular, art designed for a wider audience. For example, many film and video artists have made the decision to produce work for mainstream television broadcast, to which the public can relate, in order to broaden the impact of their ideas on a wider audience. This is a very different concept from the stance of sixties Pop artists whose work became contained more within the art world itself, and in the final analysis, became "privileged objects." Other artists are using mass-media images "quotations" in their work to comment on the powerful potential of the mass media to influence public thinking. Their work serves to alert us both to the power as well as the danger of myths, whether they are based in the past or in present-day popular culture. For the past (in reruns) is mingled with the present to an astonishing degree on the living-room stage provided by television.

Neopop works have dazzled gallery viewers with their punk sensibility since the early eighties, have used photography, and have appropriated commercial images from comics and media along with collage and an effluvia of found materials. However, the new Pop differs in its implicit critique of commercial culture by unmasking the "manipulative nature of the message bearing images fed . . . through various media and designed to keep us consuming goods, goods produced solely to be consumed. The

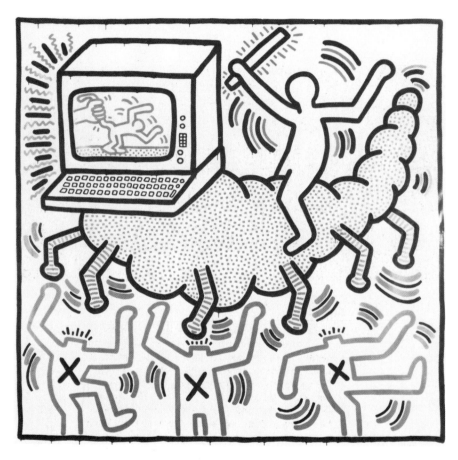

Figure 46. Keith Haring, Untitled, 1983
Vinyl paint on vinyl tarp, 10′ × 10′.
(Courtesy Tony Shafrazi Gallery, New York;
Photo: Ivan Dalla Tana)

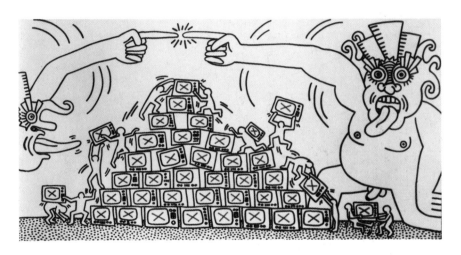

Figure 47. Keith Haring, Untitled, 1983
 Sumi ink on paper, 72″ × 134″.
 Part of the Neo-Pop phenomenon, which grew out of
 street culture, Haring has the ability to synthesize and
 capture contemporary ideas in a powerful vernacular.
 One part doodle-graffiti, one part Paul Klee, one part
 design, he sets out to influence public opinion about such
 things as drugs and nuclear war. In both of the images
 shown here, he comments on the control of the public
 by T.V. Haring's popular success has made him into an
 art star with important clout for disseminating his ideas.
 *(Courtesy Tony Shafrazi Gallery, New York; Photo: Ivan
 Dalla Tana)*

Figure 48. Kenny Scharf, *One Man Show*, May, 1983
 Gallery installation.
 Part of Kenny Scharf's work is the "customizing" of
 cultural icons, such as cars and T.V. sets. In this gallery
 installation, Scharf's T.V. is raised high on a Doric pillar
 as the ultimate image machine.
 *(Courtesy Tony Shafrazi Gallery, New York; Photo: Ivan
 Dalla Tana)*

result is not only an appropriation of that imagery but also an appropriation of the power of that imagery."[9] The methods used by artists such as Keith Haring, Kenny Scharf, Rodney Alan Greenblat, and David Wojnarowitz to convey their messages make use of the same mannerism, exaggeration, and sense of easy fun mixed with wrenching disjuncture that characterizes television itself. While sixties Pop established an equation between aesthetic appreciation and commodity consumption of images, and as a result, made their works more accessible to the public, the work had a "disinterested" nonpolitical subjectivity to it which in effect refashioned the images, abstracted them, and effectively detached them from the context of their social relations. The reincarnation of Pop however, is socially aware and uses incongruous, out-of-context imagery of all kinds to make its point. This new work apes the energy and the glitzy unabashed directness of commercial advertising style, of television and magazine style, but with its own agenda.

Pop Culture and High Culture Converge: Art Stars and Music Video

Part of the "art scene" of the eighties is the prevalence of the trendy media promotion of artists (celebrity consciousness) who have become prominent (like Warhol) as "art star" impresarios. Many have helped to push the fortunes of popular rock clubs like New York's Palladium by appearing there in person or by decorating them with their art work. This can be seen as crass commercialism—an obvious danger which confronts every aspect of the popularization and democratization of culture which is now taking place. Yet the politics of public attention can also be interpreted as providing for artists of integrity a more powerful communication structure for interacting with the public. For example, socially conscious attitudes are communicated in new music videos (such as those of Laurie Anderson and the recent massive international benefit concert which raised millions of dollars to aid famine relief in Ethiopia) and in enormous artist-organized exhibitions that encompass networks of major galleries and exhibition spaces such as the Art Against AIDS, Artists Against Intervention in Central America, and the antiapartheid ones organized by the Political Art Documentation group in New York. Today, an overt connectedness is beginning to develop between art and its social function. Electronic media will play an even greater role in this relationship in the future.

A Changed Technical Standard in the Arts

The meteoric rise of Cindy Sherman and Doug and Mike Starn to mainstream international art-star status is a major Postmodern phenomenon. The quality, scale, and dimensionality of their work in the photographic medium

Figure 49. *The Palladium,* 1988
Photograph.
The Palladium, a huge converted movie theater, features
changing art shows and a succession of art-world events.
The computerized dance floor with lighting systems and
giant video walls keyed in to dance music has created a
popular craze for the new relationship between sound,
body movement, and changing lights and visuals. The
influence of the Palladium in the art world was at its
height in the mid-eighties, when the East Village Neo-Pop
movement centered around clubs and performances.
Now, the Palladium features special music concerts and
media events.
(Courtesy Cornellis Craane, The Palladium, New York)

Figure 50. Doug and Mike Starn, *Film Tunnel with Man,* 1988
Mixed media (orthofilm with silver print, wood and glue), 106″ × 216″.
In their use of segmented and appropriated aspects of photographic imagery assembled in dimensional and
sculptural compositions, the Starn Twins seem to stretch the picture in any direction they desire. Rembrandt's
image placed as a somber weight juxtaposed against the stygian image of a parking tunnel space creates a
kind of surprising sublimity. Their work transcends divisions between art movements and collapses the
distinctions between photography and painting.
(Photo: Dan A. Soper; Courtesy the Stux Gallery)

collapses distinctions between painting and photography. The title of Richard B. Woodward's October 1988 article in the *New York Times* poses the by now ironic question in our debate about the use of photography: "It's Art, But Is It Photography?" The final barriers have been broken and the tables reversed.

The dramatic options for "seeing" and for representation opened up by new electronic tools as they increasingly make their way into artists studios[10] create the opportunity for invention of new forms and new aesthetic experiences. Just as photography transformed and enriched the field of art, acting as an influence, a catalyst, and a tool for representation, the more powerful potential of electronic media will similarly raise difficult questions about representation and new relations between artist and society.

Part Two

Systems

4

The Copier: Authorship and Originality

Mechanical reproduction emancipates the work of art from its paradisical dependence on ritual. To an ever greater degree, the work of art reproduced becomes the work of art designed for reproducibility. From a photographic negative, for example, one can make any number of prints; to ask for the "authentic" print makes no sense. But the instant the criterion of authenticity ceases to be applicable to artistic production, the total function of art is reversed. Instead of being based on ritual, it begins to be based on another practice—politics.

<div style="text-align: right;">Walter Benjamin</div>

The Copier and Postmodernism

In his essay "The Work of Art in the Age of Mechanical Reproduction," Walter Benjamin acknowledged the power of photographic technologies

Figure 51. William Larson, Untitled

Photographic, text, sound, voice, music, and various other visual elements transmitted sequentially by telephone as an electro-carbon print, 8 1/2" × 11". Although the transmission of digitized photographs and other data via telephone is not a new phenomenon, William Larson's electro-carbon prints are a form of personal poetry in which he simply makes use of a technological vernacular and transcends its commercial and industrial constituency. The common telephone is used to transmit faithfully from anywhere in the world the data that are the basis for his prints. Once the original image is transformed into an electrical code through a scanning operation that assigns variations in voltage according to the grey levels it sees, Larson transmits his collected fragments of words, images and sounds to be printed together onto a special three-layered graphic-sciences paper. As the various voltage levels reach the paper, a stylus burns the image line-by-line through the surface to the layer of carbon below—the higher the voltage, the darker the burn.

(Courtesy William Larson)

to transform the nature of representation, our cultural attitudes, and the role of art in society and its social meaning. At that time, he was referring to "works of art completely . . . founded in mechanical reproduction"—photography, the cinema, and the potential photomechanical reproducibility and dissemination of all images. Although he could not have foreseen the even greater cultural impact of the extensions of his theory toward electronic reproductive media (photocopy or videocopy machines, fax machines, and a range of electronic printers and plotters hooked to computers), he was the first major critic to analyze a cultural phenomenon which today has even more powerful implications. For now, as further subsumed by electronic technologies, "photography has historically come to mediate, if not wholly represent the empirical world for most of the inhabitants of industrialized societies (indeed, the production and consumption of images serves as one of the distinguishing characteristics of advanced societies), it has become a principal agent and conduit of culture and ideology."[1]

Yet until the seventies, photographic imagery was excluded from validation in the archive of categories previously set aside only for art and its history. "After waiting out the entire era of modernism, photography reappeared, finally to claim its inheritance. The appetite for photography in the past decade has been insatiable. Artists, critics, dealers, curators, and scholars have defected from their former pursuits to take up this enemy of painting. Photography may have been invented in 1839, but it was only discovered in the 1970s."[2] The new "museumization" of photography has involved forcing the medium to submit to norms of aesthetic discourse: the aura of the "rare" original, authorship, genre, and style—criteria of "high art." Recent exhibitions of photographs, Photographs Beget Photographs and The Art of Appropriation, explored the relations of photography to the copy and to the original.

Photography today is a dominant tool of visual production, transforming expediently and promiscuously all cultural usages without being captive to any of them. It is an impassive and malleable conductor of messages whether they are banal or disturbing, poetic or popular. In this sense, photography and its reproductive copying technologies (either mechanical or electronic) evade the traditional "aura" of the rare (and thus more valuable in the marketplace) artwork.

It has become the chief catalyst in rendering out-of-date many mythical and mystical notions about art, including originality as it refers to the aura of the one and only and "authorship" and "genius" as being more important than the real social value of art as a form of originality in communications. Photography in all its forms strongly participates in collapsing distinctions between private art and public art. This change is due to Postmodern conditions brought about by the unprecedented technologies for reproduc-

Figure 52. Richard Torchia, *La Reproduction Interdit ("Not to Be Reproduced")*, 1983
Color photocopy, 11″ × 17″.
Torchia appropriates through photocopying the Magritte mirror image *Not to Be Reproduced,* which shows the mysteriously deficient mirror that does not "copy" or reflect the face of the figure in front of it. This surprising lack leaves us in a quandary in the same manner as Torchia's punning repetition of the image—which is the copy and which is the original (which will not reproduce the original)?
(Courtesy Richard Torchia)

tion, representation, and communication, which are transforming the production, transmission, and consumption of images. These conditions have produced new consciousness and a new set of possibilities.

The photocopy machine—ever-present in all its many incarnations—has by now been usurped from its original function as a mere office tool to come into its own as one of the most ubiquitous aspects of art production of our time. Its power to make hundreds of copies per minute place it at the center of the Postmodern controversy about the copy and the original.

Copies and Originals: Deconstructing Modernism

The copier has become an access instrument for appropriating and reusing absorbed image references from the art of the past as well as new pop culture images. In a sense copier technology represents the act of appropriation itself and stands out as a site for the Postmodern because it addresses directly questions having to do with the copy and the original, authorship and originality.

How does the copy affect our ideas about the originality of the original? In a recent pun-filled lecture, art historian Linda Nochlin amusingly described the loss of an original painting by Courbet titled *The Origin of the World*. In her far-reaching search for the original painting, she encountered only photographic or photocopied records of its existence. Having exhausted all available leads, she was forced to admit that of the "original," only copies remain. In the case of a painting, a photocopy cannot be said to replace the aura of the physical presence of the painting. Yet media, which are rooted in mechanical multiple reproduction methods (such as prints and some sculpture) are imbued with an aura of their own precisely because of the conditions of their mechanical production. In the gallery or museum context, these prints and sculptures, when they are signed and supervised by the artist, are regarded as "originals" by virtue of their limited manufacture. But does this artificial distinction separate them from the idea of their being copies? Does the fact that they are copies lower their value as an aspect of cultural communication valuable to the society in which they were produced? We are now surrounded by reproductions of paintings printed in the millions of copies which help us to receive cultural messages from the past as well as from our own times. Although reproduction affects the physical "aura" of the original entity, it does not affect its value as communication. It only changes the object value as an "original," as property items to be bought and sold.

The use of the copy, reproductions of art historical references, is one of the new strategies of postmodern artists who are appropriating images and styles of the past to critique the conventions of art history itself—to

deconstruct or unmask the modernist notion that the "original" and "originality" rightfully dominate in assigning value to art. Sherrie Levine created an outstandingly radical critique of this aspect of modernity by rephotographing and thus "appropriating" in their entirety the works of other well-known artists (such as Walker Evans, Rodchenko or Mondrian) and by signing the fabricated copy. Her Neodada work created a sensation and forcibly brought the issue of the copy into strong focus. Paradoxically (both because her work aroused so much controversy and because of its special Postmodern relevance) it has been reproduced countless times, thus raising the market value of it as an "original" Sherry Levine work, which is about the copy of another original.

Suddenly in demand, she was recruited by the prestigious Mary Boone Gallery. In his July 26, 1987 *New York Times* article, "When Outs Are In, What's Up?," Andy Grundberg comments on the contradictions of Postmodernism, specifically the phenomenon of artists normally outside the mainstream becoming co-opted by it. Trends in acceptance of this "outsider" art "suggests shifts in the perception of what art should do." Mike Bidlo (another artist who, like Levine, appropriates other artists' work in order to critique the originality, authorship, and market system) has created an entire exhibition of Bidlo Picassos including *Guernica*, the *Gertrude Stein* portrait, and *Les Demoiselles d'Avignon*, which he showed at the Castelli gallery in January of 1988. When is a copy an original, and what is its market value in relation to the original? Bidlo and Levine challenge concepts such as the authenticity of the original, the primacy of the creative act, and the genius of the artist. Walter Benjamin provides an apt context for their efforts: "The criterion of authenticity ceased to be applicable to artistic production. Here the total function of art is reversed. Instead of being based on ritual, it begins to be based on another practice—politics." He is referring not only to the politics of the art world as an antiaesthetic, but to the methods of public consumption of the art itself and its penetration into the public domain through its reproduction.

Barbara Kruger (also represented by Mary Boone) is another artist who has chosen to raise ironic Postmodern issues about representation in relation to social constructs. She uses the copy and appropriation as the major site for her conceptually based work. Her strategy is to reproduce found images from published sources and to add texts to them. This forcefully raises issues which as she comments "attempt to ruin certain representations, to displace the subject and to welcome a female spectator into the audience of men." Kruger's media conscious work is at the intersection of mass media/mass culture in its nexus with high art, especially through her engagement with the copy and the politics of art. Her work is confrontational, agitational, and is aimed at destroying a certain order of representa-

Figure 53. Barbara Kruger, Untitled, 1987
Photographic silkscreen on vinyl, 110″ × 181″.
Barbara Kruger's images are elaborations of pre-existing images and are a comment on mass culture and reproduction as representation. She rephotographs and reformulates images to assign them different meaning by adding texts and other graphic elements.
(Courtesy Mary Boone Gallery, New York; Photo: Zindman Fremont)

tion: the glorification of the original which up to now has also been all male. "I want to deconstruct the notion of being a great artist," she says. Gender politics and how it relates to representational issues (and the heroics of Modernism) have become an important aspect of Postmodernism.

In answer to the present debate about the copy-of-the-copy-of-the-copy and its relation to the original as it pertains to the fabric of representation, Jean Baudrillard attempts the final synthesis: "Whereas representation tries to absorb simulation by interpreting it as false representation, simulation envelops the whole edifice of representation as itself a simulacrum."[3]

Use of Copier Technology Raises Fundamental Distinctions between Private Art and Public Art

The technological opportunity provided by the copier provides the unprecedented means for art to become inexpensive communication in the same way that records, books, and video are available to the public at large either through lending libraries or outright purchase or rental at reasonable cost.

Although copier prints can be produced as limited edition originals, signed and validated for sale in the art market in the same way as lithographs, etchings, screenprints, and woodcuts, they create a curious paradox. Unlike the usual print technologies where the original block, stone, plate, or screen matrix can be worn down in the production process, copiers (like photography) are inherently designed for endless reproducibility (through the agency of light and electricity) without damaging the original matrix.

Copiers can produce prints without end, costing only a few cents a piece—depending on the quality of the paper support employed, the cost of using the machine, and whether the copies are color or black-and-white. Thus they are prime participants in the larger debate about the value of a work of art in relation to its rarity or uniqueness (and thus its art market value) and its value as an art statement which has a different relationship to society. For example, a signed, numbered copier print may only be seen by a collector or by the museum-going public as opposed to its appearance on countless billboards in the streets, on subways, or on buses, sponsored by such organizations such as the Public Art Fund[4] or Art-Matters Inc. In the one case, the artist employs the copier to produce a limited number of "rare" prints which are signed as an edition; on the other, to consciously use the medium as an inexpensive production forum for ideas. In each case, the originality of the art statement is the same, as are the medium and the cultural value. However, the chosen method of distribution for the work creates fundamental distinctions between private art and public art in terms of its commodity value.

Think It—Have It

Since the 1950s—when photocopiers[5] began to overwhelm the modern office in a high-speed inflation of instant paper copies—they have become indispensable efficient slaves in every post office, library, pharmacy, and educational institution. They are an integral, characteristic aspect of everyday Postmodern life. From the start, artists have used copiers to experiment with the copier medium itself, to explore art ideas and concepts, to produce, and to go beyond their production of predictably uniform instant prints. Recently, a less costly generation of miniaturized copiers have begun to invade the private home and are often purchased as peripheral outputs to computers.

In the sixties, Andy Warhol deliberately appropriated existing popular mass-media photographic images and embraced industrial assembly line procedures for the production of his serial images as part of their overall style. He dubbed his studio "The Factory" and declared "If I paint this way, it's because I want to be a machine." Although Warhol's Neodada Pop stance was different from E.A.T.'s idealism about the use of technology, his attitude and use of business tools helped to validate them. The use of industrial and business tools (such as the copier) for art-making was thus pioneered.

Artists who began pioneering a partnership with copier machines came from a wide range of creative perspectives that included painting, printmaking, photography, video, film, conceptual art, artists' books, sculpture, and design. They accessed copiers in locations far from the context of an art-making environment—in the hostile commercial surroundings of offices, supermarkets, cigar stores. The equipment, financially beyond the reach of individuals at that time, could normally only be acquired by businesses on a rental basis. What excited them was the machine's very immediacy, its electronic instantaneousness (paralleled only by polaroid photography and the "real time" of video) in producing instant paper or acetate multiples—several prints each minute. It rivaled the "you-push-the-button-we-do-the-rest" claims of photography. However, its very optical differences from photography, in that it could reproduce text, images, and (foreshortened) objects only with a grainy, high-contrast, highly textured visual quality, created a unique new look or style very much in keeping with contemporary "information society" culture. The instantaneity of making a print is nearly as rapid as the thinking process itself, adding an important dimension of time to the creative act. The rapid electronic pulse of the machine provides instant gratification. It injects an element of spontaneous play and openness towards innovation.

As an imaging tool, the machine is a unique, electronic photographic

device with a fixed field (the glass image platen—normally 8½" × 11" to 11" × 17") and a shallow depth of field designed primarily for copying flat materials. Three-dimensional objects placed in contact with the glass platen are rendered sharply in defined detail with the focus diminishing in areas further from the glass, creating unusual illusory effects. Commenting on these characteristic imaging qualities, Pati Hill, pioneer copier artist, wrote: "It repeats my words perfectly as many times as I ask it to, but when I show it a hair curler it hands me back a spaceship, and when I show it the inside of a straw hat, it describes the eerie joys of a descent into a volcano."

David Hockney calls the collection of office copiers in his studio "magic new presses." In love with the fact that the copier is a camera as well as a printing machine, Hockney uses it to make extremely spontaneous prints as quickly as he can draw. He can vary the scale or the color toners and play all manner of technical tricks. In 1988 he produced a series of prints for a popular magazine (as a promotion for his major retrospective at the Metropolitan Museum) which he claimed were "originals" because he himself prepared the drawings, color separations, and printing plates for them.

On his copying machine he was able to personally prepare the color separations by creating a separate print for each of the three colors, cyan, magenta and yellow, and then print them in black to be used by the printer for the magazine offset reproduction printing system, which would produce 600,000 copies. Hockney engages the question of high and low dissemination of his art work—he thought of the magazine prints as being akin to "original" production of the copies. His wish was to provide each of the readers with an "original" copy—a form of private art for mass distribution.

The rapid feedback aspect of copiers allows the artist freedom to focus on the resolution of pictorial problems by evaluating the immediate result of their work as a fully realized print, and to make rapid corrections or additions both in terms of subject matter, color, composition, or pictorial effect whether through manipulating the machine or further changing the elements on the image platen. This rapid generation of successive images enhances the process of resolving solutions to visual concepts. Thus the working process is tied to that of thinking: a process of evaluation and selection is taking place directly which is similar to the critical analysis that occurs in photography, where skill of hand is replaced with skill and speed at manipulating the machine. The creative mind is set free to operate at an intense level.

However, working with a copier is fundamentally different than photography for several reasons. First, it allows for quick, inexpensive experiment with color and image manipulation in real time (without the lag time

Figure 54. David Hockney, *Black Plant on Table,* April, 1986
Photocopy print, 22″ × 25 1/2″.
David Hockney is attracted by the spontaneity and speed
involved in the copier printing process as a way of
bypassing the usual lengthy editioning process in making
conventional prints. He produces what he calls "Home
Made Prints." He creates separate drawn plates or
matrices for each of three colors, and then, by passing the
same paper through the copier several times, he is able
to create the whole print the way he wants it in a few
minutes. He has experimented with ways the machine
"sees" and has gradually discovered a repertoire of marks
and textures of his own that reproduce the way he wants
them to. He has used three different machines: the Canon
PC.25, the Canon NP 3525 and a Kodak Ektaprint 225F.
(Courtesy David Hockney)

required in photographic processing) using extremely diverse materials directly as a source of imagery. These materials include drawings, photographs, slides, objects, reproductions, computer and video imagery, and parts of the body—everything is reproducible to varying degrees depending on its flatness. In this sense, some artists regard the copier as a "pencil." Manipulations of the materials on the image platen itself can create a kind of "motion" image or "light painting" by taking advantage of the inherent structural vagaries of the machine's operating functions.

Secondly, it can be regarded as a sophisticated printmaking device which can literally copy anything, imparting special pictorial qualities in the process. As a result, it has been used extensively for directly imaging collage items placed on the platen or for the copying of items which are later collaged and possibly recopied. The copier promotes a special brand of aesthetic organization and a type of visual statement which grows out of the assemblage or collage of contradictory, diverse elements. The copier alters contextual relationships between images for surprising and unsettling effects as fresh visual metaphors for contemporary life. For example, Carl T. Chew's 1979 *George Eastman Hunting Elephant with Stamp* is an ironic commentary on Eastman as head of the Kodak empire reducing the "big game" to the small size of the photographic reproduction making it into a true commodity item. The frontier of the hunter becomes simply a reproduction—a postage stamp.

Color-in-Color: Artists Collaborate with Copier Designers and Engineers

Enthusiasm for a machine which could immediately render copies in full color attracted copier artist pioneer Sonia Sheridan, Professor at the Art Institute of Chicago, and Keith Smith to work with Dr. Douglas Dybvig, who headed the 3M Corporation team that developed the first full color copier in 1968. Invited to be official artist-in-residence at 3M, she helped research the creative potential and the color rendering capacities of the new machine. The "Color-in-Color" was advertised as capable of producing an 8½" × 11" full color dry copy in 60 seconds. Designed as a truly interactive, automated machine, it allowed for the alteration of color relationships, values, and densities on command and permitted the creation of 27 different color combinations from a single original.[6]

Due to their collaboration with the 3M engineers, Sheridan and Smith were given full access to equipment and materials in an effort by 3M to assess a wide audience and market for the machine's potential. The result was a "landmark body of copy art work that dissolved many of the preconceptions about the new process held by the industrial and artistic communities. Perhaps the most stunning example of this work was a two storey

Figure 55. Carl T. Chew, Portion of *George Eastman* Issue, 1979
Color photocopy, 9 1/2″ × 5 1/2″.
Chew combines drawing, painting, and sculpture with new technologies such as video, computer, and the photocopy machine. Perhaps best known for his witty simulated postage stamps created on the copier, Chew has brought the genre to a high level. The stamps, a form of miniature art, cover a variety of witty obsessions and topics interconnected by humorous narratives. Using the three-color Xerox 6500 to reproduce his works on perforated sheets, Chew sells the stamps in limited editions.
(Courtesy C. T. Chew)

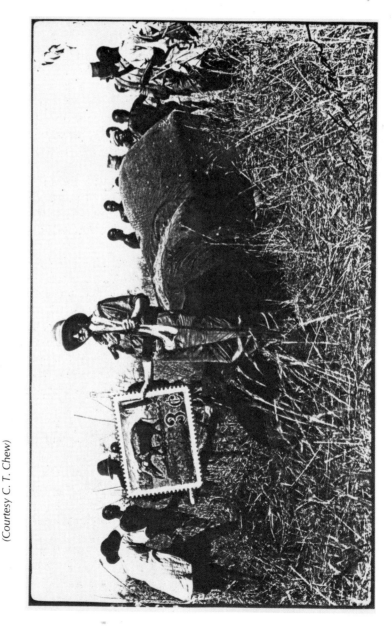

modular image of a human figure, generated part by part on the Color-in-Color copier, transferred to cloth, sewn together, and hung in the foyer of the Museum of Modern Art in New York, in 1974."[7]

Sheridan founded the Generative Systems Department at the School of the Art Institute of Chicago as a result of her extensive experience with copiers and other communications equipment such as the early Haloid copiers. Her program generated wide acceptance of the new technologies and was of inestimable value in the education of a new generation of artists with heightened awareness of the possibilities for new forms of representation offered by electronic tools. Sheridan had the vision to begin conceptualizing courses which went well beyond conventional visualization of objects in space, towards the need for space-time concepts as part of students' new orientation in the electronic age. To her courses, she added investigations of electrostatics, magnetics, heat, light, and sound. This program became the model for similar ones established in the late seventies by the Visual Studies Workshop in Rochester, the Tyler School of Art at Temple University in Philadelphia, and the Center for Advanced Visual Studies at MIT in Cambridge, Masachusetts.

Artists such as Joan Lyons, Esta Nesbitt, Pati Hill, Sonia Sheridan, and Bruno Munari saw the machine as a sophisticated experimental printmaking system for directly copying objects, drawings, photographs, newspaper, or magazine materials—anything reproducible in line with their artistic concerns. The potential of the machine for collage and heat transfer of copy to other surfaces—cloth, paper, wood, or plexiglass—led to three-dimensional sculptural works which transcended the small format of the machine by artists such as Catherine Jansen, Keith Smith, and Charlotte Brown.

Tom Norton's view of the machine was as a variety of real-time interactive performance instrument. By strapping a closed circuit T.V. tube facedown onto the Color-in-Color image platen, Norton was able to capture images of a live model posed in front of the video camera by pressing the copier button and manipulating the colors.

In 1973, Xerox first introduced its new color model, the 6500.[8] The Xerox 6500 could turn out a full color copy for two-thirds of the cost per copy in half the time and 3M began to phase out manufacture of the Color-in-Color. A more limited machine with fewer, less flexible controls, the 6500 uses the original electrostatic principles invented by Carlson, but used magenta, cyan, and yellow toners rather than black and replaced 3M's thermal transfer technology (a costly production method based on the use of colored foils). For artists, it offered the advantage of color permanence. The heat-fused laminated pigment toners of the Xerox machine do not fade,

unlike the fugitive dye colors of 3M color copies which tend to transmigrate through paper.

Copiers Have Changed the Way Artists Think and Work

Through experiment, artists challenged the copier to go farther, addressing it as an instrument that could be used as a new visual arts medium and tool and to press beyond the restrictions of its small office format style. This meant overcoming the stigma of using, for art-making, an automated coin-operated machine designed for use by unskilled operators to create "perfect copies every time."

Unique qualities which have a direct bearing on the development of style and attitude towards image making have arisen out of artists' expressive interaction with the copier. Because they were forced to access copiers in commercial locations, artists found it necessary to begin the extensive preplanning and conceptualizing of their creative projects in order to bring not only their process materials to the machine but also their well-worked-out concepts, like filmmakers scripting their productions and gaining access to their equipment mostly through commercial sources. Clear artistic ideas now became the most critical aspect of working with the new instant image-making tool. As artists, they interacted with the machine differently, bringing to it their heritage of visual ideas which could shift the use of the machine from its primary reproductive role in the commercial world to an expressive one in the arts. Some artists used the machine to comment directly on the dominant commercial system itself and the power relations inherent in the ownership of the machine.

Directly derived from their experiences with the machine, with no art historical precedents to draw from, they began to discover a new repertoire of methods, a new hierarchy of imagery, and new categories of art work within the discipline imposed by the small office format (8½″ × 11″; 11″ × 14″; 11″ × 17″) of the machine.

Figure 56. Sonia Landy Sheridan, *Hand,* 1976
Manual electrostatic image, 8 1/2″ × 11″.
This electrostatic image was created by Sonia Sheridan as part of an experimental series for a course, "Process I: An Art Studio Exploration of Energy—Manually, Mechanically, and Electronically," as a demonstration to her students of the simple principle involved in creating an electrostatic image. By placing her hand on a piece of paper and spraying around the edge of it with antistatic laundry spray, she created an area on the paper that would not attract charged magnetic copy machine particles (toner). When she sprinkled toner on the paper, it was attracted to the unsprayed areas only.
(Courtesy Sonia Sheridan)

Like the camera, where adjusting the controls and pressing the shutter button activates the image-recording mechanism, the electrostatic photo-copying machine is a democratic medium, where the distinctions between amateur and professional technical skills quickly become blurred. The difference lies in the ideas and intentions of the operator as to whether the resulting image copy embodies the authority and coherence of an aesthetic statement. Accessed by artists, the normative use of commercial automated devices such as copiers can be shifted, differentiated, and made to participate in a significantly new dialogue where mechanical equipment designed for copying can be used expressively to "move rapidly to the limits of ideas." The machine as a medium has become itself the subject matter of experimental work about its generative process.

Sonia Sheridan was one of the first artists to explore this aspect of the copier's own distinctive mark-making characteristics as an aspect of the copier as a medium. William Larson's artist's books use the sequenced aspect of this generative process with telling effect to create a chilling parody on the quality of degraded effects of information.

The Copier's Unique Effects Have Become Part of Style

Different from the continuous tone of photographs, the standard half-tone printed photographic reproduction, or the pixillated, striated pattern of video and computer visuals, copier images are high contrast and "have the distinctive surface texture that results from the patterns formed by static electricity and evenly distributed toner. Coated paper copies yield yet another surface texture, which is velvety.and can give rich, lustrous blacks."[9]

Figure 57. *(Top)* Tom Norton with Model and Video Input to 3M Color-in-Color Machine, 1975
As early as 1975, Norton was able to digitize and scan the image of a live model—he is shown here viewing the image on the monitor. He manipulated the image until it corresponded to his wishes. Then he placed the monitor with its image face down on the glass platen and made prints from it using the color controls of the 3M Color-in-Color copier to achieve a broad range of effects.
(Courtesy Tom Norton)

Figure 58. Michelle Zackheim Working with the Xerox 2080 Industrial Copying Machine to Create the Sections for *The Tent of Meeting*, 1983
Zackheim first made collages of images she wanted to use and enlarged them over 200%, finally copying them onto 26-inch × 12-foot long panels of 16-ounce waterproof, fireproof, mildew-proof canvas using a Xerox 2080 industrial copying machine. The images were then painted with acrylics and the panels sewn together to make the walls and roof of the tent. The tent hangs from a fiberglass frame rising to 13 feet in the center.
(Courtesy Michelle Zackheim)

Figure 59. Carl Toth, Untitled, 1983
Color photocopy assemblage, 17" × 26".
Carl Toth regards the copier machine as "a cross between a Polaroid camera
and a printing press as a vehicle for expanded vision. It is an exclusively
interior camera, the camera of the office and the library, its 'image' is one of
potentially infinite and perfect duplication." Part of his intentions in using
found objects—cameras, toys, pieces of junk, hardware and plywood—as still
life on the copier is to suggest a connection between the phenomenon of
photographic processes as a central part of the meaning/structure of his
collages. He arranges objects on the platen of the machine for copying and
manipulation. Curiously, the results are resonant of luxury items as represented
in catalogs or magazines.
(Courtesy Pace/MacGill Gallery, New York; Photo: Rick Webster)

Each copier offers slight but predictable variations in the quality of repro-
duction which can be exploited for special effect. For example, copy ma-
chine reproduction of three-dimensional still life objects is one of its unique
characteristics as a visual photocopy tool. The very limitations inherent in
the copier's reproductive process is often regarded as an attraction and as
a challenge rather than a disadvantage.

Others use it much more as a major enabling tool and general aid in
preparing their work as a whole (e.g., for simple reduction or enlargement
of their own drawings or reproductions from newspapers, books, or maga-
zines as references in the planning of collage works). Copiers are useful as
a way of incorporating many different elements into a cohesive whole in
image planning. Some artists copy their own drawings or paintings-in-pro-
gress as a record or as a way of freely experimenting with collaging of
elements. Often the copies are painted on, cut up, or realigned as a help in
making decisions about composition or color arrangement. Some artists
generate images onto acetate for use as color separation in photomechani-
cal color separations for printmaking works; others use the copies to transfer
images onto paper or fabric as the basis for further drawing or painting.

Copy Art Gains Acceptance

In the beginning, artists worked in isolation, unaware of other artists' sensi-
bilities and intentions towards using the machine. "Parallel trends devel-
oped, however, as unrelated artists simultaneously explored and experi-
mented with similar approaches, stylistic conventions and techniques."[10]
Gradually a network formed and critical reviews appeared. For example,
Untitled Nine (a publication of the Friends of Photography in Carmel, Cali-
fornia, edited by Peter Hunt Thompson) addressed some of the issues inher-
ent in copy art. Copier works were featured in major exhibitions: Color
Xerography, the Art Gallery of Ontario, Toronto, 1976; Energized
Artscience: Sonia Landy Sheridan, Museum of Science and Industry, Chi-
cago, 1978; Electroworks, a travelling exhibition originating at the Interna-
tional Museum of Photography, Rochester, 1979; Copy, Copy Art, a trav-
eling exhibition which toured Holland, 1979; Electra, Musée d'Art Mod-
erne, Paris, 1983; Copy-Art: Media Nova, Dijon, France, 1984; National
Copier Art Exhibition, Pratt Manhattan Center, New York, 1984; the New
Spirit of Photography, Marian Goodman Center, F.I.T., New York, 1985;
and the Second International Copy Art Exhibition, Cultural Center, Valencia,
Spain, 1988.

Looking back over the relatively short 25-year development of the
medium, and at the work of vast numbers who have used the copier as both
a tool and as a medium, some artists' copier works stand out as milestones

some people wo ns, some for
some for polit
humanitarian crisis, Massachusets
One of t Stu ls, earlier this
Democrat ied 93 C agressman to o-
month peri ution t would cut off
sponsor a re aid to Salvador on J
U.S. milita

Guerrillas near the besieged town of Suchitoto the corpse of a Sa
It's really a two-front war. One front is in T *ington, one in El* d soldier

osing Marxist-led guerrillas as a way to
end the Central American country's
three-year civil war: Shultz's reply: "The
guerrillas are busy upsetting people in T
Salvador, creating hell, shooting their w
around. They are responsible for the la
els of violence and difficulty in that cou-
try. If they want to take part in a civil
way in the activities of that country, t
are welcome to do that."

The exchange had an all too fan ar
ring. Once again a small but vocal nur
of U.S. legislators were expressing eir
skepticism at Reagan Administratic ol-
cy in El Salvador. Once again the Ac n-
istration was insisting that its comb tion
of support for electoral democrac ocial
reform and human rights, toget with
sizable doses of military aid ($20 illion
for fiscal 1983, $86 million pro sed for
1984), was the only solution the ould pre-
vent a Communist takeover.

The challenge to Admin tion poli-
cy was a minor but troubli ne. For the

grounds that the Rea
was mistaken in clim
been significant humai at there he
the country. Studd wh progressi
sonal conviction End oks from gr
Nam in the Salva ran ioes of le
The U.S. is facing tation. Saye
There's overwhelming into a corn
to the Administration lic opposi
icy

W heter or not t
gr onal tug e ministrati
lighted ei of the P neatly sp
tion's chit quemmas Admini ara
Democrat. Congre Salvador ays
mayer of nnsylvar h Peter est
alistic peri nist who self-style, t
of negotia ng with ports the sion
recognizes t the guerrilla but
their arms." also la nown
One front is a Wash two-fron war
vador. The A nin one i El Sal-
both fronts." ra n k ng on

Not really be

for their outstandingly innovative contributions, and have created genres of work unique to the copier. It is possible to locate some categories of work which characterize specific aspects of the copier medium itself. Categories include "light painting," generative works, direct imaging of objects, interactive works, bookworks, mural-sized installations, and mail art.

Esta Nesbitt was one of the first artists to create "light paintings" by manipulating reflective materials over the image platen to direct gestural sweeps of the machine's own light source back onto its imaging drum. She called the prints *Transcapsas*. Sonia Sheridan documented the visual disintegration that occurs when copies are generated from successive copies, coining the idea of generative works which break down the high-contrast image quality of copies into total abstraction of electronic toner patterns. Pati Hill's interests lay in imaging three-dimensional objects which she placed directly onto the platen for the special pictorial foreshortening characteristic of the copier's optical system. Her direct-imaging ideas were carried further by other artists who imaged parts of their bodies in the machine, or created a series of self-portraits, still lifes, or gestural performance prints, such as Dina Dar's important still-life work, Amal Abdenour's body prints, and Joan Lyons's portraits.

E.-F. Higgins III is one of the artists who have adopted the copier as a natural tool for his mail-art activities. Besides producing copier prints for the international mail-art movement ("the mail box is a museum"), he designs and prints his own fantasy stamps on gummed paper which he then perforates to add to the illusion. Mail art is a unique outgrowth of the copy-art phenomenon and promotes conceptual projects where copier postcards are mailed as part of the project's documentation. Mail-art networks have become international, connecting artists with each other and brings work directly to a broad public outside of the museum context. It is an inexpensive accessible form of communication which protests traditional art elitism

Figure 60. William Larson, *Two-Front War*, 1984
Color photocopy book, 13 1/2" × 8 1/2".
In this color photocopy book, William Larson plays with the concept of degraded information and how the original, when it has been copied successively from other copies, becomes broken down into an almost entirely abstract pattern, no longer recognizable as image or text. Through this process, Larson is able to suggest much larger issues involved in the concept of broken-down information.
(Courtesy William Larson)

Figure 61. Detail of *Two-Front War*
The detail shows image degeneration due to intentional successive copying of copies from copies. The image and text are now simple ciphers of the original visual and textual information. Torn edges of the paper add a further statement to the overall meaning.

Figure 62. Larry List, *An Excerpt from the History of the World*
Color photocopy print, 10 1/2″ × 17″.
The copier is a natural interactive tool for Larry List, who is interested in "making an art that suspends one in a state of flux between seeing and reading, questioning and answering." Image and words are combined in innovative graphic ways like a labyrinthian puzzle, underscoring their function as they overlay the image structure beneath. This layering of intentions creates an extremely intense bonding relationship between image and word. The photocopy machine is used as an integral, characteristic aspect of his Postmodern work. (*Courtesy Larry List*)

and makes a statement about art as communication. In the 1960s and 1970s, many mail-art exhibitions were organized in Canada and Europe. One of the most important of these was Image Bank, which originated in Toronto. More art pieces were added to it as it moved from city to city in its cross-Canada tour.

Making use of the copier's heat-transfer capability, a number of artists have created modular works combining many images on one sheet of rag paper or fabric by registering or sewing together individual transferred images. In 1981, Susan Kaprov created an enormous mural at the Brooklyn Museum with color photocopies transferred onto ragboard mounted on aluminum panels. In 1984, Michelle Zackheim exhibited her xerographic tent large enough to hold 150 people in Santa Fe. The tent was constructed of handpainted black and white print copied onto canvas using an architectural photocopy machine and dedicated to the Islamic, Judaic, and Christian cultures.

Popular applications of the copier include its use for conceptual works; two-dimensional and three-dimensional collage; artists' books; environmental sculpture and mural-sized works; transfers combined with drawing and hand coloring; animation; and as an extension to painting, drawing, and other media. Collage is a particularly strong aspect of emerging copier work when used for political commentary. Because the copier can produce seamless prints from collage items juxtaposed on the image platen, it has been extensively used as a medium for photomontage in a contemporary Neopop and Neodada spirit—but with the special pictorial qualities and style characteristic of copier imaging. The reproductive means copiers provide allows for the use of art reproductions as process materials for a commentary on the conventions of art history itself. Its use has now entered the mainstream as part of today's paraphernalia for art-making.[11]

Two artists, Peter Nagy and Joseph Nechvatal, have created works which particularly resonate with the Postmodern sensibility. Nagy's work appropriates established information to function as part of his intellectually skeptical fictions about current cultural affairs. By repackaging specific images to create a reinterpretation of cultural practice, he humorously subverts their meaning by assigning them to an impossibly fictitious art-history role. His use of the copy is part of his overall strategy to downplay the object value of his work. It remains as a form of information, its photocopy form, an aspect of its status as a cultural production.

Joseph Nechvatal uses the technology to comment on technology itself. His subject is how technology is encroaching on man's ability to control his own life and times. Nechvatal's *Informed Man* is bound and gagged by the verbal and information effluvia of his age which cover him and surround him. In the manifesto which accompanies this piece, he comments: "Infor-

PASSÉISME

mation technology is meant to make all of society run on time through control under the guise of benevolent connectednesss—it appeals to both external order (efficiency, hierarchy, security) and internal order (tiny compartmentalization, strict logic).''

The Artist as Publisher

Copiers are a vital aspect of the expanding limited edition artists' book movement, which originally drew strength from the Fluxus movement in the sixties and was fueled by the advent of the black-and-white and then the color copier machine. Artists' book productions play with sequencing of images and combine the graphic effects typical of copiers in a natural combination with textual materials. The book form allows an artist to explore sequenced images, ''a gallery of ideas,'' a record which lasts far longer than an exhibition and which possibly enjoys a wider audience. Text, image, and even acetate inserts can all be produced in appropriately sized format within a few minutes' operating time on the machine and then bound and distributed almost as rapidly using new automated copier peripherals.

Artists' book productions are often not only completely produced but also published with conventional copiers.[12] A range of excellent black-and-white copiers can now reproduce deep blacks and offer improved reproduction of photographic materials. The Xerox and Canon copiers offer full color while some copiers provide restricted access to color through the insertion of single color cartidges in the machine for special graphics effects.

Some artists' books produced on the copier achieve a high level of polish and sophistication, especially when the artist is fully involved in the presentation of material. In the realm of hand-bound presentations, Antonio Frasconi's superb Xerox-produced bookwork on Walt Whitman and his *Homage to Monet* are fine examples. Marilyn Rosenberg, Coco Gordon, and Susan Horwitz have also extended the use of the copier in their multiple works. Others, like Pat Courtney's *Persistent Stereotypes*, prepare the artwork for the book in a way which will make full use of the distinctively

Figure 63. Peter Nagy, *Passéisme*, 1983
 Black-and-white photocopy in unlimited edition, 11" × 8 1/2".
 In his photocopied rearrangements of history Nagy seems to be suggesting that it can now be seen as information with no linear connections. He places Stonehenge in the same context with Frank Lloyd Wright or arbitrarily assigns a particular artist with a piece of technology with erroneous dates—Duchamp with T.V. (1918); Kline with the video camera (1952); Matisse with the calculator (1907). The copier is ideal for his collage works, which he distributes as unlimited editions.
 (Courtesy Jay Gorney Modern Art, New York)

Figure 64. Joseph Nechvatal, *The Informed Man,* 1986
Computer/robotic–assisted Scanamural (acrylic on
canvas), 82" × 116".
In making the decision to enlarge his image to epic
proportions using the Scanamural process, Nechvatal
wanted to make a specific point in reference to *The
Informed Man,* a painting produced electronically that is
composed of degraded information patterns. The airbrush
guns that reproduce the image are guided by computer-
driven robotic arms fed with information derived from
scanning the original artwork (as a small transparency)
and enlarging it to 82" × 116" onto a canvas support.
*(Collection: Dannheisser Foundation; Courtesy Brooke
Alexander, New York; Photo: Ivan Dalla Tana)*

graphic style imparted by the copy machine as a graphic translation, but produce the work in quantity using offset lithography.

In March 1979, *Time* magazine quoted Marshall McLuhan's comment: "Caxton and Gutenberg enabled all men to become readers, Xerox has enabled all men to become publishers." In his essay, "The Author as Producer," Benjamin pointed out that with the accessibility and growth of reproduction technologies, everyman can now become a writer if not only through letters to the editor in the daily press, but also now through publishing opportunities made possible by advances in [electronic] technology. "For as literature gains in breadth what it loses in depth, so the distinction between author and public which the bourgeois press maintains by artificial means, is beginning to disappear." The new electronic publishing technologies open communications possibilities to artists which were never available to such an extent before. Worldwide instant distribution of images and text via the fax (telephone facsimile)[13] machine is creating another extremely important opening. This new freedom in communications lessens the amount of possible control over an individual's action and voice and brings the copier into a new realm as a public, democratic forum for art.

Copies, Originals, and Copyright

Due to the explosive growth of new technologies for electronic copying of all varieties of imagery and text, films, video, computer processed images, and software, more and more individuals and businesses have access to copying devices. Recent technical advances of a broad range of these devices has lowered their cost and they have now entered the mainstream consumer market for home use. For example, computers are normally sold with an accompanying low-cost printout device. More than one-half of U.S. households with color television are equipped with videocassette recorders (VCRs) and may also buy low-cost video to hardcopy machines to capture frames from television broadcasts or from rented videocassettes. The act of copying raises serious questions about the moral rights of those who produce original materials including artists, writers, filmmakers, software programmers, musicians, and choreographers. Complex copyright regulations have been enacted to legally protect the rights of creative artists.

First enacted in 1790, U.S. copyright law was extensively revised by Congress in 1976 in an attempt to keep pace with accelerated technological advance. The law implies control by the original creator, yet allows public access. It is designed to protect the artists' rights to profit from a work (and to prevent others from profiting from it at the artists' expense), to control the work, and to protect it from defamation and misuse. The law attempts to promote a working relationship between makers and consumers of art

Figure 65. Antonio Frasconi, *Max Ernst's Dream* Parts 1 and 2, 1981
Color photocopy book, each page 8 1/2" × 14" (extends to 70").
In referring to Max Ernst's various collage works created from appropriated nineteenth-century engravings, Frasconi appropriates in turn from Ernst via the color copier to create yet another illusion by experimenting with all the derivations of the color copier. Figures appear and disappear in what seems like layers of history and memory. Like Hockney or Frasconi, Ernst would no doubt dream of having his own copier as a studio printing press.
(Courtesy Antonio Frasconi)

Figure 66. Paul Zelevansky, *The Shadow Architecture at the Crossroads Annual 19—*, 1988
Offset book.
Zelevansky's complex work is made up of hundreds of pictures, signs, and symbols extracted from a variety of media—
advertisements, paintings, stamp catalogs, currency, handbills, textbooks, etc.—which form the environment and the
spatial structure of the plot for the city he is creating in book form. The photocopy machine plays a significant role in
distribution and placement of these images, providing the power to capture, compose, and decompose images or text.
Zelevansky has also produced an interactive computer book, *The Case for the Burial of Ancestors, Book Two*.
(*Courtesy Paul Zelevansky*)

where the common good is ultimately served—for both artists and the public feed one another's needs through public dissemination of the work where profit is not an issue.

Under the law's provisions, a creative artist (termed "author") "automatically comes into possession of a bundle of exclusive rights when an original work is fixed in a tangible, durable form. These rights, any or all of which an author may transfer, generally last the creator's lifetime, plus fifty years."[14] The rights to reproduce a work or prepare derivations of it (e.g., translations, posters, movie versions); to distribute copies by sale or other transfer of ownership such as rental, lease or lending; and to exhibit it publicly falls within the domain of original ownership by the artist (or his/ her executor) during this time period. A user must therefore seek direct permission and/or pay a fee for use of the material from the author/artist.

An infringement of a copyright—that is, violating one of the exclusive group of rights of the copyright owner by, for example, reproducing a copy of a work without permission—can be accomplished by using a copier or a VCR. This is just as serious an offense as reproducing a copyrighted oil painting or sculpture. However, exceptions in the copyright law provide for the concept of "fair use" and "first sale" as they relate to copiers and videocassette recording where consumers reproduce in the privacy of their homes or for extremely limited classroom use. The copyright law is violated if copies are sold without permission of the author/artist. The law hinges around private use as opposed to commercial exploitation. "When faced with new technologies, courts have tended to narrowly construe the exclusive rights of authors and inventors to encourage the free flow of ideas. The test seems to be always balancing the rights of society to have access to new ideas and technologies against the rights of copyright owners and inventors to exercise their statutory monopoly and receive maximum compensation."[15]

The Future

When Tom Norton placed his closed circuit T.V. screen on the image platen of a copier to make prints of a model posed before the nearby video camera, he was essentially foreshadowing the future. Recent developments in electronics improve on Norton's approach by, in effect, replacing the optical "front end" of the copier (the image platen, lamp, and lens) by a laser beam, inkjet, or thermal dot matrix scanner electronically controlled by the video camera and driven by computer graphics output mechanisms.

The challenge has now been met, to create low cost versions of electronic front end copiers for improved quality and high speed (100 copies per minute) in on-demand publishing (in black-and-white or color). This

Figure 67. Oliver Wasow, *Untitled #134*, 1983/86
Photograph from photocopy, 8 1/2″ × 11″.
Oliver Wasow operates on the edge of the copyright law
in the sense that he appropriates small segments of
advertising images and enlarges them to create entire
abstractions from their parts, often colorizing them in the
process of converting them to large photographic prints.
He uses the photocopy process frequently to work on his
appropriations. According to Wasow, this image is meant
"to function as a metaphor for inner and outer space. It's
'out there,' evocative of technological hardware and
architectural harmony, and 'in there' like a brain
synapse."
(Courtesy Josh Baer Gallery)

equipment is already becoming available to complement the familiar optical devices and to fully integrate the image-processing possibilities of computer and video with the copier's new generation of electronic printers and plotting devices. Canon, Xerox, Kodak, and others have recently announced fully integrated electronic laser printing systems which incorporate much speedier, higher quality black-and-white copying with special features, including more flexible reduction/enlargement and positive/negative functions as well as limited color using interchangeable color cartridges. Full-color laser printing is under rapid development.

The most major change apart from the new laser printers is the quickening development of a new range of "hard copy" devices for direct printing from computer graphics terminals and video screens (both color and black-and-white). Plotters and printers have existed for many years. Now these computer-driven outputs have been supplemented by an array of large format electrostatic, inkjet, and thermal transfer printers for full-color reproduction on wide beds—up to 70 inches. Since the paper for most of these is roller driven, the length of an image is determined only by roll length. Also available are new thermal video printer technologies which can reproduce—in full color—images from television or video/computer graphics monitors.

Xerox scientist Robert Gundlach suggests that improved speed and reproduction quality (particularly of laser technologies) will affect book publishing and seriously challenge the lower-cost conventional offset litho industry. Copiers will provide the capability of printing on-the-spot "on demand" entire books from a compact optical disk or from a microfiche the size of a playing card. Justification for this trend comes from savings in traditional printing, inventorying, and monitoring for reorders. Backlist and out-of-print books could be digitized and printed on demand. Many publishers are considering the release of materials in the form of compact optical disks which can store hundreds of megabytes of information. Users could then print out information as needed. Electronic storage systems seem appealing to libraries already running out of floor space. Such systems are about to revolutionize not only the printing industry, but the dissemination and use of information.

For artists, however, the 3M Architectural Painting Machine is the ultimate. It can read small photographic transparencies (35mm to 8" × 11") and reproduce them in monumental proportions (no smaller than 4' × 6') by means of four computer-driven robotized spray guns onto a variety of supports, including canvas. The machine produces airbrushed paintings of impressive scale and beauty. This machine is now used as an output by many artists who, like Joseph Nechvatal, are working with the computer as a medium.

5

The Computer as
Dynamic Imaging Tool

It appears that not since the invention of perspective (and its descendants in the optics of photography and film) or the appearance of movement in film through persistence of vision have we added such a powerful new tool to our culture. Perspective offered the analysis of space; film, the analysis of motion; and updated dynamic images, the analysis of abstract relationships.

Gene Youngblood

An Interface for High-Speed Visual Thinking

The modern digital computer's capacity for varying and combining programs; for testing and modifying vast quantities of information; for generating and combining digital sound, text, or imagery; and for storing and printing what it produces makes it, in the most important sense, the ultimate machine. It is a device which can be programmed to move, shuffle, receive, send, and test information. It can make decisions on the basis of tests or in response to if-or questions and perform long chains of activities based on any of the above command functions. Those who understand how to select a computer's commands and how to combine and interrelate the machine's corresponding actions are called programmers. Simple operators are called users.

The computer is the new tool, the new medium which links the concept of information and art together. The computer is about completely new aspects of image processing, simulation, control, fabrication, and interaction, and acts as an interface between other tools to expand or control their use. Due to the computer's complexity and its capability of being used for

Figure 68. Edward Keinholz, *The Friendly Grey Computer—Star
Gauge Model #54,* 1965
Mixed media, 40″ × 39 1/8″ × 24 1/2″.
Keinholz's Neodada piece makes use of popular folklore
about the computer as a wonder child, able to solve any
problem, answer any question. He is perhaps creating a
commentary about its human friendliness, as a joke about
the user-friendliness issue of a machine that must
accomplish all of its tasks through mathematical
calculations. His directions for its use advise us: "If you
know your computer well, you can tell when it's tired and
in a funky mood. If such a condition seems imminent,
turn rocker on for ten or twenty minutes. Your computer
will love it and work all the harder for you. Remember
that if you treat your computer well it will treat you well."
(Collection: Museum of Modern Art, New York)

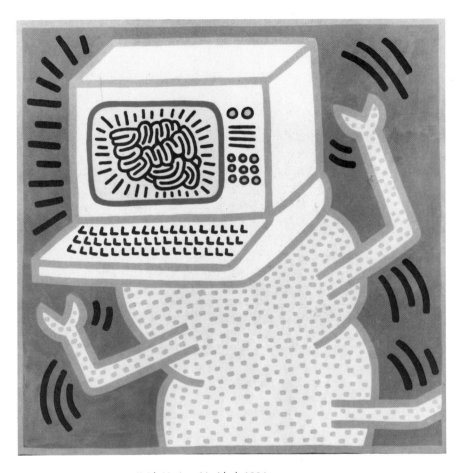

Figure 69. Keith Haring, Untitled, 1984
 Acrylic on canvas, 5' × 5'.
 *(Courtesy the Paul Maenz Gallery, Köln, and the Tony
 Shafrazi Gallery, New York; Photo: Ivan Dalla Tana)*

such diverse possibilities, it is a tool and a medium with its own built-in agenda. Electronic tools have a hidden point of view—far more complex than that built into a brush, printing press, or a camera.

In his May 1969 *Artforum* article "Computer Sculpture: Six Levels of Cybernetics,"[1] sculptor Robert Mallary analyzed the benefits of the computer as a tool for "high-speed visual thinking" in art-making and grouped them into two major categories: calculation functions (tools), and as an optimum creative interface between artist and machine. In the first grouping, the computer performs calculating chores to specify articulation of color and form, sorting out visual data on receding planes of objects in space. It adds stochastic randomness to a structured idea to test variable solutions and new proposals where speed and precision lessen the need for tedious work, thus making possible a new level of interactive decision-making. The relationship between artist and computer can be synergistic or symbiotic—for each depends on the other, and both do together what neither could do alone. However, at every step, the artist may veto and monopolize the decision-making process, accepting, rejecting, and modifying while prodding and coaching the machine in the right direction. Another aspect of calculation functions can lie in the area of programming the computer to move in a set way over a prescribed route according to a scenario of set commands which contain guidelines and criteria designed by the artist for making tests and permutations on an existing idea. Such research can be stored for future reference and further decision-making.

In the second context of artist-machine interaction, the computer begins to make decisions and generate productions even the artist cannot anticipate. At this level, all the contingencies have not been defined in advance. In fact, the program itself manufactures contingencies and instabilities and then proceeds to resolve unpredictable productions, not only out of random interventions (which dislocate and violate the structured features of the program) but out of the total character of the system itself, modifying and elaborating its own program. At this stage, there can be a redefinition of relationship between artist and machine—where the computer is alternatively slave, collaborator, or surrogate. The artist operates the machine, monitors it, or leaves it to its own resources. "He is active and passive; creator and consumer; participant and spectator; artist and critic." The computer can check against past performances of consensus criteria stored in its program file, for the heuristic[2] program embodies its artist's preferences. At this optimum creative level, the true synergistic potential of the artist-machine relationship can be achieved.

These prophetic understandings grew out of Mallary's research into the possibilities for kinetic sculpture and optics at the end of the decade of the sixties, although developments in computer science were still in their in-

fancy and few artists were able to gain access to computer labs to experiment and innovate. The prediction he made then is still true today, i.e., that the possibilities inherent in the relationship between new computational tools and artists provides a challenge which exceeds the "powers of contemporary imagination."

Harold Cohen, an internationally known British artist, has been involved with computers since his 1968 visit to the University of California, where he now teaches. Cohen thinks of the computer as an interface for the creation of his work—a collaborator, and an assistant in the drawing phase.

> I took to the computer like a duck takes to water. I didn't think of it at first in terms of art-making, just as a form of mental exercise. It stretched my brain. I was immediately taken by the curious sense that one could write programs that would appear to be thinking about things. They could make elaborate decisions about all kinds of matters . . . as an analogue for human intellectual activity. . . . I was never interested in art as simply making objects, but as a natural philosophy through which you find something out about the state of the world and your own self. Whatever art is, it's also a dialogue about the nature of art. . . . In order to write a program that draws indistinguishably from human drawing, for instance, you have to know something quite powerful about what human beings do, and know it in sophisticated detail. . . . Actually, it's built on a rather elaborate model not of art-making, but intelligent activity of a general nature—something like human associative memory. . . . It will become more creative in the carefully defined sense of being able to change the contents of its own memory—and consequently, its performance.[3]

Cohen's drawing program is what he terms a formal distillation of the rules and habits a human artist follows during the process of drawing. The computer sifts through these programmed rules and drives an artist-built drawing machine (called a "turtle") by steering it with separate commands.

Cohen's program instructs the turtle to be interested in such issues as spatial distribution, figure-ground relationships, and figure integrity (avoiding the drawing of one figure over another); and to be aware of "insideness" and "outsideness." Cohen has defined the rules for image-making, but because the rules combine and interact in a complex, dynamic way, the results are satisfyingly unpredictable. If both wheels of a turtle move at the same speed, the mechanism will go in a straight line; different ratios make it move in arcs. The changing location of the turtle's path is defined to the computer by sonar devices installed at two corners of the paper. The complex works contain closed and open figures, abstract asymmetric forms which resemble natural shapes like fish, stones, and clouds. The artist sometimes hand-colors the work. In 1983, the Tate Gallery in London and the Brooklyn Museum in New York both featured Cohen's mural-sized computer drawings.

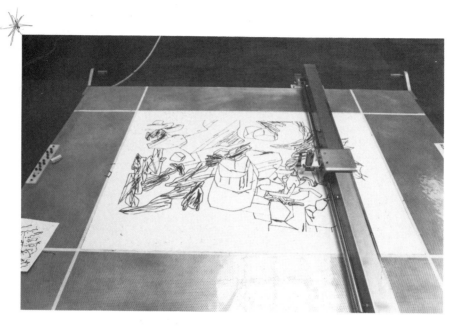

Figure 70. Harold Cohen, *Brooklyn Museum Installation*, 1983
 Drawing, India ink on paper, 22" × 30".
 The drawing turtle is an "adjunct" artist guided by a
 computer program designed by the artist, Harold Cohen,
 and used to generate drawings that investigate the
 cognitive principles that underlie visual representation.
 Called AARON, the knowledge-based program addresses
 fundamental questions—what do artists need to know
 concretely about the world in order to construct plausible
 representational objects? What kind of cognitive activity
 is involved in the making and reading of these?
 (Courtesy Robert A. Hendel; Photo: Linda Winters)

The Power of Memory

How do we see and how do we think? Development of computer technology has spurred a veritable avalanche of broad research to fathom these perplexing and fundamental riddles which until now have resisted solution. An April 1986 *New York Times* article by Daniel Goleman, "Investigations of the Brain Finding Clues to the Mind," drew together results of research by many scientists. For example, Harvard psychologist Kosslyn reports: "Picturing something in your mind involved at least four major mental acts. There is forming the image, fixing it in your mind, scanning it, and seeing it move in various ways." Mental acts entail conjuring up the parts of the image, interpreting their combinations, and seeking out the correct relations between them. These scanning, analyzing, and computing relations are all functions which are now part of computer technology. Goleman reports on

Overleaf and following page:

Figure 71. Manfred Mohr, *P-159/A*, 1973
 Plotter drawing (ink on paper), 24" × 24".
 Mohr's intense and imaginative investigations of the cube and its spatial relations
 have for many years been carried out through programming the computer and
 printing the results of his work using a plotter on paper or canvas. There is a
 rigorous, philosophic, aesthetic, and mathematical structure to which all of his
 work refers in its countless transformations and variations. In this early minimalist
 work, the process is revealed as Mohr uses the set of 12 straight lines required to
 create a cube in two dimensions. The cube's repertoire of 12 lines are assigned
 numerical values in order to unleash a compelling scheme of line arrangements,
 suggesting a form of movement and harmony. Mohr is a hybrid artist, at ease with
 both programming and visual innovation.
 (Courtesy Manfred Mohr)

Figure 72. (Top) Mark Wilson, *NACL 17(C)*, 1986
 Plotter drawing, acrylic on canvas, 44" × 84".
 Like Mohr, Wilson programs his own images and has experimented with different
 surfaces, such as paper and canvas, and with materials, ink, and paint as part of
 the output aspects of his work. Plotters are capable of executing intricate detail in
 multiple colors. Pens can be easily changed in the apparatus.
 (Courtesy Mark Wilson)

Figure 73. James Seawright, *Houseplants*, 1983
 Microcomputer-controlled kinetic sculpture, 2' H × 5' D.
 Houseplants is an interactive computer-controlled sculpture that can respond to
 changes in environmental light levels or follow preprogrammed patterns of
 movement. The "plants" open to reveal their LED studded "leaves," and the flip
 disks on the domed plant click open and shut creating a whirring sound. Seawright
 has been producing interactive works since the early seventies.
 (Courtesy James Seawright; Photo: Ralph Gabriner)

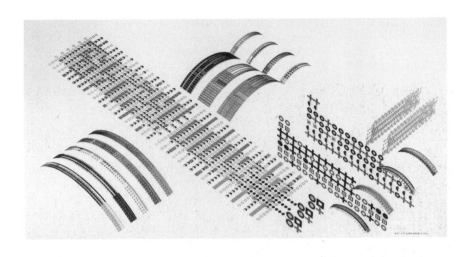

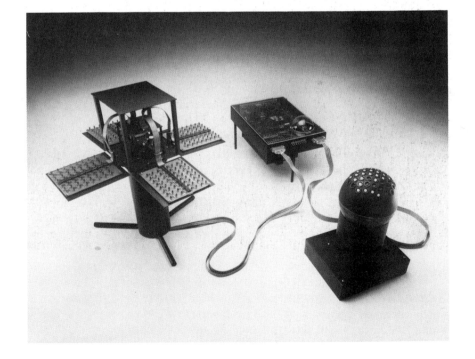

a book by cognitive psychologists Rumelhart and McClelland who propose that:

> What is stored in memory is not specific facts or events, but rather the relationship between the various aspects of those facts or events as they are encoded in groupings of neuronal cells or patterns of cell activity. For instance, a painting may be evoked in the mind as a collection of its parts—its colors and shapes—or as part of a genre rather than its details. Memory, then, is not so much a copy of the experience as the storage of the connections between aspects of experience. And, in this view, learning entails mastering the proper strengths of the connections between them. Knowledge accumulates by the progressive association of these connections, not by isolated impressions.

Thus meaning is a further dimension of the mind's operation which can only be achieved by creative association and insight.

Walter Benjamin saw human memory as a form of resource power much more tied to the deep personal psychological levels which form the basis of all our thinking, judgment, and—in the end—wisdom. Photography was closely allied to this view because photography allows us to activate memory. Yet memories can be conjured at will in the mind and are the basis for all meaning.

> Memory is not an instrument for exploring the past but its theater. It is the medium of past experience, as the ground is the medium in which dead cities lie interred. He who seeks to approach his own buried past must conduct himself like a man digging . . . he must not be afraid to return again and again to the same matter, to scatter it as one scatters earth, to turn it over as one turns over soil. For the matter itself is only a deposit, a stratum, which yields only to the most meticulous examination what constitutes the real treasures hidden within the earth. The images, severed from all earlier association that stand—like precious fragments or torsos in a collector's gallery—in the prosaic rooms of our later understanding.

If photography has always been part of the memory of time passing, offering records which can recoup and reconstruct important events to pin them down in history, then the computer offers a quantum jump in the potential to make us see and think. "What we see today is not what was seen even a decade ago, for the art of memory and the loss of history imply a remarkable shift in our perception whose special effects we are only beginning to discover."[4]

The amount of "memory" or "K" a computer contains in its operating system determines the degree of "information" of all kinds it can process at a given moment. Linked to the new theories of seeing and of the mind's functioning, the computer is becoming an active tool in storing in its *electronic* memory whole aspects of visual, textual, and sound simulations which can now be called up specifically with software commands for deci-

sion making to reveal what is to be seen. We can call forth and close down whole files of textual material or of pictures, depending on which software is placed in the computer.

Information thinking leads quite naturally also to the use of the computer for music (a music score is already coded information, as is text) and for combinations of sound, text, movement, animation, and combinations of imagery—opening unparalleled possibilities for aesthetic experience. Use of the computer linked to video and other outputs broaden aesthetic experience by expanding and altering our definitions of the genres of art through new aspects of integration.

The New Alphabet: Sound, Text, and Image as Digital Information

Information represents also a new mode of thinking and seeing and hearing. A digital alphabet where image, sound, and text can be addressed using the same numerical code can be generated by the on-off switches of the computer. This radically new capability is creating a major shift in publishing, in music composition, and in image production. Letters can be produced and printed by a system of digitized dots, musical notes can have a coded scale and intensity digitally assigned to them, and images can be created through a system of pixels or dots which have varying degrees of intensity. Hooked to an electronic synthesizer and the correct software, the sounds can be produced by a digitized program or by drawing directly on a monitor screen.

The computer can read electronically scanned (digital) information about a scene and transform it into numerical data which can be made visible as imagery. For example, light recorded by electronic digital impulses processed through a computer's mathematical algorithm (instead of a camera) can address a whole range of lights and darks—also essential "information" about a scene—and arrange them as a series of pixels or dots which together form discrete images on a video screen or which may be later printed on paper as varying sizes and intensities of dots via plotters, printers, or copiers. Once an image's "information" or light structure has been analyzed and digitized by the computer into its numerical data space, the lights and darks that make up the picture elements (as a series of pixels) can be controlled individually—altered, manipulated, weighted, warped, or repositioned to create not only a photographic simulation, but also a fake or synthetic reality[5]—for each pixel, or picture element, can be controlled. Each contains within it a complete range of lights and darks (or for color, a complete chromatic scale).

This new digital alphabet allows for combinations of all three important aspects of information—sound, image, and text—to be joined together in a

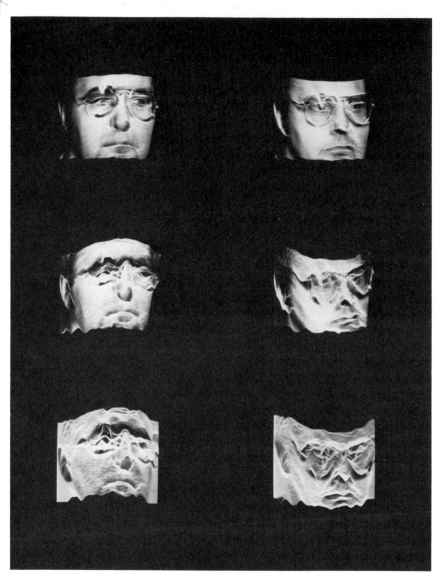

Figure 74. Woody Vasulka, *Number 6*
These visual investigations make use of the process of
scanning or digitizing the information about lights and
darks into the computer. The information is then altered
by a scan processer, an analog device, or other image-
processing equipment. Vasulka has played a pioneering
role in developing such image-processing tools.
(Courtesy Woody Vasulka)

completely new way, whose promise we are only beginning to fathom. It creates the moment, for example, for visual artists to become musicians or for musicians to become more interested in the visual. The computer allows for fusion between artistic forms to happen in an unprecedented and yet natural manner because all the information can be contained in a single tool or medium. (For example, software for drawing can be ejected and replaced by software for music.)

Electronic Representation and Seeing Goes Beyond Photography

The computer "sees" images digitally and records lights and darks of an image as "information." "Information" is part of a new form of global "seeing." Vast amounts of visual information about a particular subject or scene can be encoded via a computer-controlled video disk as a visual data base. For example, a landscape view could comprise sequences of satellite photos which first show aerial views of the coastline, then closer portions of the region, for example, a far view of New York City, a closer view of the pattern of streets, and finally isolation of individual buildings, with a tour of their rooms. Recently, Bill Viola, well-known video artist, referred to the effect:

> "What fascinated me," he said, "was that the progression was *not* a zoom or a blow-up. It's not as though they used four different lenses and made four different pictures. All the buildings in the close-up existed already in the global view because it's actually a computer data base and they're in the information so the image doesn't lose detail or become grainy when it's enlarged because it's computer enhanced. That's not zooming. You determine the scale of what you're seeing by processing information that's already there. Everything is encoded into the system and as a viewer or producer you just determine what part you're revealing."[6]

This new computer-enhanced "global information" vision, where a particular image or sequence of images can be called at will from the data bank, goes far beyond conventional photography. In its general effects, it resembles the struggle of consciousness where there is a dilemma about what we will choose from the flow of life to show as an important moment—what we ourselves are seeing and what we want others to see as meaningful. It operates, in a curious sense, like memory where we struggle to resurrect a version of the past to provide a context and perspective of history and received messages which have been enhanced by the process of total experience.

The computer is capable of producing these completely artificially processed simulations of visual material using numerical algorithms. This capability is at the heart of a revolution in image-making called digital

image processing. Although there is a tendency to "mystify" this new technological achievement as being beyond the realm of artistic representation, artists have, from earliest times, always been fascinated by mathematics and numerology.[7] Countless examples surround us of the geometrical and mathematical constructions of artistic practice apart from the formal geometries of perspective and the golden rectangle. Computer algorithms create ready access to finding new geometrical and numerical associations as part of representation.

Simulation of Artificial Images: Seeing Is No Longer Believing

Until recently, photographs were recognized as the epitome of a truthful reflection of "the real" seen as in a flawless mirror. A photograph (made up physically of tiny grains of blackened silver bromide emulsion or printed as halftone dots in conventional photomechanical reproductions) is actually, of course, an illusion of the "true." It is "information" about reality. In 1859 Baudelaire called photography art's most mortal enemy. At the time, most thought of photography as a way of recording information, not as a possible art form. Now we are aware that electronic photography is *truly* information—but of a different sort than that provided by conventional photography. It is information that can be stored, manipulated, warped in the computer to create images which are complete simulations—ones which have been processed or changed by manipulating or warping their structural light components, or pixels on the monitor screen.

For example, Nancy Burson challenges our ideas about the objectivity of photographic truth by creating computer-generated information "portraits" where programmed information statistics simulate seemingly photographic images to make a political point. In a series of "Warhead" portraits, she combines the faces of the leaders of countries possessing nuclear weapons, statistically weighted by the number of warheads at each leader's disposal. "What we have here, in short, is a powerful new tool for creating likenesses of what does not exist, or can only be imagined."[8] Burson's computer altered photographs can be termed a "simulacra" or artificially processed enhancement or dislocation of the real.

Burson[9] scans individual portraits for her composites into a computer by means of a television camera, encoding their images as digital information. Each of these images now consist of tiny pixels of information about the lights and darks which actually form the visual patterns of the individuals' faces, just as the tone patterns we see in newspapers are capable of representing the patterns of lights and darks of the printed images. The difference between them is that each pixel is not inert like a halftone dot.

Figure 75. Nancy Burson with David Kramlich and Richard Carling,
 Androgyny (Six Men and Six Women), 1982
 Simulated photograph, 8″ × 10″.
 In this composite image, the portraits of six men and six
 women have been scanned into the computer and fused
 into one simulated portrait. The work suggests the tension
 and fascination of "face value"—i.e., whether male or
 female characteristics predominate in a face. Yet,
 information simulation resonates with the impossible,
 revealing what refers to nothing, a ghostlike personality
 without real substance and history. Burson taps an
 important Postmodern vein in her subject matter and in
 her use of information as simulation.
 (Courtesy Nancy Burson)

Figure 76. Tom Leeser, *Indicted Invited,* 1988
 Simulated photograph, 30″ × 40″.
 Designed as 15-second color-video works, Leeser grabs
 at various disparate images produced by the electronic
 media and grafts them together with found language. In
 a kind of "media archaeology" the words and images are
 exhumed and then exhibited in a new context. The results
 of this process are visual puns that strike back at the
 original source with an irreverent voice. These words and
 images seem like dense core samples from a twentieth-
 century information base.
 (Courtesy Tom Leeser)

Rather, it contains a complete halftone scale which can be endlessly manipulated by the computer, and this changes relationships within the image.

Each of the scanned in images are adjusted as to size and format and then they are stacked and "averaged," stretched and warped in a complex program. When they are realigned, a conventional black-and-white photo is made up of the hybrid image on the screen.

Writing in the catalog for the Infotainment exhibition, George Trow writes:

> No wonder art has had another nervous breakdown: the invented image had been its specialty, its raison d'être ever since photography took over 'lifelike rendering' more than a century ago. Indeed, art's current crisis is analogous to that which occurred when photography was introduced, only now the crisis in art in Peter Nagy's words, has finally reached vision itself. The discovery that seeing is no longer believing is not so frightening when you consider that truth itself can only be leased. Show me the truth and I'll ask to see the out-takes.[10]

By the turn of the century, the computer will replace the camera, an eventuality which has profound implications both for art and for sociopolitical relations.

Information as Simulation: Living with Abstraction

The curator of the 1985 Les Immatériaux exhibition at Paris's Centre Georges Pompidou, Jean-François Lyotard, used the exhibition to provoke questions about contemporary states of artificiality and synthetic "nonbeing" which grow out of the instabilities and changes inherent in postindustrial society where the primacy of the manufactured object has been dissolved into other states of energy (or microelements) rather than into concrete matter: a "disappearance of the object" in favor of its artificial facsimile. The exhibition space designed as a labyrinthian tour of "sites" or hanging islands, each with a separate theme, interpreted and defined many of the major features of Postmodernity as a new moment in culture and offered a significant perspective on how the terms of our cultural conditions and their relation to historical and philosophical issues have brought about a crisis of outlook in the late twentieth century. "A series of key themes was brought forth and reiterated: the primacy of the model over the real, and of the conceived over the perceived. That we live in a world in which the relation between reality and representation is inverted was made clear by countless examples. Much attention was paid to the copy, to simulation, and to the artificiality of our culture. In fact, Les Immatériaux suggested nothing so much as our common fate in living with abstractions."[11] For example, completely artificial flavorings, fragrances, experiences—an in-

version of former experience of "the real thing" as part of new but artificial states. The exhibition's dramatically lit theatrical spaces, where suspended objects and images loomed out of the darkness, demonstrated the already pervasive artificiality of our present existence—for example, *Site of Simulated Aroma, Site of All the Copies, Site of the Shadow of Shadows, Site of the Indiscernables, Site of the Undiscoverable Surface.*

Lyotard comments on this major change in the relations between the Modern concept of mastery and production as opposed to the Postmodern:

> Whereas mechanical servants hitherto rendered services which were essentially 'physical,' automatons generated by computer science and electronics can now carry out mental operations. Various activities of the mind have consequently been mastered. . . . But in so doing . . . the new technology forces this project to reflect on itself. . . . It shows that man's mind, in its turn, is also part of the 'matter' it intends to master; that . . . matter can be organized in machines which, in comparison, may have the edge on the mind. Between mind and matter the relation is no longer one between an intelligent subject with a will of its own and an inert object.[12]

Due to current strong interest in the field of artificial intelligence and robotics, the mind itself is under study. There is now an especially strong impetus to understand its functioning more precisely. So far, it has been possible to imitate only the most primitive aspects of the human voice or of behavior.

The Postmodern self is transformed and atomized. It is seen as a multi-layered complex which represents a new diversity of understanding encompassing multiple heterogeneous personal domains sheared away from conscious life. This suggests that there is no one single platonic "truth," but many vantage points to experience—not one single truth, but only many aspects. This remarkable shift toward decentering personal perception (which has gradually taken place over the past decade) marks a new period whose special effects we are only beginning to discover. Its characteristics, for example, are like those brought on by the too-rapid consumption of information (as in T.V., newspapers, and magazines, where real events are homogenized and equalized for fast perusal) where the individual has lost the power to respond to any of the material he is consuming. The poet Archibald MacLeish warned as early as 1958 "We are deluged with facts, but we have lost, or are losing our human ability to *feel* them."

Early Years of Computing Images

Since computers had been developed originally[13] for solving scientific and engineering problems, it is not surprising that their use for producing digital sound and textual and visual images was initially limited only to those scientists who had access to the cumbersome mainframe machines located

in remote air-conditioned settings in university research labs. Because music scores and letter texts represent coded information, it was possible to program these into computer language as early as 1955. Composers such as Lejaren Hiller, Iannis Xenakis and Herbert Brun, working out of university labs, used the computer as a compositional tool. These early experiments opened the way for later extensive development of computer synthesizers as the popular musical instrument in use today.

By 1965, computer research into the simulation of visual phenomena had reached an important level, particularly at the Bell Labs in Murray Hill, New Jersey. Here the pioneer work of Bela Julesz, A. Michael Noll, Manfred Schroeder, Ken Knowlton, Leon Harmon, Frank Sinden, and E. E. Zajec led them to understand the computer's possibilities for visual representation and for art. That same year Noll and Julesz exhibited the results of their experiments at the Howard Wise Gallery, New York, concurrent with Georg Nees and Frieder Nake's exhibition of digital images at Galerie Niedlich, Stuttgart, Germany. Research in Germany at the Stuttgart Technische Universität was conducted under the influence of the philosopher Max Bense, who coined the terms "artificial art" and "generative aesthetics," terms which grew out of his interest in the mathematics of aesthetics.

Some of the earliest computer experiments related to art included the ones by A. Michael Noll in which he simulated existing paintings by Piet Mondrian and Bridget Riley in an effort to study existing style and composition in art. In approximating the Mondrian painting *Composition with Lines,* Noll created a digital version[14] with pseudo-random numbers.

An Artists' Tool Programmed by Artists

Although computer graphics research was, by the late sixties, being conducted internationally in the highly industrialized countries of Europe, North America, and in Japan, few artists had access to equipment or were trained in the specialized programming needed at that time to gain control over the machine for their work. Those artists' (primarily from the Neoconstructivist tradition) main interests lay in the modernist study of perception and the careful analysis of geometrically oriented abstract arrangements of line, form, and color rather than descriptive or elaborated painting. They were especially drawn to finding a means of researching their visual ideas on the machine and sought the collaboration of computer scientists and engineers as programmers.

Ken Knowlton, in his essay "Collaborations with Artists —A Programmer's Reflections," points to important differences in temperament and attitude between artists and programmers as a major difficulty. He describes artists as "perceptive, sensitive, impulsive, intuitive, alogical," and often

unable to say "why" they do things; whereas, programmers are "logical, inhibited, cautious, restrained, defensive, methodical ritualists" with layers of logical defenses which helps them to arrive at "why." Although these are obvious stereotypes, they illustrate the difficulty of finding in one person all the qualities which created that hybrid breed—an artist-programmer.

By the early seventies, a new generation of such artists began to emerge. For example, artist Manfred Mohr (self-taught in computer science) and Duane Palyka (with degrees in both fine arts and mathematics) began to program their own software as a result of frustration with existing programs and systems which did not serve their creative needs. "Hybrid" artists have since made important contributions to the field of visual simulation. Some have custom-designed paint systems and video interfaces for interactive graphics as well as working with robotics in sculpture. Following development of powerful new microprocessing chips, their work was simplified by the advent of microcomputer turnkey systems which freed them at last from large mainframe support.

By the mid-seventies, important advances in technology opened possibilities for the computer to become a truly personal tool for artists. The invention of the microprocessor and more powerful miniaturized transistor chips changed the size, price, and accessibility of computers dramatically. Commercial applications in design, television advertising, and special image processing effects in film and photography became an overnight billion dollar industry, providing the impetus for incredibly powerful image-generating systems.

The need for intimate collaboration between scientists and engineers with artists was no longer so essential, for custom "paint system software" and "image synthesizers" began to appear on the market. Programmed and developed by "hybrids" such as John Dunn (Easel, or Lumena Paint software), Dan Sandin (Z-Grass, a digital image processor), and Woody Vasulka (Digital Image Articulator) out of their own imperatives as artists, new interface software for the computer provides easy access to two-dimensional and three-dimensional image processing in combination with animation and video. As a result, artists may now come to the computer with their visual arts training intact, without the need to learn programming (in the same way that using a modern camera does not require full knowledge of optics). Learning to use a contemporary turnkey system is now comparable to a semester's course in lithography. However, programming is essential to any pioneering of new use of equipment. This need has led many artists to collaborate with engineers or scientists or to study computer sciences for themselves.

Computer Exhibitions Launched in the Spirit of Modernism

In the late 1960s a spate of exhibitions indicated the arrival of the computer as an artists' medium, and as a metaphor for modernity. All of these exhibitions focused to a greater or lesser degree on emerging electronic technologies, publicly questioning the relationship between computers and art. The 1968 I.C.A. exhibition Cybernetic Serendipity curated by Jasia Reichardt was the first major exhibition devoted entirely to computer applications for poetry, sound, sculpture, and graphics. "As its title suggests, this dizzying display of technology presented a paradisical vision of the capacity of the machine, and to this day it remains one of the central projections of a technological utopia based on the notion of modernization. Underlying it was the premise of 'technoscience' as a prosthetic, or aid to universal mastery; the cybernetic revolution appeared to accomplish man's aim of material transformation, of shaping the world in the image of himself. Cybernetic Serendipity was launched in the name of modernity, an ideal that, since the time of Descartes, has focused on the will and creative powers of the human subject."[15] In the catalogue which accompanied the exhibition to a further showing in Washington, Reichardt wrote: "Seen with all the prejudices of tradition and time, one cannot deny that the computer demonstrates a radical extension in art media and techniques. The possibilities inherent in the computer as a creative tool will do little to change those idioms of art which rely primarily on the dialogue between the artist, his ideas, and the canvas. They will, however, increase the scope of art and contribute to its diversity."

That same year Some More Beginnings at the Brooklyn Museum in tandem with Hultén's MOMA exhibition showed computer works, primarily kinetic sculptures which emphasized interactivity between optics, light, and motorized, controlled movement, such as those by Thomas Shannon, Jean Dupuy, and Hilary Harris. A witty attempt to humanize the computer was Edward Keinholz's motorized *The Friendly Grey Computer*. Hultén felt compelled to comment in his catalogue to The Machine show, that since the computer "is not capable of initiating concepts, it cannot be truly creative; it has no access to imagination, intuition and emotion."

In 1970, two further exhibitions, Software (at the Jewish Museum) and Information (at MOMA) opened in New York. Curated by sculptor Jack Burnham, Software: Information Technology; Its Meaning for Art explored "the effects of contemporary control and communication techniques in the hands of artists ... information processing systems, and their devices." Agnes Denes, Hans Haacke, Les Levine, Dennis Oppenheim were among the artists who explored use of computer concepts in their works. In his catalogue for Software, Burnham used the body-machine-controlled-by-the-

mind metaphor when he quipped "our bodies are hardware, our behavior, software."

Curated by Kynaston McShine, the Information exhibition demonstrated the concept of systems analysis and its implications for art. Information explored groups or networks of interacting structures and channels as a functionally interrelated means of communication. The computer was a natural metaphor for this exhibition. The use of computers in art grew out of existing Minimalist, Neoconstructivist, and Conceptual tendencies in the art world. This was one of the first exhibitions to espouse the reductive, Minimalist principles of Conceptual art where the idea is the total work (no object is produced).

The hostile response of the critics to the costly 1971 Art and Technology exhibition at the Los Angeles County Museum was a backlash against technological "corporate art" as it was termed. The Vietnam War and its aftermath of instability signaled a rupture with the waning of deterministic "Modernist" philosophical ideals and optimistic goals toward a unified future.

A broad range of sculptors interested in kinetics were particularly drawn to the computer both as an influence and as a tool. This group, which included Nicholas Schöffer, Nicholas Negroponte, James Seawright, Aldo Tambellini, Takis, and Otto Piene, used the computer to control and move their constructions. Some artists sought collaboration with scientists or engineers. In some cases the enthusiasm for "technoscience" made too little distinction for art between artistic imagination, scientific innovation, and technological experimentation.

The new cultural crisis called for revision of outworn categories and assumptions. New issues beckoned which up to then had existed only for the avant-garde. Existing "underground" tendencies toward a return of figuration in art (e.g., the Pop movement, video, and performance works) were taken up, resulting for example, in the Neorealist movement. "Postmodern" also became a current mainstream word for the return of melody and harmony in music and of pattern, narrative, decoration, Neoexpressionism, and political commentary in art—rich elements excluded for so long under the purist reductivism of Modernist theory and practice.

In the short 25-year history of computer use in the visual arts, the first 10 years ("first wave" 1965–75) was dominated by computer scientists with easy access to equipment. In the "second wave," significantly larger numbers of artists began to gain access and realize the potential benefit for their work. Many of these were interested in kinetics and interactive works. The computer in the early seventies, still cumbersome, outrageously costly with limited access for artists, still better used as an analytic tool for formal Modernist works rather than as an active partner, became stigmatized and

Figure 77. Otto Piene and Paul Earls, *Milwaukee Anemone,* 1978
 Mixed-media sky work.
 The figure depicts an inflatable flying sculpture by Otto
 Piene with outdoor laser projections by Paul Earls on
 steam emissions by Joan Brigham. Similar computer-
 controlled laser drawings have been used to produce a
 sky opera, *Icarus.*

receded into the background in the onrush of developments in art which now took place. This period represents the end of the first decade of the computer use in the arts. In the next decade, the continuing work of many pioneer artists probed at the fringe of the computer's potential, participated in developing new software tools, and made vital contributions in laying the foundation for future achievements.

New Potential Creates a Quickening of Interest

Although use of the computer by artists in the last 25 years has until recently brought the same rebuff by critics as early reactions to photography, the wide dispersal and greater access to greatly improved equipment for a far broader group of artists and to much more "friendly" technology has created important new conditions. More and more artists are gaining access to flexible and challenging ultrapowerful computer hardware and software at affordable prices (see the Appendix), and a new aesthetic is emerging as a broader range of artists come to the instrument with visual arts training rather than from computer science. It is always good artists who make good art.

The computer allows for rapid visualization of complex spatial concepts at a different level of conceptual decision-making and for ease in quickly cycling through color harmonies when making decisions about color composition. Pluralistically, applications for the computer open out important new avenues to art-making beyond rigid categories. Interactive environments enter an expanded realm where a different set of abstract relationships can be brought into play. Increased control of light, sound, and movement facilitate further developments in film, video, animation, and their crossovers into intermedia productions.

A growing tide of international exhibitions in galleries and museums demonstrate the quickening of interest in the computer's use for art. From East Village galleries of Manhattan (International with Monument, the New Math Gallery), to Soho (Metro pictures), to 57th St. (Tibor de Nagy Gallery), to New York Museums (the Whitney, International Center for Photography, the Bronx and Brooklyn Museums), recent exhibitions have included work that has begun to bear a mature, integrated stamp. At the Musée d'Art Moderne, Paris, the Electra exhibition in 1982 linked computer work both to kinetic art tradition and to interactive influences. Two Artware exhibitions curated by David Galloway have been exhibited at the Hanover Fair, which brought together European and American artists working in the field. The Immatériaux exhibition pointed to new directions and to new Postmodern issues inherent in the use of the computer as a reflection of the artificiality of technological life. A broad spectrum of countries including, for example,

England, Canada, Germany, Spain, Italy, Japan, and Mexico, have either originated exhibitions of computer-assisted art or have hosted traveling exhibitions such as the Siggraph Art Show.[16]

The National Endowment for the Arts, along with other state arts foundations around the country now include computer-generated works as a genre for funding. Artists' support groups are springing up, research in computer graphics and other applications is continuing at centers such as MIT's Center for Advanced Visual Studies and the New York Institute of Technology.

In general, the major museums have tended to acquire works which incorporate computer influence as part of their photography, video, and sculpture collections—works such as Jon Kessler's kinetic sculpture, Dara Birnbaum's video installations, and Jenny Holzer's computer-controlled electronic message-boards. These tend not to isolate the computer aspect of the art but, rather, to enhance its overall conception. Lucinda Furlong, associate curator of film and video at the Whitney Museum and one of three curators who juried the 1984 Emerging Expression Biennial: The Artist and the Computer exhibition at the Bronx Museum, finds a parallel between the development of photography and the computer as image processor: "People asked, 'How can it be art when there is mechanized production?' They rejected photography because they felt threatened."[17] William A. Rubin, former director of painting and sculpture at the Museum of Modern Art remarked: "The quality of the results is only as good as the person who uses this tool. The computer itself doesn't make art."[18]

The Issue Is Not Technology, But What the Artist Is Doing with It

A criticism often leveled at artists using the computer is that they rely on outdated ideas as Modernist ideas for their art. "Ironically, most of what is understood as 'computer art' today represents the computer in the service of those very same visual traditions which the rhetoric of new technology holds to be obsolete,"[19] i.e., that technology itself has produced Postmodernism. Yet some technologically oriented artists do not see the important issues which arise from the present conditions. Whenever artists begin working in a new medium, they initially mimic conventional visual antecedents as a point of departure. For example, early photography was informed by nineteenth-century painting and the first video works of the early seventies reflected issues in Modernism and were judged in the same category.

Gene Youngblood, well-known author and lecturer in the field of electronic art, takes the position that

Figure 78. George Dyens, *Big Bang II*, 1988
Sculptural installation with holograms, fiber optics, computerized lighting and sound.
Dyens's poetic vision unites many media while addressing issues that question a technological
civilization which seems to have fallen from grace. In locating the viewer somewhere between the
past and the future, he offers an experience of spiritual connections and room to "complete the roles
we play in a universal drama."
(Photo: Courtesy the Alternative Museum)

there is, in fact, no such thing as computer art. In the first place, art is always independent of the medium through which it is practised: the domain in which something is deemed to be art has nothing to do with how it was produced. . . . It is not paint that makes a painting art—even if the subject of the painting is painting itself. . . . The boundaries of computer art . . . are circumscribed by a much larger history—that of the fine arts tradition—which contains all visual art and defines its possibilities.

Questions as to whether "masterpieces" have yet been produced through the agency of the computer must be measured against its brief history in producing visual images with the greatest activity only in the last five years. It is too early to form such judgments, for the computer and its applications in art are still at the stage of experimentation and development and the full realization of its potential is yet to come. "Masterpieces" are winnowed out through cultural and historical processes which measure a work's significance through the perspective of time and the influence of the critics, the gallery system, and granting institutions. When the use of photographic imagery and processes were widely adopted by commercial designers early in the century, the fine arts reacted by moving into the realm of abstraction, taking up an antirealist posture. In a sense, widespread commercial use of photography tainted its use by artists for more than 100 years. The proliferation of computerized images in television and magazine advertising has a parallel in photographic history. Premature exhibitions of sometimes poor art work based on obsolete art issues, or work that is more technically than aesthetically interesting—lacking in artistic intention—has further stigmatized the computer as an imaging device and artistic collaborator.

The 1987/88 traveling exhibition, Digital Visions: Computers and Art, curated by Cynthia Goodman, originated at the Everson Museum in Syracuse and traveled to other museums including the IBM Gallery in New York. It was meant as a survey of works by artists over the past 25 years who have used the computer either as a direct tool for their work or as an influence. It included work by most of the medium's pioneers, among them Lillian Schwartz, Ken Knowlton, Ed Emshwiller, John Whitney, Charles Csuri, Manfred Mohr, Robert Mallary, and Otto Piene. The show is the largest and most recent of its kind—exhibitions which have served to introduce the computer as a site for art production. By including the work of Andy Warhol, David Hockney, Jennifer Bartlett, Jenny Holzer, Keith Haring, Howard Hodgkin, Les Levine, and Bruce Nauman, proof was established that the computer has entered the studios of mainstream artists. It has established for itself recognition as a medium in its own right and as an indispensable artists' tool for drawing and painting, with additional important applications in animation, and three-dimensional modeling. One of its most important applications is in its direct interface relationship to video.

Eloquent Testimony to New Perspectives

The contemporary technological base provided by the computer offers not only a tool and a medium which can be used for both conceiving and executing works of art, but it also opens a significant new window on the understanding of perception and the artistic process itself. Since there are no strong aesthetic directions—rather a multiplicity of applications—the following comments by artists from different disciplines in the visual arts are offered as testimony to their experiences with the computer as an artists' tool.

Vibeke Sorensen states that "It is like speaking a foreign language; at first one memorizes the words and struggles with the grammar, and after a while one begins to think and even dream in that language. I felt that I was fluent in synthesizerese."[20]

Charles Csuri writes: "I can use a well-known physical law as a point of departure, and then quite arbitrarily, I can change the numerical values, which essentially changes the reality. I can have light travel five times faster than the speed of light, and in a sense put myself in a position of creating my own personal science fiction."[21]

Terry Blum: "[It is] not merely a 'new tool' but a way of assimilating a new level of information by which to process ideas. It permits a new order of decision-making . . . [where] the data from one image [is used] to create the next. Spatial movement and dimension are contained within the boundaries of the structure, which itself exists as a unit in space." In this case, the computer is "a servant of ideas, an enabling mechanism" but one which has potential to allow the creation of complex new ways of doing things.

Hubert Hohn, a structuralist artist from Canada, thinks of the computer as the subject matter for his work. In *Untitled Binary Dump 1985* Hohn focuses his wall-sized installation of print-outs on the concept of machine memory vs. human memory. In his piece he "dumped" the contents of the Apple II computer memory as sixty-four art-historical references, e.g., *A Memory in Memory of Magritte; Its Artist Fails to Gain Access to the Proceedings Despite the Magnitude of His Contribution; The Machine Performs a Work by Its Artist; The Original of Its Reproduction; The Object of Its Criticism;* or *The Determined Machine Seeks Freewill through Self Deception.* The work took the form of patterns of information—black-and-white sequenced print-outs assembled as a complete wall project measuring 8' × 32'.

Jonathan Borofsky has used the computer to perform the different counting tasks that have been a major referent for his work as counting towards the concept of infinity in his daily diary entries.

Keith Haring became enamored of the computer during a special, partly government funded, New York University program in 1981. When asked if he felt limited by the paint software of the machine, he replied: "There is a sense of displacement. Your hands are on a keyboard, or you are holding an electric pen which separates you from the screen. There's no direct brush-to-canvas or ink-to-paper contact. This makes drawing on a computer a much more mental process than a tactile one. Still, as a technique, I find it just as interesting as drawing right on paper."[22]

Ed Paschke recently digitized into the computer many of the references he regularly uses in his work—images from film, T.V., newspapers, and magazines, and then animated them. He was able to create from this database many new images in the space of several days, a process which would normally have taken infinitely longer. Painters Gary Stephan and John Torreano see using the computer as part of their thinking and research process. Stephan would like to be able to experiment quickly with art ideas and be able to store the images for future reference in the computer's memory. "The notion of art is to deal with the unknown," says Torreano, who finds experience with the computer helps him the understand new psychological aspects of space for his *Universe* paintings. "The artist working alone with paint and canvas is symbolically the last of the Mohicans," he comments. "The extra input often helps you make a stronger artistic statement."[23] In 1982, his electronic work was displayed above New York's Times Square on its 20' × 40' computerized "Messages to the Public" Spectacolor billboard. The Public Art Fund is continuing to recruit well-known artists to create, with a computer programmer, animated works which can be repeated every 20 minutes.

The Message Is the Medium

Use of the Spectacolor Board changed Jenny Holzer's art. Using the Public Art Fund's concept of "Messages to the Public" for her computerized signs, Jenny Holzer makes use of computer technology to animate her aphorisms on topics such as anger, fear, violence, war, gender, religion, and politics. Her art, in the form of tersely written texts with iconic images embody conventional truisms but with a strong wry twist. For example, *What Urge Will Save Us Now that Sex Won't* has its moving image and text information equalized and written in raw color sign lights. Her work is intended as a form of communication with the public: "I try to make my art about what I am concerned with, which often tends to be survival. . . . My work has been designed to be stumbled across in the course of a person's daily life. I think it has the most impact when someone is just walking along, not thinking about anything in particular, and then finds these unusual statements either

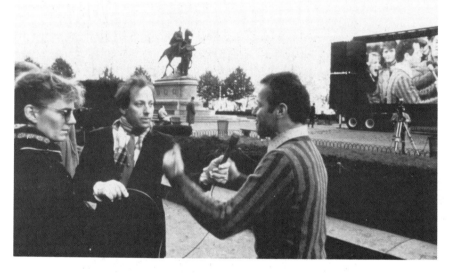

Figure 79. Jenny Holzer, *Sign on a Truck* Project, Grand Army Plaza,
New York, 1984
Holzer makes use of a Diamond Vision 2000 Mitsubishi
electronic lightboard mounted in a truck to interact with
the public during the 1984 election campaign.
*(Sponsored by the Public Art Fund. Courtesy Barbara
Gladstone Gallery, New York; Photo: Pelka Noble)*

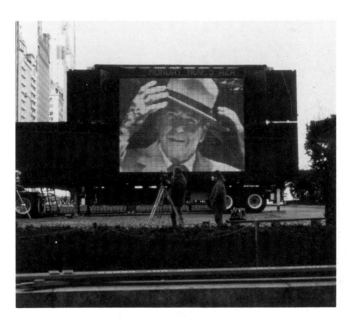

Figure 80. Jenny Holzer, View of *Sign on a Truck*
Interviews were interspersed with pretaped programs,
some by other artists, which were displayed on the truck.
Sign on a Truck has appeared also at the Pompidou
Center in Paris, 1987.

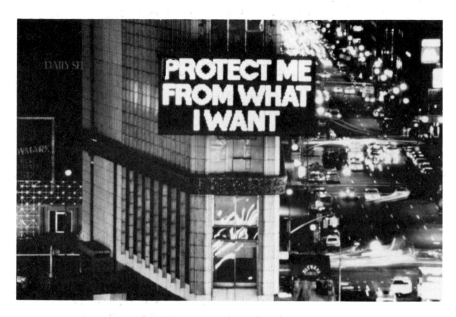

Figure 81. Jenny Holzer, *Protect Me from What I Want,* 1986
Electronic billboard, Spectacolor billboard over Times
Square, New York.
Influenced by her experience in creating messages for the
spectacolor board, Holzer went on to use electronic
signboards as a personal medium for her truisms. Holzer's
work speaks to many viewers because it uses the
commonplace to voice the subconscious. Holzer will
represent the U.S.A. at the 1990 Venice Biennale—the
first time an electronic-media artist has been so honored.
*(Sponsored by the Public Art Fund. Courtesy Barbara
Gladstone Gallery, New York)*

on a poster or a sign." Her work argues that art is an accessible language. If it is blended into a public environment through electronic means, the impact can be as profound as that of traditional media.

Following her first use of the computerized Spectacolor Board, Holzer began to use electronic message boards as a major medium of her own as her art work. Her programs for LED machines have various levels of complexity but have been seen around the world from Paris to Documenta and back on huge message boards and on mobile boards mounted on trucks. In the same public spirit as her electronic signs installation is her intention to buy 15-second blocks of commercial time on T.V. to feature her texts— which she will adapt for T.V. People buy her LED signs and objects but her art is not confined to the context of museums and galleries: it is out in the streets. Holzer resists the traditional notions of art as a rare and precious object. Her works are unsigned. They question power. Her words and voices make room for thoughts and feelings that people generally keep to themselves and that art has generally excluded.

The Computer as a Dynamic Partner with Interactive Potential

Possibilities for change in the relationship between the viewer and the art work has been affected by increasingly sophisticated interactive systems that control artworks which are capable of responding to the commands of each viewer. Creation is dependent on collaboration between the intelligent system designed by the artist and the actions of the participant which trigger causal relationships. The computer then perceives and interprets incoming information from the viewer and responds intelligently. Another type of interactivity is environmental—where the viewer's presence is monitored and sets up a pattern of interference triggering different aspects of a computer programmed display of lights or shapes which appear often on a large screen. Some of the most developed and interesting of these responsive environments are by Myron Kruger and Ed Tannenbaum. Christopher Janney has used installations with sound in his interactive works. Originally, interactive media grew out of developments in electronic computer games. Due to the popularity of "games," the early technology became so developed that many artists decided to use the concept of branched-out situations to involve the audience in a different kind of art experience. Jane Veeder, Nancy Burson, and Ed Tannenbaum have created different genres of interactive pieces. There are by now, many types of projects.

About Face is an outstanding example of an artist-designed interactive project created to capture the imagination of the public. Prepared by the Reuben H. Fleet Science Center, it is also an example of how many interactive works have originated in science museums like San Francisco's Explo-

ratorium rather than in fine arts institutions. So far, science museums show greater acceptance towards this new kind of public interactive work. The projects are designed so that visitors will become engaged in the exhibition to lose themselves by interacting with a variety of experiences related to the range of "information" communicated by the human face (e.g., when does a visual pattern become recognized as a face? or: is it easier to mask an expression of anger or one of surprise?). The viewer can choose from among many sites where their faces are scanned and digitized and then manipulated according to the software programmed by the artist. The exhibition draws on findings in the fields of anthropology and psychology. *About Face* deals with questions of identity and desire by allowing, for example, playful manipulation of programs which allows people to create their own computer self-portraits by inserting on their own face a nose, eye, forehead, etc. from famous prototypes.

Computer Controls

Possibilities opened up by the interactive videodisk technology engage Duchamp's concept that the artist begins the artwork and the witness completes it. Although first experiments in the use of interactive videodisks (where the viewer chooses various experiences branching from a range of predetermined solutions) have not yet been on a level of those that artists might pursue, the potential exists for more poetic, aesthetic use of this significant computer video medium. For example, the Architecture Machine Group at MIT has created a "movie map" of Boston which allows the viewer to interactively choose to travel down particular streets, enter se-

Figure 82. Ed Tannenbaum, *Recollections*, 1981
Interactive video sculpture.
Recollections takes the idea of motion in art a step beyond Marey's multiple exposures on a single frame, beyond conventional film and video by demanding viewer participation. If one remains immobile within its boundaries, only a single silhouette will appear on the large screen. The viewer must actively complete the piece by moving. Viewer movements directly affect the preprogrammed elements of the piece—color, dissolve patterns, and silhouette types—freeing them to create a wildly rhythmic panoply of color that moves in unison with the participant in quickly dissolving patterns. A black-and-white camera at the base of the video screen in the exhibit records the shadow cast by a participant on the retro-reflective screen behind the viewer. The shadow is processed by a computer programmed with eight to ten alternating modes. The processed image is then projected onto the video screen from behind. Besides programming and constructing video installations, Tannenbaum also plans live performances. His work has been seen in museums around the world.
(Courtesy Ed Tannenbaum)

lected buildings, zoom in on their contents and furthermore, to pick times of day or season of the year as part of the journey. All the global visual information for such an interactive movie is prerecorded as information in the computer database. The viewer decides which part to reveal.

Every one of the over 54,000 still-frame pictures on a videodisk can be assigned a number. This frame number can be coded along with the picture for the disk player to "read." By punching in selected programmed instruction key numbers, the machine will advance to those frames and hold them on pause for viewing and possibly propose textual multiple-choice questions for further selections. The machine would then reverse or advance to another frame, depending on choices made—and further opportunities for decision-making. Images do not lose detail or become grainy because they are computer enhanced.

At the Tsukuba Expo '85 in Japan, videodisk computer interactivity was taken a step further. NEC Pavilion audiences were given plastic boarding passes to insert into the computer terminals placed in front of every three seats. The concept presented was one of navigating a spaceship through typical hazards such as meteor showers and a black hole. Viewers could see the action via 27 giant 133-inch diagonal rear-screen video projections (announced as the world's largest video multiscreen system). A central computer hooked to laserdisk players totals up audience interactive response to questions listed on the 13-inch touch screen T.V.'s at each of the consoles. A total of 81 variations is possible. Color cameras hidden beside the computer consoles at each viewer station project unexpected sudden portraits of individual spectators on the big screens.

Lyn Hershman is one of the first artists to have taken interactive laser-disk technology beyond this type of science-fiction exploitation. Her project *Lorna* was produced by the Electronic Arts Archive, Texas Tech. It represents an important beginning artistic involvement with a potentially powerful interactive medium. Grahame Weinbren's and Roberta Friedman's complex interactive videodisk project *The Erl King* was chosen for the 1987 Whitney Museum Biennial. Based on Schubert's song of the same title ("*Der Erlkönig*"), it exploits new technology to shape a contemporary way of telling a story with images. It is a multidimensional narrative in which the viewer manipulates and reconstructs its images by touching the monitor's screen.

Quest for a New Realism: Reality Is Just a Test

At Siggraph and National Computer Graphics (NCGA) Conferences, bursts of audience applause hail each new visual and technical breakthrough towards reaching what can only be described as "naturalism" or "ability

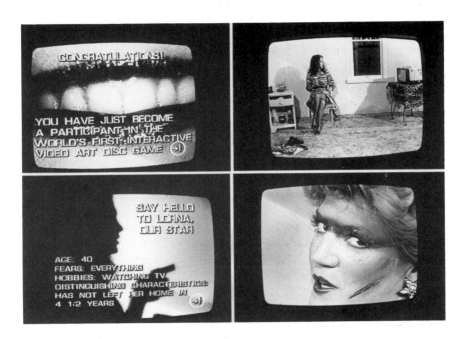

Figure 83. Lynn Hershman, *Lorna*, 1980–84
Interactive videodisk.
Hershman is attracted to the interactive-disk medium
because its branching-out possibilities provide for a more
intense way of dealing with reality and because of her
desire to actively involve her audience by empowering
them to self-direct the video screen. Lorna, her heroine,
suffers from agoraphobia (fear of open spaces) and hides
in her apartment, relating to the world only through
objects that make her neurosis worse: the television and
the phone. Viewers can choose various channels to
explore Lorna's options by accessing her possessions.
When touched on the screen, these open out individually
to comment on many issues—from women's rights to the
threat of nuclear war.
(Courtesy Lynn Hershman)

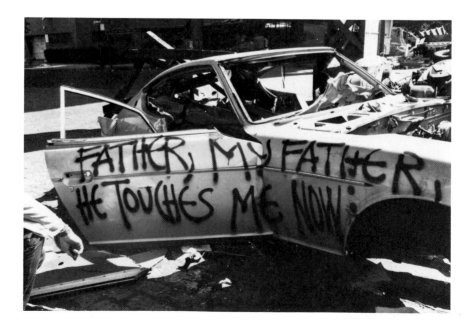

to simulate reality." The thrust towards forging an artificial reality (made by algorithms and programs) that is convincing as real is being approached seriously, with missionary zeal, as a major goal. The best computer scientists in the country are now analyzing how to make persuasive simulations of trees, clouds, water, reflections, transparencies, textures, shadowing. Their efforts are toward coaxing the perfect cloud, mountain, or shining goblet with reflections and shadows from the computer. Charles Csuri, head of Ohio State University's computer graphics group keeps a reproduction of *The Origin of Language* by René Magritte on his office wall. The image is of a huge rock suspended above a shimmering sea, surmounted by a soft cloud of the same size. "I bought that because it reminds me of what we cannot yet do realistically," he says. "Water, clouds, rock, . . . fire, smoke. These are the major problems in computer graphics now. Natural phenomena, things that change shape over time, and things that are soft."[24] The problems that artists have always faced in creating illusion—solving problems of rendering light, form, texture, and perspective, has now fully entered the computer realm of artificial simulation by mathematical algorithm. However, reality is vastly more complex than it seems. Scientists are devoting more attention than ever before to solving problems of vision and optics, color perception, perspective, and how to interpret textures such as softness and hardness. Computer research is pushing rapidly also into investigations of speech simulation and the workings of the mind as part of the study of artificial intelligence.

At IBM's Watson research center near New York, Benoit Mandelbrot, Shaun Lovejoy, and Richard Voss have generated persuasive computer imitations of landscapes and clouds. More than just pretty pictures, these

Figure 84. *(Top left)* Grahame Weinbren and Roberta Friedman, *The Erl King,* 1983–86 Interactive videodisk.

The technology involved in *The Erl King* is formidable. Three videodisk players are fitted with touch-sensitive monitors operated by a system of computerized infrared-ray signals with access to 30 minutes of visual material. Much of the material in the three videodisks is played back in slow motion and some in still frames. Each has two audio tracks that are used separately much of the time. Weinbren has remarked, "I think of *The Erl King* as a model of the conscious mind. You're wandering around someone's mind and go down a little path and see one of his memories. You take another path and see that person's desires. Another path will show you his beliefs, and another what he imagines. The medium is so incredibly rich. It's as different from the ordinary video as sound cinema was from silent movies."
(Courtesy Grahame Weinbren)

Figure 85. Detail of *The Erl King*

Figure 86. Detail of *The Erl King*

scenes are proof that the branch of mathematics they work with, called fractal geometry,[25] accurately describes the real world. They can create programs using real data that simulate the growth of what seem like real clouds, and in this way, obtain a better understanding for example of how real clouds do in fact grow.

> Nobody's quite got it yet. In every image there's something that's a little off: the vase that looks more like plastic than glass, the shadow that's too sharp-edged, the city streets that are too clean. They're all missing detail, the richness and irregularity that our eyes and brains crave. And the world of computer graphics is mostly static and rather lonely—a viewer may swoop over a seascape or whirl around bottles on a table, but no waves lap at the shore and no people sit at the table. It's all a matter of the right instructions. Computers, of course, can't do a thing without instructions. But it's hard to think up a routine of steps that automatically and randomly puts cracks in sidewalks or mimics the action of wind.[26]

A variety of simulation techniques called texture mapping, ray tracing, three-dimensional modeling, and figure animation interpolation, have grown out of this high-level research which puts mathematics at the service of the quest for the "new realism." Originally pursued on the multimillion dollar supercomputers like the Cray I, research results in some of these areas have gradually trickled down to materialize in specialized custom software programs now available for the more affordable middle-range ($20,000–$100,000) minicomputer. A tool of inestimable use for artists is the "image grabber" or digitizer, a video camera that can scan an existing image, object, or real-time event and convert its lights and darks into numbers that are stored within the computer.

One of the most formidable tasks the computer can accomplish is to simulate a three-dimensional shaded model. Once all the physical measurement information about the object has been fed into the computer's data bank, the object then materializes on the screen, can be rotated, skewed, made to zoom in and out of space in perspective, with a choice of where the light source originates. According to instructions, the computer will calculate the range of highlights and shadings which define an object (depending on the choice of light source), add appropriate shadows, and animate it in full color.

At Lucasfilm, the computer graphics team "has perfected the technique called procedural modeling, in which the computer is given the general characteristics of a class of objects and then makes many such objects, each unique. For example, the computer "grew" the flowering plants from a program that "knows" how a plant grows. Grass is simulated by providing the computer with information about range for the height and angle of the blade of grass and letting it draw different blades; fire is produced by telling

the computer the basic characteristics of a flame and letting it do the work. "Reality is just a test, like controls in an experiment. If you can make a convincing computer picture of a silk scarf falling on a wooden table, then you can make a convincing picture of a wooden scarf falling on a silk table."[27]

To create an image, the computer generates many tiny square picture elements called pixels. Each pixel has the capacity to generate a numerically controlled range of effects such as tone and color intensity. The computer can sort through all the instructions and models which describe the scene: its tone, color, optical laws—factoring out all the instructions, checking and sorting out what each piece the mosaic of pixels should represent. The more powerful the computer, the more image information the computer can process at greater speed. Images are commonly seen on televisionlike monitors composed of 525 lines of 525 pixels each, or 275,625 total pixels. This image resolution is extremely poor. To achieve equivalent smooth resolution of a 35mm film—about 3000 by 3000 or nine million pixels would be needed. Resolution this high needs special high resolution monitors and much more computer time. If it takes 30 minutes to create a 500 by 500 pixel picture, it could take 18 hours to create a 3000 by 3000 picture. The more complexity and resolution demanded of the computer to create more lifelike simulations with reflections, highlights, and the like, the more time the computer needs to make a picture. (See also the Appendix.)

Realization of the dream to recreate the real world by machine in all its infinite detail and variety is still far off, calling for more memory and faster computers to do millions of calculations simultaneously. This goal, the Mount Everest of computer scientists, is sure to occupy them into the twenty-first century. What does it mean for art? These new technological advances are creating profound changes in our general perception and relate directly to questions of representation and communication. The issue of artificial reality is bound to find its place in Postmodern attitudes and aesthetic theory and practice.

Recent advances in new computer chip development point to further miniaturization of equipment, adding to its lightness, its low cost, and its more sophisticated possibilities for integration with video. However, "state-of-the-art" pictures are created with the newest, most advanced large systems which can only be afforded by the military-industrial complex—government, industry, and commercial production facilities. Of all the electronic media, the computer most strongly represents the split between this "haves" power group and the "have not" artists. This distinction raises a question which has long plagued artists using electronic media—whether the aesthetic cutting edge need be tied to high-tech innovation. The problem of access to costly production and postproduction media technology is

a major political and economic one crucial to the independence of those artists who need to innovate and thus take risks for the sake of their artistic integrity.

Fusion: The Computer as a Tool for Expanding Art

The computer is a metaphor for Postmodernism itself in the sense that it makes possible a melding of genres where art forms become fused. Because it is a universal tool which can perform whatever tasks it is assigned (with the correct software commands as electronic signals), it is capable of eventually combining work in not only our major means of representation in the visual arts—video, photography, drawn, painted or sculpted forms—but all forms of communication: music, literature, and theater, leading to inter-arts crossover productions.

Information thinking leads quite naturally to the use of the computer for music (a music score is already coded information as is text) and for combinations of sound, text, movement, animation, and combinations of imagery—opening expanded possibilities for aesthetic experience. Use of the computer linked to video and other outputs alters our definitions of the genres of art by integrating them in a new way. It leads to a fusion of computer and video and to multimedia productions where the computer program operates the entire program (for example, the audiovisual, computer-controlled projection installation works of Richard Baim, Dorit Cypis, and Margot Lovejoy). Live performance, film, slide projections, and music are fused in the work of Robert Longo to convey commentary on power relations in society.

A fusion of media is to be found in the work of Gretchen Bender. The subject matter of her computer controlled video works is the media itself. Seeing television as a giant machine spewing out symbols, signs, and referents, image materials which have often been reprocessed and subjected to reprocessing, she confronts in her work the uncontrollable torrent of information by which we are surrounded. She asks the question about how an image, once having been absorbed into the undifferentiated flux of T.V., can also have meaning by being brought into a system of control imposed by the artist and then by the viewer in a process of critical awareness to be stabilized and experienced—in effect to remove it forcibly from its milieu for examination. Another system of control she implies, and uses in a practical sense, is in the technological reduction of all image components, signs, and referents, to a code which can be addressed by a computer and video system. Images which can be created, edited, controlled and manipulated digitally and reproduced for dissemination on a flat digital plane where all aspects of it are undifferentiated create a very different kind of fragmentation

from that of a Rauschenberg media collage. Her work often takes on the form of a multichannel video wall, sometimes with accompanying film loops as in *Total Recall*. Part of her strategy in commenting on our social and perceptual experience of watching television is to intensify this experience of watching, to create an ambiance of "overload" to force the viewer to extremes in the experiencing of fragmented, multiplied versions of it. Her fast flowing explosive collage full of swirling logos and frantic speeded-up movement, take advantage of new digital codes to address any part of any image (reminiscent of Maurice Denis's earlier comment about how a horse is a two-dimensional flat surface before it is a horse). The same digital impulse can act as a control for both image and sound.

The Computer Used for Public and Private Art

Les Levine has always used media tools for his work. He was one of the earliest artists to become fully identified with the use of video and the computer. Both a public and a private artist, Les Levine produces video projects and paintings and combinations which he exhibits regularly in major galleries and museums. However, a large part of his work is also devoted to reaching a much broader audience through his billboard projects which are sited in the flow of public urban life. Levine consciously decided to use mass advertising effects in his work to get attention for his messages. "Advertising style is the most effective means of communication of our time because it is specifically designed to capture the attention," he maintains. In the confusion and complexity of city streets, the eye is bombarded with thousands of messages and details and the spectator is a distracted onlooker.

Levine unites text with image with telling effect. For example, in a series of 20 billboards (10' × 21') installed at the ICA gallery in London simultaneously with their outdoor display in the streets of London, Derry, and then in Dublin, Levine uses the single word "god" with a verb, such as "kill," "create," "block," "torture," and "attack" (each followed by the word "god"). Levine's images are based on photographs. His billboards bring into focus the premise that the war in Northern Ireland, allegedly a religious war, is really open to the thought that the idea of killing anything is to kill god. He engages many different levels of response—political, religious, psychological, and deeply human. His use of technology is very simple in the sense that he uses, for example, a Fairlight CVI (Computer Video Instrument) for its ability to scan in and to manipulate the image and for its paint effects and textual applications. He then takes the color slide he produced from the monitor and projects it onto a large canvas for painting with an oil stick, or (as in the billboard) has it producd as a mammoth silkscreen print suitable for outdoor display. He has produced another series

Figure 87. Gretchen Bender, *Total Recall*, 1987
Electronic theater, 24 monitors, 3 film screens, 8 video channels.
Total Recall is meant as a critique of the optical overload in the media culture of today. Employing sophisticated editing effects to manipulate a powerful array of logos and images appropriated from T.V., Bender inquires into cultural desires and the techniques and seduction of media representation, and she investigates the networks of information-communication transfer. Bender uses the computer to control the video multiple-monitor performance film and synchronized installed effects. In this ambitious work, she bombards the viewer with high-speed images.
(Courtesy Gretchen Bender)

Figure 88.　Gretchen Bender, Diagram of Monitor Arrangements for *Total Recall*

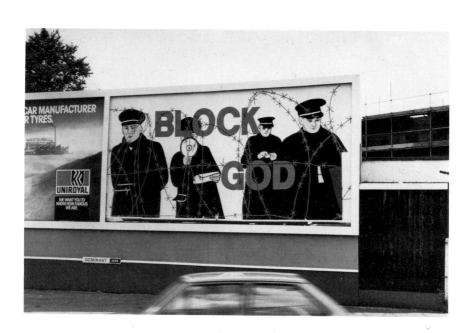

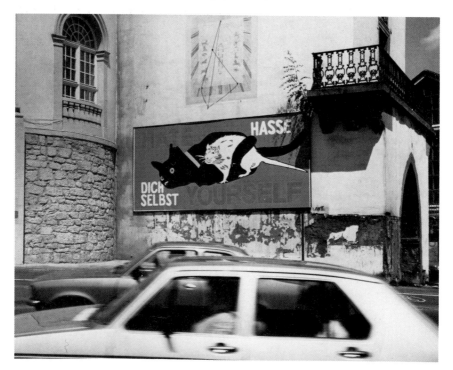

of 27 silkscreen billboards ("Create Yourself;" "Free Yourself;" "Forgive Yourself") for the 1987 Documenta exhibition. Levine's concept for the Spectacolor Board series (1985) programmed into the computerized board controlling the hundreds of lights blinking above Times Square used single words which used the imperative verb alone. These verbs—"cheat," "hate," "kill," "lie," "starve," and "steal"—resonated in the charged, highly commercial setting of the Square where the blinking messages compete with so much other information. The piece suggested that this very media-surrounded environment tends to reinforce or even promote those kinds of behavior. Levine's words and images investigate the very gap between the two in order to form a question. His intention is to force the viewer to think by raising questions which he does not attempt to answer. "Levine emphasizes the ideas that art can examine anything in the world and that art is permissive in that it is a means to empower or permit people to engage in new attitudes."[28] In his works, the gap in the relationship between image and text is the palpable questioning relationship with the viewer that Levine believes to be central to his work. For he wants the viewer to give his own definition to the question, to find his own meaning raised by that gap. Levine designed the question to work at many levels so that the investigation would demand a response which keeps on resonating in the mind—similar in character to the power of an advertising message which cleverly hooks itself by its own form of power to the consciousness of a distracted public which does not want to be bothered but is nonetheless a participant in the circuit of desire which is part of the way we inhabit the present.

Figure 89.　*(Top)* Les Levine, *Block God,* 1985
　　　　　　Silkscreen billboard, installed in London, Dublin, and Derry.
　　　　　　(Courtesy Les Levine)

Figure 90.　Les Levine, *Hate Yourself,* 1987
　　　　　　Silkscreen billboard, installed in Kassel, Germany, during the Documenta 8
　　　　　　exhibition.
　　　　　　Levine's use of computers grew out of his earlier engagement with video as an
　　　　　　integral part of his art-making process. In these "computer-assisted" billboard
　　　　　　prints, Levine uses the Fairlight CVI (a computer video instrument), which allows
　　　　　　him to create special effects by painting video images through an image-
　　　　　　modification process. In his working process, he scans in his drawings or
　　　　　　photographs, manipulates or "paints" them, and alters their coloration or
　　　　　　composition. He may add textual material. He can then work from the monitor
　　　　　　to create the color separations for the billboard projects or project the image
　　　　　　large-scale to do further drawing.
　　　　　　(Courtesy Les Levine)

The level of discourse and the control and direction of the creative process is essentially the artist's task. However, the new media are revealing connections and meanings which were hidden until now and are expanding the possibilities for art.

The poem within the image reads:

a sparrow flew past my head was swimming
weather fell the peonies
filled with memories
that day i took a walk down to lilacs blooming
for some silence
out to hear
the wind blew through the trees i quickened my pace
the wind was bitter
bent
stopped thoughts about us being together still
at the flower bed
of you
apart
the fragrance bending the limbs
was heavy

i looked up for you
and down

Figure 91. Keith Smith, *Overcast—Book 112,* 1986
 Computer-assisted offset book, 112 pages.
 Recently, Smith began using the computer to assist in the
 design and production of his self-published bookworks
 because he is able to combine text, image, and graphic
 layout so easily. The grainy, graphic patterns that make
 up the image are typical of the software program of the
 Macintosh computer. The Macintosh has proven to be
 very flexible and interesting for artists who use the
 bookwork form.
 (Courtesy Keith Smith)

Figure 92. Adele Shtern, *Love,* 1987
Laserprint scanned from drawing.
Using her original drawings as source material, Shtern
scans them into the computer using MacVision software
and manipulates the images, playing with their tonal
range and using all the possibilities for image
modification offered by the software package. She then
prints the work with a laser printer, which provides
extreme sharpness and clarity to the beautiful range of
graphic dot textures in the image translation.
(Courtesy Adele Shtern)

Figure 93. Warren Lehrer, *GRRRHHHH, A Study of Social Patterns,*
1987
Offset computer-assisted book, 7″ × 7 1/2″.
In *GRRRHHHH,* Lehrer animates the imaginary,
pseudomythological creatures suggested by the tapestry
designs of his collaborator Sandra Brownlee/Ramsdale
and the chants of Dennis Bernstein. To produce this work,
Lehrer scanned copies of the weaving into an Artron 2000
computer, transforming the tapestry warp and weft into
pixels which could then be stretched, copied, spliced,
enhanced, sliced, and generally painted and drawn upon
in the computer to create the necessary page alignments,
color separations, and drawings that make up this rich
visual book. It was printed offset in opaque, transluscent,
metallic, and iridescent inks.
(Courtesy Warren Lehrer)

Figure 94. Paul Berger, *Print-Out* (Detail), 1986
Multiple print from digital photographic information,
18 5/8" × 14".
This detail is from a larger installation in which
photocopied lists of database entries create a background
to photographs. The photographs are portraits of the men
who inhabit the world of business graphics. Paul Berger
consistently uses information in text and image for the
basis of his bookworks. The database lists create a
network or "web of information." The photographs are
"enlargements" from these videotape lists. The
photograph begins as a digital frame grab printed out on
a dot matrix printer, photocopied, airbrushed, and
rephotographed as a multiple exposure.
(Courtesy Paul Berger)

6

Video: New Time Art

In the past, art was 3D and 2D and didn't deal with time. Visual artists need to deal with time components—and that means video.

<div align="right">Nam June Paik</div>

Art is not the reflection of reality, it is the reality of that reflection.

<div align="right">Jean-Luc Godard</div>

Video, A Transmitter/Receiver Time Medium

When Nam June Paik and Wolf Vostell began using T.V. sets as part of their Neodada assemblage combines, they were influenced not only by tendencies in the art of their times but also by commercial television. They were part of the first generation to grow up with T.V. Their machine collages using readymade T.V. sets were meant to comment on and subvert the presence of television as a mass culture icon by placing it out of context in an art gallery. They playfully demystified its "invisible" broadcast technology by experimenting with the medium's scanning components. Paik's machine collages with their unexpected electronic effects were first exhibited at the Galerie Parnasse in Wuppertal, Germany in 1963. That same year Vostell was displaying his brand of partially demolished T.V. collage works at New York's Smolin Gallery.

In 1965, the first video camera/recorder, Portapak, was released in New York by the Sony Corporation. Although the early equipment was relatively heavy and its black and white 1/2-inch image quality poor (not NTSC broadcast quality) and there was no editing equipment, it provided the first access to the potential creative use of video as an artist's T.V. medium. Until then, video equipment existed only as enormously expen-

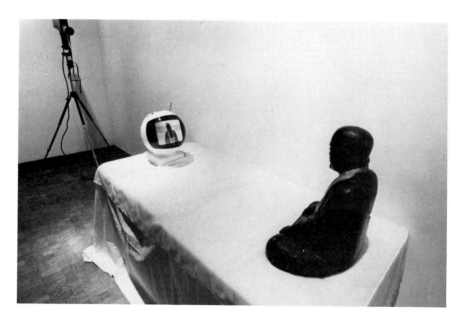

Figure 95. Nam June Paik, *TV Buddha,* 1974
Video installation.
Paik's *TV Buddha* represents an important early phase of
experimentation in video feedback in which the self-
reflexivity of the transmission technology of the camera
was exploited in various ways. The camera focused on a
point which could then be seen on a monitor. In this
piece, Paik captures the playful yet ironic distance that
exists between the mindless technological stare of the
T.V. monitor and the Buddha's contemplative gaze.
(Photo: Peter Moore)

sive, cumbersome television-camera-and-broadcast-apparatus restricted to use within tightly controlled broadcast transmission facilities.

In the sixties, Fluxus performance events and Happenings in Europe and the United States (organized by artists such as Allan Kaprow, Robert Whitman, Jim Dine, and Claes Oldenburg under the strong influence of John Cage and Marcel Duchamp) created a different climate of aesthetic ideas which laid the basis for artists' attraction to video as a medium. Traditional boundaries in the arts shifted to include broad new genres where the focus was on art as idea, art as a process—performance, environmental sculptures, street theater, conceptual projects—rather than art as a materialized, unique object. By that time too, the pervasive influence of broadcast television itself had also strongly contributed to new cultural assumptions and attitudes. Plugged into almost every living room of the industrialized world, television began to change the way people saw, thought, and lived. It soon surpassed the influence of the printed word, radio, and cinema with its power to intensely communicate and influence the public mind-set.

The very nature of the video medium attracted the attention of a diverse interdisciplinary group of artists who saw the potential for the new Portapak technology as a unique possibility for exploring ideas and creating new relationships within their work. They were attracted to video technology for the same reasons as earlier artists used film (Léger, Man Ray, Moholy-Nagy) as an outgrowth of their continuing projects in painting, sculpture, and a range of conceptual practices. They came from such aesthetically different fields as painting, sculpture, independent film, photography, music, performance, dance, and theatre. Nam June Paik, Wolf Vostell, Vito Acconci, Dan Graham, Bruce Nauman, Chris Burden, Lawrence Weiner, Peter Campus, Les Levine, Frank Gillette, Richard Serra, Nancy Holt, Juan Downey, Ira Schneider, Beryl Korot, and many others pioneered development of video as a "crossover" art form. They worked within the context of the art world and were thus drawn to the conceptual aspects of the medium. Their broad interests helped shape and elaborate it.

The unique electronic recording capability of video provides immediate "live" feedback in seeing moving images recorded by the camera directly on a T.V. monitor screen. Unlike film technology, there is no processing lag time in seeing what has been captured by the camera, and images are stored on inexpensive video cassettes which can be erased and reused. Video is capable not only of recording images, but of immediately transmitting them in closed-circuit systems on multiple monitors (or for long distance transmission of its signal via cable or on the public airwaves). Part of the strong attraction of the video Portapak was its flexibility and ease of operation in the studio or outdoors without the need for special crews or operators. In their studios, artists could direct the camera at themselves to

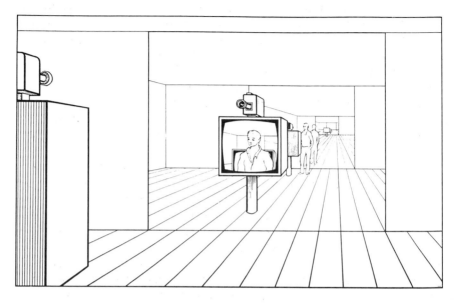

Figure 96. Dan Graham, *Opposing Mirrors and Video Monitors on Time Delay,* 1974
Installation diagram showing position of mirrors, T.V. monitors, T.V. cameras and recording decks.
Graham was one of the first video artists to fully explore the relation between video and the process of viewing and being viewed; between architecture, illusionary space, and the "time-present" transmission aspects of the medium. In this early experiment of time delay, he pointed the video camera mounted on monitors at opposing mirrors. The viewer became involved in a fascinating experience of illusion and perception. Interaction with the viewer in a closed space was important. The length of the mirrors and their distance from the cameras are such that each of the opposing mirrors reflects the opposite side as well as the reflection of the viewer within the area.
(Courtesy Dan Graham)

explore personal narratives or as a record of performance or body art. Out-of-doors, they could record real events as part of political statements or as experimental documentary interpretations of the urban or rural environment (to be played back later on a monitor). Some saw video as an agit-prop tool. Installed in closed-circuit elaborated gallery settings, the video camera with a delay feedback loop could confront and interact with the viewer in a new dialogue which placed the spectator within the production process as part of the conceptual intentions of the artist. Combined with sound, music or spoken dialogue and text, the medium opened up new aesthetic ground for exploring time/motion/sound/image relationships in a broad range of contexts.

Some artists were attracted to the newness of video for the very reason that it had no past history, no objecthood, and no agreed-upon-value. They attempted to distinguish it from other art forms by stressing its uniqueness as being an exclusive new category of its own and by denying its influence from other mediums. It was not film, not T.V., not theater. In his 1970 *Expanded Cinema,* Gene Youngblood separated the video medium from the history of film and of film language and theory because of its very self-reflexivity, its personalized ability to provide the immediate feedback of a mirror image. The individual artist could use it experimentally. It was seen as a personal rather than as a collective institutional enterprise such as film. In many ways, the early video screen had the fascination of projected "luminous space," suggesting a painterly but conceptually abstract site for the play of light and dark which in a metaphysical sense is reminiscent of Malevitch's 1918 *White on White* painting and Moholy-Nagy's early experiments with light and shadow. Its ability to organize a stream of audio-visual events in time suggested poetry and music.

As artistic practice, video grew out of the formal modernist context of Minimalism and Conceptualism. However, its rise coincided and overlapped with the broadcast medium of television. The pervasive influence of television strongly contributed to new cultural assumptions and attitudes which were gradually leading to the new Postmodern condition. Plugged into almost every living room of the industrialized world, television had begun to change the way people saw, thought, and lived.

The very history of video is the history of the rise of Postmodernism. Video usage by artists is a particularly significant example of the shifts to which art in general has been subjected in the transformations it has undergone from Minimalism and Conceptualism to Postmodernism. Within the Modernist framework of its beginnings, video production as a valid practice for artists did not seem at first to overlap with broader social attitudes about the congruency of culture, consumption, and ideology which were growing. Thus it was the extremely rapid development of video technology itself

which brought it to the level where its capabilities began to converge with film and where it could be used as a potential media tool—one whose productions could be broadcast. This development brought with it deep changes in attitudes towards the use of video as a medium.

Pioneering Video

Because no editing equipment was available until the mid-seventies, and the tapes were not compatible with the broadcast signal, most of the early artists' videos focussed on real time closed-circuit conceptual projects. Installed in public places or controlled elaborated sites in museums, the video camera, with a feedback loop, could confront the "on-camera" spectator who became part of an interactive dialogue as an aspect of the artist's intentions—a unique way of exploring fresh relationships in the triangle which exists between artist, object, and viewer. For example, in Bruce Nauman's *Corridor* (1969--70), a passageway became a sculptural space surveyed and mediated by the video camera's point of view. The viewer, although he could never see his own face on the monitor, progressed through the corridor as part of a self-reflexive (art about making art and its own materials) interactive inquiry into time and space. The real time of the camera (which stays on continuously) is watchful of the viewer's intrusion into the space and the space becomes abstract, flattened information on the black and white monitors.

Other important pioneers who used video for exploring the camera's viewpoint as part of a study of perception and illusionistic and architectural space relations were Dan Graham, Peter Campus, Ira Schneider, and Frank Gillette. Their closed-circuit multimonitor works took on a variety of forms as complex installations, where one could see immediately what the camera was recording or see it as part of a delayed playback loop, as part of a play with space and time.

Apart from these interactive video installations in site-specific architectural environments, other types of installations use multimonitor, multichannel forms as more self-contained sculptures and assemblages. Video sculptures are compact units and are usually composed of several monitors located within specifically built sculptural forms. For example, Shigeko Kubota's *Nude Descending a Staircase* (1976) is a witty video tribute to Duchamp's key twentieth-century painting. Kubota's contemporary work is a plywood staircase with four monitors inserted into the risers showing a colorized videotape of a nude repetitively descending a stairway. Other multimonitor installation works weave together prerecorded contrasting elements as in Beryl Korot's *Dachau*. The audience views the carefully edited four-channel work from a single vantage point.

Another direction in early video manifested itself as a variety of what critic Rosalind Krauss has termed "narcissistic" performance. Here, the body or human psyche of the artist took on the central role as the most important conduit in the simultaneous reception and projection of the image received via the monitor as a kind of immediate photographic mirror. For example, Vito Acconci in his twenty-five-minute work *Centers* (1971), centered his body between the camera and the monitor and pointed to the center of the monitor. The viewer's line of sight could encompass simultaneously the artist's, sighting his plane of vision towards the screen along his outstretched arm and the eyes of his transmitted double on the monitor. Krauss describes this narcissism as a kind of psychological strategy for examining the conditions and traditions of the relationships between the process of image-making and the viewer's perception of it. Nancy Holt, Richard Serra, Lynda Benglis, and Chris Burden are a few of the artists who explored conceptual aspects of performance-oriented video.

Art World Acceptance

The phenomenal early growth of museum response to video is due to two major factors: the growing interest by a diverse group of major artists in the medium's open possibilities; and important shifts in museum acceptance and evaluation of radical, conceptual work which questioned the museum's very role as preserver and collector of "art as object." Art movements at the end of the sixties and early seventies focused "on art as idea and art as action." Art became "dematerialized," as expressed through energy and time-motion concepts. The medium itself defies objecthood—a key Postmodern characteristic. It is dispersible, reproducible, and interdisciplinary.

By 1969, Howard Wise,[1] a New York gallery owner, created the first video exhibition, T.V. as a Creative Medium, featuring the work of Nam June Paik, Frank Gillette, Ira Schneider, Paul Ryan, Eric Siegel, and others. The works in the exhibition demonstrated strong differences in artists' approaches to video. Some saw video as a way of integrating art and social life through a critique of television as a dominant cultural force or as a social documentary tool. Others saw video as a new artists' tool for formal conceptual projects or for synthesizing and transforming images with electronic devices such as the computer.

One of the most interesting works in the Wise Gallery show was Frank Gillette and Ira Schneider's multimonitor/multichannel installation work *Wipe Cycle*. The piece (with its nine monitors, live camera imagery of observers in the exhibition space, mixed with prerecorded tape units, delay

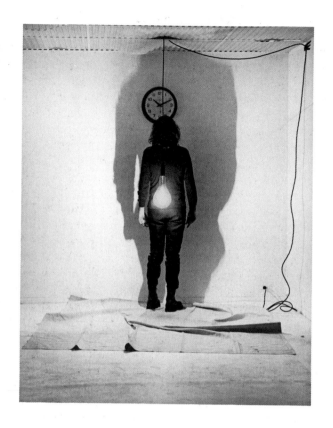

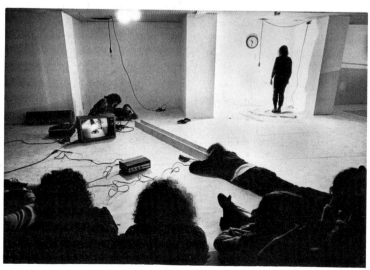

loops, and unifying gray wipe that swept counterclockwise every few seconds) was an attempt at manipulating the audience's time and space orientation by including the viewer as an integral part of the "live" installation. The complex structure of the work, which fed live images from one set of monitors to the other, was typical of many video installation works which explored the self-reflexive formal codes suggested by the time-delay feedback aspects of the medium itself. As cameras recorded events within the installation, the events themselves were manipulated and transformed to create an illusionistic model of communication and dialogue.

Vision and Television at the Rose Art Museum (near Boston) in 1970, and Kinetics at the Hayward Gallery in London were part of a growing tide of exhibitions which asserted video as a viable art form. Funding institutions began supporting video: the Rockefeller Foundation (by 1967); New York State Council for the Arts (1970); and the National Endowment for the Arts (1972). The Canada Council and European government-based arts funding also began supporting video activity. Early grants went to facilities, such as the newly founded Electronic Kitchen[2] in New York and the Experimental T.V., Center in Binghamton, N.Y. (later, Owego), where small format and postproduction equipment were made available to artists together with gallery screening of video. As networks of production centers grew, so did exhibition possibilities in Europe, Canada, Japan, and the U.S. video festivals and conferences helped to broaden the exchange. These provided a forum and meeting ground for artists, as well as important exposure. In 1972, the First Annual National Video Festival took place at the Minneapolis College of Art and Design and the Walker Art Center. Later that year, the first Women's Video Festival was mounted at the Kitchen in New York. Video also became part of the annual New York Avant-Garde Festivals. It was widely exhibited in new media centers such as the Visual Studies Workshop in Rochester, N.Y. In 1970, the magazine *Radical Software*, published by the Raindance video group in New York, began disseminating both technical information and news about individual artists' productions.

Figure 97. (Top) Vito Acconci, Performance Reese Paley Gallery, New York, Jan. 15, 1971
(*Photo: Harry Shunk*)

Figure 98. Vito Acconci, Dennis Oppenheim, and Terry Fox, Performance Reese Paley Gallery, New York, Jan. 15, 1971
Acconci thought of video "as a working method rather than a specific medium." Using the video camera as an impulse for witnessing and recording, he focused on the physical reality of his body-presence, orchestrating his movements and gestures, investigating interior/exterior dialogues between himself in relation to the viewer—role playing, conceptualizing his body as a container, as a locus for action or contemplation defined by its presence in a public space.
(*Photo: Harry Shunk*)

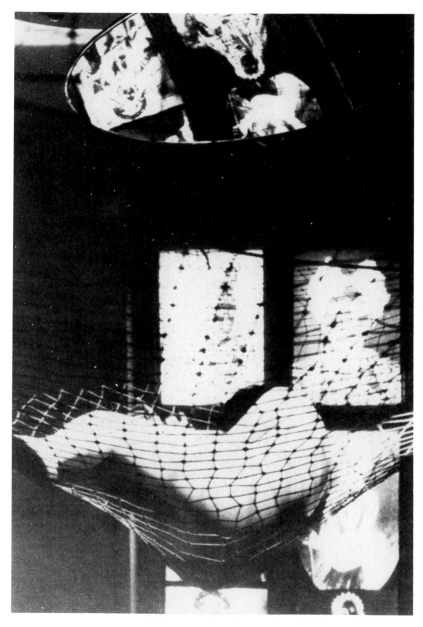

Figure 99. Ulrike Rosenbach, *Meine Macht Ist Meine Ohnmacht (To Have No Power Is to Have Power),* 1978
Video performance.
(Courtesy Ulrike Rosenbach)

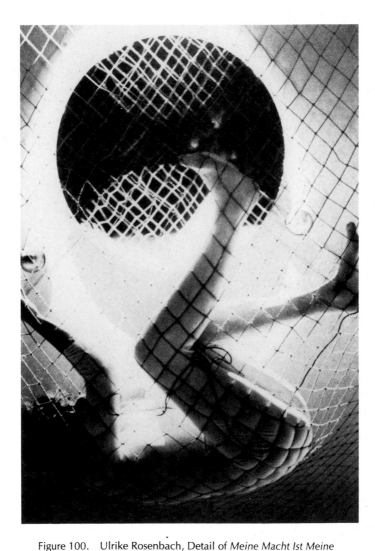

Figure 100. Ulrike Rosenbach, Detail of *Meine Macht Ist Meine Ohnmacht*

One of the foremost European video performance artists, Rosenbach creates feminist rituals by projecting images from art history and popular culture iconography in which her own presence is captured and recorded within the scene. In this early 1978 piece, she is shown trapped as an unwilling victim in front of T.V. monitors that are in turn reflected from an overhead sphere. *(Courtesy Ulrike Rosenbach)*

Portable video equipment is constantly being updated and modified by manufacturers. Magazines and journals such as *Radical Software, Afterimage, The Independent,* and *Art Com* have provided important technical information, news about media centers and grants opportunities, and criticism for artists. These magazines have helped to unify the video movement.

From the late sixties, video became important to feminists as an alternative, progressive, and flexible medium for expressing their political and cultural objectives. Women's video collectives sprang up during the seventies and an annual women's video festival was organized. Many of the early works were documentary in style, influenced by cinema vérité and focused on issues of sexual difference and feminist consciousness. Part of its attraction was its newness and its lack of other cultural baggage and connotation.

The first museum video department was established in 1971 by James Harithas and curators David Ross and Richard Simmons at the Everson Museum in Syracuse, New York, with a closed-circuit gallery. Two years later, Ross set up the Long Beach Museum program in California. In 1973, the Whitney Museum of American Art included video in its important Biennial exhibition and soon afterwards added video as part of its independent film department headed by John Hanhardt. The Museum of Modern Art instituted a video department in 1974 under the direction of Barbara London. Video Art, the first comprehensive video survey, was organized in 1975 as a traveling exhibition by Suzanne Delehanty at the Institute of Contemporary Art in Philadelphia. It consisted of single-channel videotapes and multichannel sculptural installations by 79 international video artists.

Open Circuits: The Future of Television was organized in 1974 by Douglas Davis, Gerald O'Grady, and Willard Van Dyke under the sponsorship of the Museum of Modern Art. The conference opened out to include discussion of what was seen as the beginning of a new period for art. Robert Pincus-Witten indicated that video works based on exhausted conventions of Modernist practice were often dismissed, not because they were poor, but because they no longer reflected relevant issues. In referring to the genre of video that relied overly on experimental self-reflexive "art about making art" manipulation of the medium, he commented that video art was "deficient precisely because it was linked to and perpetuated the outmoded clichés of Modernist Pictorialism" and that it overused "a vocabulary of Lissajous pattern-swirling oscillations endemic to electronic art."

The rug was swept out from under many video artists whose work in video relied completely on the experimental and clung to formalist art issues. However, those whose work resonated with their interests in other fields, particularly those less rooted in traditional mediums such as painting and sculpture, opposed the hermeticism and separation often associated

with Modernism. They were the first to grasp and make use of the important technological changes coming to the fore to move their work to new territory.

Convergence with Film (and Television)

The relationship of artists' video to broadcast television and to cinema, and the differences between them, form the context of an important history and confrontation.

Early experimental emphasis on the conceptual, formal image transmission/reception aspects of video technology separated it completely from the moving image medium of cinema. However, artists who saw the use of video as a communication tool for social action and documentary were attracted to it because of its flexibility, immediacy, and its low cost in comparison to the use of film. By 1968, a diverse group of artists took their Portapaks into the streets to record real events or outdoor performance works. They faced difficult technical obstacles. Appropriate professional editing facilities[3] were inaccessible, Portapak batteries were heavy, image quality was poor. Tapes produced were not broadcast quality and therefore could not be publicly transmitted. They could be exhibited only to small audiences on T.V. monitors in corners of galleries and museums and not under the controlled darkened theatrical conditions normally provided for the projection of film.

Although these major technical differences separated video work from the cinematic medium of film, a link between film and abstract formalist tendencies in the visual arts had already been established by avant-garde independent filmmakers whose work with flexible hand-held 16mm cameras[4] had grown in opposition to the dominance of American commercial cinema since the 1940s. (In Europe, independents such as Jean-Luc Godard found a greater public consensus for their important work.) Independent filmmakers experimented with the dynamics of camera movement and the relation of image sequence through shooting and editing strategies that questioned the reality of spatio-temporal events. They broke away from the established theatrical story-telling "grammars" or conventions of commercial shooting and editing techniques and substituted intense, abstract "metaphors of vision." Their use of edited repetition and juxtaposition to build psychological or poetic parallels created a different kind of visual structure with more complex layers of meaning.

Two broad tendencies exist in the aspirations and history of avant-garde independent film which somewhat parallel artists' intentions in video: film as related to, or associated with, the "formalist trajectory" of the fine arts; and film as the "ideological site for the mediation of social and political concerns."[5] Although technologically, film is radically different from video,

the strong influence of the experimental vision of avant-garde cinema is apparent in the work of video artists who attempt analytic and social documentary critiques as well as those who experiment with more conceptual projects rooted in performance and illusionistic concerns.

Early videomakers neither used the camera as an objective observer nor clearly separated the filmmaker and subject. In their work these were combined, and the artist performed for the camera using it as a mirror. They would perform in front of the camera until the tape ran out—tape length became performance length. Video was perfect for this type of "real time" performance. Warhol's experimental fixed-camera-position films (*Sleep* was eight hours long) had established the precedent and were a strong referent for performance artists such as Joan Jonas, Bruce Nauman, and Vito Acconci.

This intensely personal real-time video practice of some artists was far removed from the condensed time of commercial film and of the segmented, broken-up, regimented time of broadcast television with its highly produced, fast-paced programming. By 1975, when important advances in video technology became available—editing facilities and the time base corrector—some artists began to see video as a possible tool for T.V. media production.

By the early eighties phenomenal technological advances (the introduction of color, radically improved computerized editing systems, lighter improved cameras, computer processing, and digital animation), brought video to an important point of ascendancy as an electronic (broadcastable) moving-image medium relatively accessible to artists. By now it could challenge and sometimes rival, co-opt, and absorb the industrial technology of film as a dominant mode of communication and representation. Television itself had, from its very beginnings, appropriated film and co-opted its existing commercial productions. It could broadcast film to a vastly expanded audience.

Thus some artists using the video medium today find themselves confronting the issue of seeking a different, mass audience for their work. For these, the convergence of artist's video with T.V. raises important issues about public and private art, about access to the public airwaves mostly controlled by commercial interests, and about art as a means of communication or art as a cultural object.

The relationship of artists to television has always been complex. On the one hand, its potential as a showcase for reaching a broad audience is a strong attraction. But on the other, it presents the danger of losing control over production of their work—for commercial network television is dictated by a complex system of hierarchies, conventions, and economics with its programming pitched towards mass audiences. It raises questions about

how to reach this audience. For in relation to the mainstream programming designed for specific audiences, the relatively esoteric works by artists shown out of context is rather like reciting poetry in the middle of a soap opera or like seeing an Abstract Expressionist painting reproduced on the front page of the *New York Times*.

With roots effectively reaching back into the 1940s,[6] television is no longer merely an activity of the culture. It is a powerful agent of culture—an electronic conduit via cable, network, and satellite services to a global public which is increasingly dependent on electronically communicated ideas and information. Artists in the mid-seventies saw their video work as a possible new cultural voice with a special relationship to T.V.

Early T.V.: A "Window" on the World

The concept of public broadcasting, of public service in mass communications centrally transmitted via the airwaves to private home receivers, was developed first for radio. Government commissions were established to license stations, to set laws, and to consider the implications of programming and its potential impact on the public. In the United States, television regulation was placed under the jurisdiction of the Federal Communications Commission (FCC) and followed a framework already set in place by 1937 for radio transmissions. The FCC debates public service issues such as political fairness, public morality, and social usefulness. By 1941, the National Television Standards Committee (NTSC) had been formed to set government regulations regarding the number of transmission lines per picture[7] and what technological form the new mass communication service should take.

Decisive development of sound broadcasting as a major sector of industrial production came about in the late twenties when production of radio receivers became a successful profitable aspect of manufactured "consumer durables" aimed at the privatised urban dwellings—an industrialization of the home. Manufacturers were quick to seize on the parallel consumer market potential in the development of television. By 1958, T.V. was in 42 million living rooms.[8] The phenomenal growth of global T.V. broadcasting has been fostered by satellite communications and cable facilities set in place by 1972. Yet public access to the means of broadcast transmission is tightly controlled through FCC regulation (the Federal Communications Commission). The FCC regulates the content of programming and the quality of broadcast transmission, licences access to the public broadcast frequency band, and scrutinizes compliance with regulatory legislation.

By 1972, more than 90 percent of the seven-channel broadcast band was licensed to corporate networks. Access to the public airwaves is thus

almost completely dominated by powerful commercial networks through sales of T.V. time to advertisers who normally recoup the high costs of T.V. production by using it to sell their products and a way of life based on them. Yet in the eighties, consumers have invested at least 10 times more for their home T.V. receivers as compared to what commercial network owners have spent on their transmitting facilites. In this one-way situation, the commercial network stations hold licenses to transmit on specific channels within the broadcast frequency spectrum, while the consumer/receiver pays for a selection of programs almost entirely mediated by corporate management, which allows for little, if any, programming innovation.

The viewer becomes a consumer—one who selects but cannot control—with the on-off switch as the only option. The experience of television, with its homogenized format of standardized packaged programs, with required edited content and formularized break-up of program time, has established an expectation for home viewers for its ideological and informational perspective. The familiar design of broadcast time, structured around 30- and 60-minute time blocks punctuated by commercials, competes for audience attention in the home installation.[9] Its hidden meanings and fictions are meant "to deliver the myth of television's being a window onto the world"[10] with its technological transmitter/receiver production process invisible to the viewer. The prime-time world of commercial T.V. offers a seriously skewed picture of reality, for viewers tend to see the real world much as it is presented on T.V.[11] In the 1988 presidential election, T.V. played a more powerful role than ever before in swaying the electorate.

Television Leads to a New Postmodern Cultural Condition

Our overloaded T.V.-image culture has brought about changes in the way we see and understand and the way we lead our lives. T.V. has trained us to focus on many planes all at once and to assimilate large quantities of information both obviously and subliminally. Within the frames of our household viewing space, we often do not watch television directly—we have learned to glance at its easily assimilated packaged time segments as a distraction while answering the phone or working. For large numbers of people, the T.V. stays on, an appendage to other aspects of life. It contributes to a diverse, multifocus experience, a way of consuming effects and information. It is as if our continual stimulation by the programmed variety of old movies, soap operas, depictions of family life, news, and historical documentaries has contributed to a nostalgic state where artificial representations of reality have become dominant features—an obstacle to direct personal meaning and significance. One of the first effects on the mind is the "marked mitigation of the distinction between public and private con-

sciousness. A manifestation of this is an increasingly altered sense of ourselves as we become more media dominated; our tele-selves become our real selves. We lose our private selves in publicity."[12] The phenomenon of communications technology is creating a "crisis of meaning," not only in personal life but in the way culture as a whole is produced and experienced.

Instead of relying on a sense of reality gained from direct experience and belief in a single authoritative system, we depend on a variety of communicated information. "Let's turn on the T.V. to see if it's raining." We alternate and are suspended between the reality of daily life and the representation or edited copy of the diverse, pluralistic copy of it that we respond to via T.V. This shifting response contributes to an assault on the concept of the self as the center of a single reality with a single viewpoint. What has been added is an artificial reality capable of making us lose ourselves between the private self and an artificial representation of life. An extreme example of loss of the real giving way to the artifical comes from the film *Being There*. The hero (Peter Sellers) is ejected into the outside streets from the constancy of his hermitlike existence in front of a T.V. set. He tries to resolve the unpleasant violent street scene he confronts by pressing the button on his remote control. His reaction provides a metaphor for the experience of television fiction in life.

Above all, the home-received T.V. broadcast represents a radical compression of time/space. "Implicitly, within our perception of television is that it is immediately delivering events to us. The soundtrack of the studio audience, the mistakes of the performers, the sports events, and the urgency of news events appear live but are in fact, for the most part, all effects deliberately added, edited, and manipulated to convey an urgency and feeling of being live."[13] This perception that we are home participants connected to "live" events is reinforced by a technologically induced manipulation of the time and space of reality which seems to provide immediate access to what is seen and experienced. Disconnectedness to real time and space effects our senses disproportionately and creates vicarious expectations for immediate gratification.

This artifical change in the sense of duration and of time flow is characteristic of the speeded-up effects of electronic media. "Space and time are found to be more constrained for children who watch T.V. than those who read books. The edited, at most eight-minute, segment compresses space, making any point in that space immediately and passively available. Seemingly direct and intimate contact via satellite broadcasting further compresses space. Interaction takes place at the touch of a button, is detached, and is perceived as an abstract happening"[14] not bound by time.

Television has, after 40 years, strongly contributed to a new cultural condition, a shift of assumptions and attitudes to a different climate of

Figure 101. Chris Burden, *Leonardo, Michelangelo, Rembrandt, Chris Burden,* 1976
T.V. commercial.
Best known as a conceptual artist, Burden is noted for his startling performances where he explores the psychology of personal risk. In 1973, he began to purchase commercial advertising time on local T.V. stations in Los Angeles. He showed short ten-second clips of his work. In the illustrated commercial shown here, he drew attention to the idea of high art and its relation to the commercial world of advertising. The work has shock value in that "genius" is presented as a commodity like any other consumer product on T.V. Another commercial consisted of three statements: "Science Has Failed," "Heat Is Life," and "Time Kills." Burden spoke the statements, then they were flashed as graphics on the screen, followed by the words "Chris Burden sponsored by CARP." This commercial appeared a total of 72 times in a five-day period.
(Courtesy Ronald Feldman Fine Arts, Inc.)

Figure 102. Juan Downey, *Information Withheld,* 1983
 Color video, 29 min.
 In his work, Downey applies his fluid camera style to
 investigate the semiotics of culture and society. A native
 of Chile, he is familiar with government policies of
 internment and persecution of political enemies. Here
 he equates the transmission and reception of
 information with the "mind oppressive" nature of the
 television medium which he sees as part of a coercive
 attempt to control.
 (Courtesy Electronic Arts Intermix)

relationships. Use of compressed, intensified images and messages, with their edited forced sequences and shock value, has now become part of everyday visual vernacular, an absorbed aspect of Western aesthetic tradition and mass culture which has led to the diversity and the melting down of forms which is the Postmodern.

First Artist Access to Television Broadcast Labs

The single noncommercial broadcast channel open to meeting the cultural needs of a sophisticated, diverse audience lay in the establishment in 1967 of government-funded national public television (PBS) and of cable transmissions. Although funding for PBS has been limited in comparison, for example, to the BBC in Britain (especially channel 4) or CBC in Canada, and has now been cut back further in the eighties, it sometimes fulfills television's potential as a powerful cultural force.

By 1972, the Artists' Television Laboratory of WNET (Public Broadcast Corporation) was founded by grants from a variety of sponsors including the Rockefeller Foundation, the New York State Council on the Arts, and later, others. PBS stations KQED in San Francisco and WGBH in Boston also initiated experimental video production. The TV Lab was founded to mediate between the fine arts and T.V. A few artists (including Stan Van Der Beek, Douglas Davis, and Nam June Paik) were given access to these television labs. At a time when most artists had no editing equipment, this access to broadcast facilites was vital. Independent funding for use of broadcast technology created the opportunity for creative risk. In the realm of television production, budgets are tightly regulated, leaving little or no room for experimentation. Use of sophisticated high-tech devices at the WNET television studio represented an unprecedented departure from common practice, for artists were allowed to experiment for aesthetic effect. Some artists such as Nam June Paik, Ed Emshwiller, and later, Mitchell Kriegman, John Sanborn, Kit Fitzgerald, and Bill Viola received funding to do more than one artist-in-residence production. For these artists, multiple access to high-tech equipment represented a quantum leap in their professional growth in the video medium.

Early support of artist-in-residence institutional programs fostered visionary freedom and widespread utopian optimism that television could become a democratic alternative medium—one that could reject the priorities of the commercial industry and be used as a tool for cultural and social change. These hopes grew out of the global village attitudes of the sixties and did not take into account the huge distance between high culture style and mass media realities. Some artists were primarily interested only in seeing their work shown on television. Others were committed to subverting

T.V.'s dominantly commercial voice. Some took their cameras to the street as a form of guerilla tactics.

Public T.V. screening of artists' video both in North America and Europe created a clash of tastes. Video, growing out of prevailing philosophic and aesthetic currents in the arts, exists primarily for the art world as a special interest group (and has received funding and encouragement for its experimental independence). Public taste has been formed by fast-paced formula entertainment and information programs punctuated with smooth advertising messages. Unaccustomed to video's "difficult," unfamiliar vocabulary and greater intellectual complexity and to the high level of attention and interpretive participation required, the average viewer tunes away and thinks of it as bad T.V. The mass audience seeks leisure-time distraction: art demands concentration—it is a process of exploration, inquiry, and discovery. This clash between artists and the realities of the television world brought many issues into sharp focus.

Video artists using nonprofessional low-tech equipment were accustomed to independence in developing their ideas through spontaneous improvisation where they had integrated control over all aspects of writing, directing, and performing. By contrast, standard broadcast programs are generally produced by a consortium of writers, producers, and film crews whose work is subject to strict regulation by unions and to control by network owners, commercial sponsors, and the FCC regulatory commission. Eventually, artist-made works and the video tools artists helped to produce had a strong stylistic influence on T.V. production, although public broadcast of this work did not attract the popular viewing public.

However, very few of these early experimental artist-produced works were ever broadcast. PBS owned the rights to them which they annoyingly refused to relinquish. *Video and Television Review* (*Video/Film Review* by 1979), a late-night Sunday series, was grudgingly produced as a showcase for these works by PBS in 1975. The big name artists at T.V. Lab attracted grants to the station. Although artists-in-residence were required to spend all their NYSCA funded stipends at the station, videomakers had no rights and WNET was not obliged to air works produced at the Lab. This situation did not satisfy major funding sources. NYSCA raised several serious questions. Rockefeller pulled out.

Funding difficulties caused the demise of WQED's National Center for Experiments in T.V. in 1975, WGBH gave up its studio in 1978, and the WNET-T.V. Lab ceased operation in 1984, forcing artists to find other support systems for professional-level broadcast quality work. The only funding agency still operational is the Contemporary Art Television Fund (CAT) in Boston founded in 1980.

It is ironic that more than a decade after the first broadcasts in 1975, a

new late-night program on PBS, *The Independents,* is finally airing these early tapes and treating them reverently as historical documents.

Cable Transmission and Counter-Culture: The Right to Be Seen and Heard

Although many video artists turned away from the issue of public broadcast and remained within the exhibition context of museums for showing their work, those with an activist or documentary commitment embraced it and sought to air their work on the more open flexible public access cable stations. Cable[15] represents one of the few vestiges of the public service concept of T.V. communications still in place. Initially, FCC law required cable owners to include a prescribed number of hours to community-based transmissions. The growth of cable broadband communications (non-over-the-air broadcasting in the VHF or UHF frequency band) opened the way for at least 20 and, ultimately, many more operating channels. Many early video artists had seen the future expansion of cable TV as a major opportunity for creating new cultural options, experiences, and perspectives as a public alternative to conventional network broadcasting.

By 1971, the counter-culture group Videofreex began regular low-power T.V. programming in Lanesville, New York. Other groups began their own public access series—Byron Black, Clive Robertson, and Ian Murray in Canada; and Jaime Davidovich and later Paper Tiger Television and the Artists' Collaborative in New York. *Night Light TV* is a series organized by Ira Schneider which continues to be shown on Manhattan cable. Their aim is to inject alternative insights and criticism of the media monopolies—its genres, editing, camera techniques, and politics.

These groups reacted to the segmented, formulaic handling of significant events and issues as edited, blanked-out interpretations. Counter-culture video raised analytic questions about the hidden agendas behind standard programming formulas and challenged the delimiting power of commercial T.V. to set the dominant agenda for public assumptions, attitudes, and moods through its interpretation of news and information.

From the early seventies, counter-culture video artists such as Telethon (William Adler and John Margolis), Tom Sherman, and Stuart Marshall have appropriated elements of broadcast programs as "found materials" in their recent analytical critiques of the medium. The latter continued to produce video which addresses commercial television. Chris Burden took another tack when he bought a commercial time slot on network television in a mock advertisement for the value of his artwork-as-a-commodity product.

In 1972, the Time Base Corrector became available. Its arrival meant that "nonprofessional" independent video could now be broadcast on national television, for deviational errors in the video signal caused by incon-

Figure 103. Ant Farm, *Media Burn,* 1974–75, Edited for T.V. 1980
Color and black-and-white videotape, 30 min.
The Ant Farm Collective—Chip Lord, Doug Michels,
and Curtis Shrier—worked in the areas of architecture,
sculpture, performance, and media in San Francisco
from 1968–78. Their trailblazing work in the social
aspects of art led them to explore its relation to popular
culture, the media, and violence. In their *Media Burn*
happening, presented before a large crowd, they created
a performance spectacle where a car fitted with video
cameras and driven by two of the group crashed through
a pyramid of burning T.V. sets. Beforehand, a mock
address by a John F. Kennedy impersonator proclaimed:
"Who can deny we are a nation addicted to television
and the constant flow of media?"
(Courtesy Electronic Arts Intermix)

sistencies in equipment could be electronically corrected. Among the first documentary videos made with nonprofessional equipment were Downtown Community Television Center's report on Cuba and coverage by Top Value Television (TVTV) of the 1972 political convention. Both were aired on WNET.

Founded much later, in 1981, Paper Tiger Television—a group which still actively broadcasts a weekly series on public access Channels C and D in New York—attacks corporate economic control and the ideology of mass media. Its producers state: "The power of mass culture rests on the

Figure 104. Daniel Reeves, Production Still on Location for
 Smothering Dreams, 1981
 In this powerful videotape based on autobiographical
 experience, Reeves weaves myth with the reality of
 organized violence as seen through the eyes of a soldier
 and the imagination of a child. In this production still,
 we see Reeves shooting on location. The work was
 broadcast on PBS in 1981.
 *(Courtesy Electronic Arts Intermix; Photo: Debra
 Schweitzer)*

trust of the public. This legitimacy is a paper tiger" (thus the group's designation). Although their shows are local, Paper Tiger T.V. "encourages its audience to consider global issues, to think about how communications industries affect their lives and their understanding of the world. Consciously mixing almost primitive video techniques with sophisticated ideas, adding humorous touches to enliven serious questions, Paper Tiger T.V. can be described as a 1980s version of Brecht's didactic theatre (for it) weds analytic processes to popular forms in order to reveal social relations and social inequities."[16] Through its simple unveiling of its communications process and its method of functioning as a broadcast apparatus different from highly stylized network productions, Paper Tiger T.V. raises questions for its audience about how television communicates. It reveals the power of broadcast communications and attacks the power and the economic structure of the mass media cultural apparatus.

Costs for the half-hour program are about $200 as compared to the $150,000 normally spent on a typical half-hour commercial program (a comparison that is often stated for political effect at the conclusion of Paper Tiger programs). The style of Paper Tiger shows reflect practical and conceptual considerations. Their "talent" is a wide range of commentators, visual artists, writers, economists, lawyers, musicians, and psychiatrists. Their "live" format is eye-catching and spontaneous. Consciously avoiding the slick high-tech style of network programs, they opt for simplicity and low-budget effects. For example, titles and credits are displayed on a hand-cranked paper movie strip or hand-lettered cards are held in front of the camera. The flavor of their sets is equally inventive—often cartoonlike cloth backdrops depicting scenes such as the interior of a graffitied New York subway car; a homey domestic setting with flowered wallpaper; or a stone basement wall with its pipes and meters. The overt effects and content are meant not only to engage and attract the viewer, but to question the issues and methods implicit in media seduction and production.

Artists Design Electronic Image Synthesizers

From 1965, many artists saw a strong link between the computer and video both as an extension of kinetic art and as a means for electronic visualization, animation, and processing of their images. Early filmmakers John and James Whitney, Stan Van Der Beek, Ed Emschwiller, and Lillian Schwartz, working out of facilities such as Bell Labs, New Jersey and the New York Institute of Technology, used the computer to generate, animate, and mediate their imagery. Artist access to WGBH, WQED, and WNET-TV labs' array of postproduction equipment fired the imagination of first-generation video artists and created the energy to develop artist-designed imaging tools such

Figure 105. Paper Tiger T.V., *Herb Schiller Smashes the Myths of the Information Industry at the Paper Tiger Television Installation at the Whitney Museum*, New York, 1985 *(Courtesy Paper Tiger T.V.; Photo: Diane Neumier)*

Figure 106. Paper Tiger T.V., *Taping the PWAC (People with AIDS Coalition) Talks Back,* 1988
Paper Tiger T.V. Show.
Paper Tiger T.V. is a weekly series on public access television in Manhattan. The group is devoted to criticism of media monopolies and analysis of the politics of the communications industry. One of its leading advocates, Herb Schiller, is shown here giving one of his readings—a presentation of specific revelations critical of the press. The group's sets, intentionally designed to be striking for their simplicity and low cost, are an important commentary on the power principles involved in the economic disparities between the public's right of access to the airwaves and those commercial companies that can afford to "buy time" from commercial network companies.
(Courtesy Paper Tiger T.V.)

as the Paik/Abe video synthesizer by 1970. Image processing grew out of intense experimentation and idealism with the medium. In his first manipulations of the video signal, Paik had used a magnet to interrupt and interfere with the raster scanning process of T.V., i.e., the beam of electrons which moves continuously across and up and down to form the image on the monitor. The Paik/Abe video synthesizer was a tool specifically designed to cause interference with the raster scan and to direct it in a controlled way. Other kinds of manipulation devices, colorizers, mixers, and synthesizers could produce images which looked startlingly different from those on standard T.V.—tools which could produce moving, swirling colors, distorted forms, and disjunctive patterns by extensive intermixing of signals to create totally new images—a new genre of "tech art" that had strong appeal because of its relationship to the formal modernist concept, "the medium is the medium." Many idealistically thought in terms of a kind of lingo of futurism where technology would somehow create new realities which could link up the universe with the unconscious energy flow of the nervous system to achieve total communication.

The new image-processing genre of video depended on the pioneering efforts of a dedicated few who designed flexible, relatively inexpensive tools. Because it is unusual to find both artistic and engineering ability in one person, the need to invent new tools led to important symbiotic collaborations such as Nam June Paik's with the engineer Shuya Abe, Stan Van Der Beek's with Eric Siegel, and Bill Etra's with Steve Rutt.

Some of these toolmakers—Steven Beck, Eric Siegel, Bill Etra—were obliged, in the end, to find outlets for their skills outside of the arts or to set up their own commercial companies. Some, like Tom de Fanti (Z-Grass) were able to get commercial video game commissions to design new equipment. Others, like Woody Vasulka (Digital Image Articulator), Dan Sandin (Digital Image Processor), and Ralph Hocking and Sherry Millner saw that sharing new development of tools could bring about important relationshps in the video community. An awareness of easily learned inexpensive systems could counter the mentality that technology was too costly and unwieldy to be "habitable" or usable by artists. Sandin rejected the idea of marketing his device and instead offered to give the plans to anyone wishing to build it themselves. His Digital Image Processor (completed in 1973) combined many functions in one tool—keying, colorizing, fading—and was set up as a set of stacked boxes which could be rewired or reconfigured.

The Community Center for T.V. Production, later called The Experimental Television Center, was set up by Ralph Hocking and Sherry Millner through a large NYSCA grant in 1970. It has been a major site for investigations into the video medium. Hocking and Sandin have been "committed to the idea that artists should be able to work with video technology much

the same way as a painter works with his or her materials in isolation in a studio. In this sense, they both adhere to very traditional modes of artmaking."[17] Both have had institutional support for their work.

By 1977, image processors had been programmed and built which could achieve new visual effects such as the mixing together of live and taped images on a split screen and the digital painting and matrixing of forms—effects which had not previously been possible even through the use of then-available professional broadcast equipment. These pioneering innovations to the technology of visual transformation by independent video artists dramatically highlighted the possibilities for replacing outmoded models of film/video practice and production. Their contributions were vital to software and hardware developments in producing the new generation of powerful but inexpensive computer/video instruments later built commercially.[18]

Artists continue to play an important role in defining new areas where specific software can be produced to fill a specific need. Many firms have found that important benefits can be derived from granting after-hours access to artists. Their intelligent use of equipment can often open up unexplored aspects of a machine's potential or raise important questions for the future which have direct application to the development of a system.

Video Is a Cutting Edge in the Arts

Video is now seen after 25 years as a mature art form in the sense that it has influenced other art works or has become part of them. It has a developing visionary corps of recognized practitioners, as well as an expanding body of criticism and analysis through such serious journals as *Afterimage, The Independent, Art Com, Screen,* and important interpretive books such as *Transmission, New Artists Video,* and *Video Culture.* Catalogs of video exhibitions and festivals contain history and analysis. John Hanhardt, curator of video at the Whitney Museum of American Art, regards independent video as "a cutting edge," for it is at the forefront of theoretical and aesthetic thinking in the arts, and, in its nexus with the media, is a vital link to interpreting the world around us. He is convinced that because technology is changing our way of living so rapidly, artists and the museum itself must respond to cultural changes positively by providing alternatives. In his view, the museum should seek creative use of the broadcast medium for special artists' projects and for interpretive programming through its education department, possibly via publicly and privately disseminated cable productions.

New York Times critic Grace Glueck comments that video has come into its own. It has passed the point where the public need be video-shy

because of its newness or its considerable claim on time—for a video piece unfolds in time, and therefore demands a time commitment from the viewer.

> We're accustomed to looking at art that addresses us in a more or less known grammar and time-honored materials," she writes, "art that can be 'placed,' both in a critical-historical context and literally—on a fixed site within the walls of a room. . . . The video screen lacks the surface richness to which art has accustomed us. While the basic property of video is that it moves and changes, we are used to an art that we can contemplate, that stands still for our eyes to return to in sensuous or cerebral appreciation.Yet we'd do better if we stopped trying to relate video to fine art, film, or even commercial television, and began to regard it as a developing medium in its own right.[19]

The great majority of video artists have built their reputations through international museum and gallery exhibitions. A small sampling from the years 1983–88 includes: Video as Attitude, Museum of Fine Arts, Santa Fe; Electronic Vision, Hudson River Museum, Yonkers; The Second Link: Viewpoints on Video in the Eighties, Walter Philipps Gallery, Banff; Video, a Retrospective, Parts I and II, Long Beach Museum of Art, California; The Luminous Image: Video Installations, Stedelijk Museum, Amsterdam; Video: A History, Parts I and II, Museum of Modern Art, New York; Alternating Currents, Alternative Museum, New York; Video Art: Expanded Forms, Whitney Museum at Equitable Center; Bill Viola Installations and Videotapes, Museum of Modern Art, New York; and Documenta Seven (and Eight), Kassel, Germany.

In 1982, video made a striking impact on the museum-going public through a major retrospective of Nam June Paik's video work at the Whitney Museum. By now identified as the "father of video" because of his long history in working with the medium and because of his strong influence on the entire field, Paik contributed also to the identification of video as the art form of the future. Paik comments: "As collage technique replaced oil paint, so the cathode-ray tube will replace canvas." Paik's early Neodada video works—*T.V. Bra, T.V. Bed, T.V. Cello,* and *T.V. Buddha*—combined the genres of performance, installation, and sculpture. His work is always in the vanguard. It now encompasses not only his Neodada works using television as building-block icons, but has passed on to include his personal and intuitive highly edited single- and multiple-channel tapes which make use of chaotic stream-of-conciousness montage using image-processed materials from many sources. Paik's open strategies for video sculpture include an assemblage approach. He installs large numbers of monitors in elaborated contexts—from the ceiling, or, for example, set among plants in an out of context garden environment completely alien to normal T.V. usage. His intention is to subvert the viewer's normal visual relations with the familiar T.V. monitor by challenging the viewer's referential reading and

interpretation of T.V. Assemblages of television sets are piled in pyramids, arches, or as multiple channel "video wall" works in which 20 or more monitors are hooked together. His adventurous experimentation and wily analysis of the medium itself is a playfully irreverent pastiche of the language of the commercial reality of broadcast T.V. Interested also in broadcasting itself as a form of public art, especially in "real time" international satellite communications, Paik has produced a number of live avant-garde performance works which bridge continents, East and West. "I think video is half in the art world and half out" he says, drawing two overlapping circles, one labeled ART and one INFORMATION, "I think I am here," he comments, pointing to the overlap.

Another major video artist, Bill Viola, whose work has completely different intentions from Paik's, was also accorded a major retrospective (1987–88, Museum of Modern Art), where he showed both single channel works and installations. His works, drawing more on the traditions of independent film, are like "visual songs" which have all the elegance and music of a poet's voice. He has achieved a remarkable synthesis between using video, the technological medium of his time—with personal vision. His work has the quality of touching an inner core in his viewer through effortless exploitation of his technical medium in a radically expressive way. His use of slow motion, rapid editing, deep zooms, and panoramic scans is never obtrusive, but seems rather a natural process of perception. Several themes recur in his work: powers of the human mind, passage of time, personal identity, and contemplation of the nature of species. For example, Viola shares with us those images which have powerful archetypal significance for all time: landscape is seen as a sacred setting for humans and animals; metaphors for life and regeneration are suggested in the way he uses fish, bread, and wine by contrasting them with their antithesis in nature: decay, overcrowding, industrial pollution.

Attracted early to the teachings of non-Western traditional cultures, which regard life as a continuum lived in its reference to nature, Viola has traveled and worked in the Far East, Africa, and the Pacific. In a 1986 single-channel work, *I Do Not Know What It Is I Am Like,* he contrasts a view of prairies in long, slow sequences showing movement of birds and buffaloes as a way of seeking, asking, who are we? At the tape's end, as a way of reaffirming the power of the mind, we see a view of Solomon Islanders walking on fire.

In his 1983 installation *Room for Saint John of the Cross,* Viola focuses on creating a metaphor for understanding the mind's capacity to escape the confines of any restrictions. He places within a larger room containing a black and white landscape with sound, a miniaturized reconstruction of the cell where the seventeenth century Spanish mystic, St. John, was imprisoned

Figure 107. Nam June Paik, *Family of Robot* Video Installation, Holly Solomon Gallery, 1986
Paik, long recognized as elder statesman and key figure in the history of video art, has
explored every aspect of the medium as seen from his witty and unique Neodada Fluxus
stance. In this installation, his two video sculptures present the idea of T.V. as part of history
by the arrangement of a collection of vintage television sets like a triumphal arch, a signal
between T.V.'s past and a poetic claim to its arrival and its future. The work becomes a
celebration of the video medium itself.
(Courtesy Holly Solomon Gallery; Photo: Adam Reich)

for his heretical beliefs. Viola helps the viewer to realize that St. John continued to write his ecstatic poetry despite confinement. On a tiny T.V. monitor within the enclosed cell, a small color image of the mountain is shown with a voice-over of the monk's verse in Spanish. The installation has all the deep resonance of a Bill Viola masterpiece.

Today, video represents an astonishingly diverse range of ideological viewpoints, stylistic currents, and interpretations of aesthetic issues. Many artists whose major medium is painting or sculpture, theater or dance have made videos a natural crossover for their art ideas (e.g., Robert Wilson, Merce Cunningham, Robert Longo, Laurie Anderson, and David Byrne). This diversity was reflected in the important 1985 and 1987 Whitney Biennials where, relative to the other art forms represented, large numbers of video works were featured. Works ranged from figurative to nonfigurative, using animation and image processing, and the use of autobiographic and diaristic formats. Issues often involved investigation into the meaning and relationship of word and image as they relate to representation itself, and explored through interpretations of historical and political texts and events. These were strong commentaries on the media itself and on the forms and styles appropriated from it. Some restate mass-media style directly or simply appropriate its entertainment format and mix it with other vestiges of popular culture, such as Lyn Blumenthal's two-part *Social Studies*.

Image processing and glossy high-tech style characterize many video works which rely on electronic effects and computer-controlled editing such as Woody Vasulka's *The Commission* or Joan Jonas's *Double Lunar Dogs*—a science fiction parody with eerie lighting and spacy music. Others, like the Yonemoto's, quote pseudo-psycho narrative to show the hollowness of their characters. Doug Hall's *Song of the 80s* presents brief, high-concept vignettes which convey anger and meanness below their glossy surface. He captures the look of media slickness with terrifying accuracy while exposing its rules and its strategies.

Installation works are a major interest of many artists. Judith Barry's *Echo* uses a video projection device to focus sound and image in unexpected places where the viewer is least expecting to receive a message. Some installation works combine video and film, others like Shigeko Kubota's consist of sculpturelike video objects. Bucky Schwartz combines his interest in perceptual problems into a work which intrigues the viewer into a balancing act of discovering relationships between all the parts. The rich possibilities offered by multichannel video walls have by now engaged the serious attention of important video artists: Nam June Paik, Mary Lucier, Dara Birnbaum, Marie Jo LaFontaine, and Gretchen Bender.

Exhibitions which are not video-specific integrate video as an important aspect of their theme development, such as the Sexual Difference exhi-

Figure 108. Bill Viola, *Room for St. John of the Cross,* 1983
Video installation.
A black cubicle with a single illuminated window stands
in the center of this video installation work. Inside the
tiny lighted room, which is filled with amplified sound,
is a small color monitor that transmits the same
mountain view projected in black-and-white on the
larger wall screen of the room.
*(Collection: Museum of Contemporary Art, Los Angeles;
Photo: Kira Perov)*

bition at the New Museum. While exhibitions of video installation works such as the 1984 Stedelijk Museum show are costly to mount, single channel videotapes can easily be shared by mail. An indispensable network of international festivals, conferences, and distribution centers has grown as a video support system and cultural circuit. Video is also shown actively in a wide range of alternative settings such as rock clubs and libraries as well as on cable and public television. For example, the Palladium, a converted movie house which features art works by well-known artists Haring, Basquiat, and Scharf, has made a strong impact on New York night life. It commissions artists to make videos for its huge video walls—25 monitors in a 5 × 5 block that is lowered up and down over the dance floor in time to the pulsing music and the computerized lighting ambiance.

Many institutions have ongoing video collections and exhibition programs. Video research centers exist at the Paris Centre Georges Pompidou, the Amsterdam Stedelijk Museum, the New York Museum of Modern Art, the Whitney Museum of American Art, the California Long Beach Museum, the Boston Institute of Contemporary Art, the London Institute of Contemporary Art, the Vancouver Art Gallery, and the National Gallery of Canada, Ottawa.

Participating in an Electronic Public Dialogue: Strategies for Some in the Eighties

According to Marita Sturken, video critic and writer, "Network television as we have known it is slowly becoming obsolete. Vast, expensive, centralized, inflexible, it is the dinosaur of the 1980s and 90s gradually giving way to an electronic entertainment industry that includes multiple channels, increased distribution via satellite, home recorders, and, for viewers, a radically new element of choice."[20] Economic forces of distribution and technology are prime factors in the state of commercial transition that is currently taking place. Although much of the guiding impulse for early artists' video experiments in the 1970s grew out of a rejection of the monolithic warp of U.S. commercial television, there is no doubt that many of the new models they created outside of its mainstream were absorbed and eventually reflected in T.V. production, editing, image-making styles, and new imaging tools.

Video artists in the eighties are posing new questions. These grow not only out of changes in the T.V. industry itself, but arise also from new Postmodern conditions, attitudes, and issues which are altering artists' view of television and their future challenges to it, at a time when video has become an increasingly accepted medium. Exploration of some of these issues involve distinctions between mass culture and high culture; their

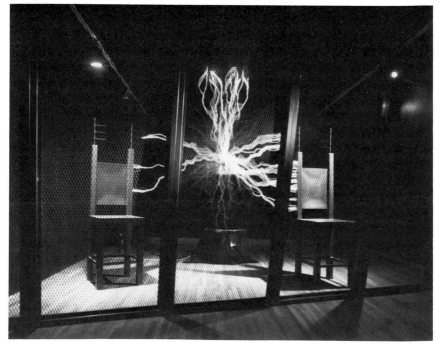

relation to a growing thrust towards democratic populism in the arts and how they might change the function and parameters of art through a more public cultural dialogue. These interests coincide with expanded viewer choice. As some video artists take up the challenge to work within the construct of the T.V. industry as a broader forum, they are unsure how it will change their art. The issue of "what is art" is raised whenever a new technology radically penetrates cultural constructs.

It is always the serious intentions of the artist which separate popular film from the art film, the popular novel from the more serious poetic work, pop music from symphonic, the Broadway musical from contemporary dance and opera. Although critical distinctions are made between these forms as to their popular or art intentions, the public perception is that they are democratically available by tuning into them via libraries, radio, cinema, or T.V. Their cultural value is as special relatively inexpensive forms of communication, not as material objects to be bought and sold. In the visual arts, the perception that art is a precious unique object to be sold to the highest bidder is a concept that became common only following the Renaissance, and has served to create far greater barriers to the perception of painting and sculpture, for example, as elitist rather than as popular forms. The hierarchical conditions set up by the museum and commercial gallery system for validating the most important "art" has further set up strong distinctions as to what is popular or mass art, and what is high or elite art. Video is becoming a crucial testing ground in what is now becoming a major debate in the visual arts between "art as object" and art as "dematerialized" communication of ideas.

Testing of popular forms in mass media culture and reacting to the negative influence of T.V. media on society are now issues for many artists who wish to produce work that can find a wider audience beyond the "high

Figure 109. Doug Hall, *Songs of the 80s,* 1983
 Color videotape, 17 min.
 (Photo: Jules Backus)

Figure 110. Doug Hall, *The Terrible Uncertainty of the Thing Described,* 1987
 Three-channel video installation with sculpted elements.
 Interested in contrasting powerful documentary images of natural meteorological phenomena with concepts of our alienated experience of a world of our own making, Hall has curated an installation where the theatrical artifice of man-made lightning is evoked intermittently. In his installation work *The Terrible Uncertainty of the Thing Described,* two large chairs and a ten-foot-high mesh barricade loom out at the viewer, hiding the existence of a Telsa coil which emits a large bolt of electricity at random points when the monitors depict extreme natural turbulence.
 (Photo: Hansen/Mayer)

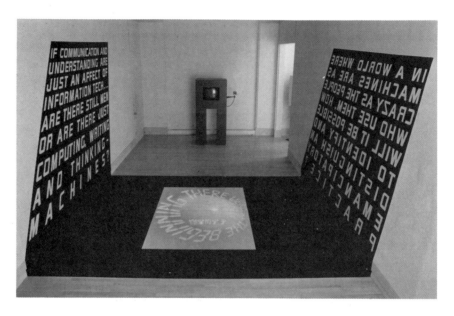

Figure 111. Judith Barry, *Maelstrom* (Part One of a Multipart Video-Environment Work), 1988
Video-beam projection installation shot from Whitney Equitable.
In her installations, Judith Barry uses video cameras, monitors, and projection systems to explore aspects of our media-ridden consumer economy. She is fascinated by the way these systems function and the way they communicate with our private and public selves and how we are potentially controlled by them. In *Maelstrom,* she creates a video environment through the use of a video-beam projector installed in the ceiling. It projects on the floor where the viewer steps, flanked by two large panels displaying texts as questions. The welter of images engulf the viewer while demanding interaction through a process of decoding the meaning of the messages displayed. The installation raises questions about real communication in relation to the information spewed out by electronic-media systems. *(Courtesy Judith Barry)*

art'' museum context. Their work often appropriates some existing ''corporate style'' formats from the T.V. media—news, sports, soaps, and sitcoms—but use their direct quotation and stylistic influence to create new structures.

> Some restate mass-media style directly, whether to critique it or simply borrow its familiarity and emotional force for different ends, while others incorporate elements of media style into new syntheses in which art, video, film, and the ''entertainment values'' of popular culture are mixed together. . . . The media look that some of these works use is a style that's explicitly, self-consciously ''attractive.'' It alludes to the flawlessness of fashion photography, the perky zest of ''happy news,'' the posturing of MTV, the seamless manipulation of desire in advertising. It's a style that insists that you like it, that uses its seductive gloss to bludgeon you into buying this product, watching that show. . . . Media influence is expressed (also) through the superslick, high-tech style adopted by many of the works. The most obvious components of this style are the electronic effects and computer-controlled editing.[21]

Driven by synthetic rock soundtracks, glossy style, high-key lighting, and simplified plastic-colored graphic images, the new populist videos capture the media slickness of the eighties while commenting on it. Charles Atlas's *Parafango* and Ken Feingold's *The Double* are good examples of catchy T.V. images used as a form of collage to state very different intentions. The work grows out of a sense that a continuum exists—a circular relationship between T.V., which makes the public, which in turn makes T.V. Some artists see themselves as one of the links in the exchange.

Is the Avant-Garde Ready for Prime Time?

The traditions of ''high'' culture have always maintained a distance between artist and viewer. For example, a painting is designed to be seen by a primary audience of single individuals in a gallery, museum, or home. It needs specialized contemplation and interpretation and may not be understood. Unfamiliar ''difficult'' language has been used to frame the artist's vision and communicate its autonomy and independence. The painting is not conceived for mass viewing or reproduction, whereas film is specifically designed for a simultaneous mass collective viewing experience to be seen by thousands in large cinemas. Responses to film experience are designed along pathways and sequences organized to demand direct, immediate personal response from audiences. Film is designed for reproduction to reach as large a viewing public as possible. Early experimental works produced at the television labs by artists coming from the visual arts traditions of painting and sculpture were utopian in their dream of reaching out to attract a broader audience for their art on broadcast T.V. because they had no experience as yet in designing work to be seen by mass audiences. Yet

they wanted to obliterate mainstream parameters of the medium, not just stretch them. They looked to the promised development of smaller cable networks as a way of reaching more specialized audiences. However, these hopes were dashed by the late seventies when it was revealed that cable, too, had essentially been bought out by commercial interests.

By the early 1980s, a few artists—Dan Graham, Dara Birnbaum, and Richard Serra among them—came to the realization that unless a work was specifically made for T.V., by addressing the specific conditions and needs of an audience not made up of gallery-going specialists they could not begin to free the weight of their art from its high cultural practice to reach a larger audience. Bertolt Brecht, struggling with the same problems of interpretation in the thirties, had argued "truth not only had to be beautiful but entertaining."

Artists put themselves at risk through evaluation of their work by a nonart public in a T.V. framework that offers no special museums or gallery ambiance. Risk also lies in the possible eventual contamination and co-optation of their ideas or compromise of their methods by a powerful, inflexible system which normally assigns editorial control to business executives rather than autonomous individuals. Artists searching for a more public forum must create a consensus for ideas, in order to intelligently layer intentions and arguments within a given work in order to shift old perceptual habits of viewers to alternative ground. It involves the concept of working within the system for change rather than from the outside. Just as the art world has its traditional institutional boundaries, such as the private collection, the gallery, and the museum, so does the world of broadcast television. These boundaries are defined by its programming formats, style of presentation, institutional setup of networks, channel distributors, and programming demands. For one to penetrate the other is so far extremely problematic.

To date, among the increasingly broad groupings of artists working in the video field, those who produce low-cost documentary or educational productions are closest to being able to subvert T.V. by creating a commentary in an accessible style which has "a certain look"—i.e., immediately recognizable hooks—to attract the average distracted viewer who has no inclination for art world poetics or polemics. Access to the public already exists through nonprofit public cable stations which, like New York's Channel "L" and Global T.V., are located around the country in most urban centers. Downtown Community Television has a special free training program oriented to expanding the use of media tools directly for those who wish to use them in the community.

One of the most striking examples of artists who have used video directly and whose work has been successfully shown on broadcast T.V. in

Europe is Jean-Luc Godard, the well-known avant-garde French filmmaker. He has always seen his ideas and his goals as being conjoined in subverting the broadcast medium to create new cultural debate and meaning. He illustrates the relationship between its structure, its economics, its social relations, and its use as an instrument of repression. He has always been aware of the loaded, hidden agenda of images and his public forum for the use of them with words or captions or words standing in for images has been an important strategy in his television work. In *France/détour/deux/ enfants,* he explored the specific relationship between mass media and his avant-garde work in film.

Can the avant-garde successfully participate in a public T.V. forum for its work? From among the many strands of new artists attracted to video coming from traditional documentary, performance, film, and visual arts, there is a new breed whose background is less in the traditional academic discipline of art but comes rather from film or T.V. studies. Their concepts and vocabulary are oriented to the more public cinematic and media forms.

Due to the intense amount of viewing (50 hours per week is average), audiences themselves have become more sophisticated in their ability to understand complex story structuring such as flashbacks and dream sequences, highly metaphorical dreams and fantasies, and dealing with half a dozen interwoven stories, some left unresolved. Music videos have accustomed viewers to surrealist image sequences and editing tied completely to the rhythms of music.

The miniseries has introduced a new genre of epic storytelling made practical and possible only through the agency of the T.V. home entertainment center. Werner Fassbinder (*Berlin Alexanderplatz*) and Ingmar Bergman (*Scenes from a Marriage*) were among the first film directors to seize the challenge of creating extended films which could be seen in segments made popular as a genre by television viewing. This new approach to the extended narrative as epic introduces an important new aspect of communication which lies outside of commercial cinema showings where such long viewings are impractical.

Given the new conditions of Postmodernism (where traditional distinctions between genres are melting away and the need and growth of communications are at an all-time high), the strong desire by audiences for program options, the T.V. industry's diverse growth and transition, the valuable learning experience gained through models of past mistakes and gains, and the broadened base of video practice (which now includes many genres), an opening to the future for a vital new public television art could eventually develop. The struggle to break down barriers, find funding, and attract new audiences are bound to engage artists well into the next century.

Figure 112. Jean-Luc Godard and Anne-Marie Mieville, *Six Fois
Deux (Sur et Sous la Communication)*, 1976
Still frame.
*(Courtesy Electronic Arts Intermix; Photo: Marita
Sturken)*

Figure 113. Frame from *Six Fois Deux*

Figure 114. Frame from *France/tour/détour/deux/enfants,* 1978
Jean-Luc Godard's work is designed to raise questions
about the relations between the media producer and the
viewer. In the works shown here he sets out polarities,
drawing distinctions from the way information is
presented to the public. He inserts these questions over
a live news report to dramatize the dynamic questioning
of the power in mediating or editing information. He
tries to reveal the hidden economic and ideological
assumptions in media presentations by "professionals"
who are "just witnessing an event"—but who claim not
to bring to it any bias of their own or of their producers
or of the media network carrying the report. He asks
questions about the currency in photographs: Who pays
and who doesn't? What is the monetary value of news
photographs colonized by photographers who benefit
monetarily from their images of disasters—of wars,
terrorist attacks, victims, etc.? He asks questions about
captions, who writes them, and how they can be
interpreted.
*(Courtesy Electronic Arts Intermix; Photo: Marita
Sturken)*

Influence of Independent Film on Music Video

Recent appropriation by popular music video of the legacy of visual ideas and poetic techniques used in early experimental independent film and video is testament to the influence of these genres. Recent rock videos have, for example, freely raided ideas from such films as *Un Chien Andalou, Blood of a Poet,* and *Scorpio Rising.* To borrow from Nam June Paik's analysis: If two drawn circles are shown to overlap, the first representing independent film (with its crossover roots in both film and the visual arts traditions), the second representing T.V., the overlap can be seen to be video with influences from all these circular areas resonating one with the other.

The new generation, turned to music television (cable MTV or network broadcasts) or to videotaped[22] versions of the latest music/dance productions, is growing up on a steady daily diet of co-opted editing and shooting techniques, an extraordinary vocabulary pioneered originally by independent filmmakers. Though vulgarized and commercialized, the popular music video form is being elaborated and propelled by a broad front of new innovators. In a sense, music video has "upped the ante" in the dilemma about artists' access to television. Commercial co-optation and promotion of music video can or may create popular acceptance of avant-garde innovation; but it could also trivialize, consume, control, and corrupt the independent artist's voice. To work in more commercial areas, artists have always had to give up the "pure" aspect of their work.

The problem is that music television isolates visual ideas and techniques out of the context of their artistic application within coherent statements. Bill Viola remarked:

> The thing about the industry that I resent very much is that they're into the business of image appropriation, images as they relate to fashion, and fashion as it relates to capitalist economics ... like a fashion designer from Paris going into Central Africa, not caring about the culture or cosmology of the people, just looking at decoration on spears so they can take them back and make a lot of money. . . . As experimental as people like to think music video is, the little parts of it that are experimental are also being consumed by the system. In only two years it's as pat as the standard dramatic narrative structure. And unfortunately, for a lot of people, it has become their avant-garde experience.

The conglomerate control by record companies and T.V. industry financing allows little chance for independents to create works which go beyond the usual sexual titillation and "star hype." A few more mature recording artists with enough vision and clout to gain control of their productions have realized important videos. For example, David Bowie's *Ashes to Ashes* (1981) presents haunting views of identity changes where gestural

choreography and camera presence suggest mysterious rites of passage, psychological alienation, and the mystical isolation of the self. David Byrne's "Talking Heads" group and Peter Gabriel have also explored important themes about alienation and contemporary artificiality: the loss of instinct and anima; the confrontation betwen dream and action; the sense of living out of time.

Interdisciplinary performance artists such as Laurie Anderson and David van Tiegheim whose work integrates theater, dance, and music are making highly developed, coherent contributions to artists' music television. Laurie Anderson's mature vision represents a developed critique of the politics of contemporary life and of technology. In *O Superman* and *Sharkey's Day*, she has created work which exploits the qualities of the T.V. medium. *Sharkey's Day*, a reenacted performance by Bauhaus choreographer Oskar Schlemmer (and dedicated to him) is a reflection on Nature and Art, Man and Machine, Acoustics and Mechanics. It is designed to demystify technology just as much as it comments on its influence. Although Anderson produced her work with state-of-the-art-electronic technique, she always employs simple elements to create sophisticated effects, e.g., using a light projection as a way of creating a huge shadow as in *O Superman*, or, a slide wipe made of cardboard coins and a string as in *Sharkey's Day*. Laurie Anderson's successful work as a performance artist, with feet in both popular and avant-garde camps, is now an international phenomenon.

David van Tiegheim, working with John Sanborn and Kit Fitzgerald, has constructed dance performance videos which encompass the streets themselves. Electronic visualization techniques and elaborate high-tech postproduction are pursued more and more by video artists as integral aspects of their approach to developing a new vocabulary of images.

Some artists use the brief intense visual music format ("operatic cinema") as a base for works which do not as yet reach such a wide audience, but are important for their experimental contributions to its form. Max Almy, Bill Viola, and Michael Smith are artists whose videos, although they are not specifically made for T.V., embrace both the museum context and television. Could public taste gravitate from MTV, once there is a realization that there are other kinds of things to look at—and in the process, discover the type of work that is normally found only in museums (usually considered a place for multiple viewing of art)? Most music videos are dull, have no soul, do not sustain repeated viewing unless they are the work of someone like Zbigniew Rizbczynski who has unusual vision and a vast technical skill.

It is possible that the very nature of T.V.'s multiple viewing presentation of music video encourages more absorption of meaning than a museum or gallery can. Some music videos because of their extremely compact format may require a number of viewings to absorb all their I.P.M.'s (ideas per

minute). The sheer exuberance and innovation of music videos makes them viably interesting. Many high-budget productions are originally made in 35mm film[23]—consciously encouraging the concept of a minimovie style or "look." The pressure of changing technologies and a different aesthetic climate is bringing about a new relationship between film and video.

Although it cannot be classed as music video, Robert Ashley's visual opera *Perfect Lives* has been produced as a 3½-hour video and was shown on Britain's Channel Four in 1983. Five years in the making, the T.V. opera was composed by Ashley and visually produced by John Sanborn and Dean Winkler. Its seven half-hour episodes are based on repeated "visual templates." These structure and illustrate the story of two traveling musicians who finally arrive at the last whistle-stop, a contemporary "Our Town, USA." As composer-librettist Ashley sees it, *Perfect Lives* is meant as a comic opera—a curious metaphor for the Tibetan *Book of the Dead*—as a prayer spoken into the ear of a corpse to speed it through the seven chambers towards reincarnation. Ashley worked closely with Sanborn who developed the concept of visual templates as a structural foundation for the piece corresponding with each of its seven episodes.

Before production began, Sanborn and Ashley worked on the overall visual concept of the work based on an agreed-upon interpretation of the libretto. Sanborn used a 3/4-inch deck and an inexpensive camera for shooting the images which were later image-processed and color enhanced by Winkler. Sanborn designed a visual "overture" for the opera's opening sequence by combining all seven visual templates. In one section, which allowed for a radical compression of time from 28 minutes to one minute of visuals, Winkler devised a way of recording and rerecording the tapes fast forwarded at three times the normal rate each time until the images were radically compressed.

Perfect Lives required an enormous amount of funding and support over the years and involved high levels of collaboration on all fronts—financial, conceptual, technical, as well as in performance talent. It began as a video opera performance suggested by the Kitchen Center for Video and Music and evolved into an opera for television though additional encouragement, broad-based funding, and expertise. It is an example of how the lure of high-tech for postproduction of some artists' video works is straining the budgets of many arts support organizations.

Another aspect of video combined with opera form is Miroslaw Rogala's innovative video opera installation presented at the 1988 Chicago International Art Expo. This complex production features a five-channel sound, programmed multiscreen Videowall, with live dance and performance elements. Entitled *Nature Is Leaving Us,* its theme is the destruction of the ecology by human misuse of technology. The video installation in-

cludes 14 parts, each of which portrays a different aspect of contemporary life: birth—arrival; life—movement; death—leaving and absence.

Video in the Eighties

Live via satellite from New York, Paris, and San Francisco, Nam June Paik's interactive television broadcast celebrated not only the dawn of a new year (1984), but a new direction for video. His *Good Morning Mr. Orwell* was seen throughout the North American continent, Europe, Japan, and Korea as a form of what he termed "global disco." The piece, a collaboration of many artists and broadcast facilities, was meant to refute the "Big Brother Is Watching You" auguries made famous by George Orwell's *1984* as they relate to media. Paik explains: "Orwell only emphasized the negative part, the one-way communication. I foresee video not as a dictatorial medium, but as a liberating one. That's what this show is about, to be a symbol for how television can cross international borders and bridge enormous cultural gaps ... the best way to safeguard against the world of Orwell is to make this medium interactive so it can represent the spirit of democracy, not dictatorship."[24] Paik's excitement about global satellite communications as a real time live international performance work is also found in works by other artists such as Douglas Davis and Don Forresta, who have used real-time television broadcast systems as a locus for their work.

After a three-year process of assembling the necessary international funding and sponsors, Paik masterminded a complex program that mixed diverse aesthetics—pop and the avant-garde, superstars of rock-and-roll, comedy, avant-garde music and art, performance artists, surrealism, dance, poetry, and sculpture. John Cage played amplified cacti, Laurie Anderson presented her new music video, Charlotte Moorman performed on Paik's T.V. cello, surrealist painter Salvador Dali read poetry, and French pop star Sappho sang "T.V. will eat our brains." Host George Plimpton presided over the array of global interactive events with all the aplomb of an avant-garde Ed Sullivan despite technical hitches due to the show's "live" international satellite format. Paik's decision to create an interactive broadcast which challenged technological structures derives not only from his knowledge of the medium and what it represents, but also from his usual risk-taking sense of fun. "Live T.V. is the mystery of meeting onceness," he said. In 1986, he produced *Bye-Bye Kipling,* jumping live via satellite communications networks in real time from Tokyo and Seoul to New York as a way of challenging Kipling's East and West dictum: "Never the twain shall meet." In 1988, he produced *Wrap around the World*—an Olympics tribute, broadcast live from three continents. Paik worries about how people perceive each other in a world that television is constantly reducing to the

long-promised (or threatened) "global village." His ultimate goal is to set up a gigantic television screen in Times Square and one in Moscow's Red Square that would allow the citizens at either point to talk to each other 365 days a year. "It will cost one-millionth of Star Wars," he argues, "and be a lot more effective." Television *sans frontières* is rapidly becoming a formidable new reality due to new satellite broadcasting and receiving technologies. According to the August 1988 (British) *Economist* headline, "All the world's a dish."

As one of video's earliest gurus, Paik's work spans the 25-year history of video as an artist's medium. The first exploratory generation of video artists, primarily sculptors, performance artists, and painters who carved out the "low-tech" beginning direction for the medium in the "high art" context of museums and galleries, has given way to a new generation whose work is governed by different aesthetic intentions and by major technological advances in equipment and special effects processing. Although some of the early pioneers gave up the medium around 1978, discouraged by financial, technical, distribution, and access problems, early artists such as Paik, Dan Graham, Joan Jonas, Juan Downey, the Vasulkas, Bruce Nauman, and many others have matured in the medium and have helped in defining its shift towards new territory.

As an artist who has effectively used the multichannel video installation form combined with still imagery, Dara Birnbaum stands out for her forceful exposition of television's hidden agenda and manipulation of public consciousness. She uses as texts a vivid fusion of T.V. commercials and popular news programs. To exhibit her 1982 work *P.M. Magazine*,[25] she papered the museum walls with enormous 6' × 8' still photographs and set five monitors into the panels in an architectural environment dramatically lit to create an artificial videolike luminescence. The effect she achieves is to surround the viewer literally with the media, a headlong plunge into it—as an invitation to examine critically our relation to it. The densely layered images on five monitors are hypnotically repeated and manipulated against a raucous background of rock-oriented music to articulate the alienating influence on the human psyche of messages appropriated from commercial television.

An impressive number of diverse women's voices are represented in video today (technological media have traditionally been dominated by men): Mary Lucier, Dara Birnbaum, Max Almy, Laurie Anderson, Sherrie Millner, Barbara Buckner, Eleanor Antin, Judith Barry, Ardele Lister, Margia Kramer, Lyn Blumenthal, Joan Jonas, Martha Rosler, Sarah Hornbacher, and Carol Ann Klonarides are a few of the best known, although there are thousands of others in the field creating a variety of work representing alternative perspectives.

Figure 115. Dara Birnbaum, *Damnation of Faust, Evocation,* 1983
Color-video installation.
This image from Birnbaum's poetic evocation is one of
several set into a large wall installation as a sculptural
aspect which completes her concept. Using Faust as a
point of reference, a touchstone, Birnbaum presents a
haunting contemporary reading as in this children's
playground scene. Her piece is highly structured while
evoking free-flowing associations.
*(Courtesy Electronic Arts Intermix; Photo: Dara
Birnbaum)*

Two recent exhibitions featured the video work of well-established women artists—Revising Romance: New Feminist Video (a traveling exhibition organized by the American Federation of the Arts) and Difference: On Representation and Sexuality (a traveling show originating at the New Museum of Contemporary Art, New York). Although the intentions of both shows were different, they were both based on the premise that there is a specifically different outlook and aesthetic related to gender issues and the way social and cultural issues are perceived. The New Museum exhibition explored the question of sexual difference and emphasized psychoanalytical approaches to discussing art. The AFA show broaches the issue of romance—a subject associated, of course, primarily with women—and asks, in effect, what are the psychological, political, and aesthetic consequences of popular ideals of eternal passion and transcendent love? Stereotypical sexual roles are addressed through these tapes which portray the use of romance in popular culture.

Although often marginalized as avant-garde video, or as a minority voice in a male-dominated culture, the work of many women video artists continues to be an exploration of the mythologies and stereotypes, the economic and social realities that form the content and perception of female experience. Ranging in style from low-tech grainy images to the high-tech gloss of expensive postproduction collaborations,the work is diverse, intelligent, and provocative. Artists who raise issues that the dominant culture has suppressed—women, minorities, gays, political activists—face difficult problems of access to equipment and funding to support production of their work.

High-Tech Collaboration

Some recognized artists are able to put together enough funding for complex projects that involve high-tech collaboration. Recently, Dara Birnbaum received a large grant which she used to gain access to the expensive world of a commercial postproduction video house where special-effects tools for state-of-the-art electronic and computerized effects are available. Artists' access to these special-effects tools represents access to extensions of video's visual vocabulary. For her most recent work, *Damnation of Faust: Evocation,* she collaborated with well-known New York video editor John Zieman who served as the work's postproduction supervisor and coeditor.

Instead of using "found" or appropriated T.V. images as in previous work (such as *PM Magazine*) Birnbaum chose to shoot her unstaged images "live" in a fenced children's playground. The new work has a different style and range. She worked with the technical limitations of a one-tube camera to create the unreal special mood and lyrical quality of the piece. As she

Figure 116. Aysha Quinn and John Sturgeon, *Nomads*, 1986
Color video, 26 min.
Nomads is an exploration of the wrenching aspects of
change measured by contrasting the distance between
the Anasazi civilization and a contemporary
autobiographical experience of it by Quinn and
Sturgeon. They employ the conventions of the home
movie with electronic image manipulation to mediate
this distance. Their attempt to probe the balance
between mundane material reality and dreams, hopes,
and spiritual vision brings their work into the central
arena of contemporary existence.
(Courtesy Aysha Quinn)

explained: "I love to shoot but I'm not an experienced camera person. Zieman advised me not to use my budget to rent an expensive camera, but to save the money for postproduction. . . . (He said to) use my own single-tube camera, push it to the limits and take advantage of that single tube, knowing it can't give realism. A lot of what looks like special effects in *Faust* were actually done in the camera."[26] *Faust* is a layered, highly structured three-part work which uses its centuries-old theme simply as a touchstone in an evocation of a free-floating memory and a shifting dream of loss and change in the contemporary world. Zieman worked closely with the artist during the entire project by getting to know her ideas and footage and suggesting some of the final editing process. Birnbaum's multichannel installation was exhibited at the 1985 Whitney Biennial.

The Future of Video Is Projected and Interactive

Although large-scale video projection capability has been promised for some time, the newest and most startling technologies clearly indicate that big-screen video will soon seriously challenge film projection. Coupled with Japanese development of HDTV[27] (High-Definition Television), the new generation of screens—which can receive live broadcasts, video tape and disk playback, or live transmission—provide impressive scale, brightness, and resolution.

Sony's Jumbotron, the world's largest T.V. and video display screen, 82 feet high by 131 feet wide, can receive both HDTV as well as standard NTSC signals. The screen (10,000 times the size of a 20-inch T.V. monitor and 30 times brighter) is composed of 150,000 high-luminance "Trini-lites"[28]—red, blue, and green light-emitting devices. Instead of being scanned as in standard T.V. technology, the entire field of 6300 groupings of 24 Trini-lites is excited at once by digitized video signals transmitted via optical cables. This technology offers impressive brightness. Jumbotron's picture is clearly visible in broad daylight even at a distance of 500 yards. The control room also contains cameras, monitors, an editing system, switchers, VTRs, 3/4-inch and Betacam VCRs, and character generators used in the preparation of news reports. On-site live broadcasts feature live views of the spectators themselves projected on the giant screen. Other marvels include three-dimensional T.V. (without glasses); 10' × 14' liquid-crystal T.V. display panels, and large multiple video monitors for multi-image shows controlled by computers and interactive videodisks.

Rapid development of large-screen video projection facilities is creating a convergence, a crossover tendency between film and video (see the Appendix). The large screen installation encourages a theaterlike context for video viewing (instead of the small, often badly tuned monitors found

in gallery exhibition settings). High-definition T.V. and liquid-crystal display units are bringing image resolution to the level of 35mm film quality. As a result, changes in international standards for broadcast image resolution are under serious discussion. Eventually, home T.V. receivers of the type in use today will have to be modified or scrapped.

In a purely technical sense, the history of video as a medium can be seen as a history of its gradual convergence with the medium of film by offering further control over optical effects, motion, and time; improved audiovisual storage, editing, and resolution; and finally, projection possibilities on the scale of theater events.

A More Public Discourse

Uses of compressed, intensified images and messages characterize the shift to diversity and pluralism of the Postmodern. Instead of dealing with the specific, video artists are appropriating "found styles" and formats from mass culture—replete with their widely known and understood cultural references and meanings—to create new "structures of meaning" by quoting from well-known media sources. This direction is opening toward open engagement with influences from the medium of television itself in the contemporary movement towards trying to establish a more active dialogue within mass culture as a whole. As yet, although video is a "mass media" tool, the projects most artists have produced with it are still not mass audience works. The major aesthetic impetus of the eighties is, however, to comment on the influence of mass media by reacting to it, quoting from it, and seeing everything in relation to its perspectives.

Video raises questions about mass audience works, for whenever new technological media deeply infiltrate communications structures they both influence culture and raise questions about the nature of art itself. Its expanded technologies open up radically new options for image-making and communication.

> Postmodern art is characterized by its involvement with new media which cross the traditional boundary between art and life. This is manifested in such trends as crossover, populism and performance. The significance of Postmodern art is in its move away from private aesthetics, and personal expression and representation, toward an actively communicating public aesthetic.[29]

Video is a medium which strongly engages these theoretical and aesthetic issues in the relationship between the media and art-making which are at the very heart of Postmodernism.

Figure 117. Dieter Froese, *Not a Model for Big Brother's Spy Cycle (Unpazise Angaben)*,
1984
Installation diagram, 8 1/2″ × 11″.
(Courtesy Dieter Froese)

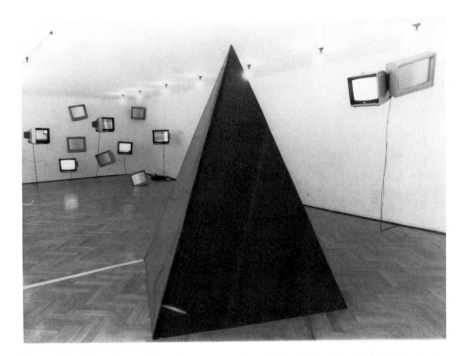

Figure 118. Dieter Froese, Bonn Kunstmuseum Installation of *Not a Model for Big Brother's Spy Cycle*

In his extensive gallery-wide installation, Froese combines closed-circuit television with a two-channel pretaped video work, using both real and dummy surveillance cameras and monitors. Walking up the stairs through the corridors and into the gallery space, the viewers become aware that they are part of a spectacle while they are also watching individuals being questioned about their political activities. Froese's intentions are to create a situation where the public postures and private lives of the viewer are observed and heard throughout the gallery spaces. Avoiding simple parody, he comments on video as a surveillance tool.

(Photo: Kay Hines)

Figure 119. Nic Nicosia, *Domestic Drama #7*, 1983
Cibachrome, 40″ × 50″.
(Courtesy Nic Nicosia)

Figure 120. David Mach, *Adding Fuel to the Fire*, 1987
Installation using magazines and objects, Metronom,
Barcelona.
*(Courtesy Barbara Toll Fine Arts Gallery; Photo:
Anthony Critchfield and David Mach)*

7

Future Currents

But a storm is blowing from Paradise; it has got caught in his wings with such violence that the angel can no longer close them. This storm irresistibly propels him into the future to which his back is turned, while the pile of debris before him grows skyward. This storm is what we call progress.

Walter Benjamin

The Modernist/Postmodernist paradigm we have been examining shows the relationship between technology and art. It has become clear that while new technologies directly extend the possibilities for representation and tend to create new art forms, it is their influence, their palpable intrusion into every phase of cultural life, which releases a new dynamic whose force and direction is almost impossible to predict. The unprecedented new electronic technologies for image-making provide a potential which poses more questions than it answers for the future of art.

Predicting the Future

As yet, though we live in a culture in which images are the dominant currency of communication, we have been unable to form an adequate picture of the future. Despite the new electronic power to create instant image flow, the ability to see the more diffuse Postmodern connections within cultural, social, economic, and political life has become more difficult. It is harder to visualize a multinational identity than a local entity. We can only see the world by forming a picture through various specialized mediations.

The times too, are unprecedented, for we no longer accept a single notion of history as progress. There has been a sea change. Old familiar structures have either disappeared or become problematic and we have no

unified structure to replace them. The great narratives of enlightenment have failed to fulfill our expectations of a perfectable world. We now lack a convincing vision. Without a linear structure of historical process to build on, many are pessimistic. Utopian dreams are viewed cautiously today.

The actual future is ultimately unknowable. Yet in each era of human development science fiction and futurology have provided imaginative insights into how people thought about social and technological change in their era. In fact, we are heirs not only to a wealth of utopian polemics and a vast science-fiction literature but also to a special genre—a history of predictions about the future. Thomas More's *Utopia* written in 1516 evoked a view of man as an integrated part of nature. In the second half of the nineteenth century, Jules Verne and H. G. Wells, passionate in their social commitment, popularized the genre of science fiction. In more modern times, science fiction has reflected widely differing ideologies and points of view about the future. For example, American science fiction tends towards the dystopian and is often played out against mystical, violent "Star Wars" images of regressive totalitarianism. Typical of Soviet science fiction is Efremov's highly literary "Andromeda" which provides a utopian view of a socialist future. Feminist scholarship has revealed that the rhetoric of technological mastery and conquest in Western science fiction has been stereotypically masculine. Feminist writers imply that intrinsic to the ideology surrounding technology is the sense that the future would be controlled by men. The feminist movement, however has turned to science fiction (writers such as Ursula Le Guin and Joanna Russ) as a tool for creating a vision of the future and for dramatizing an open, egalitarian society.

There has been a long succession of universal exhibitions fairs since the first one in 1851 at the Crystal Palace in London. These have promoted similar glowing pictures of the future based on demonstrations of astonishing new technologies and their relationship to progress. Fairs in 1939 and 1967 stand out as being high-water marks in the feeling they generated of hope and euphoria for the future before there was again wrenching proof of technology's ability to expand negatives as well as positives. The more we have lived with technological conditions, the more we have learned difficult lessons. How can we reap its benefits while dealing with its dangers? "Our life is half natural and half technological," comments Nam June Paik. "Half and half is good. You cannot deny that high-tech is progress. . . . Yet if you make only high-tech you make war. So we must have a strong human element to keep modesty and natural life."

Exhibitions about the Future

Several recent New York exhibitions have chosen the future as subject matter for interpretation. Sometimes the future is presented through a juxtaposition of images past and present, sometimes as an analysis of past exhibits dealing with the future. The Clocktower Gallery of the Department of Art and Urban Resources has been the site of both kinds of exhibitions which explore the future. In the 1984 San Francisco Science Fiction exhibition, the kinetic works of a number of artists reflected the extraordinary Neodada ambivalence and pessimism about the dangers, effects, and influence of technology. This group of San Francisco artists used machine parts as vindicated Dadaist icons to fabricate kinetic machines (often with moving parts run by computerized electronic devices), diagrams, paintings, and installations as an ironic demonstration of the threat seen in the unbridled use of technology. For example, Bobby Cook-Bedell's *Descartes Confrontation* uses a functioning but decrepit mechanical kiddie ride which jolts its mechanical dolls as passengers in a nearly narrative figuration. According to the artist, the effect is a metaphor for "dismemberment of the sacred within our society."

Lee Roy Champagne's installation *Chapel Champagne Shrine of Latter Day Neon Nuanced Naivete,* with its neon light, mirrors, television, and other mundane media, includes a motorized prayer stool which, when kneeled upon, activates an electronic media program as a parody on the relationship between propaganda and religion. He shows how both can mystify and confuse—and how they become a metaphor for the media itself. Paul Pratchenko's painting *Let Them Eat Technology* depicts a room fitted out with a large screen with rear-view projections. On screen is a woman's face covered by a heavy metal mask for breathing and viewing. The audience, wearing eye masks, lounge on a gridlike floor surrounded by a jungle environment as a photographic facsimile. A single framed picture of a car and house hangs on the jungle wallpaper elaborating the artificiality of the metaphor. Pratchenko's catalogue is captioned: "Food is more expensive and VCRs are getting cheaper. So there's going to be a time when people can videotape their own starvation." Several large machines by the collaborative Survival Research Laboratories focus on technology as nightmare—"the unrestrained use of excessive force." *Crawler,* a huge motorized assemblage with human teeth embedded on one of its thrusting phalliclike forms, jolts back and forth in rhythmic violence of movement and exudes a stream of oil. According to Mark Pauline, spokesman for the group, the pent-up violence of machines is used as a powerful metaphor for the relationship between humans and the society of machines they have created. In May 1988, the collective staged an ambitious media art event, which

Figure 121. Lee Roy Champagne, *Chapel Champagne, Shrine of the Latter Day Neon Nuanced Naivete,* 1982
Multimedia electronic installation, 10'H × 16'W × 30'D.
Champagne describes his large-scale multimedia installation electronic chapel altar as a way of leading "the senses through contemplation to a state beyond the senseless." The pentagram-shaped video screen above the altar shows clips of nuclear mushroom clouds which are activated by kneeling on the prayer stool.
(Courtesy Lee Roy Champagne)

Figure 122. Research for Survival, *Misfortunes of Desire*, June, 1988
Performance, Shea Stadium, New York.
Research for Survival intend to shock the viewer into a
consideration of some of the more unsavory aspects of
industrial culture and the politics of power. Either
actuated by remote control, or operated by assistants,
the mechanical creations of the group develop
frightening scenarios of machine anarchy as a way of
demonstrating the power of technology to destroy when
it is unbridled and out of control.
(Photo: Adams/McCandless)

featured movement, lights, and the ominous actions of monster machine robots, on the grounds of Shea Stadium in New York. Entitled *The Misfortunes of Desire,* the action took place in a mechanized "man-made paradise" inhabited by roaring, fire-spewing mechanical beasts. "The show is about the power of the things we've created. It's about unadulterated, uncontrolled greed. It's about how paradise once gained is soon lost."[1]

Counter to this negative view of technology is the reinstallation of the historic British experimental exhibition This is Tomorrow, a timely reminder of the original show staged in 1956 at the Whitechapel Gallery in London. This exhibition was the first manifestation of the British Pop movement and demonstrated a more hopeful, but tongue-in-cheek embrace of technology as reflected in consumer culture. Its new title This is Tomorrow Today sets up a strain of nostalgia for simpler times. It also sets up science fiction itself as a special genre of pop culture "camp." Both of these exhibitions comment on technology, one in a basically Dada manner using the machine as an icon to create a scathing commentary, while the other proposes to alter attitudes about fine art by appropriating and quoting photomechanically produced images from mass culture. As the first of a series of three reinstallations, these historical exhibitions from the fifties examine artists' concepts about the future both past and present through the use of appropriated paintings, prints, installations, and architectural diagrams. They serve as a timely focus for important issues which are once more emergent in the Neopop movement and to reveal the roots of a movement which has gathered important momentum. The exhibition strove "to be casual, topical, and disposable, . . . invited viewer participation and a broader consciousness of everyday culture, and . . . did not elevate aesthetic experience beyond reach."

Fictions,[2] a recontextualization of art work spanning three centuries, created an allegory of the future by contrasting a variety of equally romantic realisms and world views. "The exhibition suggests how art from different periods as well as images from advertising, scientific illustration, the news, and movies overlap and infiltrate one another"[3] to create fictional images which resonate with our ambivalence and curiosity about the future. Paintings by Vermeer, Whistler, Eakins, Millet, and many others were placed side by side with contemporary painters Mark Tansey, Troy Brauntuch, Komar, and Melamid, while production stills from movies such as *Destination Moon, When Worlds Collide, Dr. Strangelove, 2001: A Space Odyssey,* and *Bladerunner* were juxtaposed with diagrams of the 1938 World's Fair, architectural drawings and engravings. In the catalog, an important new set of correspondences was set up technologically by the pairing of these images from extremely disparate sources, in a near same-size format. Past and present were dislocated, recontextualized.

Figure 123.　Fred Riskin, *Sub Rosa,* 1987
　　　　　　　Photograph from installation, 20″ × 27″.
　　　　　　　Using the idea of electronic surveillance or "remote
　　　　　　　seeing" to discover "secrets" of other nations, Riskin
　　　　　　　evokes a whole realm of consciousness about the issue
　　　　　　　of trust and nontrust and the importance of authenticity
　　　　　　　in assessing the distance between viewers with different
　　　　　　　points of view. His work opens the dark world of
　　　　　　　surveillance, counterintelligence, artifical intelligence,
　　　　　　　and games of secrecy. Information is acquired through
　　　　　　　the use of photographs taken at a great distance. The
　　　　　　　work has all the flavor of science fiction.
　　　　　　　(Courtesy Ronald Feldman Fine Arts, Inc.)

Figure 124. David Blair, *Wax, or the Discovery of Television among the Bees,* 1988
Still from videotape.
In his recent videotape, Blair presents science-fiction concepts as he explores the civilization of a new race of bees who have a knowledge of the ghosts of past technologies.
(Courtesy David Blair)

Figure 125. Betty Beaumont, *Toxic Imaging*, 1987
Mixed media installation, 30' × 50' × 10'.
Using T.V. newscasts of disasters, bound volumes
containing ten years of photocopied news clippings
relating to chemical poisoning, and slides of industrial
pollution in waste dumps such as Love Canal, Beaumont
comments on the relationship between society, the
misuse of technology, and the personal in relation to
toxic waste. Dominating the installation is a greenhouse
structure that contains four black oil barrels. On the
floor, lighted T.V. monitors act as illumination for X-rays
of humans.
(Courtesy Betty Beaumont)

Figure 126. Piotr Kowalski, *Time Machine*, 1978–79
Microprocessor with remote control and audio.
In *Time Machine*, Kowalski uses a computer-
programmed device to suggest what we have all wanted
to do—control the passage of time. He arranges for this
by cutting the electronically displayed time stream into
discrete segments. The length of this time segment is
displayed on the Remote Control Box and can be chosen
by pushing the plus button to lengthen the time segment,
and the minus button to shorten it.
*(Courtesy Ronald Feldman Fine Arts, Inc.; Photo: eeva-
inkeri)*

Figure 127. Steve Barry, *Polyphemus*, 1987
Mixed media, 4'D × 13'L.
Barry's description of his metaphorical work
Polyphemus: "A carnivorous giant with a single eye,
traps Odysseus and his men in his cave, and is
devouring several of them daily. The presence of the
viewer in front of the cone is recognized by the scrutiny
of an enormous projection of an eye. The viewer is
looked at for only five seconds before Polyphemus, with
his voracious appetite, turns away in search of new
subjects."
(Courtesy Steve Barry)

Another important Postmodern exhibition, The Art of Memory: The Loss of History at the New Museum of Contemporary Art in 1986, used photographs and video documents to "provide access to history . . . not as a succession of images of the past . . . but as referents demanding reconsideration to the 'now' and thus to the future." Its use of video and photography underscores the importance of imagery which functions as an act of historical retrieval and reclamation. While Walter Benjamin endowed photography earlier (in a premedia era) with a potentially transformative function as a "conduit of human consciousness," Guy Debord (*Society of the Spectacle*), whose more contemporary observations arise out of the media age, sees photography as a cultural apparatus medium harnessed to social control and consumerism. "Photography both *feeds* the spectacle and *is* the spectacle; history and memory, congealed as image, are not animated but annihilated."[4] The media is the very arena where cultural pessimism and technological optimism collide.

The media itself is the site of a struggle and confrontation in Martha Rosler's video installation *Global Taste*—an excellent example of technology being used to question technology. The video works of Judith Barry, Dan Graham, Martha Rosler, Paper Tiger T.V., Vanalyn Green, and Dan Reeves are a form of cultural inquiry which quickens awareness of the perceptual shifts and special effects we are experiencing. Sarah Charlesworth, Louise Lawler, Richard Prince, Hiroshi Sugimoto, and Christopher Williams use photography to confront issues and to provide a context of meaning for a culture where reality is becoming lost in simulation and consumer obsession.

These contrasting contemporary exhibitions about the future serve to emphasize and restate the issues in the relationship between art and technology that we have been examining: Neodada as a critique of technology's influence, using the machine as an icon; Neopop as a possible review of technology. The latter gains further significance as a yardstick of 20 years' distance in the restatement of This Is Tomorrow Today when it is by contrast seen against the intensified imperatives and conditions of today's more technologized consumer culture. In both Fictions and Art of Memory photography and video play a vital role as referents to past and future. However, if artists are using the same media that Debord speaks of as "feeding the spectacle," the same media used to "harness social control and consumerism," then it is important to be clear about what baggage these more complex tools bring with them. This is especially true now that their use is implicated with the much larger issues tied to the use of technology itself, and its influence in society.

Locating the Future

One of the major questions to be raised concerns the real influence electronic media will have in the future of aesthetic experience. However, we cannot locate a correct mapping of future directions in the arts without a much more pragmatic critical reconsideration of current realities in relation to technology.

In an epilogue to a book of essays, *Imagining Tomorrow,* edited by Joseph Corn, the history of past predictions about the future is summarized to provide cautionary insight. Corn names the three fallacies most common in predicting the impact of new technologies: 1) new technologies bring about a total revolution in their field by totally replacing all other existing forms; 2) new technologies will perform only old known tasks and fulfill only known needs; and 3) the technological "fix"—new technologies will bring about miraculous utopian, global change.

The first notion conjures up as an immediate analogy the extravagantly foolish promises about nuclear power. New technologies do not replace old ones—we still use fossil fuels and have even harnessed improved natural alternatives like solar and wind power. The same is true in art. People will still continue to paint, draw, and sculpt despite the invention of new forms for image-making. The new technologies simply expand the range of possibilities for expressiveness and perception. Photography and electronic media are an extension of our ability to make art. In predicting the place of new electronic media, it is important to remember that they will not replace older tools, but rather add power to them, extend them, and create the conditions for new art forms to develop.

The fallacy that new technological inventions will bring about a complete revolution in our way of living is tied to a further fallacy—that new inventions will *only* replace obvious existing needs. For example, the first innovators of the digital computer saw their work applied *only* to the "super-calculator" needs of science and could not imagine or predict the completely universal applications in business, publishing, education, and, of course, art. The computer has, in fact, become a major engine of technological progress in spite of how limited the vision of its impact was at the outset. Its application in the arts has so far mostly mimicked prevailing forms and styles of art within the existing arts framework because new forms take a long time to evolve. Once its potential becomes deeply integrated into the field, new uses and forms of computer art will develop.

A further fallacy combines elements of the first two. We might call them the "technological fix," the utopian idea that new technology has the supernatural ability, a guarantee of omnipotence, a condition of absolute global transformation which might make all men brothers. Technology will con-

Figure 128. Jon Kessler, *The Fall,* 1985
Mixed-media multiple with electronic controls, 24″ ×
20″ × 16″.
Kessler's kinetic sculptures are finely-tuned homages to
machine aesthetics. As seen from the front, *The Fall* is a
rhapsody of rhythmic movement and change. Seen from
the side, its inner Rube Goldbergian workings are
unashamedly revealed for what they are—a plastic
figure from a tennis trophy minus its racquet stands in
front of two film reels of different sizes revolving on
motorized belts, behind which are green, yellow, and
blue lights. The kinetics of movement and light are
computer controlled. This work has been produced as
a "multiple" of six.
*(Courtesy Luhring, Augustine, and Hodes Gallery,
New York)*

Figure 129. Jon Kessler, *Taiwan,* 1987
Mixed media with lights, motors, and other electronic
controls.
In this more recent work, Kessler combines his high-tech
wizardry with kinetics to produce a work which falls
between the contemporary, science fiction, and neo-
Oriental kitsch.
*(Courtesy Luhring, Augustine, and Hodes Gallery, New
York)*

quer distance, abolish national boundaries, guarantee equality. This kind of thinking is represented in the global view of Marshall McLuhan's *The Medium Is the Message*. Global utopianism was countered by Lewis Mumford who, throughout all of his writings about the effects of technology, tried to inject a note of balanced realism, criticism, and caution by stating that true change would only come about with significant economic growth, better planning, and social commitment. Many wild predictions about the advantages of electronic media are represented by this category of the "technological fix," characterized by technoscience talk and "future babble." Electronic media will not "take over" art. Rather, it forces a reexamination of what art is because it provides new capacities for representation—much in the same way that photography did—and creates major shifts in collective awareness.

The fantasy of a harmonious and affluent future as promised by the new technologies was mythologized and used as a form of successful ideology in order to obscure real conditions—that actual technological changes have been accompanied by so much privation, conflict, dislocation, and wrenching transformation brought about by the unbridled appetite of industrial capitalism. The promise of the future as it resonated in popular dreams and expectations amounted to a faith in a better tomorrow through a "technological fix." It was tied to a society based on mass consumption where a firm faith prevailed that democracy and technology were symbiotic. "As an ideology, a powerful system of rhetoric and belief, technological futurism . . . faith in technology (or more accurately, in the future as promised by technology) became not only a kind of secular religion but also a substitute for politics"[5] and social justice. This faith continues to influence policymaking at all levels even though there has been the growth of fundamental change in ideological attitudes about technology ever since the dark years of the Vietnam defeat and the renewed fear of a nuclear Armageddon of the Reagan years. There is now a realization that we must dismantle this dream of utopian progress in order to gain insight into the true function of technology without all the accompanying cheerleading.

Living with Technology Is a Riddle We Must Constantly Solve

The brilliant French thinkers Sylvère Lotringer and Paul Virilio in their book *Pure War* explore and question the politics of the future of technology by asking the question:

> *Is technology . . . not progress so much as alienation?*
> Since the eighteenth century—since the Age of Enlightenment, to use the well-known terminology—we have believed that technology and reason walked hand-in-hand to-

ward progress, towards a "glorious future," as they say. It went without saying that we would find the solution: to sickness, to poverty, to inequality. We found it, all right, but it was final, not optimal. It was the solution of the world ending in nuclear war, in Total War, in extermination and genocide. Thus, my intention is to say: no more illusions about technology. We do not control what we produce. Knowing how to do it doesn't mean we know what we are doing. Let's try to be a little more modest, and let's try to understand the riddle of what we produce. Inventions, the creations of scientists are riddles which expand the field of the unknown, which widen the unknown, so to speak. And there we have an inversion. This inversion is not pessimistic *per se*, it's an inversion of principle. We no longer start from a positivistic or negativistic idea, we start from a *relativistic* idea. The problem is the following: technology is a riddle, so let's work on the riddle and stop working only on technology.[6]

It is vital to see technology from different points of view for its real value as a force, a form of dynamic leavening in society, and as a pragmatic agent of growth and change—some of which is positive and some of which is not. We cannot stop the process of technological growth: technology is here to stay, and once new technologies are created, we must learn to live with them. This process has its own inevitability—nothing is ever gained without something being lost. Since we have no choice about its existence, the question becomes how to find ways of living with technology. What possibilities does it have? What challenges does it present? Artists in all eras have used whatever tools are at hand to make their art. They learn how to adapt new technologies to their needs and often make important innovations which lead to other new tools. Because the new tools are ever more complex, no longer innocent but rather implicated with larger issues, their use is associated also with their inherent possibilities for good or evil, as is the use of all technology. There is no such thing as neutral technology. These are the issues we must face. We cannot escape them.

The Future of Art

In his essay "The Author As Producer," Walter Benjamin sounded a warning note about the risk to artists of all kinds—musicians, actors, writers, filmmakers, dancers, visual artists—of being drawn into use of a powerful technology used against them which in reality possesses them.

They defend an apparatus over which they no longer have control which is no longer, as they still believe, a means for the producers but which has become a means to be used *against* the producers. This theater of complex machineries, gigantic armies of stage extras and extrarefined stage effects has become a means to be used against the producers (artists), not least by the fact that it is attempting to recruit them in the hopeless competitive struggle forced upon it by film and radio [and T.V.].

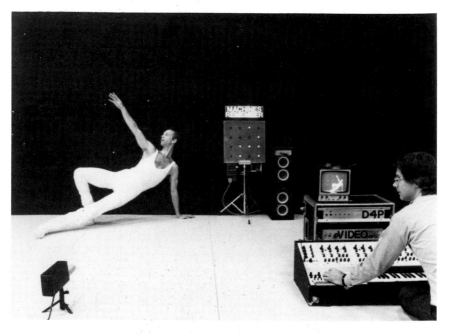

Figure 130. Christopher Janney, *Tone Zone,* 1983
Performance, commissioned by the Institute of
Contemporary Art, Boston.
Janney's experiments with movement, sound, and
electronic media has led to interactive collaborative
projects that rely on the collective efforts of dancers,
musicians, designers, and technicians for their
realization. *Tone Zone* translates the body's movements
and inner pulses into sound. The musical score is thus
produced by the movement patterns of the dancers.
Tone Zone uses a synthesizer, an electronic sensing
device, a video camera, and three dancers. The
equipment is rigged to capture any move from the
dancers. The synthesizer booms out sounds that reflect
the speed and location of each movement. For example,
a quick leg jab may create a sharp bleep or a slow
twisting arm movement may produce a low braying
sound. The choreography, composed by Tom Krusinski,
is playful and open-ended, the perfect complement to
Janney's electronic intentions. In *Heartbeats,* a solo
designed for dancer Sara Rudner, a monitor is fastened
to her chest so that the electrical impulses of her beating
heart are carried on the sound system, creating the
rhythm for the piece, like a percussion instrument.
(Courtesy Christopher Janney)

Figure 131. Group Material, *Anti-Baudrillard*, 1987
Mixed-media installation with video at White Columns,
N.Y.
This installation was meant as a kind of forum to raise
questions about differing interpretations existing in the
art world based on the influential theories of the French
philosopher Jean Baudrillard. The Group Material
collaborative sees their work as a site for cultural
resistance to mainstream values. They see their "art
materials" as being culture itself, rather than
succumbing to the idea that art must stay within a
certain system of boundaries that characterize the
traditional concept of what an "artwork" is and where
it should be seen.
(Courtesy Group Material; Photo: Ken Schles)

Benjamin urged a careful *questioning* and subversion of the use of new technologies so that out of this dialogue what has been learned from their simpler original incarnations (such as theater) is what they *do* (their function) in relation to their audience. He is referring here to Brecht's notion of epic theater where "the functional relationship between stage and audience, text and production, producer and actor" becomes a guiding principle. An example of what he meant is *Paper Tiger Television*—a low-cost, low-tech cable T.V. program, transmitted directly on public airwaves, which comments directly on the fictions of the medium itself while dialoguing (with an independent voice) on current affairs with its listeners.

These arguments about the power of technology *can* also be applied to the power of visual arts institutions such as the museum system, the gallery system, and the granting institutions which can be used against the artist to stifle his productive freedom and his relationship with his audience. Artists need to be aware of "the decisive difference between merely *supplying* a production apparatus and *changing* it."[7]

Technology Has Transformed Art

As early as 1827, Hegel was predicting the inevitability of art's end. In 1839 when the invention of photography was demonstrated, Delaroche announced the end of painting. Similar predictions arose at the turn of the century, in the 1920s, and in the 1960s. In the 1980s more predictions have emerged. Despite those dire predictions to the contrary, in each of these strikingly new periods the concept of art did not die, nor did the need for it disappear. Rather, the notion of what art is and its ontological status was altered. It has always been shaped relativistically by powerful social and technological forces, a relativistic relationship which is more and more coming into focus through the scholarship of a new crop of revisionist art historians (such as Timothy Clarke) "who are studying the visual arts as more than a purely aesthetic phenomenon."[8] Harking back to Ruskin and to the Constructivist period, we have noted that artists have many roles to play in society.

In his important essay "Revising Modernism, Representing Postmodernism: Critical Discourses of the Visual Arts," Michael Newman, a well-known freelance art critic and curator, discusses the progressive stages:

> It is possible to isolate two tendencies under modernity which could be taken as answers to the question "What is art?" One answers "Art is art": it is the tendency towards autonomy, "art for art's sake." The other answers "art is not-art": the category of art is supposed to "wither away" into social and political practice and/or theory. If we recognize anything as "postmodernist," it is the impossibility of either answer. Art as suppos-

edly autonomous remains dependent upon its Other for its very autonomy, and so is infected by heteronomy. And artists' repeated attempts to defeat art have either been re-incorporated into art, its institutions and ontology, or else have forgone the radical potential that inheres in art's relative autonomy.[9]

Newman's analysis confirms that the need for art as an autonomous force in society does not fade or change, but rather our perspective changes about its role and its form. The latter are subject to wildly fluctuating external influences in the form of political and social forces which grow inevitably out of changing technological conditions. These transform awareness, provide new tools from which new art forms develop. Each time new conditions arise, the question "What is Art?" surfaces. We are once more at this juncture. Once again we are examining art's different categories of value: use value, exchange value, commodity value, aesthetic value; as well as its different categories of production—whether by hand or by technological means—and what these mean; its forms of dissemination; and its effect. These questions are all raised again as a result of the electronic era with its new influence through technological conditions and its new tools for representation. The question is not whether art is dead but how the need for it has been transformed by technology, how technology has changed its very nature, the way it is used and its very form.

Today we see that all the media of the past have found their place without losing their essential individual relationship to image-making. As Man Ray said, "I photograph what I do not wish to paint and I paint what I cannot photograph."[10] When asked why he moves so easily from painting to collage to photography to photocopy machine in his work, Larry List commented recently that he uses the potential of each medium in his work for what it can offer in terms of scale, effect, style, expressiveness, economy, and all-important communicating effects.

Electronic Media—Power for Change

Advances in electronic media have brought new freedom of access for artists to highly sohisticated equipment for their studios—unavailable up to now because of its high cost and relative user difficulty. Before 1984, access for artists to the technology for each of the electronic media under discussion was beyond the means of most artists. However, now that all three— video, copier, and computer—have entered the market as relatively inexpensive but sophisticated consumer items, it is possible for the first time for artists to add these tools to other art-making paraphernalia in the studio. Up to now, accessibility has been a major problem. The new technologies offer unprecedented opportunities for work—using still and moving images

(animation), combining images with sound and text, transmitting them to faraway places, or duplicating them as large mural-sized paintings. The new equipment is beginning to blur distinctions between amateur and professional in terms of quality work. Typically, an artist working on video, for example, may now shoot his work with a low-end camcorder and edit it in his own studio. He may then decide to postproduce the work by accessing more elaborate equipment in a special video production house. An inexpensive video copier can now be extremely useful in capturing images from T.V. or videocassettes. Although inexpensive copiers do not offer the control and quality of the high-end equipment, consumer models are surprisingly helpful.

Desktop computers which can produce extremely precise, well-defined images (up to 16.7 million choices of color and hue) are now relatively low-cost additions to the studio. The computer itself can be used not only as a tool for drawing/painting functions as well as for controlling equipment in interactive works, but is a medium in its own right for producing two-and three-dimensional animation or still drawings in combination with text. The computer may be used as an interarts tool for music production, word processing, choreography, and many other tasks.

The computer, when linked with video and copier, transforms their functions and adds to the power of these technologies. For example, computer controls harnessed to video allows for the endless manipulation, editing, copying, or accessing of images on video discs, as well as for their use in interactive projects. Hooked to copiers, the computer can control multiple delivery functions. In the 3M Architectural Machine, scanning operations combined with a robotized airbrush system for reproducing an original transparency can produce a mural-sized painting on canvas from a small original.

In each of the media we have been discussing, there is evidence for the future of unprecedented advance and expansion in the possibilities for representation and convergence of media. Images can now be reproduced, scanned, digitized, or simulated, reprocessed and manipulated, edited, transmitted internationally via satellite or telephone, or printed digitally using electronic printers of all kinds. They can be inserted seamlessly into other images either as still or moving elements to give the true impression of a false reality. They can be instantly copied, reduced, enlarged, changed from positive to negative, or printed in color. Digitized images are set immediately into the electronic page set-up for printing in millions of copies, one aspect of the revolution occurring in the printing trades.

Electronic technologies are overtaking conventional photographic ones by replacing film stock with digitized image capture for both stills and moving pictures. Image tubes are being replaced by silicon chips to record

visual reality as digitized information directly in-camera (as in video), thus making even more instantaneous possibilities for electronic reproduction or display of images. New High-Definition T.V. projection will increase the convergence between film and video.

This alone is enough to make us seriously "re-think representation." However, the explosion of electronic imaging devices is further accelerated by other influential developments in communications such as the popularization of the VCR (see Appendix notes). In the home entertainment center of the future, we will be able to project whatever films from the past we can acquire on videocassette on High-Definition T.V. This ready new access to the riches of film archives is comparable to the benefit provided by the advent of photography, which allowed for the first time ready access to the study of art history. Although the primarily visual nature of film is widely acknowledged, scant attention has been paid to its influence by art historians in the past. This access to film history through VCRs is of extreme importance also to a whole new generation of artists who will be able to more clearly than ever before absorb the powerful relationship between film and their new interarts productions. Videocassettes provide access also to an entire range of documented historical as well as contemporary dance and theater performances.

Use of technology for art-making intersects with the fact that technology transforms society, affecting and broadening the need for art as well as changing the form of art. It creates new media which expand the possibilities for aesthetic experience by opening out to new forms and new correspondences among the media. Use of electronic media opens the possibility of a broader forum for art in every sphere and for a different audience. Electronic media pose questions about the form of art and its status.

The true nature of electronic media as dynamic imaging using light, movement, time, sound, and interactivity is rarely demonstrated in exhibitions. This ironic refusal by the museum world of the most meaningful characteristics of electronic media's new forms (because they do not fit the traditional exhibition spaces of museums and galleries) was reflected in a 1986 exhibition, Television's Impact on Contemporary Art, at the Queens Museum in New York. Ironically, it was composed mostly of paintings or sculpture of television and did not show the work of video artists who have dealt with the medium in depth.

Although the Digital Visions: Computers and Art (which originated at the Everson Museum in 1987) made an attempt to show a range of interactive computer-controlled works (Myron Krueger, James Seawright, and Wen Ying Tsai) and the plotter drawings of Mark Wilson, Manfred Mohr, and Harold Cohen, the exhibition showed mostly static works. Due to many factors, including that of cost, we have not yet had an exhibition of com-

puter-based art which exhibits the true potential of the computer as a dynamic medium. It is a tool capable of moving and building shapes and color in time; scanning images in real time; manipulating them; seeing color as vibrant colored light rather than as a comparatively dull Cibachrome print; or seeing objects, planes, and materials constructed, pulsed, and moved by the computer's power as it is harnessed to other media.

Almost no video was in evidence. Yet video is the occasion of the computer's greatest convergence, so far, in art-making. Without the computer, video's incredible range of time/movement and image/event transformations, its ability to paint in real time in combination with sound, and its complex editing patterns and postproduction, would not be possible.

Too often, viewing of single-channel video is ghettoized into small hard-to-find back rooms. New projection for video will help to affect much-needed change and commitment to the medium in the museum and gallery context. Not many commercial galleries show video because it has so little "object value," though artists' sculptural installations with video continue to be dramatic and theatrical experiences for viewers. Documenta '87 featured an unusually large number of video works which were room-sized. These were the most powerful aesthetic experiences at this important international exhibition. Works by, among others, Marie Jo Lafontaine, Klaus Vom Bruch, Shigeko Kubota, and Ulrike Rosenbach captivated the viewer because of their scale, presence, and relevance.

Influence of Technology Raises Basic Questions about Cultural Institutions

In his recent essay, "The End of Art and the Origin of the Museum," Douglas Crimp raises questions about the relationship of art to the museum system. He explores Hegel's idealist views that art "has lost for us genuine truth and life and has rather been transferred to our ideas instead of maintaining its earlier necessity in reality. . . . Art invites us to intellectual consideration, and that not for the purpose of creating art again but for knowing philosophically what art is."[11] Crimp calls attention to the fact that the first museum (1823–30) designed for the King of Prussia by the architect Karl Friedrich Schinkel coincided with the rise of Modernism and with the founding of a "theology of art," an idealist concept which separates art from its social and materialist role in society to one of idealist aesthetics connected to the object and property value. "It is upon this wresting of art from its necessity in reality that idealist aesthetics and the ideal museum are founded; and it is against the power of their legacy that we must still struggle for a materialist aesthetic and a materialist art."[12]

His study raises questions about the role of the museum in the new conditions of the Postmodern. Now that the concept of the museum as the

ultimate cultural institution is so deeply integrated into our thinking about art and the museum's methods for validating, presenting, and posing as an educational and theological site for art, we must examine again the role and the contribution of museums and raise questions about what they could be. Is the museum a validator of art to be sold in the marketplace or a site where the public can gain a rich and satisfying experience? Could the museum become a dynamic location for the production of art as experience and process rather than a repository for art that people cannot have (except as postcard reproductions)?

Museums are now able to record their entire collections on videodisks. Images can be accessed by the viewing public via high-definition video monitors, and interactive equipment makes it possible to zoom in for close-ups or to bring onto the screen several works for simultaneous comparison. Viewers will be able to "curate" their own exhibitions by making choices from the huge database now being compiled. This international effort to create computerized image simulations of works in museum collections everywhere is creating an extraordinary opportunity for art scholarship, for exhibition curating, and catalog publication that will rival the impact photography has had on the study of art history. Will museums suffer a dropping off of interest as a result of the new accessibility and familiarization of their collections? Or will the new technology make art more accessible to more people? Will museums now be freed to offer new kinds of art experiences to the public?

What is the relation between art as a stock market investment and the value of art as public communication? Should art be taken out of the market system of property control? How can the closure being brought into cultural practice be turned around so that the public can participate more democratically in art as part of public need? For example, a 1988 PBS T.V. program called "T.V.—Public Trust or Private Property" addressed the relationship between the public's rights for important cultural experience and the use of the public airwaves to make money for big business, i.e., commercial control has taken precedence over the rights of consumers.

Electronic media in the arts and the use of it in art-making raises important questions that need to be answered:

- What is the relationship of electronic media and its expanded forms—complex, interactive, dependent on light, movement, space installation works—to the museums, the gallery system, and the public?
- What different institutional structures need to be set in place to create settings for the new aesthetic experiences which grow out of full use of electronic media and its expanded forms?

- What will be the relation of the artist to his audience?
- What new aspects of the artists' role need to be explored?
- If the need for aesthetic experience is growing so rapidly, should the arts receive a greater degree of support ? How could this be set in motion?

Influence of Technology Creates a Wider Public Forum for Art

There are many artists who seek a larger public forum for their work. For example, the goals of some video artists is to show their work on the public airwaves. Although the numbers of these artists is still small in comparison to the total field, they are having an impact as a result of new strategies they are developing, combining normal gallery exhibitions with their work toward commitment to social change in the immediate atmosphere of the streets. Their aspirations have been helped by the Public Art Fund,[13] in existence since 1977, when two organizations coalesced: City Walls (which sponsored large outdoor murals by prominent artists) and the Public Arts Council (which coordinated placement of sculpture in city spaces). Since then the scope of their work has increased to include artists' outdoor billboards, printed poster displays in subways and buses, and temporary site installations on traffic islands, vacant lots, and department store windows.

The experimental collaboration impulse of the sixties' artists has also now moved from experimental to more direct involvement and heightened public activity. Many groups have formed—such as the Colab, the Guerilla Girls, Political Art Documentation, and Group Material—to produce projects that require a collective effort in seeking funding and in sharing labor, talent, and equipment required by the ambitious nature of their goals. Their desire is to build new audiences outside the museum and gallery system.

Often important and lasting friendships and alliances are formed through these activities. For example, the Times Square show (June 1980) was a project organized by the Colab, a group loosely held together by "Rule C": collaborative, collective, cooperative, and communal projects only. A force of more than 100 art workers "occupied" the site of a four-story office building completely, transforming the decrepit urban environment into a powerful communicating space that attracted a curious public because of its loud, carnival atmosphere. Inside, the walls were covered with photocopy murals, slapdash paintings, graffiti, and hangings and were encrusted with found-object sculpture and collages in a wild profusion which announced a new kind of approach to an art experience which had its roots directly in popular culture. Some of the Neopop artists who worked on this project—Keith Haring, Christy Rupp, Kenny Sharf, Jane Sherry, and Tom Otterness—later became well known as individual artists.

In May 1988, Group Material (funded by the Public Art Fund) created a project called INSERTS—a 12-page newsprint booklet to be inserted in the Sunday magazine supplement of the *New York Times*. The insert contained copies of 10 art works created specifically for the project by well-known artists—Barbara Kruger, Louise Lawler, Richard Prince, Nancy Spero, Jenny Holzer, Hans Haacke, Mike Glier, Felix Gonzales-Torres, and Carrie Mae Weems. Their project was designed to get art off the wall, out of the plaza, and into everyone's hands through the daily paper.

Group Material, founded in 1979, describes itself as an organization of artists "dedicated to the creation, exhibition, and distribution of art that increases social awareness." It believes strongly that art should not be just for "initiated audiences of the gallery and museum" but is intended to "question perceived notions of what art is and where it should be seen." Its work, also seen in exhibitions throughout the U.S. and internationally, bridges the culture gap between high and low, elite and popular. This group organizes public lectures and discussions for important forums such as the Dia Art Foundation. For example, their part of the 1988 program centered on various crises in democracy. The artists' galleries—Mary Boone, Josh Baer, Barbara Gladstone, Metro Pictures, and John Weber—are cooperating in this extension of their artists' public committment outside of the gallery. The artists themselves see that their public image helps them to attain status and recognition as a necessary aspect of clout for their public voice. Grants and sales of their work support some of their activities.

This shift toward the democratization of art has been happening slowly since the late seventies. The Guerilla Girls have created a powerful public dialogue through their strategies of anonymity, theater, and humor and have scored stronger feminist points by their collective spirit and their use of information and its technology than any one painting could have. Dennis Adams's bus shelter projects with their double-sided illuminated display panels are similar to regular bus shelters but use large photographic transparencies to comment on history or to underscore the politics of poverty and wealth apparent in city neighborhoods. Krzysztof Wodiczko's mammoth night projections beamed onto city buildings and monuments create a political ripple whenever they appear. Based on the idea of spectacle and risk in the urban environment, he dramatizes the architecture of public buildings to supply the real identity of its public function. For example, over the South African embassy in London, he projected a swastika; on a war monument the image of a missile; on a public monument in Boston, the figure of a homeless man.

Another aspect of the greater public stance of art, made possible through the agency of technology, is in the field of artists' books. Printed Matter, the leading distributor of artists' books, carries more than 3,000 titles

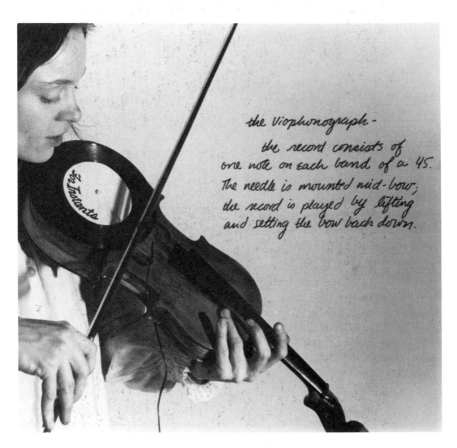

the Viophonograph -

 the record consists of
one note on each band of a 45.
The needle is mounted mid-bow;
the record is played by lifting
and setting the bow back down.

Figure 132. Laurie Anderson with Viophone
(Courtesy Holly Solomon Gallery, New York)

Figure 133. Laurie Anderson, *United States, Part II,* 1980
 Performance.
 (Courtesy Holly Solomon Gallery; Photo: Paula Court)

Figure 134. Laurie Anderson, *United States, Part II,* 1980
 Performance.
 Much of Laurie Anderson's polished work addresses the
 demystification of technology. Using obviously simple
 techniques—shadow plays, the distortions of her voice
 with a mouth-held viaphone, or the elaboration of her
 violin with a cassette machine—to resonate with more
 powerful ones, she demonstrates that the power of the
 human mind to innovate is the most important function
 of the artist.
 (Courtesy Holly Solomon Gallery; Photo: Paula Court)

Figure 135. Merce Cunningham, Performance Installation
Merce Cunningham's use of video to record, compose,
and document dance choreography is typical of the
interest dancers and choreographers have in video as
an important new interactive tool. For example,
extensive use of chromakey and other television special
effects enable the transposition of a dancer's movements
against various backgrounds. Easy access to other artists'
performance documents via video creates an important
new study and teaching tool.
*(Courtesy Electronic Arts Intermix; Photo: Terry
Stevenson)*

Figure 136. The Wooster Group, *The Road to Immortality,*
 Part II, 1987
 Left to right: Jeff Webster, Michael Kirby, Anna Kohles,
 and Willem Dafoe.
 The Wooster Group has created a new aesthetic that
 uses video in connection with their performance work
 as a commentary on how conventions created by T.V.,
 radio, and film mediate our present reality. Their
 performance acknowledges that technological
 mediation is part of actuality. Live images on monitors
 become an active part of the live performance in a
 commentary on how the technological shapes our most
 fundamental perceptual habits.
 (Courtesy The Wooster Group; Photo: Bob Van Danzig)

by 2,500 visual artists. Artists such as Paul Berger, Keith Smith, Paul Zele-vansky, Warren Lehrer, Tom Phillips, and Sue Coe are commited to the project of creating part of their work in book form, thus creating a gallery of ideas available in bookstores as art for a broader public. Although artist book outlets mostly exist in museums and small specialty shops, the move-ment is being strengthened by quality electronic reproductive equipment like the photocopy machine and computerized "desktop publishing."

The work of Mierle Laderman Ukeles stands out for her strong social commitment and for the innovative video methods she used in producing the Touch Sanitation show (featured at the Feldman Gallery in 1986). Ukeles chose to work with the Department of Sanitation thus not only focusing on the stigmatization of those workers by the public, but also showing that the work they do participates in an important relationship between culture and maintenance. She created a four-part video environ-ment utilizing 34 monitors, 28 of which were stacked into four 14-foot high T.V. towers in an environment which is a reconstruction of two sanitation lunch/locker room facilities. (These were literally taken out of the real workplace and reinstalled in the gallery space.) Ukeles dramatized her 11-month involvement with the workers through a kind of performance where she criss-crossed the city making contact with all of them through her video documentation concept. She engaged them directly in the process of creating the installation.

Influence of Media Brings about a Fusion of Artistic Forms

What Walter Benjamin predicted as a meltdown of forms in which the differences in particular special genres would fast disappear is in full swing. Distinctions are being erased by the media itself, where an easy switching of a dial infiltrates opera and music video, Shakespeare and soap opera, avant-garde productions of dance or theater and late-night talk shows. Ac-celerated consumption of new artistic works is playing a role. For instance one of the "First Wave" productions in the 1988 season was Nixon in China by John Adams. It was shown with only a small lag time of a few months in a special made-for-T.V. production (which—through close-up and some careful image enhancements—tended to be an improvement over the staged version).

The "strangeness" of avant-garde productions grows less painful as the public becomes more used to seeing the work of important artists "on the tube" and are more aware of the new vocabulary the artists are using. Artists themselves have also become more interested in making their work more accessible to the public. For example, Laurie Anderson is one of the first of the new wave of visual arts performance artists to combine electronic media

Figure 137. Richard Baim, *World Fair,* 1987
Projection installation.
Interested in the relationships between architecture,
history, and manifestations of power as spectacle, Baim
uses photography as a way of synthesizing and
presenting his ideas, often as multimedia presentations
in which he fuses image and text in a sculptural
installation context. The audiovisual technologies he
uses for his projection works include programmed
computer drives.
(Courtesy Richard Baim)

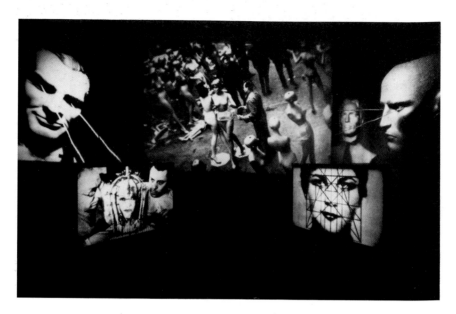

Figure 138. Margot Lovejoy, *Labyrinth*, 1988
 Projection installation, 14 min.
 Lovejoy is interested in the multimedia possibilities of
 electronic projection installations as a vehicle for
 presenting complex, multilayered ideas. In *Labyrinth*,
 she examines gender issues in relation to representation
 by examining the power of the media to create false
 consciousness and false identity. Her audiovisual works
 are accompanied by commissioned scores. The
 installation aspect is important to the whole concept,
 particularly in *Labyrinth*, where the placement of
 surveillance cameras in the dark passageways is
 designed to disorient the viewer.

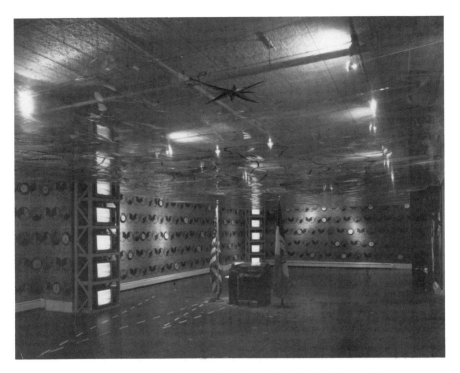

Figure 139. Mierle Laderman Ukeles, *Touch Sanitation Show,* 1984
Installation, four-part video environment with
T.V. towers.
Through this immense multimedia installation Ukeles
posits maintenance as a literal artwork existing in real
time. Five years in preparation, this exhibition has
resulted in a new kind of public art. For the first time, a
public service agency collaborated with an artist in a
project that portrays the important relationship between
culture and maintenance. Virtually every unit of the
Department of Sanitation participated with the artist in
the creation of these art-environmental works. The four-
part video environment includes thirty-four monitors,
twenty-eight of which are stacked into four 14-foot-high
"T.V. Towers," running five different tapes in eight
separate locations. The installation, some of it prepared
by the sanitation workers themselves, also includes a
1500-square-foot transparent map of New York City
suspended overhead, a special print installation of
clocks in 53 colors, and forms designed for all the walls
of the gallery.
*(Courtesy Ronald Feldman Fine Arts Inc.; Photo: D.
James Dee)*

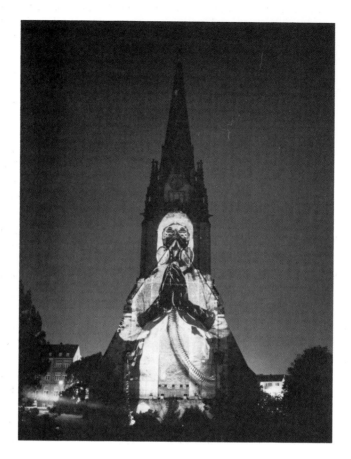

Figure 140. Krzysztof Wodiczko, *Projection on the Martin Luther Kirche,* 1987
Environmental work.
To draw attention to the environmental pollution caused by industrial waste accumulations in the atmosphere of Kassel, Germany, site of the eighth international Documenta exhibition, whose theme was "The Artist and Social Responsibility," Wodiczko produced as his entry for the exhibition a projection work that focused attention on the old Martin Luther church by way of its witness. His projected image of a praying figure clothed in protective garments connects the memory of the city's destruction during World War II with the contemporary threats of industrial pollution and nuclear, post-Chernobyl environmental damage. The image was projected from three xenon-arc projectors.
(Courtesy Hal Bromm Gallery)

effectively. She writes her own music and vocals; and her unique stage presence is enhanced through her innovative use of sound, light, motion, and the use of projections—strong graphic images combined with photographs. She uses any and all methods to convey her message—usually global in character, but wittily derived from everyday experience—a method which helps her communicate successfully with the large audiences. Artists like Laurie Anderson and David Byrne are now able to attract a wide following for their work, a far cry from the less polished, experimental sixties' Fluxus and E.A.T. performances.

Robert Wilson's theater of illusion is essentially the creation of a magical tableau in space and time with music which he imbues with theatrical invention more poetic than narrative. It has its own dimension. Not opera, not theater, not mere tableau, it is a completely different form of abstraction which combines many genres—an experience that holds the audience in suspended, collective thrall. Dancers like Martha Clark and Pina Bausch are combining theater, dance, music, and opera to create new aesthetic experiences. Multimedia groups such as the Squat Theater, the Wooster Group, and Social Amnesia combine a cinematic impulse in their use of projections in combination with video, performance avant-garde ambiance, and costume to convey their complex statements.

In the eighties, there has been a veritable explosion of avant-garde productions, notably Pepsico Summerfare and the BAM Next Wave Festival. BAM has found a way of widening its base of support by acquiring funding support from many levels, including corporate, state, federal, and individual. Transporting the works to other centers helps to spread out the burden of high production costs. What is clear is that this Postmodern tendency towards a fusion of genres touches a deep public need. This impulse resonates and is influenced by the media itself, which also transmits and supports it.

Crucial to the work of the most prominent artists of the 1980s is their ambivalence toward the mass media for its ability to influence what we see and what we think. Those who do not share this love-hate relationship cannot fully respond to the work of these artists which plays off the Medusa of T.V., advertising, fashion, and cinema on some level. It is significant that Jenny Holzer has been chosen to represent the U.S. at the Venice Biennale in 1990. Her site-specific electronic signboards, rings, and laser beams (combined with wood benches and stone sarcophagi) will be complemented with 5- to 15-second works transmitted on Italian T.V. The prestigious advisory committee made up of curators and directors of major museums chose Holzer because they wanted to create a precedent by moving to a new generation of artists to show work about the end of the eighties as a contrast to preceding exhibitions. Symbolically, it is technological, un-

Figure 141. Miroslaw Rogala, *Nature Is Leaving Us*, 1987
Video opera.

This complex, electronically extended mixed-media production employs a programmed multiscreen Videowall display system, live vocals, dramatic performance, dance, and five-channel sound. It is designed as a commentary on humanity's frightening misuse of the environment.

(Courtesy Museum of Contemporary Art, Chicago)

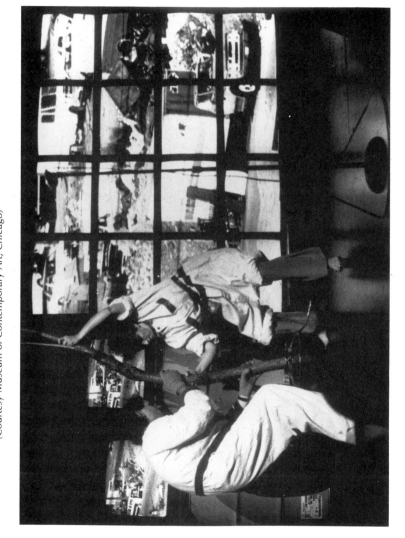

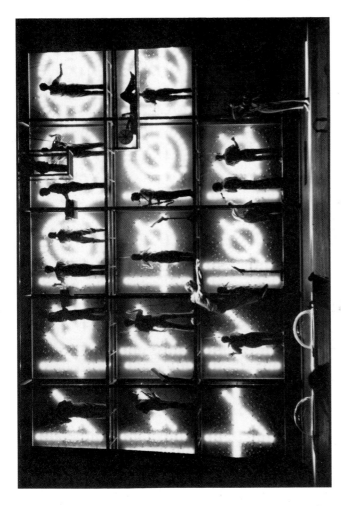

Figure 142. Robert Wilson, *Einstein on the Beach* (Final Scene by the Lightboard), 1986 Wilson's *Einstein on the Beach* is a new genre of work, a performance-visual arts form that fractures language and content and alters our perception of the possibilities of theatrical experience. With composer Philip Glass and choreographer Lucinda Childs he has created a "cosmos" of the arts. As an evocation of ideas and elements covering the span of Einstein's life with the emphasis on technological advancements from steam engine to space exploration, it brings together symbols and referents that seem to evoke a "fourth dimension" where time is atomized. The melding of space and time in Wilson's spectacle parallels scientific thought, where space itself is endowed with time attributes and vice versa.

(Photo: Babette Mangolte)

signed, presented outside of a museum/gallery context—participating in daily life. Martin Friedman, director of the Walker Art Center, and member of the advisory committee commented that her work functions at many levels. It is topical, psychological, involved with myth. A further shift of "established wisdom" in the arts is the High and Low: Modern Art and Popular Culture exhibition being prepared by Kirk Varnedoe, MOMA's new painting curator, for the spring of 1991. Using the detritus of Western con-sumer culture, comics, graffiti, and advertising, the exhibition will tackle the distinction between art, popular culture, and society in part by showing Pop artists of the past with today's artist-critics who quote T.V. and science fiction.

The Western concept of the avant-garde depended on a resistance to new forms. However, now, due to the melting down of forms within the media, there is less of the resistance to new ideas that made an avant-garde possible in the nineteenth and twentieth centuries (when artists could find a position from which to operate against social norms).

> New art forms and movements once took years to sway younger generations even as they shocked older ones. Now new forms and movements have instant influence since the mid sixties. Pop Art, attacked in 1962 as phony, was reshaping fashion and advertis-ing design by 1965. The recognition that the mass culture could effectively absorb the avant-garde for economic gain—'radical chic' was the slogan that was coined—effec-tively ended the notion of avant-garde. From then on no matter how radical, new artistic developments enjoyed . . . substantial acceptance as soon as they appeared.[14]

Although acceptance of new forms is still not generalized outside of urban areas, there is still the chance for eventual familiarization via satellite.

The concept of an electronic "global village"—of a world united through electronic communications—has come a long way since the term arose in the 1960s. As we come closer to it, its shape seems different than the one that we expected. For Postmodernism represents a "global shift"—a new way of seeing and a different attitude towards political and cultural possibilities, a direct corollary of the electronic era. A more diverse group of artists than ever before are participating in an unprecedented forum for art. They are part of a growing cultural exchange of exhibitions, perform-ances, and special projects world-wide in response to an ever-expanding circle of need for aesthetic experience.

> What we see, we see
> and seeing is changing
>
> the light that shrivels a mountain
> and leaves a man alive

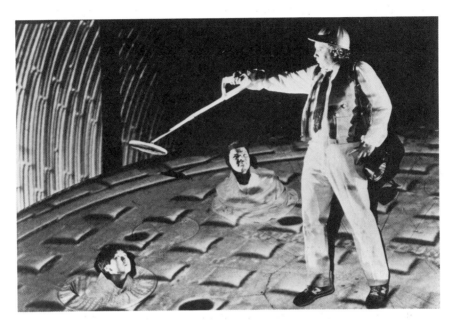

Figure 143. George Coates, *Actual Sho,* 1988
Multimedia theater, music, movement spectacle with
electronics.
This elaborate music-theater production makes dramatic
use of the electronic wizardry involved in the computer
programming of 26 slide projectors to beam East-West
archetypal images onto many kinds of surfaces,
including a system of blinds that can be opened and
closed to reveal or hide. Interested in creating a place
where art and technology meet, Coates employs a
character who is responsible for change and for taking
the audience on a kind of journey as a "requiem for
people who are passing." His work brings together a
team of 30 artists, technicians, and engineers, 14 of
whom are the performers.
*(Courtesy Summerfare, International Performing Arts
Festival at SUNY Purchase)*

Figure 144. John Cage, *Europeras I and II,* 1988
 Multimedia opera with electronics.
 In a true Postmodern vein, John Cage combines
 elements of chance, randomness, information, and a
 fusion of genres in his *Europera,* first performed in
 Frankfurt in 1987. A combination of opera fragments (no
 longer protected by copyright), music scores
 (photocopied at random), singing types (chosen at
 random from the 19 styles), arbitrary stage backdrops
 (chosen from a range of available photographs), and sets
 moved in random time form the main scene, while a
 computer program compiled by chance operations
 controls the computer-assisted lighting process,
 generating 3,500 separate cues. Having combined this
 wealth of disparate elements into a giant collage, Cage
 proceeds to add elements of his own, including amusing
 visual jokes and puns interwoven with twelve alternate
 plots, thus creating a beguiling and entertaining pastiche
 of cultural productions of the past as a gaming collage
 for the present.
 *(Courtesy Summerfare, International Performing Arts
 Festival at SUNY Purchase)*

Heartbeat of the pulsar
heart sweating through my body

the radio impulse
pouring in from Taurus

 I am bombarded yet I stand

I have been standing all my life in the
direct path of a battery of signals
the most accurately transmitted most
untranslatable language in the universe
I am a galactic cloud so deep so invo-
luted that a light wave could take 15
years to travel through me And has
taken I am an instrument in the shape
of a woman trying to translate pulsations
into images for the relief of the body
and the reconstruction of the mind.[15]

Appendix

Video and Computer

New Outlook on Imagery and Technical Dynamics

Computer-simulated or processed images open broad new territory for video exploration. Using the structured algorithms of the computer as a means, "natural" reality can be reshaped, processed, and transformed at will. Completely synthetic images can be entirely computer simulated (and transferred to video)—images which no longer have anything to do with traditional optical techniques, such as photography. A new visual order, a new ground for elaboration of the language of images in motion, has been revealed by harnessing video to the computer for electronic processing. Now special effects and animation techniques fall within the realm of relatively inexpensive software programs.

This merger of video and computer is the foundation for new forms of art and provides a different level of decision-making. Every picture element (pixel) can be addressed through the logic of the computer, which can also control editing and produce animated interpolations. The order and duration of image-events can be manipulated, skewed, repeated, or made three-dimensional by means of controlling functions within the computer video instrument. Bascially, this means that an "image-event can be submitted to nearly infinite spatio-temporal transformation, since the 'image' is only a matrix of digital codes in a data space. It means that any element of any image can be inserted into any other image seamlessly, without the appearance of being an 'effect' . . . it becomes a hybrid reality standing somewhere between photography and a kind of painting."[1] Films and videos are now being designed for insertions of animated figures with live photographed ones in the most complex interactions of reality and fiction yet attempted. In *Hard Woman,* the Mick Jagger 1985 music videotape by Digital Productions, the aggressive line-drawn animated figure seems to be in total control of the real-life action.

The other side of the imaginative potential unleashed by the new digital

image processing is its potential for deception and falsehood. We can no longer rely on the old system of "truth in images." The authority, the truth of photography, can no longer be trusted.

Video, Animation, and Digitized Scene Simulation

Computers can now be programmed to produce extraordinarily complex and lifelike animated effects. At Lucasfilm in California, a powerful computer graphics machine called Pixar has been designed to capture the essential character of real forms and textures through the programming of digital instructions which control every picture element or pixel. For example, an algorithm has been designed to simulate the diminishing size of tree branches as the trunk rises from the ground. An enormous number of such algorithms are required for realistic simulation of mountains, clouds, and water. The Lucasfilm team has even been able to recreate the blur of motion that is caused by a wave striking the shore or two billiard balls colliding. Various computer programs which build in a randomness factor have been developed to make images seem more lifelike, even though they are completely computed mathematically.

Apart from generating specific images, the computer can calculate in-between frame of movement between separate drawings. This is the "interpolation" technique used by animators, where the computer is issued commands to compose as many slightly different intermediate images as required in the metamorphosis of a movement from one stage to the next. Thus the animator's task in movement simulation and color transformations is enormously facilitated by the computer.

Computer-animated films have been produced by artists since 1961. A remarkable early example is Cannes Festival prize-winner *Faim* (Hunger) made by Peter Foldes at the National Film Board of Canada in 1974. Foldes not only generated by computer the film's intermediary motion frames, but used interpolation techniques to make transitions between two different themes—images of the starved "have-nots" transposed against the greed of the "haves." Computer-assisted animated effects now dominate commercial advertising and have been used extensively for special effects in films such as *Tron* and *Star Trek II*. Artists' use of animation "paint" effects and drawing interpolation methods combined with special effects generators are a growing phenomenon now that software support animation packages are widely available at low cost. Expressive three-dimensional modeling of human facial expressions and of the figure in motion is reaching a high level of development but requires more powerful computers to manipulate the immense quantity of digital information involved.

Computer-simulated graphic images or animated passages can be en-

coded as a video signal and inserted into a work as part of its totality. This provides for an unprecedented expansion of pictorial variety and texture; and in the future, the computer may play a greater role than the camera in filmmaking. Although they will have the look of photographic reality, most backgrounds and locales in Hollywood films will eventually be computer-generated. The actors will be electronically keyed-in, using computer/video techniques. Experimental computer animation is underway to perfect human imagery. We will soon see the first examples of three-dimensional actor-simulated, feature-length animation.

The Computer as Decisive Editing Controller

Computer-controlled video editing allows for freer decision-making and for a different set of conceptualizing strategies which lead to a completely new vocabulary of image/motion/sound. The graphically represented Edit Decision List is somewhat analagous to a musical score, for it represents the entire composition as a whole as it will unfold in time. Thus conceptualization of a work can even be predetermined via the Edit Decision List and approached holistically from many aspects—so that idea, image, and sound become an organic unity like a music composition before orchestral detail is determined. Added to this, the entire composition may be fed into the computer before any of it is edited. In a sense, the Edit Decision List provides the contemporary diagrammatical equivalent of the Tantric art analogies mentioned earlier.

Developed in 1974, the first viable computer-controlled editing system, the CMX, provided the equivalent of cinematic "sprocket holes" for video, and created the first opportunity for the editing of the original onto another tape and for rerecording the signal. However, basic optical techniques typical of film (such as slow motion control) could not be accomplished in video until the one-inch helical Video Tape Recorder (VTR) was introduced in 1978, when both the order and duration of motion sequences in video could be controlled by the logic of the computer as an addressable time code. Different from the tedious technique of hand-splicing film and audio mixing on an added soundtrack, video editing involves transfer of electronic image signal and sound to an auxiliary tape where it is assembled, viewed, and played back on a different tape. Electronic push-button controls are used instead of the slow hand work in splicing the original film and processing it. Multiple video signal transfers can result in loss of image quality. But advances in computer-assisted video technology have made possible far more accurate, less costly editing procedures than in film, while retaining quality.

Video pre-viewing[2] techniques to assist in shooting, and computer-

controlled editing are now regarded as indispensable by large numbers of leading filmmakers, including Francis Coppola, Jean-Luc Godard, and George Lucas. For example, unedited film footage is scanned by a video camera and etched by lasers into videodisks. In seconds, frames or sequences of frames can be located and flashed onto the preview monitor. Sequences are electronically marked and stored on a computer. When insertion is required, the editor calls back images needed and adds them to image footage already compiled. The computer list of marked frames is then turned over to a film lab where the actual film, rather than the video version of it, is copied in edited order.

The aesthetic potential of this approach, where sound and image are both recorded and addressable as electronic signals and digital information in the data space of the computer, is still under major exploration and development. The handling of large amounts of digitized information for both complex sound and image formulations require enormous computational power. Access to this technology is thus still out of reach for most artists except through outside funding and the intermediacy of a trained engineer. In the future, technological consumer advances will create even more user-friendly control structures which will also include editing instructions by voice command.

A Blurring of Distinctions between Amateur and Professional

Although advances in video technology are gradually bringing costs of high-tech equipment down, there is still a wide "opportunity" gap between the small number of artists who can get enough funding to gain access to truly broadcast-quality professional "state-of-the-art" editing and production facilities (and collaboration with top technical engineers and editors), and the larger number of independent video artists struggling to produce good work. Access to government- and state-supported media centers is one existing route. Another is joint ownership of equipment by groups of artists.

However, a new generation of miniaturized video technology aimed at the consumer market is rapidly being developed, thus bringing the concept of video use before a wide public. For example, the new camcorder, which combines in a single lightweight package the video camera and recorder, is now available in two competing forms. One of these has a standard VHS format 1/2-inch cassette, while the other has the new 8mm format with the cassette the same size as an audiocassette (8 mm camcorders are replacing the consumer super-8 movie camera).

The new video cameras incorporate a CCD (charge coupled device), which is a semiconductor silicon chip, in place of the vacuum camera tube;

and new developments in audio/visual cassette technology offer far better image and sound reproduction than ever before. Improvements in the chips made for CCDs have dramatically improved image resolution and low light capability. The public is rapidly becoming aware of the advantages of tape over film—videocassettes are less expensive, do not require processing, can be erased and reused, and can be shown immediately on the family T.V. monitor. However, Video 8 is not professional-level equipment of broadcast quality and it is aimed at the consumer market.

Industrial quality 1/2-inch Super VHS and Beta Camcorders are now capable of producing high resolution broadcast-quality video signals. Combined cost for camera and sophisticated editing console with monitors is about $7,000—phenomenally low compared to the cost of the early technology. This middle-range equipment is widely used by independent video artists who often improve and retain the quality of their images by editing on 3/4-inch consoles. Yet it is in the upper range of professional equipment where real financial obstacles to equipment access for artists exist. Top professional 3/4-inch and one-inch camera and editing equipment are still beyond the resources of most individuals (in the $30,000–40,000 range). Upper levels of professional equipment involve one-inch broadcast equipment and sophisticated computer image synthesis and processing such as the expensive equipment and expertise available at postproduction houses like Tectronics.

However, due to the strong expansion of the video market and radical new developments in video technology, the range and type of equipment which will be available at far lower cost is already on the horizon. For example, the Fairlight Computer Video Instrument which can produce sophisticated special effects is already in the $6500 range; the modified Dubner is in the $20,000 range. For the moment this price range is still out of limits for individual consumers who must still either rent equipment or own equipment collectively. Powerful new options on the level of relatively inexpensive studio equipment will gradually eradicate distinctions between professional and amateur productions in terms of access to advanced technological tools.

A widening group of autonomous artists will have access to quality video and computer technology that was once the exclusive domain of the high-tech film and video production lab. Most shoot and produce work with inexpensive cameras and special effects devices and then seek more elaborate postproduction. Some also have video printers hooked to their television sets in order to be able to print out images. For the first time, independent video artists are beginning to expect far freer rein in assuming control over the production technology of a medium. The latter rivals the potential

of film not only for its flexible dynamic approach to imagery, but also for its value as a communication tool to be shown in galleries and in homes, and also because of its ultimate transmission possibilities.

Dean Winkler, senior design engineer of VCA Teltronics in New York, is able to modify and reprogram vanguard hardware and software programs used in creating and editing video optical effects (such as the new montage system, the ADO, and the MCI/Quantel Paintbox and animation package). His extraordinary expertise has helped to attract many artists to the Teltronics postproduction facility, including Laurie Anderson. The trademarks of John Sanborn's work (particularly his music videos)—repeated, fast-paced imagery building to a dynamic fusion of forms—is a tribute also to the technical literacy of Winkler.

The prohibitive cost of renting time at highly professional production houses is sometimes over the $250 per hour mark. Artists wishing access must seek grants and court high-tech editors, find work which permits after-hours access, or seek commissions in the commercial field, all of which are highly possible and even welcomed by some companies.

Problems of Access, Training, Employment

Similar to the unemployment fears that arose following the invention of photographic processes and equipment, there is universal concern about the threat of job loss due to the growing use of computers in all the art and crafts trades. Will there be fewer jobs, for example, in the design field, in architectural drafting, or the book arts? Yes and no. Some kinds of employment will change drastically—particularly the laborious, tedious variety such as drafting and layout preparation (paste-up and mechanical). However, on the whole, this loss will be offset by an even greater variety of work requiring higher level decision-making skills. Creative ideas will be more crucial than ever. Computer literacy, in combination with a strong visual arts training, is essential in the schooling of art students if they wish to participate successfully in the changing job market. Applications lie in each of the arts: film and video (editing and production); dance (notation and choreography); music (composition and new instruments); theater (documentation and robotics); and the visual arts (photography, design, sculpture, painting, and printmaking).

Already, an impressive number of visual art departments in schools and universities in North America and Europe are acquiring equipment and reformulating their curricula to train the next generation. Recently, the North Carolina State Board of Education decided to equip all of its schools' art departments with computer graphics stations from kindergarten through high school. Demand created by graduating, computer-literate students is

already shifting university-level art training into new territory. For example, Sonia Sheridan's prototype curriculum at the Art Institute of Chicago in the 1970s (the Generative Systems Program) grouped special courses designed to create a unified "studio context for studying the implications of altered tool use" for the artist who wished to investigate critical new aspects of illusion from a Space/Time arts perspective using electronic means as well as manual and mechanical ones. At the University of Massachusetts, sculptor Robert Mallary originated a computer course for art students as early as 1973. By now, a long list of major university-level art schools offer computer graphics courses: e.g., University of Illinois, California Institute of the Arts, Minneapolis School of Art and Design, New York University, and the Pratt Institute. The School of Visual Arts, New York, offers a Masters degree program. The sentiment felt by art students that they will belong to the horse-and-buggy era if they do not know how to use a computer is being reflected in enrollments for computer graphics courses in university fine arts departments coast-to-coast.

At conferences such as Siggraph and the NCGA (National Computer Graphics Association) artists, critics, computer scientists, and vendors meet yearly in different cities around the country to survey the latest in technical and aesthetic achievements. Courses are offered in developing technologies and approaches to imaging on such topics as animation, three-dimensional solid modeling, fractals, color perception, and many other aspects of image processing. Juried exhibitions of computer-related art works ("hard copy," interactive environments, video, and film) are mounted and circulated internationally. During panel discussions such as "Aesthetics of Computer Graphics" and "The Creation of New Kinds of Interactive Environments," issues in the arts are raised and debated. Magazine articles and exhibition catalog essays are have helped to develop a critical language and a growing dialogue between artists, computer scientists, and manufacturers of computer graphics hardware and software.

Video Festivals, Conferences, Media Centers

Since the sixties, the ever-widening network of video artists has helped establish organizations to oversee cooperative working centers, set up conferences where critical issues can be debated, and organize video festivals for international screening of their work. Due to these efforts, a constant exchange of information and a cross-fertilization of ideas have taken place at a level of vital importance for artists. For example, the network is invaluable in the realm of technical information exchange because of the explosion of technical developments in the medium and its influence on the type and quality of work that can be produced.

Video conferences bring together experienced curators, artists, and critics chosen to debate theme topics. These normally include lectures, panel discussions, screenings, and provide an occasion for interpersonal dialogue and exchange. Although conflicting viewpoints are often presented, particularly between European and North American counterparts (outlook on video differs in Europe, where the accent is on installation), no other context at present can match the magnitude of ideas and experience assembled for immediate absorption at video conferences.

Other annual conferences, such as those of the American Film Institute (AFI), the National Association of Media Arts Centers (NAMAC), and the Media Alliance, are vitally important not only for their conferencing activities but also for their important policy meetings where grant-seeking strategies and future priorities are discussed.

Drastic cutbacks in federal funding due to the conservative government policies of the 1980s have led to agonizing changes in the structure of such groups. Since they elect their own officers and conduct their business democratically through open discussion, there is often strong debate about media center organizational problems and future planning. Such groups require sustained involvement and support by the independent video community in order to continue receiving grants for the vital artist services they provide: equipment rental, postproduction access centers, education, information, and video exhibition and distribution channels.

The American Film Institute has been presenting an annual National Video Festival since 1981 (cosponsored by the Sony Corporation). One of the Festival's goals is to increase video literacy by proving that its expanded possibilities are a vital new aspect of expressive communications on a broad scale, from Hollywood to broadcast television. The American Film Institute now offers enlarged video production facilites at the Center for Film Studies in Los Angeles, where about 100 full-time first-year students work in Beta I. AFI sees itself as a training ground for video and T.V. workshop production, as a granting institution, and as a showcase for exciting and innovative work.

Access and Distribution:
Cultural Archives and Public Libraries in the Video Age

The making of a television production generally requires collaboration, a factor that a widening group of independent artists is taking into account. Artists are beginning to organize, to bring their ideas into focus, and to gain important experience in locating funding and support for their ideas, for building consensus and a reputation for their work, and for trying to find distribution outlets. Some are pooling their resources to acquire new image-

processing equipment. Others are joining organizations such as the not-for-profit Media Alliance, an association of some 60 New York media arts centers and independent video producers. The Media Alliance in 1983 introduced *On Line,* a program that makes commercial-level postproduction facilities available at 50–90 percent of the market rate. The three *On Line* production facilities (two in New York and one in Rochester) provide independents with access to 3/4- and 1-inch CMX digital editing equipment, ADO and Quantel "special effects," and Chyron video titling for production of broadcast-quality tapes. Video artists can shoot on inexpensive video 8 or 1/2-inch formats and then postproduce onto the 3/4-inch or 1-inch format. Even so, it is a costly medium to work with and requires adequate postproduction facilities for a quality result. The fate of many of the organizations which make up the Media Alliance depends on funding from the New York State Council for the Arts and other public granting institutions. Not only has there been a conservative cutback in funds for media organizations and suspicion of progressive, minority group activism, but also a trend toward grants to individuals rather than institutions. The demise of midsized not-for-profit institutions such as Artist Television network, Ithaca Video Project, and T.V. Lab/Thirteen—all former Media Alliance members—points to a growing problem for independent video which is being pushed more and more into the entrepreneurial sector of the economy despite the rise of new video exhibition /production venues. The impetus of a vast new consumer interest in video is now being felt.

One of the most severe problems for independents is that of distribution. A remark made by artist Ardele Lister, panelist at a Media Alliance Conference in 1984, summed it up: "We all want an audience. I can make technically perfect work, but my work won't get on broadcast T.V. because it's weird." When it is "other" or "difficult"—intellectually challenging, expressive of strong activist points of view, abstract nonnarrative—independent video is denied showings through broadcast and cable television channels and has as yet no place to go except museums, galleries, or independent video distribution centers such as Electronic Arts Intermix, Video Data Bank libraries, or a few video boutiques.[3]

When 3/4-inch video cassettes became commercially available in 1972, their advent made possible the first standardized, easy-to-handle format for artist's tapes and marked the beginning of video centers such as New York's Electronic Arts Intermix and Castelli-Sonnabend Tapes and Film, Toronto's Art Metropole, London's London Video Arts, and Berlin's Studiogalerie Mike Steiner. This independent artist video distribution network grew enormously.

As VCRs continue to proliferate at an astonishing rate both in homes and institutions, videocassettes are gradually replacing film as an audio-

visual tool. Libraries (public or private) are a strong market to be tapped—apart from the existing institutional market in the educational field, and the cultural networks of museums and video institutes. The overall network is broadening and becoming international.

The Educational Film Library Association has found that small local libraries, which lack the money for film collections and screening facilities, are the most important beneficiaries of the new video technology and are only now able to build visual media into their offerings. Independent video makers could also benefit from the voracious appetite of home video VCR viewers who typically begin to experiment once they run out of well-known features. This is borne out by the experience of some librarians who feel that the greater casualness of at-home cassette viewing encourages risk-taking, particularly in users who prefer to rent their cassettes from the local library rather than the local video shop. If independent artists can reproduce their work as 1/2-inch home cassettes instead of solely using 3/4-inch professional tapes, they can now coattail onto mainstream distribution channels and be seen by new kinds of audiences.

Widespread availability of historically important films and video in VHS videocassette form is creating the public opportunity for the study of "cinematic history." At the turn of the century, the study of art history became possible due to the advent of the photomechanically printed reproduction of art. Videocassette reproduction of important cinema is producing a similiar impact on the visual arts. Inexpensive reproduction of videocassettes is nearing a par with access to printed photographic references. Developments in video laserdisk technology will carry this accessiblity a step further. For example, the Paris Louvre and the Washington National Gallery are cataloguing their collections on videodisks which provide rapid computer-controlled visual and audio access to specific information. Even now, specialized museum publishing of videocassettes about artists such as Gauguin, Hockney, and Degas are cheaper than books.

Impact of the VCR

Few products have penetrated the home internationally as quickly as the VCR. By 1988, 55 percent of American households owned them as compared to 33 percent in 1986. The VCR is an important phenomenon because it provides control over leisure time by allowing for more choice—rental of movies to be viewed at home and the recording of television programs for later viewing—and opens new levels of communication and influence. Home ownership of VCRs has changed the public viewing habits for both television and film and contributed to a breaking down of regulations (viewing of uncut versions of films, political films, porno films, and instructional

films), greater variety, free choice, and control of leisure time. It has allowed the establishment of new kinds of communications networks, such as inexpensive videocassettes as promotional information (selling of talents, products, events). For example, artists are making videos of their entire art production as a substitute for a studio visit; and small firms now send out promotional videos about new projects instead of paying for site visits. Family videos allow for immediacy in interpersonal communications; business videos have reached a high level of elegance and professionalism. Peace groups and political organizing groups raise money to create issue-oriented productions such as *Faces of War*—a T.V. documentary which can be shown at meetings or—if enough clout can be brought to bear—eventually on television itself. The breaking down of regulations has brought new freedom but has opened up vast areas of concern as well: the copyrighting of materials because of the ease of videocassette duplication; public rights of freedom of access to materials heretofore under government censorship; and the safeguarding of public privacy from the undue influence of private interest groups.

In 1984, the Home Recording Act was enacted specifically exempting home noncommercial VCR use from copyright laws. Challenges to existing statutes are growing with the increased pirating of software and of videocassette recording of films. Although some of this is done in the spirit of sharing, for example, among computer buffs who make copies of proprietary software disks for friends and colleagues, it is leading to stiffer controls by owner-distributors. For example, software designers and producers are building electronic "locks" into their disks so they can only be copied by a secret computer formula. Satellite communication-link commercial broadcast TV programs are fitted with electronic scrambling devices so that only paying subscribers to the programs can receive the image on their screens. The debate between public "fair use" and the legitimate claims of ownership by those who produce by using their creative intelligence is a complex one. Further challenges will arise through the development and use of more complex technologies which can either duplicate original work, or produce work specifically designed as copies.

Economically, the advent of the VCR and the prevalence of the videocassette as a powerful communications tool has caused enormous upheaval, both good and bad. The astronomical rise of the VCR rental shops has created a profitable new business while, at the same time, it has had a drastic effect on small local movie houses, forcing them either to close or to convert to multiplex theater arrangements. The whole film industry has been deeply affected now that 39 percent of the movie industry's total revenues are accounted for by videocassettes (which makes it difficult also to predict audience potential). Due to new public choice, and control over

viewing and a more educated audience, the network television industry faces loss of audience and diminished influence for their sales of commercial advertising. Viewers abandoning network television for cable, PBS, and VCR viewing tend to be more demanding, affluent, and better educated. Major questions remain unanswered as to the future of television and film industries and as to the impact of greater choice on the public itself. A recent survey showed that the VCR is promoting family togetherness by creating a functional "family viewing" of agreed-upon video materials instead of prime time T.V. fare.

Notes on Cable Television: Prospects for Expanded Viewer Choice

Community Antenna Television (CATV) was developed in the 1940s to meet two fundamental objectives. First, to obtain clear reception where natural or artificial obstacles impeded the path of the broadcast frequency channels and to bring reception to communities remote from the urban transmitters. Signals could be received by high antennas which relayed clear images to those homes that paid an original installation fee for the service. Later, cable systems were installed (in structure rather like telephone networks or gas and electric utilities) which required capital investment and led to profit-making franchises. Secondly, it was recognized by 1970 that broad-band communications (i.e., cable, because it is not over-the-air broadcasting and therefore does not take up crowded VHF or UHF spectrum space) has a capacity of up to 40 operating channels. In 1966, the F.C.C. assumed regulatory powers over cable and in 1972 specified that it allot a certain amount of free access programming to local groups. In the eighties a variety of services exist and large profits are being made. Viability of F.C.C. cable regulation was challenged in 1979. The Supreme Court ruled that even its mild public access stipulations were unconstitutional. However, the battle for free access continues.

Outside of the seven-channel broadcast network, of the electromagnetic frequency spectrum, television distribution technology falls into two categories: cable (CATV) and pay T.V., which utilizes cable as only one of several routes to households and stands as cable's largest competitor and its fastest growing aspect by encouraging development of alternative "demand" distribution linked via satellite stations and computers with a range of services. Both are subscription-supported. Most systems now in operation have a 12-channel capability, while some have 20-channel. A 40-channel system is under development.

Cable operators base their programming solely on the widest possible appeal to audiences, thereby gaining advertising support. The growth of cable has been phenomenal. In the United States it serves approximately

30 million households (about 35 percent of the market). Cable actually consists of three levels of programming: Local Origination—subscription-supported, local community-oriented, including public access; Basic Services—advertising and subscription supported, includes both local and national services such as Cable News, USA Network, ARTS, and also hooks in superstations such as WTBS (Atlanta) and WGN (Chicago); pay T.V.—subscription-supported programming includes HBO (Home Box Office), movies, Showtime, Disney Channel, etc.

Pay T.V.'s cable development also includes a broad front of competitive distribution routes and alternate delivery systems such as STV (broadcast subscription television, requiring a decoder), SMATV (satellite master-antenna T.V., requiring a receiving dish), DBS (direct-broadcast satellites, requiring a receiving dish and designed for households with several channel capacity), MFS (multipoint distribution service distributed by line-of-sight microwave with multichannel capacity), LPTV (low power T.V. community-based serving up to 15 miles), and HVN (home video network via broadcasting requiring a decoder for private video cassette recording).

Computer-linked services with cable are capable of providing such information services as wired news, weather and traffic information; educational programs; "demand" information from libraries and memory banks; medical consultancy services; public meetings, discussions, conferences and voting; "telefax" or "homofax" replication of newspapers, magazines, and other printed material; "demand" television programs, films, etc. ordered from libraries; shopping services keyed to telephone so that goods can be seen and ordered. In France, the UNITEL system is already well established.

Future expansion of delivery systems is staggering and provides possibilites for a much wider range of public services and options, including openings for cultural innovation by artists to fill the wider programming needs envisaged.

Perhaps the most revolutionary technical development lies in the area of interactive television, where the audience can respond to programs in certain ways. For example, audiences by the use of reactive button-pressing equipment, can choose the ending of a play. New advances in the next decade will open up a fascinating, broad area for exploration in the arts.

Notes

Introduction

1. Barry Blinderman, "Ed Paschke: Reflections and Digressions on 'The Body Electric,'" *Arts Magazine* (May 1982): 130.

2. Marshall McLuhan, *The Gutenberg Galaxy* (Toronto, Canada: University of Toronto Press, 1962), p. 23.

3. Quoted in Aaron Scharf's *Art and Photography* (London: Pelican Books, 1968), p. 146.

4. Katherine Dieckmann, "Electra Myths: Video, Modernism, Postmodernism," *College Art Association Art Journal* 45, no.3 (1985): 195.

5. Lucinda Furlong, "Artists and Technologists: The Computer as Imaging Tool," *Siggraph 1983*, catalogue.

6. Barry Blinderman, "Ed Paschke," p. 131.

7. Frank Popper, *Origins and Development of Kinetic Art,* translated by Stephen Bann (Greenwich, Connecticut: New York Graphic Society, 1968), p. 14.

Chapter 1

1. Sonia Sheridan, *Electra,* catalog (Musée de l'Art Moderne de la Ville de Paris, France, 1983), p. 396.

2. Ibid.

3. Ibid.

4. Andreas Huyssen, "The Hidden Dialectic: The Avant-Garde—Technology—Mass Culture," essay in *The Myths of Information: Technology and Post-Industrial Culture* , ed. Kathleen Woodward (Madison, Wisconsin: Coda Press, Inc., 1980), p. 158.

5. Sheridan, *Electra,* op. cit.

6. For the Greeks, the work *technē* meant both art and technology. The oldest engineering text, the *Mechanica* was written by the philosopher Aristotle (384–22 B.C.).

7. Recently, extensive research by art historian Charles Seymour has shown that the optical effects in Vermeer's paintings are the direct result of viewing and recording through a camera obscura. Seymour describes Vermeer's *View of Delft*: "The highlights spread into

small circles, and in such images the solidity of the form of a barge for example, is disintegrated in a way that is very close to the well-known effect of circles (or disks) of confusion in optical or photographic terms. This effect results when a pencil of light reflected as a point from an object in nature passes through a lens and is not resolved, or 'brought into focus' on a plane set up on the image side of the lens. In order to paint this optical phenomenon, Vermeer must have seen it with direct vision, for this is a phenomenon of refracted light." —Charles Seymour Jr., "Dark Chamber and Light-Filled Room: Vermeer and the Camera Obscura," *Art Bulletin* 46 (1964): 325.

8. In England, Sir Charles Eastlake, president of the Royal Academy, accepted the presidency of the Photographic Society of Great Britain; and in France, the well-known painter Baron Gros became the first president of the Société Héliographique whose other founding members included Eugene Delacroix and many prominent artists.

9. "A daguerreotype is more than a tracing, it is the mirror of the object, certain details almost always neglected in drawings from nature . . . which characteristically take on a great importance, and thus bring the artist into a full understanding of the construction. There, passages of light and shade show their true qualities, that is to say they appear with the precise degree of solidity or softness—a very delicate distinction without which there can be no suggestion of relief. However, one should not lose sight of the fact that the daguerreotype should be seen as a translator commissioned to initiate us further into the secrets of nature; because in spite of its astonishing reality in certain aspects, it is still only a reflection of the real, only a copy, in some ways false just because it is so exact." Quoted in Aaron Scharf, *Art and Photography* (New York: Penguin Books, 1986), pp. 119–20.

10. F. Lanier Graham, *Three Centuries of French Art* (Norton Simon Inc., Museum of Art, 1973), p. 41.

11. Walter Benjamin, "The Work of Art in the Age of Mechanical Reproduction," essay in *Illuminations* (New York: Schocken Books, 1978), p. 236.

12. Quoted in Van Deren Coke, *The Painter and the Photograph* (Albuquerque: University of New Mexico Press, 1974), p. 299.

13. Calvin Tompkins, *Off the Wall* (New York: Penguin Books, 1983), p. 273.

Chapter 2

1. Douglas Davis, *Art and the Future* (New York: Praeger, 1973), p. 27.

2. Michael Newman, "Postmodernism," ICA Document #4 (1987), p. 33.

3. Later, they began to collage ordinary "found" elements (such as newpaper fragments, postage stamps, nails, string)—as a kind of effluvia of the machine age—both as a reflection of the times and as a challenge to the conventional "preciousness" of standardized art materials used in the production of art projects as commodity items for the art market.

4. Their radicalism included using noise as music, shock and nonsense in theater, and the destruction of all traditional forms and institutions (including museums) in order to create an anarchistic living culture "made in the present for the present" before man could progress "beyond painting" which was seen as a symbol of the old order and thereby represented a tyranny of "good taste and harmony."

5. Rose Lee Goldberg, *Performance Art: From Futurism to the Present* (New York: Harry N. Abrams, 1988), p. 44.

6. He is credited with discovering the photogram in 1922.

7. Calvin Tomkins, *Off the Wall* (New York: Penguin Books, 1983), p.126.

8. Duchamp designed a book to accompany the work called *The Green Box*. It contained his notes and sketches about the work and was ironically presented in the spirit of an industrial equipment manual.

9. Quoted in *Ideas and Image in Recent Art,* exhibition catalog (Art Institute of Chicago, 1974), p. 10.

10. Quoted in Pontus Hultén, *The Machine,* catalog (New York: Museum of Modern Art, 1968), p. 102.

11. Quoted in ibid., p. 103.

12. These were combined with the authoritarian teachings of Albers who transmitted the Bauhaus maxim of design and use, form and function, art and life. (Albers believed in the training of perception and consciousness, a process that also involved learning to understand the true nature of materials and the relationship between them.) Among the students were Robert Rauschenberg, Kenneth Noland, John Chamberlain, and Dorothea Rockburne.

13. Riva Castleman, *Printed Art,* catalog (New York: Museum of Modern Art, 1980), p. 11.

14. By 1959, the Artists' Technical Research Institute had been founded.

Chapter 3

1. Calvin Tomkins, *Off the Wall* (New York: Penguin Books, 1985), p. 252.

2. Information from Gene Youngblood, *Expanded Cinema* (New York: E.P. Dutton, 1970).

3. Video was welcomed in the art community also as a means of documentation. Those artists doing large-scale Earth Art environmental projects rely heavily on video films and photographs as documentation of their far-away work both for funding purposes and for public awareness of their work. In the spirit of fusing art and life and locating real objects in real space, the earth artists engaged material reality—desert, sky, water, land—and executed their projects in real locales. As a testament, the photographs could never transmit the spirit and the experience of the work's true scale and presence. However, the concept of documentation of a project through the use of all aspects of photography and video became a firmly established practice for all artists, including those in the dance, theatre, and performance genres. Funding sources for these costly environmental works also began to dry up during the economic depression of the early 1970s.

4. By 1967, E.A.T. arranged for a juried exhibition Some More Beginnings at the Brooklyn Museum in the form of an international competition. Prize-winning works were to be included in the Museum of Modern Art's The Machine exhibition.

5. Tomkins, *Off the Wall,* p. 252.

6. Among the most virulent of the reviews was that of *Artforum*'s Max Kozloff. According to the art historian Jack Burnham, "Multimillion Dollar Art Boondoggle" was "probably the most vicious, inflammatory and irrational attack ever written on the art and technol-

ogy phenomenon." It posed the museum, Tuchman, and most of the artists connected with Art and Technology as lackeys of killer government, insane for new capitalist conquests in Southeast Asia. Kozloff depicted half of the artists involved as "fledgling technocrats, acting out mad science fiction fantasies."—Jack Burnham, "The Panacea that Failed," *The Myths of Information,* ed. Kathleen Woodward (Madison, Wisconsin: Coda Press, Inc. 1980), pp. 200–215. Later, bitterly, Burnham commented in the October 1971 *Artforum:* "Whether out of political conviction or paranoia, elements of the art world tend to see latent fascist aesthetics in any liaison with giant industries; it is permissible to have your fabrication done by a local sheet-metal shop, but not by Hewlett-Packard."

7. Michael Brenson, "Is Neo-Expressionism an Idea Whose Time Has Passed?," *New York Times,* Section 2, Sunday Jan. 5, 1986.

8. Abigail Solomon-Godeau, "Photography after Art Photography," in *Art after Modernism: Re-thinking Representation,* ed. Brian Wallis (New York: The New Museum of Contemporary Art, and Boston: David R. Godine, Publisher Inc., 1984), p. 80.

9. Peter Frank and Michael McKenzie, *New Used, Improved: Art of the Eighties* (New York: Abbeville Press, 1987), p. 90.

10. Much more miniaturized, affordable electronic tools have very recently evolved and these are making access to computers, video, and copiers a reality for artists. The new video camcorder (8mm) is a technical breakthrough allowing for comparable image and sound qualty as previous professional-level equipment, with interfaces to computer instruments for image manipulation. Similarly, a new generation of computer graphics systems with "paint" software, though low resolution, offers sound, and palettes of more than 4,000 colors. Copiers with separate color cartridges are available. For the first time, it is possible to equip an artist's studio for under $10,000 with camera, video, computer, and copier.

Chapter 4

1. Abigail Solomon-Godeau, "Photography after Art Photography," in *Art after Modernism: Re-Thinking Representation,* ed. Brian Wallis (New York: The New Museum of Contemporary Art, Boston: David R. Godine, Publisher Inc., 1984), p. 76.

2. Douglas Crimp, "The End of Painting," *October* 16, 1981, p. 76.

3. Jean Baudrillard, quoted in Michael Newman "Revising Postmodernism," 40. Gilles Deleuze writes further in his "Plato and the Simulacrum": "The simulacrum is not degraded copy, rather it contains a positive power which negates *both original and copy, both model and reproduction* . . . no model resists the vertigo of the simulacrum. And the privileged point of view has more existence than does the object held in common by all points of view. There is no possible hierarchy. . . . Similarity and resemblance now have as their essence only the condition of being simulated, that is, of expressing the operation of the simulacrum. Selection is no longer possible. . . . Simulation designates the power to produce an *effect.*"

4. The Public Art Fund is an organization which funds public art projects such as billboards, storefront windows, and subway and bus posters. Many artists (including some well-known mainstream ones like Barbara Kruger and Jenny Holzer) have created public art projects funded and displayed or distributed through the Public Art Fund but have contin-

ued to sell works through their galleries to support themselves, reflecting the role of art in both the private and the public sphere.

5. The first electrostatic copier was invented by Chester Carlson in 1938 to fill the ubiquitous needs of businesses for inexpensive, rapid, on-demand printing and processing. By 1948, Carlson had perfected his machine and sold his patents to the Haloid Company (later the Xerox Corporation) which released, in 1950, the first commercial dry copier for uncoated paper, the Xerox Model D.

 Carlson's process used the optics of photography but ingeniously formed direct positive images with static electricity. In this process, a special paper or photoconductive surface is made sensitive to light by the application of an electrostatic charge. When the exposure is made, it loses the charge in areas where light strikes the plate. The remaining latent image is then developed by dusting the plate with a black powder called a toner, which clings to the remaining charged areas. The image is then transferred to a sheet of plain paper having the opposite electrostatic charge and the toner is fused to the paper with heat. Electrostatic copies immediately came to be popularly known as *Xeroxes* (xerography = Greek word for dry writing), as a term synonymous with the act of copying—much to the disgruntlement of later competitors such as 3M and Kodak.

 Frantic commercial competition was underway by the early sixties to research and develop copier technology for what now became a multibillion dollar market. Although other types of copiers were introduced during the same time period, such as the 3M Thermo-Fax (heat facsimile) and the Kodak Verifax (on treated copy paper), the dominant Xerox method swept the field for its fast, low-cost, effective solution to the endless information-processing needs of the commercial world.

6. The Color-in-Color forms images with a direct electrostatic process that is coupled with a thermal dye system. A color original is successively exposed through red, green, and blue filters in a manner similar to the color separation process used by printers. Each exposure is electrostatically copied as a black tonal image directly onto a sheet of zinc-oxide coated foil. This intermediate copy is then used for heat absorption in thermographically transferring dry toner layers off the three base colors (yellow, magenta, and cyan) to plain copy paper by vaporization.

7. William Larson, *Copier Art: The Precedents,* catalog (New York: Pratt Graphics Center, National Copier Art Exhibition, 1984).

8. Xerox 6500 color copiers employ the same process color pigments—magenta, cyan, yellow—used in the printing trades for full-color half-tone reproduction. These colors are synthetic, luminous, brilliant, and are unpolluted by the standard half-tone black printing which is normally superimposed as a final printed tonal overlay for color resolution and improved detail. Until recently, this final black overlay was prohibited by law to inhibit development of a truly perfect color copier through fear of possible forgery of stamps, bonds, money, and other official documents. Now that these restrictions have been lifted, special papers with watermarks and imbedded threads have been developed for the printing of valuable documents.

 The inherent color limitations of each machine, coupled with the chromatic insensitivity of the photoconductive scanning and color separation filtration process provides a limited high-contrast chromatic range, termed functional color by the industry. Functional color systems do not provide the tonal sensitivity and realistic tonal resolution available from printing systems such as four-color halftone offset lithography. The copier's high, vivid, synthetic color is often the very attraction for artistic subject matter where expressive enhancement is sought rather than imitation—through the clarity of an intense,

limited chromatic range. Manipulation of mechanical controls of the color machine offers the opportunity for altering densities of color, changing from high contrast effect to half-tone filtering, or for dialing a print in only one or two colors instead of three. This kind of intervention and control by the artist allows for innumerable options and variations from a single image, permitting a degree of rapid experiment with color that is not possible with conventional color photography. For example, by attaching a Color Index Control Module to the Xerox 6500, the machine can be made to scan the image in four different modes (for a total of 28 variations) permitting the complete changeover of original color. A naturalistic landscape could thus be printed in completely artificial color arrangements as a kind of synthesized reality. Many artists have discovered the advantage of toning a black and white image by manipulating the controls of the color machine. Although the result is more high-contrast, the final print with its darks and lights combined with delicate blues, greens, and browns is often surprisingly satisfying and provides an important alternative. The glossy finish of the print, with its fused, polymerized toners, is also an attraction, particularly if the print has been executed on fine paper as a support.

9. Marilyn McCrae, *Electroworks,* catalog (Rochester, N.Y.: International Museum of Photography at George Eastman House, 1979), p. 8.

10. Ibid, p. 6.

11. Among others, well-known artists such as Robert Rauschenberg, David Hockney, Jean-Michel Basquiat, and Francesco Clemente.

12. New computer systems now coming onto the market include specialized software for endless manipulation of the architecture of the page to insert text and imagery as well as a capability for digitized scanning. Already, the large news weeklies can receive digitized information from all over the world by satellite through their telephone lines plugged to a computer modem. Use of the telephone modem for digitized printing refers to the earlier telecopier used by William Larson for his magnificent prints which are so full of haunting disjuncture.

13. Fax or facsimile transmission is a relatively inexpensive tool for sending any type of picture or textual information from one location to another via the telephone. Located now in almost every part of the world (there are roughly 3 million in the U.S.), fax machines receive digital messages via the telephone. The image is electronically scanned and it digitizes each picture as pixels which are then transmitted as electronic impulses to be unscrambled by the receiver.

 Dial a phone number and drop a photo or piece of paper into the fax machine. At the receiving end, the image is delivered in about 15 seconds on an 8½" × 11" sheet of paper into a desk tray. It is nearly cheaper than using the post office. The cost is the same as making a phone call on regular phone lines.

 The information about digitized text and imagery can be immediately translated onto the page for further composition before going to print. The copier in tandem with the computer is producing a revolution in the printing trades.

14. Brook Hersey, "Handle with Care: Artists' Rights and the Public Good," *Vantage Point* (Nov./Dec., 1984): 12.

15. Clarence S. Wilson, Jr., "Video and the Law: Keeping Pace with the Twentieth Century," *Darkroom Techniques 7*, no. 3 (May/June, 1986): 35.

Chapter 5

1. Cybernetics, a term coined by Norbert Weiner, is defined as "an interdisciplinary science linked with information theory, control systems, automation, artificial intelligence, computer simulated intelligence and information processing."

2. Heuristic: helping to discover or learn, guiding or furthering investigation; designating the educational method in which the student is allowed or encouraged to learn independently.

3. Quoted in Grace Glueck, "Portrait of the Artist as a Young Computer," *New York Times,* Feb. 20, 1983.

4. William Olander, *The Art of Memory: The Loss of History,* catalog (N.Y.: The New Museum of Contemporary Art, 1986), p. 12.

5. Throwing a television image out of sync provides a clear example of imagery as coded electronic information, for the screen's colored images break down to reveal multicolored points of light, much like the Impressionist pointillist paintings. In focus, the screen image seems, because of the phenomena called "persistence of vision" (conventional film images screened at 24 frames per second seem continuous) to be stable and real, although the tiny phosphors of the screen are constantly being rescanned and refreshed many times per second as information about light values and color relationships composed of the basic formulations of red, green, and blue light.

6. Bill Viola, quoted in Gene Youngblood, "A Medium Matures: Video and the Cinematic Enterprise," *The Second Link: Viewpoints on Video in the Eighties* (Banff, Canada: Walter Phillips Gallery, Banff Center of Fine Arts, 1983), p. 12.

7. For example, numbers served as a formal underpinning in religious works (the universal 4 and 3 present in the 12 apostles) and was used by cathedral architects and builders. Its use conveyed meaning communicated as part of a spiritual dimension.

8. Andy Grundberg, "Images in the Computer Age," *New York Times,* April 14, 1985.

9. Nancy Burson works with her scientist collaborators Richard Carling and David Kramlich.

10. George Trow, *Infotainment,* catalog (N.Y.: J. Berg Press, 1985), p. 21.

11. Kate Linker, "A Reflection on Postmodernism," *Artforum* (Sept., 1985): 105.

12. Quoted in ibid., p. 104.

13. With roots extending as far back as the seventeenth century when mathematicians, philosophers, and scientists such as Pascal and Leibniz began to cope with problems of calculating and storing information, the digital computer or "all purpose machine" began its precipitous ascent to its major place in contemporary life. Charles Babbage's proposal for an analytic engine (1830s), Herman Hollerith's electromechanical counting machine (1890s), Alan Turing's paper "On Computable Numbers" (1936), and John Mauchly and Presper Eckert's first progammable room-sized ENIAC computer (1946), are all milestones in the long developmental search for efficient "intelligent" machines. ENIAC filled an entire room and used 19,000 vacuum tubes any number of which could be expected to burn out in a given hour. It was capable of making about 5,000 calculations a second, although it was wired to carry out only one mathematical task at a time. Mathematician John von Neumann suggested a vitally important improvement in the way instructions could be sent into the machine through the use of electronic signals to approximate the

data about mathematical sequences. This "soft" form of electronic signal known as a program instead of the "hard" form of wiring came to be known collectively as software.

14. Black-and-white photocopy reproductions of both compositions were shown to a test group of 100 people. The computer-generated rendition was preferred by 59 of those tested.

15. Jack Burnham, *Software,* catalog (N.Y.: Jewish Museum, 1970), p. 10.

16. Siggraph is the computer graphics special interest group of the Association for Computing Machinery.

17. Quoted in Ben Templin, "Museum of Monitor Art," *Computer Entertainment* (August, 1985): 77–78.

18. Quoted in Paul Gardner,"The Electronic Palette," *Art News* 85 (Feb., 1985): 66–73.

19. Gene Youngblood, "A Medium Matures: The Myth of Computer Art," Siggraph '83 art show catalog.

20. Vibeke Sorensen, *Videography* (Feb., 1979).

21. Charles Csuri, "Computer Graphics and Applications," *IEEE Computer Society Journal,* (July, 1985): 34. See also Terry Blum, *Artware: Art and Electronics* exhibition catalog (Germany: Hanover Ce Bit Fair, March 11–19, 1986).

22. Quoted in Paul Gardner, "The Electronic Palette."

23. Quoted in ibid.

24. Quoted in Susan West, "The New Realism," *Science '84* 5 (1984): 31–39.

25. "Fractal geometry describes the irregularities and infinitely rich detail of natural shapes such as mountains and clouds. No matter how many times it is magnified, each part of a fractal object contains the same degree of the detail as the whole. In science, this new geometry feeds into existing theories about randomness and chaos in nature and has important implications in the overall study of the universe. For computer graphics, fractals represent new possibilities for mathematically mimicking the diffuse irregularity of nature. Using the new geometry, an entire mountain range can be rapidly created from just a few numbers, and it will look more realistic than one made of cones or triangles. Fractals are a category of shapes, both mathematical and natural, that have a fractional dimension. That is, instead of having a dimension of one, two, or three, theirs might be 1.5 or 2.25. A line, for instance, has one dimension, and a plane has two, but a fractal curve in the plane has a dimension between one and two. While dimension usually pertains to direction, such as height and width, the fractional part of a fractal's dimension has to do with the way the fractal structure appears under magnification. This is another peculiar characteristic of fractal objects: they contain infinite detail, no matter what scale at which they are viewed. Take, for example, a mountain from half a mile away; a mountain has countless peaks and valleys. From an ant's eye view, a tiny portion of one rocky ledge on that mountain also has countless peaks and valleys" (Susan West, ibid., pp. 32 and 37).

26. Ibid., p. 32.

27. Ibid., pp 36–37.

28. Thomas McEvilley, "The Collaboration of Word and Image in the Art of Les Levine" from the Blame God catalog (London: ICA, 1985).

Chapter 6

1. Howard Wise, known for his interest in kinetic art, also staged the first computer exhibition in his gallery. He later gave up his gallery to become a champion for video art by establishing Electronic Arts Intermix, one of the first organizations to distribute video and act as a post production studio.

2. The Kitchen was founded by video artists Steina and Woody Vasulka in 1971. It is still a major center for avant-garde performance and video works.

3. Film normally cut and spliced together by hand, using the film frame and sprocket holes as a guide. In video, the electronic signal is transferred to another tape and reassembled onto another generation of tape through the editing console. Loss of image quality occurs in this transfer.

4. The light 16mm Bolex camera has been used by "independents" since the 1940s.

5. Phillip Drummond, "Notions of Avant-Garde Cinema," from the catalog *Film as Film: Formal Experiments in Film 1910–1975,* (London: Hayward Gallery, Arts Council of Great Britain, June 3–17, 1979), p. 13.

6. The key paradigm development period of modern times (1820–1965) brought together a complex of scientific advance and technological invention which made television possible: electricity, telegraphy, photography, motion pictures, and radio. The discovery of the cathode ray tube (Campbell Swinton and Boris Rosing, 1908), the concept of a scanning system (Paul Nipkow, 1884), and picture-telegraphy transmission (Herbert Ives, 1927) were further discoveries along the way that led in 1928 to the introduction of the first low definition television system (30 lines). In 1936 the first BBC television broadcast was made from Alexandra Palace, London—and in 1939 from the World's Fair, New York.

 By the 1920s modern urban industrialized conditions and improved transportation systems created new kinds of social organization which led to tendencies towards the self-sufficient family home, sometimes far from the workplace. This "privatization" of the small family home carried "as a consequence, an imperative need for new kinds of contact . . . a new kind of 'communication': news from 'outside', from the otherwise inaccessible sources. . . . Men and women stared from its windows, or waited anxiously for messages, to learn about forces 'out there', which would determine the condition of their lives." (Raymond Williams, *Television: Technology and Cultural Form* (New York: Schocken Books, 1975), p. 27.)

7. The original NTSC recommendation of 525 lines per picture, 30 pictures per second, is still the U.S. standard. After World War II, transmission in France was raised to 819 lines. In the rest of Europe, the standard was set at 625 lines with 25 pictures per second. There is pressure building to change the U.S. standard to allow for higher picture resolution.

8. Gene Youngblood, *Expanded Cinema* (New York: E.P. Dutton, 1970).

9. In the U.S., recent surveys show average T.V. consumption as seven hours per day (almost half our waking hours). An average two to five-year old watches T.V. four to four and a half hours per day; an average 12-year old, at least six hours.

10. John Hanhardt, "Watching Television," in *Transmission,* ed. Peter D'Agostino (New York: Tanam Press, 1985), p. 59.

11. From Third World countries to highly industrialized ones, the "public resource" of T.V. is dominated by those countries which can afford to produce programming for hungry global needs. Domination of T.V. programming by commercial influences reflects erosion of the autonomy of individual nations and communities struggling to voice and project their own social, political, and cultural concerns. Mass T.V. thus represents a danger, despite its possible transformative benefits in broadening international communication and cultural exchange. "Since the 1950s, the U.S.-made T.V. programs have saturated the schedules of industrialized and nonindustrialized countries alike. Italian television, for example, is practically an affiliate of the American networks. U.S. commercial television has been a major source of programming for Third World countries as well." (Herbert Schiller, "Behind the Media Merger Movement," *The Nation* (June 8, 1985): 697.)

12. Willougby Sharp, quoted in Carl Loeffler, "Towards a T.V. Art Criticism," *Art Com #22,* 6(2) (1983): 32.

13. John Hanhardt, "Watching Television," p. 59.

14. Edward Slopeck, "Shedding the Carapace," in *The Second Link: Viewpoints on Video in the Eighties,* exhibition catalog (Banff, Canada: Walter Phillips Gallery, Banff Center, School of Fine Arts, 1983).

15. See the Appendix, pp. 202–3.

16. Martha Gever, "Meet the Press: On Paper Tiger Television," in *Transmission* (N.Y.: Tanam Press, 1985), p. 225.

17. Lucinda Furlong, "Tracking Video Art: Image Processing as a Genre," *C.A.A. Art Journal,* 45, no. 3 (Fall, 1985): 235.

18. Such as the Fairlight CVI and the Modified Dubner introduced in 1985.

19. Grace Glueck, "Video Comes into Its Own at the Whitney Biennial," *New York Times,* April 24, 1983.

20. Marita Sturken, quoted in Anna Couey, "Participating in an Electronic Public," *Art Com #25,* 7(1) (1984): 44–45.

21. Charles Hagen, "At the Whitney Biennial," *Artforum* (Summer 1985): 56.

22. Music videos are on their way to replacing records and audiocassettes in the marketplace. Consumers also often tape their own versions directly from T.V. on their home VCRs. More than 55 percent of American homes now have these. The rate is as high or higher in other parts of the world.

23. Some well-known directors such as Brian De Palma, John Landis, and even Fellini have been involved in expensive productions for pop singers such as Michael Jackson and Bruce Springsteen.

24. Nam June Paik, quoted by Laura Foti in Lynette Taylor, "We Made Home T.V.," *Art Com #23,* 6(3) (1984): 10.

25. *P.M. Magazine* is a popular news and entertainment T.V. program directed at the "happy consumer" family.

26. Quoted in Robin Reidy, "Video Effect Art/ Art Affects Video," *Art Com* #24, 6(4) (1984): 58.

27. HDTV's 1,125 line system cannot be broadcast on standard NTSC T.V. receivers because the number of transmission lines (resolution) is greater than the standard 525 × 525.

28. The Trini-Lites have a life of 8,000–10,000 hours. Sony's plans for the future include lengthening their lifespan and creating smaller versions of the Jumbotron.

29. Anna Couey, "Interactive Art and Public Culture," *Art Com* #24, 6(4) (1984): 23.

Chapter 7

1. Stephen Holden, "Monster Robots Bash Paradise in Mock Battle," *New York Times,* May 17, 1988.

2. The 1988 exhibition "Fictions," curated by John Blau, was presented simultaneously at both the Kent and Curtis Galleries.

3. Roberta Smith, "Fictions, Views of Future and Past," *New York Times,* Dec. 11, 1987.

4. Guy Debord, quoted in *The Art of Memory; Loss of History,* catalog (New York: The New Museum of Contemporary Art, 1986), p. 50.

5. Joseph J. Corn, "Epilogue," in *Imagining Tomorrow: History, Technology and the American Future* (Cambridge, Mass.: The MIT Press, 1986), p. 227.

6. Sylvère Lotringer and Paul Virilio, *Pure War,* trans. Mark Polizotti (New York: Semiotexte, Foreign Agent Series, 1983).

7. Walter Benjamin, "The Author as Producer," in his *Understanding Brecht,* trans. Anna Bostock (London: Verso, 1988).

8. Grace Glueck, "Clashing Views Reshape Art History," *New York Times,* Dec. 20, 1987.

9. Michael Newman, "Revising Modernism, Representing Postmodernism: Critical Discourses of the Visual Arts," in *ICA Documents #4, Postmodernism* (London: Institute of Contemporary Arts, 1986), p. 50.

10. Susan Sontag, *On Photography* (N.Y.: Delta Books, 1973), p. 186.

11. Quoted in Douglas Crimp, "The End of Art and the Origin of the Museum," *Art Journal* 46, no. 4 (Winter 1987): 265.

12. Ibid.

13. Artists wishing to participate in the Fund's programs apply by writing a project proposal which is then reviewed by the advisory board. The many artists on this board help to keep the level of the work innovative and of a high quality. However, these "high art" projects are a considerable distance from community-based ones such as those sponsored by City Arts which brings artists in direct contact with community people to help them visualize and announce their goals, generally through mural projects as a method for coalescing community spirit and pride.

14. Peter Frank and Michael McKenzie, *New, Used, and Improved: Art of the Eighties* (New York: Abbeville Press, 1987), p. 19.

15. Adrienne Rich, "Planetarium," 1968.

Appendix

1. Gene Youngblood, "A Medium Matures: Video and the Cinematic Enterprise," *The Second Link,* catalog (Banff, Canada: Banff Center School of Fine Arts, 1983), p. 10.

2. Jean-Luc Godard, the experimental French director, uses video extensively to assist in freer visualization of the scenes he composes. By sighting through a video camera he can clearly see and control effects of foreground, background, and reflected lighting, or the effect of camera movement or placement of actors or objects without waiting for film to be developed. This saves time and money and allows a freer rein to the creative impulse.

3. Steve Savage, a video entrepreneur in New York, is selling tapes by artists such as Michael Smith, Keith Sonnier, Dara Birnbaum, Bull Wegman, Joan Jonas, Max Almy, Cecilia Condit, Merce Cunningham, and others. "New Video" and the artists split production costs ($18 per tape) and revenue (tapes sell for $60).

Bibliography

Books

Ades, Dawn. *Photomontage*. London: Thames & Hudson, Ltd., 1976.

Alloway, Lawrence; Kuspit, Donald B.; Rosler, Martha; Van der Marck, Ian. *The Idea of the Post-Modern: Who Is Teaching It?* Seattle: University of Washington, 1981.

Appognanesi, Leia and Bennington, Geoff. *Postmodernism*. London: ICA Documents 5, 1986.

Arnason, H. H. *History of Modern Art*. New York: Harry N. Abrams, Inc.

Arnheim, Rudolf. *Toward a Psychology of Art*. Berkeley & Los Angeles: University of California Press, 1966.

_____ . *Visual Thinking*. Berkeley & Los Angeles: University of California Press, 1969.

Ashton, Dore. *American Art since 1945*. New York: Oxford University Press: 1982.

_____ . *The New York School: A Cultural Reckoning*. New York: Penguin Books, 1985.

Bagdikian, Ben H. *The Information Machines*. New York: Harper & Row, 1971.

Barthes, Roland. *Elements of Semiology*. New York: Hill and Wang, 1980.

_____ . *Mythologies*. New York: Hill & Wang, 1972.

Battcock, Gregory. *The New Art* (revised). New York: E.P. Dutton, 1973.

_____ . *New Artists Video*. New York: E.P. Dutton, 1978.

Bazin, André. *What Is Cinema?* Berkeley & Los Angeles: University of California Press, 1968.

Benjamin, Walter. *Illuminations*. New York: Schocken Books, 1978.

_____ . *On Walter Benjamin: Critical Essays and Recollections*. Ed. Gary Smith. Cambridge, Massachusetts: MIT Press, 1988.

_____ . *Reflections: Essays, Aphorisms, Autobiographical Writings*. Ed. Peter Demetz. New York: Schocken Books, 1986.

_____ . *Understanding Brecht*. New York: Verso, 1988.

Bensinger, Charles. *The Home Video Handbook*. Indianapolis: Howard W. Sams & Co., Inc., 1982.

Benthall, Jonathan. *Science and Technology in Art Today*. London: Thames & Hudson, 1972.

Berger, John. *About Looking*. New York: Pantheon Books, 1980.

_____ . *Permanent Red—Essays in Seeing*. London: Writers & Readers Publishing Cooperative, 1979.

_____ . *Ways of Seeing*. London: B.B.C. and Penguin Books, 1981.

Bernstein, Jeremy. *The Analytical Engine: Computers—Past, Present and Future*. New York: Random House, 1963.

Brand, Stewart, ed. *Whole Earth Software Catalog*. New York: Quantum Press/Doubleday, 1984.

Bronson, A. A. and Gale, Peggy, eds. *Performance by Artists*. Toronto: Art Metropole, 1979.

Burnham, Jack. *Beyond Modern Sculpture*. London: Brazillier, 1968.

————. *The Structure of Art*. New York: Brazillier, 1971.

Calder, Nigel. *Timescale: An Atlas of the 4th Dimension*. New York: Viking, 1983.

Coke, Van Deren. *The Painter and the Photograph*. Albuquerque: University of New Mexico Press, 1974.

Corn, Joseph J., ed. *Imagining Tomorrow: History, Technology and the American Future*. Cambridge, Massachusetts: The MIT Press, 1986.

Corn, Joseph and Harrigan, Brian. *Yesterday's Tomorrows*. New York: Summit, 1984.

Crichton, Michael. *Electronic Life*. New York: Alfred A. Knopf, 1983.

D'Agostino, Peter. *Transmission: Theory and Practice for a New Television Aesthetics*. New York: Tanam Press, 1985.

Davis, Douglas. *Art and the Future*. New York: Prager Publishers, 1974.

————. *Artculture*. New York: Harper & Row, 1977.

———— and Simmons, Allison, eds. *The New Television: A Public/Private Art*. Cambridge, Massachusetts: MIT Press, 1977.

De Bono, Edward, ed. *Eureka! An Illustrated History of Inventions*. London: Thames & Hudson, 1974.

Deken, Joseph. *Computer Images: State of the Art*. New York: Stewart, Tabori & Chang, 1983.

De Lauretis, Teresa; Hayssen, Andreas and Woodward, Kathleen, eds. *The Technological Imagination*. Madison: Coda Press, 1980.

Demel, John T. and Miller, Michael J. *Introduction to Computer Graphics*. Belmont, Calif.: Wadsworth, 1984.

Dessauera, J.H. and Clark, H. E., eds. *Xerography and Related Processes*. New York: Focal Press, 1965.

d'Harnoncourt, Anne and McShine, Kynaston, eds. *Marcel Duchamp*. New York: Museum of Modern Art, 1973.

Ditlea, Steve, ed. *Digital Deli*. New York: Workman, 1984.

Dupuy, Jean. *Collective Consciousness: Art Performance in the Seventies*. New York: Performing Arts Journal Publications, 1980.

Ellul, Jacques. *The Technological Society*. New York: Alfred Knopf, 1967.

Evans, Joan, ed. *Lamp of Beauty: Writings on Art by John Ruskin*. New York: Cornell University Press, 1980.

Ewen, Stuart. *Captains of Consciousness*. New York: McGraw-Hill, 1977.

Ewen, Stuart and Elizabeth. *Channels of Desire*. New York: McGraw-Hill, 1982.

Firpo, Patrick; Alexander, Lester; Katayanagi, Claudia; and Ditlea, Steve. *Copyart*. New York: Richard Marek, 1978.

Foley, James and Van Dam, Andries. *Fundamentals of Interactive Computer Graphics*. Reading, Massachusetts: Addison-Wesley, 1982.

Foster, Hal, ed. *The Anti-Aesthetic: Essays on Postmodern Culture*. Port Townsend, Washington: Bay Press, 1983.

————, ed. *Dia Art Foundation Discussions in Contemporary Culture #1*. Seattle: Bay Press, 1987.

Foucault, Michel. *Order of Things*. New York: Pantheon Books, 1970.

Frampton, Hollis. *Circles of Confusion*. Rochester, New York: Visual Studies Workshop, 1983.

Francke, H. W. *Computer Graphics/Computer Art*. London: Phaidon, 1971.

Frank, Peter and McKenzie, Michael. *New, Used and Improved: Art for the 80s*. New York, Abbeville Press, 1987.

Frascina, Francis and Harrison, Charles, eds. *Modern Art and Modernism*. New York: Harper & Row, 1982.

Fuller, Buckminster. *Operating Manual for Spaceship Earth*. Carbondale: Southern Illinois University Press, 1969.

Fuller, Peter. *Beyond the Crisis in Art*. London: Writers & Readers Publishing Coop, Ltd., 1980.

_____. *Seeing Berger: A Revaluation*. London: Writers & Readers Publishing Coop, 1981, 2nd ed.

Gablik, Suzi. *Progress in Art*. New York, Rizzoli, 1980.

Gardner, Howard. *Art, Mind & Brain*. New York: Basic Books, 1982.

Gendron, Bernard. *Technology and the Human Condition*. New York: St. Martin's Press, 1977.

Gernsheim, Helmut and Alison. *The History of Photography*. New York: McGraw-Hill, 1969.

Giedion, Siegfried. *Mechanization Takes Command*. New York, Oxford University Press, 1948.

Gill, Johanna. *Video: State of the Art*. New York: Rockefeller Foundation, 1976.

Gillette, Frank. *Between Paradigms*. New York: Gordon & Breach, 1973.

Glassner, Andrew. *Computer Graphics User's Guide*. Indianapolis: Howard W. Sams & Co., 1984.

Gombrich, E. H. *The Story of Art.*. London: Phaidon Press, 1950.

Graham, C., ed. *Vision and Visual Perception*. New York: John Wiley & Sons, 1966.

Graham, Dan. *Video-Architecture-Television*. New York: Press of N.S. College of Art and Design and New York University Press, 1979.

Graham, F. Lanier. *Three Centuries of French Art*. Norton Simon Inc. Museum of Art, 1973.

Greenberg, Donald; Marcus, Aaron; Schmidt, Allan H.; and Gorter, Vernon. *The Computer Image*. Reading, Massachusetts: Addison-Wesley, 1982.

Gregory, R. L. *The Intelligent Eye*. New York: McGraw-Hill, 1970.

Grundberg, Andy Graus and McCarthy, Kathleen. *Photography and Art: Interaction since 1946*. New York: Abbeville Press, 1987.

Hawkes, Terence. *Structuralism and Semiotics*. Berkeley and Los Angeles: University of California Press, 1977.

Heidegger, Martin. *The Question Concerning Technology and Other Essays*. New York: Harper & Row, 1977.

Henderson, Linda Dalyrymple. *The Fourth Dimension and Non-Euclidian Geometry in Modern Art*. Princeton: Princeton University Press, 1983.

Henri, Adrian. *Total Art: Environments, Happenings and Performance*. New York: Oxford University Press, 1974.

Hertz, Richard. *Theories of Contemporary Art*. Englewood Cliffs, N. J.: Prentice-Hall, 1985.

Hofstadter, Douglas. *Gödel, Escher, Bach: An Eternal Golden Braid*. New York: Basic Books, 1978.

_____ , and Dennett, Daniel. *The Mind's I*. New York: Basic Books, 1981.

Ivins, William M. *Prints and Visual Communication*. New York, Da Capo Press, 1969.

Jammes, André. *William H. Fox Talbot*. New York: Collier Books, 1973.

Janson, H. W. *History of Art*. New York: Prentice-Hall and Harry N. Abrams, 1980, 2nd ed.

Johnson, George. *Machinery of the Mind*. New York: Times Books, 1986.

Kahn, Douglas. *John Heartfield: Art and Mass Media*. New York: Tanam Press, 1985.

Keinery, John G. *Man and the Computer*. New York: Scribners, 1972.

Kepes, Gyorgy. *Language of Vision*. Chicago: Paul Theobald, 1951.

_____ . *The New Landscape in Art and Science*. Chicago: Paul Theobald, 1956.

Kern, Stephen. *The Culture of Time & Space 1880–1918*. Cambridge, Massachusetts: Harvard University Press, 1983.

Klein, A. B. *Color-Music*. London: Crosby, Lockwood & Son, 1937, 2nd ed.

Klingender, Francis D. *Art and the Industrial Revolution*. New York: Augustus M. Kelley, 1968.

Klüver, Billy; Martin, Julie and Rose, Barbara, eds. *Pavilion—Experiments in Art and Technology*. New York: E.P. Dutton & Co., 1972.

Knowlton, Ken. *Collaborations with Artists—A Programmer's Reflections.* Amsterdam: North Holland Publishing, 1972.

Kostelanetz, Richard, ed. *Moholy-Nagy.* New York: Prager Publishers, 1977.

———, ed. *Esthetics Contemporary.* Buffalo: Prometheus Books, 1978.

Krueger, Myron. *Artificial Reality.* Reading, Massachusetts: Addison-Wesley, 1983.

Lawler, James R., and Mathews, Jackson, eds. *Paul Valéry—An Anthology.* Princeton: Princeton University Press, 1977.

Leavitt, Ruth, ed. *Artist and Computer.* New York: Harmony Books, 1976.

Lewell, John. *Computer Graphics.* New York: Van Nostrand Reinhold, 1985.

Lipton, Lenny. *Independent Film Making.* New York: Simon and Schuster, 1972.

Littell, Joseph Fletcher, ed. *Coping with the Mass Media.* Evanston, Illinois: McDougal, Littel & Co., 1972.

Lucie-Smith, Edward. *Art in the Seventies.* Ithaca, New York: Cornell University Press, 1983.

Lyotard, Jean-François. *The Postmodern Condition: A Report on Knowledge.* Minneapolis: University of Minnesota Press, 1984.

MacCabe, Colin. *Godard: Images, Sounds, Politics.* Bloomington: Indiana University Press, 1980.

———, ed. *High Theory/Low Culture.* New York: St. Martin's Press, 1986.

McLuhan, Marshall. *Gutenberg Galaxy.* Toronto: University of Toronto Press, 1962.

———. *The Mechanical Bride.* Boston: Beacon Press, 1967.

———. *Understanding Media: The Extensions of Man.* New York: McGraw-Hill, 1964.

Magnenat-Thalmann, Nadia, and Thalman, Daniel. *Computer Animation—Theory and Practice.* Tokyo, Berlin, Heidelberg, New York: 1985.

Malina, Frank J., ed. *Kinetic Art: Theory and Practice.* New York: Dover Publications, 1974.

Mandelbrot, Benoit B. *The Fractal Geometry of Nature.* San Francisco: W.H. Freeman & Co., 1982.

Moholy-Nagy, Sibyl. *Laszlo Moholy-Nagy: Experiment in Totality.* Cambridge, Massachusetts: MIT Press, 1969.

Moles, Abraham. *Art and Technology.* New York: Paragon House Press.

———. *Information Theory and Esthetic Perception.* Urbana: University of Illinois Press, 1966.

Monaco, James. *How to Read a Film.* New York: Oxford University Press, 1981.

Moreau, R. *The Computer Comes of Age.* Cambridge, Massachusetts: MIT Press, 1984.

Mueller, Conrad G.; Rudolph, Mae, and eds. of *Life. Light and Vision.* New York: Time-Life Books, 1966.

Mumford, Lewis. *Art and Technics.* New York and London: Columbia University Press, 1952, 6th printing 1966.

———. *The Myth of the Machine.* New York: Harcourt, Brace & World, 1967.

Nake, Frieder, and Rosenfeld. *Graphic Languages.* Amsterdam/London: North Holland Publishing Co., 1972.

Negroponte, Nicholas. *The Architecture Machine: Toward a More Human Environment.* Cambridge, Massachussetts: MIT Press, 1970.

Nelson, Theodore. *Dream Machines: Computer Lib.* Chicago: Hugo's Book Service, 1974.

Nesbitt, John. *Megatrends, Ten New Directions Transforming Our Lives.* New York: Warner Books, 1982.

Newman, Charles. *The Post-Modern Aura.* Evanston, Illinois: Northwestern University Press, 1985.

Parenti, Michael. *Inventing Reality: Politics of the Mass Media.* New York: St. Martin's Press, 1986.

Papidakis, Andreas C., ed. *Post-Avant Garde: Painting in the Eighties*. London: Academy Group, 1987.

Paggioli, Renato. *The Theory of the Avant-Garde*. Cambridge, Massachusetts: The Belknap Press of Harvard University Press, 1968.

Parker, William E., ed. *Art and Photography—Forerunners and Influences*. Rochester, New York: Peregrine Smith Books with Visual Studies Workshop Press, 1985.

Peterson, Dale. *Genesis II: Creations and Recreation with Computers*. Reston, Virginia: Reston, 1983.

Pierre, José. *An Illustrated Dictionary of Pop Art*. Woodbury, New York: Barrons, 1977.

Pirenne, M. H. *Optics, Painting and Photography*. Cambridge, England: Cambridge University Press, 1970.

Popper, Frank. *Art, Action, and Participation*. London; New York: Studio Vista and New York University Press, 1975.

_____ . *Origins and Development of Kinetic Art*. London: Studio Vista, 1968.

Postman, Neil. *Amusing Ourselves to Death: Public Discourse in the Age of Show Business*. New York: Viking, 1985.

Prueitt, Melvin L. *Art and the Computer*. New York: McGraw-Hill, 1984.

Reichardt, Jasia. *The Computer in Art*. London; New York: Studio Vista and Van Nostrand Reinhold, 1971.

_____ . *Cybernetics, Art and Ideas*. Greenwich: New York Graphic Society, 1971.

Refkin Smith, Brian. *Soft Computing: Art and Design*. Wokingham, England: Addison Wesley, 1984.

Reinhardt, Ad. *Art-as-Art: Selected Writings*. New York: Viking, 1975.

Richter, Hans. *Dada: Art and Anti-Art*. New York and Toronto: Oxford University Press, 1978.

Richter, Irma A. *The Notebooks of Leonardo da Vinci*. Oxford: Oxford University Press, 1980.

Robinson, Richard. *The Video Primer*. New York: Perigree Books, 1983, 3rd ed.

Rose, Barbara. *American Art since 1900: A Critical History*. New York: Praeger, 1967.

Rosenberg, Harold. *The Tradition of the New*. New York: Horizon, 1959.

Rosenberg, M.J. *The Cybernetics of Art—Reason and the Rainbow*. New York: Gordon and Breach, 1983.

Rossi, Paolo. *Philosophy, Technology and the Arts in the Early Modern Era*. New York: Harper & Row, 1970.

Russett, Robert and Starr, Cecil. *Experimental Animation*. New York: Van Nostrand Reinhold, 1976.

Ryan, Paul. *Cybernetics of the Sacred*. Garden City: Doubleday Anchor, 1974.

Sandler, Irving. *The New York School*. New York: Icon Editions, Harper & Row, 1978.

Scharf, Aaron. *Art and Photography*. Allen Lane: The Penguin Press, 1968.

Schneider, Ira and Korot, Beryl, eds. *Video Art—An Anthology*. New York and London: Harcourt Brace Jovanovich, 1976.

Schwartz, Arturo. *The Complete Works of Marcel Duchamp*. New York: Abrams, 1969.

Scott, Joan, ed. *Computergraphia*. Houston: Gulf Publishing Co., 1984.

Sekula, Allan. *Photography against the Grain*. Halifax: Press of Nova Scotia College of Art and Design, 1984.

Shaffert, Roland. *Electrophotography*. London; New York: Focal Press, 1975.

Shurkin, Joel. *Engines of the Mind*. New York: Washington Square Press, 1984.

Siepmann, Eckhard. *Montage: John Heartfield*. West Berlin: Elefanten Press, 1977.

Sitney, P. Adams. *Visionary Film: The American Avant-Garde*. New York: Oxford University Press, 1974.

Solomon, Maynard, ed. *Marxism and Art*. New York: Alfred A. Knopf, 1973.

Sontag, Susan. *On Photography*. New York: Delta, 1978.

Stangos, Nikos, ed. *Concepts of Modern Art*. New York: Harper & Row, 1981, 2nd ed.

Stanley, Robert H. and Steinberg, Charles S. *The Media Environment*. New York: Hastings House, 1976.

Thackara, John. *Design after Modernism*. New York: Thames and Hudson, 1988.

Toffler, Alvin. *Future Shock*. New York: Random House, 1970.

————— . *Previews and Premises*. Boston: South End Press, 1984.

Tomkins, Calvin. *Off the Wall*. New York: Penguin Books, 1983.

————— and eds. of Time-Life Books. *The World of Marcel Duchamp 1887–1968*. Alexandria, Virginia: Time-Life Books, 1977.

Toynbee, Arnold, et al. *On the Future of Art*. New York: Viking, 1970.

Trachtenberg, Alan, ed. *Classic Essays on Photography*. New Haven, Conn.: Leete's Island Books, 1980.

Tuchman, Maurice. *Art and Technology*. New York: Viking, 1971.

Tucker, Marcia, ed. *Art and Representation: Re-Thinking Modernism*. New York: New Museum of Contemporary Art, 1986.

Utz, Peter. *The Complete Home Video Book, Vol. 2*. Englewood Cliffs, New Jersey: Prentice-Hall, 1983.

————— . *Video User's Hand-Book*. Englewood Cliffs, New Jersey: Prentice Hall, 1982.

Valéry, Paul. *Aesthetics, the Conquest of Ubiquity*. New York: Pantheon, 1964.

Van Tasse, Dennie L. and Cynthia L. *The Compleat Computer*. Chicago; Palo Alto; Toronto: Science Research Assoc. Inc., 1983, 1976, 2nd ed.

Victorues, Paul B. *Computer Art and Human Response*. Charlottesville, Virginia: Lloyd Sumner, 1968.

Virilo, Paul and Lotringer, Sylvère. *Pure War*. New York: Semniotext(e), 1983.

Vitz, Paul C. and Glimcher, Arnold B. *Modern Art and Modern Science The Parallel Analysis of Vision*. New York: Praeger, 1984.

Wallace, Robert, and eds. of Time-Life Books. *The World of Leonardo 1452–1519*. New York: Time-Life Books, 1966.

Wallis, Brian. *Art after Modernism: Re-Thinking Representation*. New York: New Museum, 1984.

Warhol, Andy, and Hackett, Pat. *POPism: The Warhol '60s*. New York: Harper & Row, 1980.

Weiner, Norbert. *God and Golem, Inc*. Cambridge, Massachusetts: MIT Press, 1964.

Wertenbaker, Lael, and eds. of U.S. News Books. *The Eye: Window to the World*. Washington, D.C.: U.S. News Books, 1981.

Whitney, John. *Digital Harmony*. Peterborough, New Hampshire: Byte Books/McGraw Hill, 1980.

Wiese, Michael. *The Independent Film and Videomakers Guide*. Woburn, Massachusetts: M. Wiese Film Productions and Focal Press, 1984.

Williams, Raymond. *The Long Revolution*. London; New York: Chatto & Windus and Columbia University Press, 1961.

————— . *Television: Technology and Cultural Form*. New York: Schocken Books, 1975.

Wilson, Mark. *Drawing with Computers*. New York: Perigree/Putnam, 1985.

Wilson, Stephen. *Using Computers to Create Art*. Englewood Cliffs, N. J.: Prentice-Hall, 1986.

Wolff, Janet. *The Social Production of Art*. New York: New York University Press, 1984

Woodward, Kathleen, ed. *The Myths of Information*. Madison: Coda Press, 1980.

Youngblood, Gene. *Expanded Cinema*. New York: E.P. Dutton, 1970.

Catalogs

Abstract Painting 1960–69. New York: P.S. 1, 1963.

Alternating Currents. New York: Alternative Museum, 1985.

Attitudes/Concepts/Images. Amsterdam: Stedlijk Museum, 1980.

Aurora Borealis. Montreal: Centre International d'Art Contemporain, 1985.

Before Photography. New York: Museum of Modern Art, 1981.

Biennial Exhibition 1985. New York: Whitney Museum of American Art, 1985.

Biennial Exhibition. New York: Whitney Museum of American Art, 1987.

Blam! The Explosion of Pop, Minimalism, and Performance 1958–1964. New York, Whitney Museum of American Art, 1984.

Cadre '84. Computers in Art and Design, Research and Education. San Jose: San Jose State University, 1983.

The Challenge of the Chip. London: Science Museum, 1980.

Comic Iconoclasm. London: I.C.A. (traveling exhibition), 1987–88.

The Committed Print. Text by Deborah Nye. New York: Museum of Modern Art, 1988.

The Computer and Its Influence on Art and Design. Text by Jacqueline R. Lipsky. Nebraska: Sheldon Memorial Art Gallery, University of Nebraska, 1983.

Copy Art, Copy Art. Text by Tom Norton and Lambert Tengenbosch. Brabantlaan, The Netherlands: OCE Industries, Inc., 1979.

Copy-Art: Electrographie-Electroradiographie-Telecopie. Dijon, France: E.N.B.A.-Media Nova, 1984.

Cybernetic Serendipity. London: I.C.A., 1968.

Disinformation: The Manufacture of Consent. Text by Noam Chomsky and Geno Rodriguez. New York: Alternative Museum, 1985.

Electroworks. Rochester, New York: International Museum of Photography at George Eastman House, 1979.

Endgame: Reference and Simulation in Recent Painting and Sculpture. Boston: I.C.A., the MIT Press, 1986.

Energized Artscience. Chicago: The Museum of Science and Industry, 1978.

Fictions. New York: Kent Gallery, Curt Marcus Gallery, 1987–88.

Film as Film: Formal Experiments in Film 1910–1975. Text by Phillip Drummond. London: Hayward Gallery, 1979.

Frank Gillette Video: Process and Metaprocess. Essay by Frank Gillette. Interview by Willoughby Sharp. Syracuse, New York: Everson Museum of Art, 1973.

German Video and Performance. Text by Wulf Herzogenrath. Toronto: Goethe Institut, 1981.

Les Immatériaux: Album et Inventaire Epreuves d'Ecritude. Paris: Centre Georges Pompidou, 1985.

Influencing Machines: The Relationship between Art and Technology. Toronto: Y.Y.Z., 1984.

Information. New York: Museum of Modern Art, 1970.

The Kitchen 1974–75. Preface by Robert Sterns. Introduction by Bruce Kurtz. New York: Haleakala, 1975.

Letters to Jill. Pati Hill. New York: Kornblee Gallery, 1979.

Light and Lens: Methods of Photography. Hudson River Museum. Dobbs Ferry, New York: Morgan & Morgan, 1973.

Lumières: Perception—Projection. Montreal: Centre International d'Art Contemporain, 1986.

The Luminous Image. Essays by Dorine Mignot, et al. Amsterdam: Stedelijk Museum, 1984.

The Media Arts in Transition. Bill Horrigan, ed. Walker Art Center, NAMAC, Minneapolis College of Art and Design, University Community Video and Film in the Cities, 1983.

Media Post Media. New York: Scott Hanson Gallery, 1988.

The Museum as Seen at the End of the Mechanical Age. New York: Museum of Modern Art, 1968.

Nam June Paik. Essays by Dieter Renke, Michael Nyman, David Ross, and John Hanhardt. New York: Whitney Museum of American Art, 1982.

National Video Festival. Los Angeles: American Film Institute, 1983.

Nine Evenings: Theatre and Engineering. Text by Billy Klüver. Statements by John Cage, et al. New York: New York Foundation for the Performing Arts, 1966.

Tom Norton: Electrographics. Essay by Jasia Reichardt. London: Whitechapel Gallery, 1977.

La Nouvelle Tendance. Essay by Karl Gerstner. Paris: Musée des Arts Decoratifs, 1964.

On Art and Artists. Chicago: School of the Art Institute of Chicago, 1985.

Photography and Art: Interactions since 1946. New York: Abbeville Press, 1987.

Photography in Printmaking. London: Victoria and Albert Museum, Compton Press and Pitman Publishing, 1979.

Printed Art. New York: Museum of Modern Art, 1980.

Report on Art and Technology. Text by Maurice Tuchman. Los Angeles: Los Angeles County Museum of Art, 1971.

James Rosenquist. Essay by Judith Goldman. Denver: Denver Art Museum and Viking Penguin, 1985.

The Second Emerging Expression Biennial. New York: Bronx Museum of the Arts, 1987.

The Second Link: Viewpoints on Video in the Eighties. Calgary, Alberta: Banff Center School of Fine Arts, 1983.

Software. Essays by Jack Burham and Theodore Nelson. Introduction by Karl Katz. New York: Jewish Museum, 1970.

Some More Beginnings. New York: E.A.T. in collaboration with the Brooklyn Museum and the Museum of Modern Art, 1968.

Technics and Creativity. New York: Museum of Modern Art, 1971.

Television's Impact on Contemporary Art. New York: Queens Museum, 1986.

This Is Tomorrow Today: The Independent Group and British Pop Art. New York: P.S. 1, 1987.

United States/Laurie Anderson. New York: Harper & Row, 1984.

Utopia, Post Utopia: Configurations of Nature and Culture in Recent Sculpture and Photography. Boston: I.C.A., 1988.

Vasulka: Buffalo, New York: Albright-Knox Art Gallery, 1978.

Video: A Retrospective 1974–1984. Long Beach, California: Long Beach Museum of Art, 1984.

Video Brut. Paris: Centre Georges Pompidou, 1985.

Vision and Television. Waltham, Massachussetts: Rose Art Museum, Brandeis University, 1970.

Bill Viola. Essays by Barbara London, J. Huberman, Donald Kuspit, and Bill Viola. New York: Museum of Modern Art, 1987–88.

Thomas Wilfred: Lumia, A Retrospective Exhibition. Washington, D.C.: The Corcoran Gallery of Art, 1971.

Robert Wilson: From a Theater of Images. Cincinnati: Contemporary Arts Center, 1980.

Articles

Adams, Brooks. "Zen and the Art of Video." *Art in America,* February, 1984.

Alloway, Lawrence. "Talking with William Rubin: The Museum Concept Is Not Infinitely Expandable." *Artforum,* October, 1974.

Art Journal, Fall, 1985. Video Issue.

ArtsCanada, October, 1973. Video Issue.

Ashton, Dore. "End and Beginning of an Age." *Arts Magazine,* December, 1968.

Bangert, Charles and Colette. "Experiences in Making Drawings by Computer and by Hand." *Leonardo 7*, 1974.

Brenson, Michael. "From Young Artists, Defiance Behind a Smiling Facade." *New York Times,* September 29, 1985.

Buchloch, Berjamin H. D. "Figures of Authority, Ciphers of Regression." *October #16*, Spring, 1981.

Burnham, Jack. "Problems in Criticism IX: Art and Technology." *Artforum,* January, 1971.

Cornock, Stroud, and Edmonds, Ernest. "The Creative Process Where the Artist is Amplified or Superseded by the Computer." *Leonardo 6*, 1973.

Costello, Marjorio. "The Big Video Picture from Japan: The Future is Projected at Tsukuba Expo '85." *Videography Magazine,* June, 1985.

Couey, Anna. "Participating in an Electronic Public: TV Art Effects Culture." *Art Com #25*, 7, 1984.

Crimp, Douglas. "The End of Painting." *October #16*, Spring, 1981.

――――. "Function of the Museum." *Artforum,* September, 1973.

――――. "On the Museum's Ruins." *October #13*, Summer, 1980.

――――. "The Photographic Activity of Postmodernism." *October #15*, Winter, 1980.

Davis, Douglas. "Art and Technology: The New Combine." *Art in America,* January/February, 1968.

――――. "Video Obscura." *Artforum,* April, 1972.

Denison, D. C. "Video Art's Guru." *New York Times,* April 28, 1982.

Dieckman, Katherine. "Electra Myths: Video, Modernism, Postmodernism." *Art Journal,* Fall, 1985.

Dietrich, Frank. "Visual Intelligence: The First Decade of Computer Art (1965–1975)." *Computer Graphics and Applications,* IEEE Computer Society Journal, July, 1985.

Dunn, John. "Computergraphics: Painting by Pixels." *Audio-Visual Communications,* February, 1985.

E.A.T. News 1, nos. 1 and 2, 1967. "New York: Experiments in Art and Technology, Inc."

Fink, Daniel A. "Vermeer's Use of the Camera Obscura." *Art Bulletin #3*, 1971.

Franke, H. W. "Computers and Visual Art." *Leonardo 4*, 1971.

Fried, Michael. "Art and Objecthood." *Artforum,* Summer, 1967.

Furlong, Lucinda. "Artists and Technologists: The Computer as An Imaging Tool." *Siggraph,* 1983 catalog.

――――. "An Interview with Gary Hill." *Afterimage,* March, 1983.

――――. "Notes Toward a History of Image-Processed Video." *Afterimage,* Summer, 1983.

Gannes, Stuart. "Lights, Cameras, Computers." *Discover Magazine,* August, 1984.

Gardner, Paul. "The Electronic Palette." *Art News,* February, 1985.

――――. "Think of Leonardo Wielding a Pixel and a Mouse." *New York Times,* April 22, 1984.

Glueck, Grace. "Portrait of the Artist as a Young Computer." *New York Times,* February 20, 1983.

――――. "Video Comes into Its Own at the Whitney Biennial." *New York Times,* April 24, 1983.

――――. "Video Work on Different Wavelengths." *New York Times,* February 26, 1984.

Gottlieb, Martin. "Copier Art, Art, Art, Art, Art." *New York Sunday News,* September 29, 1974.

Graham, Dan. "Theatre, Cinema, Power." *Parachute Magazine #31*, June, July, August, 1983.

Grundberg, Andy. "Beyond Still Imagery." *New York Times,* April 7, 1985.

――――. "Exploiting the Glut of Existing Imagery." *New York Times,* January 31, 1982.

――――. "Images in the Computer Age." *New York Times,* April 14, 1985.

Henderson, Linda Dalyrymple. "A New Facet of Cubism: 'The Fourth Dimension' and 'Non-Euclidean Geometry' Reinterpreted." *Art Quarterly*, Winter, 1971.

Heresies 16, 1983. "Film/Video."

Hess, Thomas B. "Gerbil Ex Machina." *Art News*, December, 1970.

Hutzel, Inge. "Personal Paint Systems." *Computer Graphics World*, October, 1985.

Huyssen, Andreas. "Mapping the Postmodern (Modernity and Postmodernity)." *New German Critique*, Fall, 1984.

Jacobs, David. "Of Cretans and Critics: In Search of Photographic Theory." *Afterimage*, February, 1983.

John, Brookes. "Xerox, Xerox, Xerox, Xerox." *The New Yorker*, April, 1987.

Kaprow, Allan. "The Education of the Un-Artist, Parts I, II and III." *Art in America*, February, 1971; May, 1972; and January/February, 1974.

Keyes, Ralph. "Home, Home on the Xerox." *New York Magazine*, November 17, 1980.

Kirkpatrick, Diane. "Between Mind and Machine." *Afterimage*, February, 1978.

Kozloff, Max. "Men and Machines." *Artforum*, February, 1969.

Kramer, Hilton. "What Hath Xerox Wrought." *Time Magazine*, March 1, 1976.

———. "Xeroxophilia Rages Out of Control." *New York Times*, April 11, 1980.

Kuspit, Donald. "Dan Graham: Prometheus Mediabound." *Artforum*, May, 1985.

Lippard, Lucy and Chandler, John. "The Dematerialization of Art." *Arts International #12*, 1968.

Loeffler, Carl E. "Television Art and the Video Conference." *Art Com #23*, 6, 1984.

McWillie, Judith. "Exploring Electrostatic Print Media." *Print Review #7*, Pratt Graphics Center, 1977.

Mallary, Robert. "Computer Sculpture: Six Levels of Cybernetics." *Artforum*, May, 1969.

Margolies, John S. "TV—The Next Medium." *Art in America*, September/October, 1969.

Mayor, A. Hyatt. "The Photographic Eye." *Bulletin of the Metropolitan Museum of Art*, July, 1946.

New York Times. April 25, 1982. "Video Art's Guru."

Newsweek. April 1, 1968. "Hoving of the Metropolitan: Role of Museums in a Changing Society."

Noll, Michael. "The Digital Computer as a Creative Medium." *IEEE Spectrum*, October, 1967.

Owens, Craig. "Phantasmagoria of the Media." *Art in America*, May, 1982.

———. "Representation, Appropriation and Power." *Art in America*, May, 1982.

Peterson, Dale. "Cybernetic Serendipity." *Popular Computing*, November, 1984.

Preusser, Robert. "Relating Art to Science and Technology: An Educational Experiment at M.I.T." *Leonardo 6*, 1973.

Raynor, Vivien. "Video Gaining as an Art of the Avant-Garde." *New York Times*, October 23, 1981.

Reidy, Robin. "Video Effects Art/Art Affects Video ." *Art Com #24*, 6, 1984.

Rice, Shelley. "The Luminous Image: Video Installations at the Stedlijk Museum." *Afterimage*, December, 1984.

Richardson, J.E. "Toronto: Color Xerography Show at the Ago." *Artmagazine*, December, 1976/January, 1977.

Richmond, Sheldon. "The Interaction of Art and Science." *Leonardo 17*, 1984.

Ritchin, Fred. "Photography's New Bag of Tricks." *New York Times*, November 4, 1984.

Root-Bernstein, Robert Scott. "On Paradigms and Revolutions in Science and Art: The Challenge of Interpretation." *Art Journal, College Art Association of America*, Summer, 1984.

Ross, Douglas. "Computer Artists Reveal 'Esprit de Corps' as Tough Campaign Looms." *New Art Examiner*, Summer, 1983.

Schiller, Herbert I. "Behind the Media Merger Movement." *The Nation,* June 8, 1985.

Seymour, Charles, Jr. "Dark Chamber and Light-Filled Room: Vermeer and the Camera Obscura." *Art Bulletin #46,* September, 1964.

Sheridan, Sonia. "Generative Systems." *Afterimage,* April, 1972.

_____ . "Generative Systems—Six Years Later." *Afterimage,* March, 1975.

Smith, A. "The New Media as Contexts for Creativity." *Leonardo 17,* 1984.

Soper, Susan. "Xerography, Xerography, Xerography, Xerography." *Newsday,* April 27, 1976.

Soreff, Stephen. "Publication: The Medium-Less Art." *Artworkers News,* January, 1981.

Starenko, Michael. "Fast Forward: 1984 Media Alliance Conference." *Afterimage,* December, 1984.

Strauss, David Levi. "When Is a Copy an Original?" *Afterimage,* May/June, 1976.

Sturken, Marita. "Feminist Video: Reiterating the Difference." *Afterimage,* April, 1985.

_____ . "Out of Sync." (Review-Article). *Afterimage,* November, 1983.

_____ . "TV As a Creative Medium: Howard Wise and Video Art." *Afterimage,* May, 1984.

_____ . "The Whitney Museum and the Shaping of Video Art: An Interview with John Hanhardt." *Afterimage,* May, 1983.

Sutherland, Ivan. "Computer Displays." *Scientific American,* June, 1970.

Tomkins, Calvin. "To Watch or Not to Watch." *New Yorker,* May 25, 1981.

Trend, David. "Media and Democracy: Or What's in a Namac?" *Afterimage,* December, 1984.

Turner, Frederick. "Escape from Modernism: Technology and the Future of the Imagination." *Harper's Magazine,* November, 1984.

Van Dam, Andries. "Computer Software for Graphics." *Scientific American,* September, 1984.

Vasulka, Woody and Nygren, Scott. "Didactic Video: Organizational Models of the Electronic Image." *Afterimage,* October, 1975.

West, Susan. "The New Realism." *Science '84,* July/August, 1984.

Wohlfarth, Irving. "Walter Benjamin's Image of Interpretation." *New German Critique,* Spring, 1979.

Index